Raphael. Grace and Beauty

SÉNAT

MUSÉE
LUXEMBOURG

# Raphael
## *Grace and Beauty*

SKIRA

*Design*
Marcello Francone

*Editing*
Claudio Nasso, Tim Stroud

*Layout*
Serena Parini

*Iconographical Research*
Massimo Zanella

*English Translations*
Language Consulting

First published in Italy in 2001 by
Skira Editore S.p.A.
Palazzo Casati Stampa
via Torino 61
20123 Milano
Italy

Printed and bound in Italy. First edition

ISBN 88-8491-027-7

Distributed in North America and Latin
America by Rizzoli International Publications,
Inc. through St. Martin's Press, 175 Fifth
Avenue, New York, NY 10010.
Distributed elsewhere in the world by Thames
and Hudson Ltd., 181a High Holborn, London
WC1V 7QX, United Kingdom.

*Photo Credits*

Antonio Quattrone, Firenze
© Ashmolean Museum
Picture Library, Oxford
Archivio Fotografico
Accademia Carrara, Bergamo
Archivio Fotografico Istituto
Nazionale per la Grafica,
Roma
Archivio Fotografico
Soprintendenza Beni Artistici
e Storici, Roma
© Bibliothèque nationale de
France, Paris
© Photo RMN - J. G. Berizzi
© Photo RMN - Michèle Bellot
© Bildarchiv Preußischer
Kulturbesitz, Berlin 2001
© Photo Albertina, Wien
Foto Musei Vaticani
Foto Scala, Firenze
Fotostudio Rapuzzi, Brescia
© Galleria Doria Pamphilij,
Roma
Luciano Pedicini, Napoli
© National Gallery of
Scotland Picture Library,
Edinburgh
Paolo Nannoni, Firenze
© Photo British Museum,
London
© Szépmüvészeti Múzeum,
Budapest

MUSÉE
LUXEMBOURG

19 rue de Vaugirard,
75006 Paris
Tel.: 01 42 34 28 64
Fax: 01 46 34 61 62

**Raphael
Grace and Beauty**
October 10, 2001
January 27, 2002
Paris, Musée
du Luxembourg

Musée du Luxembourg
Ministero per i Beni e le Attività Culturali

Soprintendenza
per il Patrimonio Storico Artistico
e Demoetnoantropologico
di Roma e del Lazio

The exposition is presented
by Sénat de la République française
at Musée du Luxembourg

Under the Presidency of
Mr Christian Poncelet
President of the Sénat

Delegate Artistic Direction
Patrizia Nitti, Marc Restellini

---

**Scientific Committee**

*President:* Pierluigi De Vecchi, *Dean, Facoltà di
Lettere e Filosofia, Università di Macerata*
Daniel Arasse
*Director of Studies, École des Hautes Études, Paris*
Francesco Buranelli
*Deputy Director-General, Monumenti Musei e Gallerie
Pontificie*
Konrad Oberhuber
*Professor, International Christian University, Osawa,
Mitaka*
Antonio Paolucci
*Superintendent, Patrimonio Storico Artistico e
Demoetnoantropologico delle province di Firenze,
Pistoia e Prato*
Nicola Spinosa
*Superintendent, Patrimonio Storico Artistico e
Demoetnoantropologico di Napoli*
Timothy Standring
*Art historian, Denver Art Museum, Denver*
Claudio Strinati
*Superintendent, Patrimonio Storico Artistico e
Demoetnoantropologico di Roma e del Lazio*
Nicholas Turner
*Art historian, London*

*Superintendent of the exhibition*
Claudio Strinati

*Project directors*
Patrizia Nitti, Marc Restellini

*Scientific co-ordinators*
Tullia Carratù, Morena Costantini

*Production and general organisation*
Sylvestre Verger Art Organisation
Sylvestre Verger
Marie Pierre Calmels

*Director of the conservation of the works*
Sylvaine Brans, Musées Nationaux et Musée du Louvre

*Assistant*
Hélène Desmazières
*Secretary*
Hedwige De Beaufort

**Catalog**

*Edited by* Patrizia Nitti,
Marc Restellini and Claudio Strinati

*Authors of the catalogue texts*
Daniel Arasse
Pierluigi De Vecchi
Lorenza Mochi Onori
Konrad Oberhuber
Claudio Strinati

*Authors of the painting description entries*
Sivigliano Alloisi (*S.A.*)
Irene Baldriga (*I.B.*)
Tullia Carratù (*T.C.*)
Alba Costamagna (*A.C.*)
Morena Costantini (*M.C.*)
Andrea G. De Marchi (*A.D.M.*)
Pierluigi De Vecchi (*P.D.V*)
Andreina Fasano (*A.F.*)
Cristiana Garofalo (*C.G.*)
Anna Lo Bianco (*A.L.B.*)
Lorenza Mochi Onori (*L.M.O.*)
Rossana Muzii (*R.M.*)
Antonio Paolucci (*A.P.*)
Francesco Rossi (*F.R.*)
Claudio Strinati (*C.S.*)
Jürg Mejer zur Capellen (*J.M.Z.C.*)

*Editing and graphical research*
Tommaso Strinati

*Bibliography*
Tullia Carratù, Tommaso Strinati

**Press Office**
*Observatoire:* Véronique Janneau
*Head of the Press Office, Soprintendenza per i Beni
Artistici e Storici di Roma:* Antonella Stancati
*Skira editore:* Mara Vitali Comunicazioni, Lucia Crespi

**Lay out**
*Manager:* Patrick Marant
*Conception:* Laurent Guinamard-Casati
*Assistants:* Umberto Calloni, Sophie Fonteneau

**Information design**
Gilles Guinamard

**Graphical design**
Jean Claude Barotto

Our grateful thanks are extended to all those whose generous contribution has enabled this exhibition to be held, in particular:

S.E. Cardinale Paul Poupard
*President, Consiglio Pontificio per la Cultura*
Giuliano Urbani
*Minister, Ministero per i Beni e le Attività Culturali*

*For the Senate*
Alain Méar
*Director of the Cabinet and President of the Senate*
Yves Marek
*Cultural Advisor to the President's Cabinet*
Hélène Ponceau
*Secretary-General, Police Headquarters*
Generals Paul Moulian and Jean-Claude Jegou
*Military commanders of the Palais du Luxembourg*
Alain Di Stefano
*Director, Architecture, Bâtiments et Jardins*
Claude Dufour
*Architecture Service*

*For the Ministero per i Beni e le Attività Cukturali di Roma*
Vittorio Sgarbi,
*Under-Secretary to the Minister, Ministero per i Beni e le Attività Culturali*
Carmelo Rocca
*Secretary-general*
Mario Ciaccia
*Director of the Cabinet*
Bruno De Santis
*Assistant Director of the Cabinet*
Laura Napoleone
*Assistant Director of the Cabinet*
Mario Turetta
*Administrator of the Cabinet*

*For the Administrative Department, Soprintentenza per il Patrimonio Storico Artistico e Demoetnoantropologico*
Mario Serio
*Director-General*
Alfredo Giacomazzi
*Assistant Director*
Maria Grazia Benini
*Director Service IV*

*For the Soprintendenza Regionale del Lazio*
Ruggero Martines
*Superintendent*

*For the Soprintendenza per il Patrimonio Storico Artistico e Demoetnoantropologico di Roma e del Lazio*
Claudio Strinati
*Superintendent*

*Secretariat to the Soprintendenza*
Gennaro Aliperta, Giuseppina Biolcati Rinaldi, Carmela Crisafulli, Rosalba Righi, Alessandro Toni

*In addition:*
Federico Di Roberto
*Italian Ambassador to France*
Jacques Blot
*French Ambassador to Italy*
Mario Serio
*Director-General, Ministero per i Beni e le Attività Culturali*
Vincenzo Grassi
*Cultural Advisor to the Italian Embassy in Paris*
Patrick Talbot
*Cultural Advisor to the French Embassy in Rome*
David Caméo
*Advisor to the Prime Minister's Cabinet*
Alain Genestar
*Editor-in-Chief, Paris Match*

François Debouté
*Communications Director, Paris Match*
Jean-François Chaigneau
*Assistant Editor-in-Chief, Paris Match*
Laetitia de Luca
*Marketing and Communications Director, LCI*
Jean-Marie Cavada
*President, Radio-France and France Info*
Claudine Salmon
*France Info*
Jean-Pierre Elkabach
*Public Sénat*
Christian Mantéi
*Director of the Tourist Office in Paris*
Jean-Claude Decaux
*President of J.C Decaux*
Jean-Pierre Serrus
*Director-General, Avenir Société J.C Decaux*
Jean-Paul Bailly
*President of RATP*
Antoine Dupin
*Cabinet of the President of RATP*
Gérard Gros and Yann Collardel
*Métrobus*
Estée Lauder for their contribution to the restoration of *La Fornarina*
Maurice Benhamou, Mario Garibaldi, Catherine Royer, Eronimo Saavedra, Daniel Wildenstein

And to Dr. Gustav Rau for his generous support

and to all those who prefer to remain anonymous.

Our thanks are also owed to the Superintendents, Presidents and Directors of the following institutions:

**France**
*Paris, Bibliothèque nationale de France*
Jean-Pierre Angrémy, Académie française
*Département des Estampes et de la Photographie*
Laure Maillet
*Delegate for cultural distribution:* Thierry Grillet
*Paris, Musée du Louvre*
Henri Loyrette
*Département des Peintures:*
Jean-Pierre Cuzin
*Département des Arts Graphiques:* Françoise Viatte
Catherine Loisel

**Germany**
*Berlin, Staatliche Museen, Gemäldegalerie*
Jan Kelch, Roberto Contini

**Great Britain**
*Edinburgh, National Gallery of Scotland*
Michael Clarke, Aidan Weston-Lewis

**Hungary**
*Budapest, Szépmüvészeti Múzeum*
Miklós Mojzer, Vilmos Tátrai

**Italy**
*Bergamo, Accademia Carrara di Belle Arti*
Francesco Rossi, Rossella Colleone
*Brescia, Civici Musei d'Arte e Storia*
Renata Stradiotti, Elena Ragni
*Florence, Soprintendenza per i Beni Artistici e Storici delle Province di Firenze, Pistoia e Prato*
Antonio Paolucci
*Florence, Galleria degli Uffizi e Gabinetto disegni e Stampe degli Uffizi*
Anna Maria Petrioli Tofani

*Florence, Galleria Palatina e Appartamenti Reali di Palazzo Pitti*
Serena Padovani
*Florence, Museo della Fondazione Horne*
Umberto Baldini, Licia Bertani
*Naples, Soprintendenza per i Beni Artistici e Storici di Napoli, Museo di Capodimonte*
Nicola Spinosa
*Rome, Galleria Nazionale d'Arte Antica di Palazzo Barberini*
Lorenza Mochi Onori
*Rome, Galleria Borghese*
Alba Costamagna
*Rome, Galleria Corsini*
Sigliano Alloisi
*Rome, Galleria Doria Pamphilij*
Jonathan Doria Pamphilij
Andrea G. De Marchi
*Rome, Istituto Nazionale per la Grafica*
Serenita Papaldo

**Vatican City**
*Monumenti Musei e Gallerie Pontificie*
Francesco Buranelli

And, in particular, for their kind collaboration:
Gennaro Aliperta, Orsola Bonifati, Daniela Cecchini, Alessandra Chioetto, Roberto Contini, Paolo Corsini (Mayor of Brescia), Alba Costamagna, Paolo Dal Poggetto, Peter Day, Lia Di Giacomo, Laura Ferretti, Maria Teresa Gallo, Achin Gnamm, Silvana Grosso, Giorgio Guarnieri, Lorenza Mochi Onori, Serenita Papaldo, Elvira Rainone, Francesca Strano, Almamaria Tantillo, Vilmos Tátrai, Egon Verhayen, Gianfranco Zecca.

*The Musée du Luxembourg, falling within the bounds of the Palais du Luxembourg and placed under the responsibility of the Senate, has a prestigious history.*

*Since 1615, Marie de' Medici had wanted the Palais du Luxembourg to house two galleries which were to contain paintings. It was for these galleries that Rubens would paint the* History of the Queen, *now to be seen at the Louvre. From 1750, the Musée du Luxembourg became the first picture gallery to open to the public, where works by Leonardo da Vinci, Titian, Veronese, Rembrandt, Van Dyck, Poussin and... Raphael could be admired.*

*In 1818, the Musée du Luxembourg became the Museum of Living Artists and a sort of early "Museum of Modern Art". It exhibited David, Gros, Girodet, Vernet, Ingres and Delacroix. Between 1884 and 1886, the Senate commissioned the construction of the building that currently houses the Museum and was to receive the substantial Caillebotte bequest. Works by Picasso, Bonnard, Renoir, Degas and Gauguin could be admired there until 1937 when the collections were transferred to the new Museum of Modern Art.*

*With the new agreement I have signed with the Minister for Culture and the magnificent exhibition of the masterpieces from the collection of Docteur Rau, the year 2000 – with 300,000 visitors – marked the renaissance of the Musée du Luxembourg which has now regained its leading position on the Parisian and international stage. I wanted the Musée du Luxembourg to renew its*

*links with the past and to assign itself a special vocation whereby it would at regular intervals provide a showcase for the incomparable heritage of Italy. The* Raphael. Grace and Beauty *exhibition is the first outcome of this policy, a brilliant and magnificent undertaking that does honour to the Senate.*

*The Senate has the fortune to welcome an almost miraculous exhibition; seldom has the master from Urbino been the object of such a presentation, only rarely are his works lent, and in some cases not at all: they never leave the museums that hold them. The French and foreign public will for the first time see some works that have not been united for 500 years, and which will now renew a mysterious and profound association. With these portraits that symbolise the perfection of Grace and Beauty, and a certain idea of man that still underlies our civilisation, the curators of this exhibition have succeeded in putting together a group of works that makes this exhibition itself a period of grace.*

*I wish to give my special thanks to the general commissioner, Claudio Strinati, for having accepted the task of seeing this venture through, for having faith in it despite all the apparent impossibilities, and for having succeeded in bringing to fruition an ambitious, pertinent project. Equally, I thank the eminent members of the Scientific Committee, Pierluigi De Vecchi, Konrad Oberhuber, Francesco Buranelli, Nicola Spinosa, Antonio Paolucci, Timothy Standring, Daniel Arasse and Nicholas Turner, for having brought their skills, enthusiasm and authority to*

*this project so that it would prove scientifically irreproachable. The meetings of the scientific committee, held in the presidential offices of the Senate, gave rise to a pyrotechnical display of erudition, refinement and humour – for there can be no great knowledge without its celebration.*

*In this regard, I find it agreeable to note how important it is, in a cultural Europe that we all wish for, that a national institution such as the Senate at the heart of the state should receive an exhibition that pays homage to the art of another nation, and above all that it should do so by placing the criterion of competence above that of frontiers and barriers, and by relying on an international scientific committee.*

*An international project, this exhibition is above all else the result of a marvellous collaboration between the Senate and the Italian authorities, without whom this project could not have seen the light of day, and whom I wish to thank: the successive Heritage Ministers responsible who have honoured the Senate by agreeing to its plan of making the Musée du Luxembourg the location for this magnificent exhibition, Mario Serio, the Director-General of cultural affairs and his administration, and Federico Di Roberto, the Italian ambassador to France who, through his cultural advisor Vincenzo Grassi, in liaison with France's ambassador in Rome, Jacques Blot, followed this project very closely, through his cultural advisor Patrick Talbot.*

*I wish also to greet and thank for their collaboration Cardinal Paul Poupard and Francesco Buranelli, who brought the valuable assistance of the Vatican to this enterprise.*

*Finally, I must thank all the lending museums who have made a rare, exceptional sacrifice, the extent of which we are well aware of, as well as Sig.ra Patrizia Nitti, whose experience in Franco-Italian cultural relations, talent, and strength of persuasion enabled the success of the project, M. Marc Restellini, who assisted her in the preparation of the exhibition and Sylvestre Verger, who organised it with remarkable professionalism.*

*I express the wish that this exceptional exhibition, which cannot fail to fascinate a vast public, succeeds in bringing to the visitors, with this fresh view at the threshold of the century, a little of the grace and perfection that Raphael's work represents, and that it proves a fruitful symbol for a Europe of Culture that is more respectful of the richness and identity of the nations that form it.*

Christian Poncelet

*When the Senate wished to reconsider the Museum's exhibitions policy, one of President Poncelet's wishes was to lay emphasis on Italy's past and, at the same time, to recall its links with the Medicis. It seemed quite clear to us that the first painter to whom we should render homage should be the* most perfect *of them all, Raphael. This proposal was accepted straight away and with great enthusiasm by the President.*

*An exceptional painter, Raphael was also a singular personality whose work over the years has aroused many and easily understandable enthusiastic responses. Let us quote just one. During his visit to Rome in April 1906, Elie Faure was on his way back from Greece: Rome, with its overwhelming nature and sadness caused by the weight of centuries, was crushing him but his encounter with Raphael's art suddenly uplifted him.*

*"Raphael has overwhelmed me. What ease and what young and pure grace despite a consummate science and an adult reason. He is a Greek lost in a Catholic country... He is the Mozart of painting; he has the same powerful, discreet grace. He is always so knowledgeable and always remains so young. We were suffering beneath the heavy embrace of the ruins of ancient Rome. Raphael has given us back our freedom."*

*It is true to say that Raphael does not just give us something to look at, but also enables us to breathe. Perhaps, this power should be attributed to his* sprezzatura. *It is therefore legitimate that this should be evoked in the title chosen by the* scientific Committee for the Raphael, Grace and Beauty *exhibition. Here is indeed an œuvre on which dust cannot settle. Neither the dust of time, nor that of the innumerable notes and commentaries accompanying it. Not only does it preserve a perpetual freshness, but it has within it the faculty for a renewal which, whatever the century and the circumstances, brings it close to every viewer. So close, indeed, that the idea of an exhibition on Raphael did not intimidate us. However, nothing would have been possible without the trust accorded us by the Italian authorities, first among which were the two ministers for Culture, Giovanna Melandri and Giuliano Urbani. Thanks must also go to His Eminence Cardinal Paul Poupard, President of the Pontifical Council for Culture. The same also to Mario Serio, Director-General of Heritage and the French ambassador in Italy, Jacques Blot, and the Italian ambassador in France, Federico Di Roberto.*

*Together, they enabled the Scientific committee to work under the best possible conditions. This Committee, of which Professor Claudio Strinati, Commissioner for Cultural Heritage in Rome and Commissioner for the exhibition, was the soul and manager, brought together Professors Daniel Arasse, Francesco Buranelli, Pier Luigi De Vecchi, Konrad Oberhuber, Antonio Paolucci, Nicola Spinosa, Timothy Standring and Nicholas Turner. I wish to thank all of them here for the extraordinary scientific and museological work which they have provided. We must also make a special mention here of Professor Pier Luigi De*

*Vecchi for the unlimited assistance which he has given us.*

*Being able to work with such an eminent group of art historians was a constant blessing. Our thanks must also go to all the institutions that allowed themselves to be separated from exceptional works, some of which left their museums for the first time and others which are here exhibited in France for the first time. We are here thinking of the Monumenti, Musei e Gallerie Pontificie; the Galleria Nazionale d' Arte Antica, the Galleria Borghese, the Galleria Corsini, the Galleria Doria Pamphilj the Istituto Nazionale per la Grafica in Rome; the Galleria degli Uffizi, the Galleria Palatina di Palazzo Pitti, the Museo della Fondazione Horne in Florence, the Accademia Carrara di Belle Arti in Bergamo; the Civici Musei d'Arte e Storia in Brescia; the Museo Nazionale di Capodimonte of Naples; the Staatlische Museum Gemaldegalerie in Berlin; the National Gallery of Scotland; the Szépmüvészeti Museum in Budapest; the Bibliothèque Nationale de France and the Musée du Louvre. We also wish to express our greatest gratitude to Monsieur David Caméo, adviser to the minister for culture and then to the Prime Minister, for his constant, sensible support of the policies of the Musée du Luxembourg. All made an exceptional contribution to the exhibition. Finally, how could we not mention the determination of Monsieur Alain Méar, director of the Cabinet of the President of the Senate, the infinite patience and tenacity of Monsieur Yves Marek, Advisor to the President of the Senate, and the permanent support of Cultural Counsellors of France in Rome, Patrick Talbot, and of Italy in Paris, Vincenzo Grassi; likewise the invaluable assistance of Morena Costantini and Tullia Carratù of the Commission for Cultural Heritage in Rome, who were responsible for ensuring smooth technical co-ordination with the Exhibition Commission.*

*It would be perfectly unjust to forget the generous collaboration accorded us by Massimo Vitta Zelman, president of Skira publishing house.*

*Thanks also to Sylvestre Verger for the care he brought to the organisation of this exhibition.*

*Last and not least in what is everything but a formal list of thanks appear* Paris Match *and* LCI, France Info, Métrobus *and* Jean-Claude Decaux, *partners for the exhibition, and to whom we owe a great debt of gratitude.*

Patrizia Nitti, Marc Restellini
Artistic directors

# Contents

*Claudio Strinati*

# Raphael Biography from the Portrait Point of View

The face of Raphael is clearly seen in the *School of Athens* in the "Stanza della Segnatura" in the Vatican. The work may have been done in 1509 because it is recorded that Raphael was paid for the first time in January of that year. It is also probable that after having finished the first fresco in the room, the *Exaltation of the Eucharist*, now referred to as the *Dispute over the Holy Sacrament*, he got right to work on the *School of Athens* itself. At that time the master of masters was a man of twenty-six or twenty-seven years with anything but a heroic and strong-willed aspect. What is striking is the comparison that can be made with other celebrated self-portraits by artists of that day, such as the famous ones of Perugino in the Sala del Cambio in Perugia, of Pinturicchio in the Baglioni Chapel in the Duomo di Spello, or of Signorelli in the Chapel of S. Brizio in Orvieto, all dating to around 1500. They are proud and authoritative self-portraits. Raphael does it differently. With extreme discretion and modesty, his extraordinarily youthful face wedges itself in among the symbolic heads of the great philosophers Zoroaster and Ptolomy and that of another character whom the critics have always imagined was a painter. But his identity has remained a mystery and the various hypotheses advanced over the years have all been discarded. It is certainly not Perugino; it is not Pinturicchio; and it is not Signorelli. But it cannot be excluded that the beautiful, smiling head, surrounded by a soft chiaroscuro, is the head of Agostino Chigi, the Papal banker who was quite probably the great mentor of the Urbino artist and perhaps the very person who introduced Raphael to that extraordinary commission to do the Stanze in the Vatican. Raphael remained in Agostino's orbit for his whole life. Agostino commissioned him to do the frescoes in his Villa on the Tiber and to decorate his chapel in the Roman church of S. Maria della Pace. This may explain the homage rendered him. Raphael even put off doing his own self-portrait until he had finished that of his principal patron. But there is a clear and beautiful contrast between the canny face of the presumed Agostino Chigi and the meek and timid face in Raphael's self portrait.

But the reality was a little different. Raphael entered the Stanze as the absolute dominator of the world of painting and there created his gymnasium of revolutionary exercises. He founded his school in the Stanze, working out a completely different and innovative way of painting, of composing the figurative discourse, of elaborating symbols and meanings. His work expanded beyond all bounds and the results became law for future generations.

But no one looking into those eyes in the admirable self-portrait in the *School of Athens* would have seen that; they may or may not have been intimidated but those eyes certainly expressed puzzlement. It can be seen how Raphael conceived the portrait as an image "in the process of becoming", in which the intelligent observer can decipher a state of mind, a destiny, a visage, and an intention.

That the portrait is, in any case, the symbol of the history of an individual was not yet clear at the time of Raphael's early youth when the portraitist *par excellence* might have been mistaken for Antonello da Messina, the extremely sharp investigator of

faces which were realistic yet metaphysical because they were derived from a figurative ideal nourished by geometric lucidity and a lenticular depiction of light. Antonello had spent a good part of the second half of the 15th century developing a pictorial language that would be inextricably linked to him, and it was with portraits that he had achieved some of his loftiest results. He died just four years before the birth of Raphael and the outstanding Urbinite began almost where the Sicilian painter had left off. With an important clause however, that there was another great model against which Raphael would measure himself in Rome: the one created by the titan of the old generation, Mantegna, who died just three years before Raphael entered the scene in Rome. Mantegna was surrounded by undying fame and glory as the master and inescapable guiding light of the new generations, above and beyond the notable merits of Perugino, Raphael's true teacher. Little can be said about the chapel that Mantegna frescoed with great dedication in the Papal Palace, since it was destroyed in the 1800s, but it is worth recalling that this chapel dated back to less than twenty years before the Urbino artist arrived in the Stanze, and could thus still be considered a modern work worthy of full regard.

The dialectic between Antonello and Mantegna in the second half of the 15th century is fundamental in understanding Raphael's intentions as he began work on the Stanze. Mantegna was the cruel and petrifying portraitist *par excellence* as is fully attested by the Camera degli Sposi in the Castle of S. Giorgio in Mantua, to be considered one of the greatest and most secret incunabula of Raphael's Stanze. The Gonzaga portraits in that memorable room are all conceived along the lines of the most typical Mantegnesque approach, aimed at investigating physiognomy with the acumen of an inspector who does not believe in an optimistic vision of things but seeks a sort of ancestral blot in everything, an original sin of the material that the artist reveals within the immobile and impassive sacredness of the passage of time.

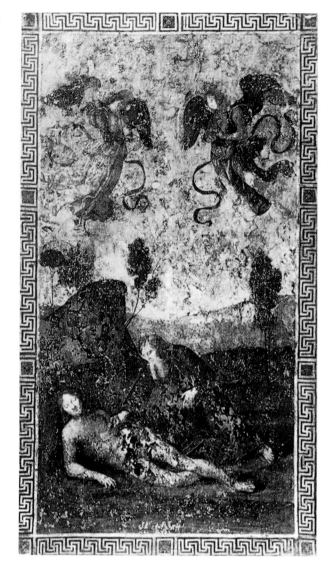

Raphael Sanzio
*Creation of Eve* (*verso* of the *Stendardo della Trinità*),
1500
Oil on canvas, 166×94 cm
Città di Castello, Pinacoteca Comunale.

Antonello, on the other hand, was animated by an extremely vivacious and alert sense of existence. He believed, as opposed to Mantegna, in a sort of universal animation that leads to an optimistic formula capable of revealing the limit that separates the articulate reconstruction of the countenance from the true comprehension of the human soul. They are the two great extremes of the Humanism and Raphael certainly knew them very well if he appears so discreet and delicate in introducing his own work into the Stanze. And all this is not strange when one reflects on Raphael's personal history. It is not strange, in other words, that such a young painter, one who was not imbued with a Humanist outlook, at least not in the year 1509, could think so big and skillfully dominate the entire history of the art of his times, apprehended at its peaks and relived with complete independence.

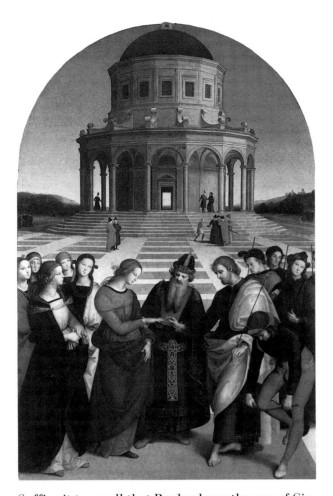

Raphael Sanzio
*The Engagement of Virgin Mary*, 1504
Oil on wood, 174 × 121 cm
Milan, Pinacoteca di Brera.

Suffice it to recall that Raphael was the son of Giovanni Santi, painter and outstanding connoisseur of the art of his day, author of a rhyming *Chronicle*, where, with great acumen, he reconstructed a sweeping overview of Humanistic art, with highly pertinent judgments that certainly were not unknown to his son. However, Giovanni died shortly after Raphael's eleventh birthday and we cannot know to what extent the paternal influence counted in the earliest experiences of his son. It is certain, however, that Raphael was born into an environment where making art and studying art history were cultivated with equal dedication and intensity and this had to be important in the young artist's complex formation.

At the beginning the concepts of the portrait and of an investigation of the visual realm that searches for a true image of reality were doubtlessly far from Raphael's thinking. They certainly were alien to his father's mindset and from the painters in whose direction Giovanni Santi urged his son, such as Evangelista di Pian di Meleto of whom very little is known except for the fact that the seventeen year-old Raphael drew up a contract with him on December 10, 1500 for the altarpiece of the Baronci Chapel in the church of S. Agostino in Città di Castello. We can go no further back into the early youth of the Urbino artist and so that date has to be taken as the beginning of Raphael's career. Since the altarpiece has been destroyed except for a few fragments, making it an arduous task to distinguish between the absolutely sure hand of the adolescent painter and the more mature hand of the almost unknown Evangelista, we are unable to gather what was, at that moment, the true figurative culture of Raphael and to what extent the great issue of modern portrait painting had an effect on the development of his style. From remnants of an 18<sup>th</sup> century copy of the altarpiece portraying *S. Nicola da Tolentino* and kept in the Pinacoteca Comunale of Città di Castello, an idea of the large altarpiece can be reconstructed. As documented by several drawings, Raphael's contribution included especially admirable graphic works demonstrating the skill that would remain with him to his final days and constitute a constant source of admiration and wonder for his contemporaries and later generations. It was a skill in defining the form, of making its presence felt in space, of constructing the image with the solemnity and composure of reason guided by an inexhaustible flow of inspiration. One understands immediately that the premises that would lead him to later prodigious works are already there in his earliest ventures, but the time was not quite ripe.

For the time being, Raphael moved in a complex and stratified area of culture comprising very important contributions and sediments of aging traditions tending to a sort of stagnancy. If the Standard of the church of the Holy Trinity in Città di Castello (now in the Pinacoteca) were really from the year 1500, as has often been supposed, we would have to conclude that Raphael had already achieved a great deal of independence from the presumably dry and anti-naturalistic style of Evangelista di Pian di Meleto and that, as often happens

with true geniuses, had immediately found his path towards modern naturalism. It is true that the Standard is in a poor state of conservation and not easily deciphered in all its components, but the power of the scene of the *Creation of Eve* has nothing in common with that polite epigonism deriving from the lessons of Raphael's father, Giovanni Santi, which were very likely also applied by Evangelista.

Urbino and Città di Castello are not far from one another and following the road that descends from the Apennines you arrive in Perugia, where, in that fateful year 1500, Perugino was involved in his great work in the Sala del Cambio in the Palazzo dei Priori. The work is interesting because it was the mature product of one of Italy's most important painters and, even if the true relationship between Evangelista and Raphael is not known, it is quite likely that a provincial painter like Evangelista di Pian di Meleto would have been connected to the Perugia scene. So it is not unwarranted to imagine that Raphael arrived in Perugia and witnessed Perugino at work. It is less probable, as has sometimes been thought, that Raphael was immediately enlisted in the Perugino circle and actively collaborated in work on the Sala del Cambio. But in the meantime, this work established a technique and a modus operandi which were decisive in the evolution of the naturalistic trends of the emerging Rinascimento. The Sala del Cambio is a colossal paradox from this standpoint because it is the work of a very powerful naturalist, as Perugino doubtlessly was. He was ostentatiously anti-naturalistic but actually full of mannerisms, and exhibited an insistence on the predominance of graphic elements and ostensible schematisms. It was as if Perugino had wanted to compress and mask his true capacities, constraining himself into a world of conventions that provided supremely pleasing results for the patrons, who care above all about the intrinsic perfection and beauty of the artistic product.

Raphael certainly worked a great deal and his contributions have been sought out in various areas

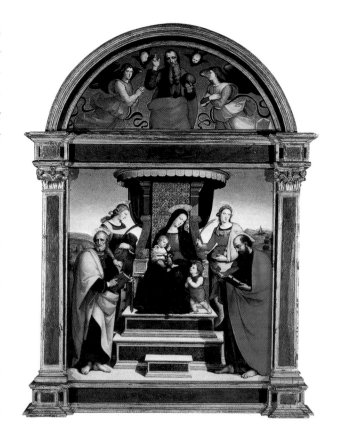

Raphael Sanzio
*Colonna Altarpiece, door* 1505
Oil on wood, 98×68 cm
(unframed)
New York, The Metropolitan
Museum of Art.

of Italian art connected at that time with Perugino's ideas. He was sought, for example, in the Libreria Piccolomini in the Duomo of Siena frescoed by Pinturicchio and pupils on the basis of a drawing in the Gabinetto Disegni e Stampe of the Uffizi with the *Departure of Enea Silvio Piccolomini* for the Basel Council, but the evidence is weak. Pinturicchio was at that time a sort of Perugino carried to extremes, insisting on a line of radically anti-naturalistic figurative thought. It was, logically, a generalized hypocrisy in which the pictorial material conceived by the artist was naturalistic but his style was anti-naturalistic. The results were and remain extraordinary, and for Raphael, that world could not fail to constitute a model to be imitated – at first. But it was soon clear to him that this was not his path, for he would risk becoming a great painter but a mediocre artist.

During this period which lasted, off and on, about three years, Raphael did not take on the great themes of naturalism and did not undertake any portraits. But according to Vasari, Pinturicchio was a great friend of Raphael's, and brought him to work in the Libreria Piccolomini. We are now in

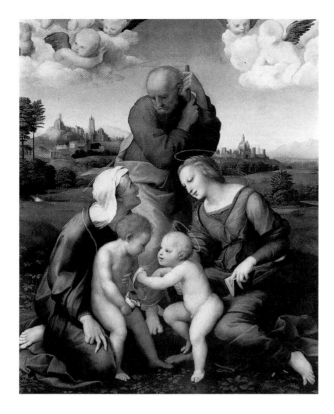

Raphael Sanzio
*Canigiani Holy Family*,
1507-1508
Oil on wood, 131 × 107 cm
Munich, Alte Pinakothek.

the year 1502. However, this evidence becomes questionable if one accepts that the Oddi altarpiece (now in the Vatican Galleries) for the Perugia church of S. Francesco was done in 1502-03 and that the Mond *Crucifixion* (National Gallery in London), an altarpiece for the church of S. Domenico in Città di Castello, dates back to 1503, because this was the date inscribed on the altar originally bearing it.

In the Mond *Crucifixion*, as in the immediately subsequent *Wedding of the Virgin* of 1504 (Pinacoteca di Brera, Milan) also done for the church of S. Francesco in Città di Castello, the Perugino style is extremely intense and almost asphyxiating in its perfect willingness to imitate. The Oddi altarpiece, on the other hand, is different and seems to be much closer to the powerful naturalism of the Standard of Città di Castello. It is important to observe that the Oddi altarpiece carries a strong sediment of naturalism that inhibits the formulation of Peruginesque types marked by the modeling of physical types according to the dictates of a presumed ideal concept of beauty. The same thing is perceptible in two other noteworthy works by the young Raphael, whose chronology is a matter of

great debate, the *Colonna Altarpiece* done for the nuns in the church of S. Agostino in Perugia (New York Metropolitan Museum), which may date from 1502, and the so-called *Ansidei Altarpiece* created for the church of S. Fiorenzo dei Serviti in Perugia, which may have been finished in or by 1505 and has, in effect, a formidable component of naturalistically oriented Peruginism. The two wholly Peruginesque works, the Mond *Crucifixion* and the *Wedding of the Virgin*, show a desire to rein in naturalism which is directly dependent on Perugino's poetics in those years. Raphael certainly was well aware of the weight, almost in a literal sense, of the Peruginesque material, which is never superficial or evanescent, unless we look at the great painter's late phase. But it is quite easy to see that the Urbinite was completely conditioned by it, perhaps also according to the will of the patrons.

And so the suspicion arises that Raphael's debut in the period from 1500 to 1504 was full of contradictions and not linear as the historiography later sought to demonstrate, perhaps with the sole aim of finding a coherence that had never been. Because if the comparative analysis of documents and artworks is fully legitimate, there is grounds for believing that Raphael began his line of powerful naturalism and great figurative aggressiveness just barely dependent on his father's example and then joined with Perugino's current, granting him his full allegiance, perhaps in the interests of his career. After all, Perugino's style was dominant in the geographic area extending from Urbino to Perugia and doubtlessly also touched Siena.

That Raphael was completely focussed on his career and his desire to get involved with the current of great Humanistic patronage, outside of the confines imposed by the Perugino school, is demonstrated by several crucial documents. At the end of 1500s the Urbinite signed a contract with the monks of the Montastery of Monteluce in Perugia to paint a *Coronation of the Virgin*, which was left undone. But it is interesting to note that in the contract he puts his residence as being in Perugia and Urbino, which is understandable, but also as be-

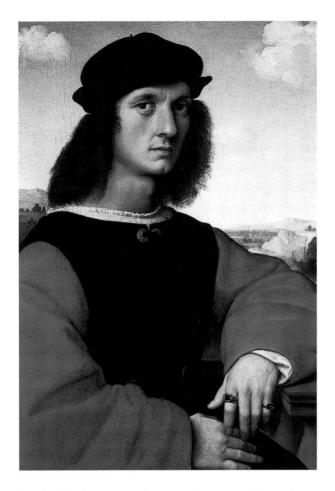

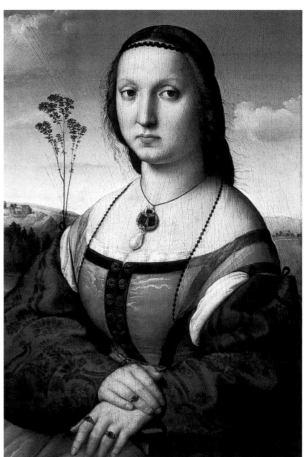

ing in Venice, something we know nothing about but that attests to his desire to broaden his horizons. Then, on October 1, 1504, there is the famous letter of recommendation helping Raphael to be able to work in Florence, written by the Duchess of Sora and the wife of Senigallia, Giovanna Feltria della Rovere, to Pier Soderini Gonfaloniere of the Florentine Republic.

After finishing the *Trinity and Saints* in the monastery of S. Severo in Perugia, Raphael did go to Florence and here the abandonment of the easy route of the Perugino style opened the doors once and for all to the deep truth of his style.

Florence meant the encounter with Leonardo da Vinci's style but also with the artist friars such as Fra Bartolomeo and with the solemn world of the perfection of drawing, of clarity and volume. The universe of painting opened before his eyes and the results are a series of celebrated masterpieces in the history of art: the *Madonna del Cardellino* of 1506 (Florence, Uffizi), the *Madonna del Belvedere* also done in 1506 (Vienna, Kunsthistoriches Mu-

seum), the *Madonna del Granduca* of 1507 (Florence, Palazzo Pitti), the *Bella Giardiniera* of 1508 (Paris, Louvre), the arcane masterpieces of the troubled *Canigiani Holy Family*, a nuptial painting probably dating to 1507 or 1508 (Munich, Alte Pinakothek) and the sensitive *Large Cowper Madonna*, which is also thought to date from 1508 (Washington, National Gallery of Art).

But Raphael's Florentine emergence was dazzling for the great naturalism of his portraits as seen in the two nuptial paintings of Agnolo and Maddalena Doni (today in Florence, Palazzo Pitti), the first done in 1505 and the other the next year.

Raphael appears to find his path suddenly, beyond his homage to Perugino and his attention to the courtly trends of his day.

Like an unexpected and prodigious synthesis of Flemish painting conflated with the tradition of Veneto and that of the great Humanism of the Italian courts culminating in the art of Leonardo da Vinci, Agnolo and Maddalena Doni are two formidable peaks of descriptive clarity and consecration

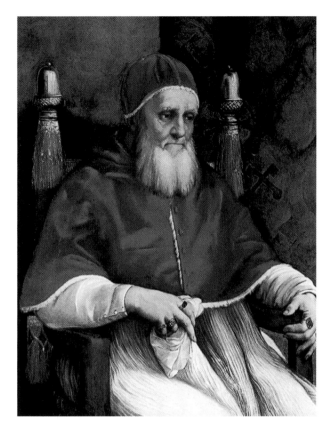

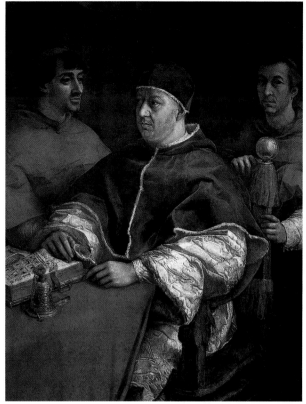

of naturalism as the supreme form of expression, which, with no sweetening of the Truth, creates beauty precisely because it is identified with the naturalness of expression.

It is clear that the two Doni spouses make up the chapter to follow the one written in Urbino by Piero della Francesca with his portraits of Federico da Montefeltro and Battista Sforza. The counterposition could not be more evident. The two Montefeltro portraits by Piero (albeit with uncertainty as to the date if it is accepted that the portrait of Federico was done while the sitter was alive and that of his wife after her death in 1472) are the apotheosis of Humanistic profile portraiture projected towards the distant, immense and sinuous expanse of nature, against which the faces of men stand out. Supreme models of impassivity and absence, the Montefeltro portraits are located at that point of equilibrium, typical of Humanism, in which highly powerful art exalts a detachment from life, consecrating it in the resoluteness of a style which transforms the images of things into their true essence.

Raphael had not known this world. Certainly, Piero

della Francesca was still alive when the Urbino artist was born and so as a child Raphael might have encountered him. Piero died at around the same time as Raphael's father, Giovanni Santi. But Piero's culture remained very distant from his Raphael's soul. The Doni portraits represent the triumph of the contradiction of that world.

We see them in a full frontal view, and true life, composed delicate emotions and a perceptible intermingling of moods, shines forth from their gaze, which is not that of Humanistic sublimity but of the distinctness typical of the Rinascimento. One seems to see how, in Raphael's mind, Agnolo and Maddalena are two small and perhaps mediocre bourgeois. There is no transfiguring or ideological intention in the formulation of the images. There is no intrinsic beauty or dazzling intelligence in these two persons. Rather, they emanate a spiritual torpor, a sluggishness of gaze, an impossibility of assuming a 'pose of the Absolute' because it is intrinsically extraneous to their world.

But here shines the immense greatness of Raphael's portrait: it is the style, nourished by a highly noble sense of volume, light, and the shaping of forms

that raises to the level of beauty that which is not beautiful and that which is not great. Raphael's hand introduces these immortal images into the realm of grace and beauty not because he improves them but because he sustains them in the power of a style that can gaze on and love the images of reality as they are. It is in learning the language of painting that humanity's education is created, Raphael seems to say. Agnolo and Maddalena enter that empyrean of perfection which would very soon, after the master's definitive entrance onto the Roman scene, welcome Julius II, Fedra Inghirami, Pope Leo X with the cardinals, Baldassarre Castiglione, Navagero and Beazzano, and the women marking history such as the *Fornarina*, the *Velata*, the *Muta* and the *Gravida*, not to mention the many portraits scattered throughout the frescoes in the Stanze that still today demand the acumen of historians in the extremely difficult work of identifying authorship. And here Raphael seems to submit to examination and then slip off in a mysterious game of explicit manifestation and then cloaking of his hand, leaving even the most canny of critics searching for the last word.

With Agnolo and Maddalena Doni, Raphael accomplished one of his most singular works, destined to appear again over the course of the following years. And so his career would be punctuated with this alternation of prodigious peaks and moments of fatigue, lesser effort and lower quality, leading up to the pandemonium of the Stanze where uncertainty reigns supreme.

But for now Raphael was placed on an incredibly high plane tempering the grand sacred fable of the extremely polished Madonnas, such as the *Madonna della Seggiola* [Madonna of the chair], with the most acute and implacable naturalism. So it was almost fated at that point that commissions would begin rolling in and dislodge him once again towards new and unknown destinations.

These commissions were, on the one hand, the Dei Altarpiece (Florence, Palazzo Pitti), destined to remain permanently unfinished, and on the other, the *Trasporto di Cristo al Sepolcro* [The Bearing of

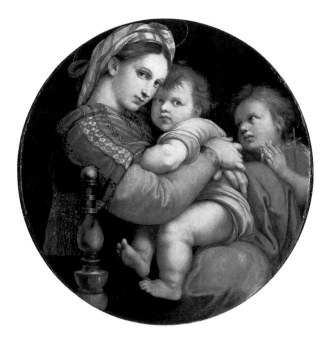

Raphael Sanzio
*Madonna della Seggiola*, 1514
Oil on wood, diam. 71 cm
Florence, Galleria Palatina di
Palazzo Pitti.

Christ to his Tomb] (Rome, Galleria Borghese) destined to be overly done, generating new doubts and misinterpretations of his dizzying ascent towards a naturalism driven to the limits of the impossible.

Neither the Dei Altarpiece nor the *Trasporto* contain true portraits, but it is clear how Raphael, nourished by the experience of Leonardo da Vinci and more generally by the "perfection" of Florentine drawing, tended to free himself of Perugino's heavy legacy to attain a completely new and incomparable style, differing from the Tuscan style and conscious of the needs of modern times in seeking a strong affirmation of the responsibility of art and of the artist.

It was logical that this came about just a few years after the vigorous condemnation of the arts in general by Savonarola, after the fateful pyre that cut short the trajectory of the great Dominican preacher and after the crisis of the Papacy following the election of Julius II as Pope. These were times of great social calamity, of violent conflicts, of appeals for dignity by the intellectuals, of a search for a deeper truth in the momentous disorientation that had brought Botticelli to the final phase of his tormented path and led to the works of Filippino Lippi, while the influence of the impeccable, immobile, error-free style of Andrea del Sarto and his determined followers was on the rise.

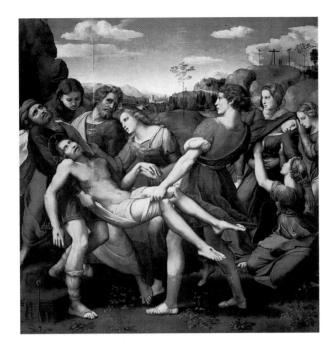

Raphael Sanzio
*Trasporto di Cristo al sepolcro*
(*Baglioni Altarpiece*), 1507-
1509
Oil on wood, 184 × 176 cm
Rome, Galleria Borghese.

The idea that art for its own sake could be the anchor of salvation was affirmed more and more often, at least among the dominant classes, as was the idea that the times were ripe to abandon a host of tendencies that had dominated the Italian courts throughout the 15th century but that had lost incisiveness and meaning.

Raphael did just this, once he had understood his destiny and freed himself from Perugino's school of painting, in spite of its importance. The rationale of the studios had to be left behind, yet Raphael did choose to follow Michelangelo's lead, who had decided to get away from it in a sort of "splendid isolation". The method had to confer onto the art of painting a role as guide in creating a school, in the literal sense, for the entire world of culture at a much higher level than the literary rhetoric of the courts, the elitist portraiture reserved to a circle of learned men, or the complexity of the language of music, philosophical dissertations, or linguistic exercises.

The idea that gradually took form in Raphael's mind was that of putting man truly at the center of the universe, as preached by the grand Florentine Humanists from Marsilio Ficino to Pico della Mirandola, but in a sense much different from that of those Neo-Platonists, nourished as they were by recondite and often secret ideas, comprehensible only to the initiates in the attitude typical of the Humanistic court.

Raphael was certainly familiar with this theory but he was not a philosopher and did not have a truly Humanistic background. He was a painter right from the beginning and his precocious initiation was to a language apparently perfect or, at least, one that could not be ulteriorly perfected.

Instead, having reached the final phase of his Florentine period, Raphael caught a glimpse of the chance to get beyond all this, to get beyond the mindset of the old studios, to get beyond the obligation to adhere dogmatically to a privileged artistic language like Perugino's, to give up on any idea of result achieved or perfection acquired, to venture into the discovery of a new dimension that had as its fulcrum an examination of the figure in the context of a deeper truth than that reached by the Humanistic circles. It was necessary to get away from the dialectic that had counterposed giants of the power of Mantegna and Antonello da Messina, and reconceive the human image as the only real center of any hypothesis of naturalism. He had to break free from the constraints of Peruginism, Florentine Leornardism and Sartesque perfection.

And so he undertook the *Trasporto di Cristo al Sepolcro*, which merely due to the accumulation of clichés cannot now be perceived with full clarity. The *Trasporto al Sepolcro* is not actually a magnificent and unreachable masterwork. It is, on the contrary, the *summa* of Raphaelesque thought and its contradictions, contradictions which would remain to the end of his life. It is a labored, complicated work full of details that are at times stupendous and at times ugly and heavy, of extremely uneven quality, bordering on unpleasantness. But it is totally and proudly innovative, innovative in the fundamental point of the whole question: naturalism and the choice of a style bursting free of the Humanist studios. The group of people supporting Christ is composed according to a memorable and marvelous principle. The heads are the quintessence of balance between the Humanistic elaboration of the universal "type", culminating in

the work of Piero della Francesca, and the individuation of personality captured in all its nuances and expressed with a density of pictorial material that produces an infinite and gradual passage of light and shadow in each head, giving the sensation of a deep gaze that does not so much reproduce as to create the idea of the image, following a naturalism beyond Antonello and Mantegna, because it tends to abolish precisely the principle of visual immobility pursued by Humanism.

The Raphaelesque image seeks to free itself from the strictures of impassivity and definitive formulation that the Humanist painter could not avoid. But in spite of all this, the figure of the youthful bearer in the *Trasporto* that many have wanted to identify with the young Falconetto, to whom the supreme work is dedicated, and those of the group of pious women are marked by a clear but poorly accomplished effort to overlay a new naturalistic dimension over the Peruginesque fetishes, which maintain a heavy and inopportune presence as if the picture were a battlefield of two worlds, one old and one new, that meet and clash without achieving either integration or an ideal dialog.

The thing is that this all happened in the same artist, one who on the one hand was impeded in his journey, while on the other was audacious and open-minded. This produced a work that lets us see perhaps too well the birth of something that has yet to be defined and pursued.

The *Trasporto* in the Galleria Borghese is dated 1507 but, from this moment on, the dates placed on Raphael's works are to be taken with a grain of salt and interpreted according to special criteria. Raphael is a painter schooled in Umbria and The Marches and so, following a custom that he had learned in his early youth, he almost always signed and dated his works, as was the custom of the artists active in that area. They took an artisan's pride in the quality of the work of art and always added the maker's stamp to the finished product to guarantee its authenticity to the patron. Here too Raphael followed the tradition to some extent but also turned it to his own purposes and his sig-

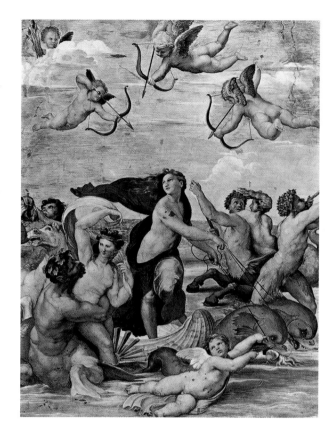

Raphael Sanzio
*The Nymph Galatea*, 1511
Fresco, 295 × 225 cm
Rome, Villa della Farnesina.

natures and dates are quite different from those of his own father, Giovanni Santi.

The *Trasporto al Sepolcro*, along with the *Sacra Famiglia Canigiani*, provide the best introduction to Raphael's Roman phase, whose beginning is not entirely clear.

But what is crystal clear is that the *Trasporto* is a work that grew out of a slow and complicated elaboration. The Peruginesque landscape, the figure of the youth and the Pious women may date to the year 1507. But it is hard to imagine that the group with Mary Magdalene, St. John, Nicodemus, Joseph of Arimathea and Christ, prototypes of the new naturalism that would find its space and its triumph in Rome, was done at the same time.

The *Galatea* in the Farnesina and the *Sybils* in S. Maria della Pace for Agostino Chigi are perhaps the evidence for this idea that not by chance emerged in Rome. Certainly, comparing the admirable heads of the bearers of Christ and those of the School of Athens, where Raphael includes his self-portrait, one notices a commonality that is absolute to the point of making one think that these works were created together out of the same stream of inspiration.

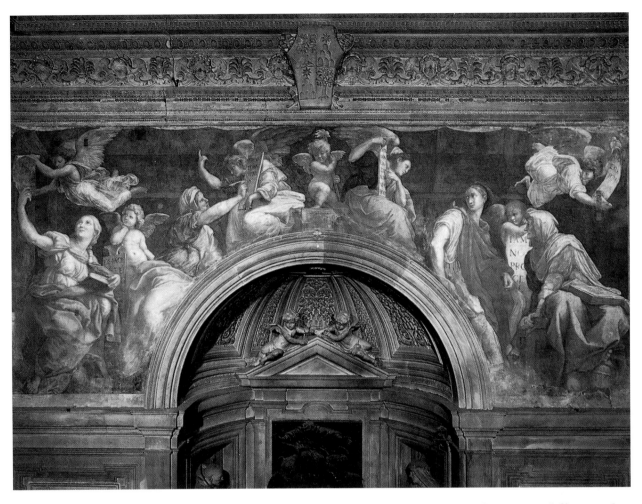

Because this is precisely the point when we try to define the fundamental character of Raphael the portraitist. A new interpretation of the very concept of "inspiration" is manifest in him. It is not by chance, perhaps, that the favorite themes of his first Roman works are linked to the idea of *inspiration* and *prophecy*. The Galatea is the very image of the "inspired figure" awaiting joy and satisfaction. The style is hard and crystal clear. The pictorial material is profound and magisterially animated. The Sybils are prophetic figures animated by an intense naturalist charge that concentrates in the contrasting representations of the various stages of life. This prophetic spirit will go on to animate the entire Stanza dell Segnatura and here, precisely in the *School of Athens*, Raphael perfects the method of the new naturalism that allows him to unite the idealistic image independent of any living being with the pure portrait. In the assemblage of the philosophers, in the theologians in the *Dispute over the Holy Sacrament* and also in the group of literati in *Parnassus*, there is no difference between the possibility of precise identification of a visage and the presentation of the universal "type". It is underpinned by the Humanistic principle of recital and identification, the same for which Tommaso Inghirami, whose portrait was most likely painted in 1509 or 1510 in admirable continuity with the Doni portraits, is always known by his nickname "Fedra" for his ability to render that personage.

The *person* and the *personage* tend to be identified in these great Raphaelesque figurative gatherings in the name of the principle that what unifies everything is "grace", and that grace alone can justify beauty.

The Raphaelesque assemblage emerges from a principle analogous to that of musical polyphony, for which that which is heard or seen has to be in tune with a law which cannot be amended, that of the harmonious expression of the suaveness and sweetness of living.

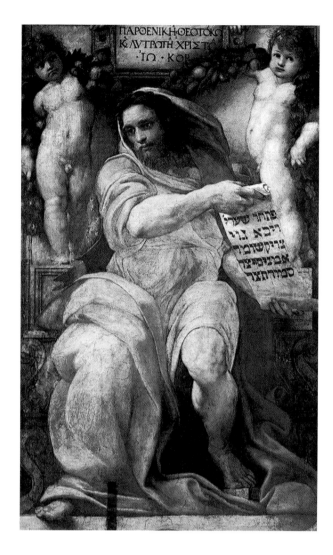

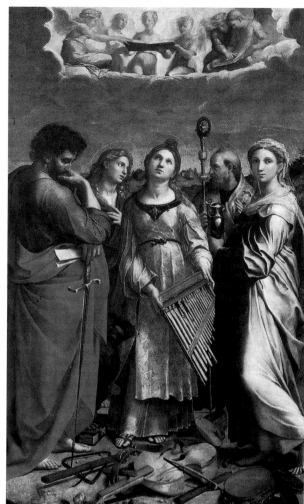

It could almost be said that there is no art outside of the dimension of sweetness. And this is the first stop for Raphael beyond the *Trasporto di Cristo* in the Galleria Borghese. From the convergence of an ideal of art based on inspiration and the consequent prophetic spirit emerges the founding principle of the now mature Raphaelesque naturalism. It is about "sweet harmony" in which it is art to confer the statute of existence onto all it touches, and the artist is the creator, in the true sense of the term, because he is in possession of a style that can compete with life, purifying it of every difficulty and pain, but keeping it reliable and "true". The idea of inspiration, as seen in the fervor of the *Galatea* or in the pain of the *Trasporto*, becomes the visible grace that realizes itself in the magnificence of the beauty generated by the visionary spirit that Raphael glimpses in the image of the Sybils and the young Falconetto.

But Raphael did not remain frozen in this position and the historians have always noted the impressive turning point between the first Stanza, the Stanza della Segnatura, and the second, the Stanza di Eliodoro, which the master undertook in 1512 and 1513.

Having reached the culmination of his expressive capacity, Raphael changed paths, but in a contradictory way and, as always, one that is difficult to comprehend for the historiographer. All have noted the terrible sense of tragedy that seems to inspire the Stanza di Eliodoro, as if, having formulated an idea of harmony and tranquillity in the Stanza della Segnatura, Raphael could go no further. He had just signed his *Isaiah* in the church of S. Agostino, completed just before he set himself to the Stanza di Eliodoro, and already in that magnificent fresco placed above a group of sculptures by Andrea Sansovino, one sees well how the

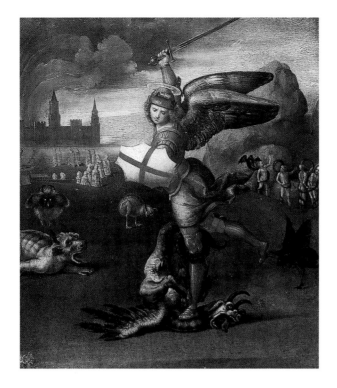

presumed Michelangelo-ism that many imputed to him was nothing more than a way to mitigate his doubts so he would not remain immobile just when the times where ripening and the crisis of the Pontificate was worsened by the death of Julius II and the ascent to the throne of the son of Lorenzo il Magnifico and a problematic Humanist, Leo X de' Medici.

The Stanza di Eliodoro is the Reformation and the Counterreformation of Italian painting, three or four years before the Protestant Reformation actually exploded. There is a remixing which is yet more terrible and difficult than that which shortly before appeared clearly in the *Trasporto* in the Galleria Borghese. From both the qualitative and quantitative viewpoints these frescoes taken as a whole will never cease to amaze. Elements of sublime and unattainable beauty join sections which are quite frankly mediocre and weak in their execution. Visions of an audacity that still today amazes are juxtaposed with iconography that was by then obsolete and abandoned. And so in the *Liberation of St. Peter* the memorable figure of the saint, at first sleeping and then leaving prison, is accompanied by an angel who seems to have come straight from Perugino's workshop. Some of the

greatest portraits of all time are visible on those walls, including the unequalled Sediari [bearers of the gestatorial chair] in the *Messa di Bolsena*. But in this work there are many figures clearly frescoed by Raphael's pupils that are quite mediocre. In the same room, the scene of *Attila Meeting Leo I* was largely done by studio assistants as if Raphael had interrupted his work for reasons that still elude us.

And yet amid this visual confusion there are peaks of supreme greatness in portraiture. A comparison between the Sediari and the portrait of Baldassar Castiglione (Paris, Louvre) show how Raphael, bringing to fruition the experiences from the Stanza della Segnatura, had reached the apex of his skill in painting portraits. The noble absence of existential burdens and an intimate and conscious self-knowledge emanate from those heads, rendering this a decisive moment for Raphael in the visual construction of an idea of grace wedded to beauty.

That these portraits are exceptionally beautiful is so evident that there is no need for its demonstration. That one will apprehend in them that dimension of grace is equally certain. We can certainly interpret such an idea as an application of a typical courtly principle of behavior to painting. It is clear that the ideals of respect for ethical and practical values, the reduction of conflicts, the desire for peaceful cohabitation and reciprocal understanding are all other constituent elements of the courtly life and they shine through clearly in images like those of the Sediari or of Baldassar Castiglione.

But this is not a mechanical transposition of an idea from a certain realm of thought to the field of art. It is painting, on the contrary, that creates the visual idea, derived certainly from a greater political and cultural reality, but autonomous in its expressive sphere.

Yet again it is from the dialectical relationship of two elements, both present in Raphael's art, that the sublime image of the inseparable union of grace and beauty emerges. The rationalist inspiration that

underlies the conception of the Stanza della Segnatura culminates in pictorial language of the prophetic spirit that animates every aspect of the Stanza di Eliodoro. Magnanimity of the image and fullness of the pictorial material are the two inseparable faces of the same conceptual "coin" which generates magnificent, and within certain limits, inimitable painting, creating a new figurative language at the end of the slow and implacable evolutionary process of Humanist painting.

Man is at the center of the world precisely because he is thought of as a sort of visual and intellectual "universe" from whom only a positive and progressive message can emanate.

At this point the great female figures were born, figures which illuminate, with a sense of fullness and delicate shaping, this phase marked by the highest figurative ideal: the Fornarina, the Muta, the Gravida, the Sistine Madonna, the Velata. And he also did the great Humanistic virile portraits such as Navagero and Beazzano in the Galleria Doria Pamphilj.

Nevertheless, this was not the final stop for Raphael.

No, he had time to experience the crisis and suffer a profound delusion. These were the last four years of his life, which not by chance corresponded to the time when the environment in which he lived and prospered as an official and favorite artist, the Roman Curia, was being challenged from all sides.

It was chance or necessity, no one can say today. But if we examine the works from 1517 to the end, we realize that there had been a new and formidable change and, as before, the most recent terms of his artistic language had again been called into question.

Certainly, the triumph of the artist was assured, after the cartoons for the tapestries in the Sistine Chapel, and his nomination, in August of 1515, as Superintendent of Antiquities in Rome (certainly with the help and collaboration of Baldassar Castiglione) and with the great altarpieces commissioned to him by high ecclesiastic offices, or done

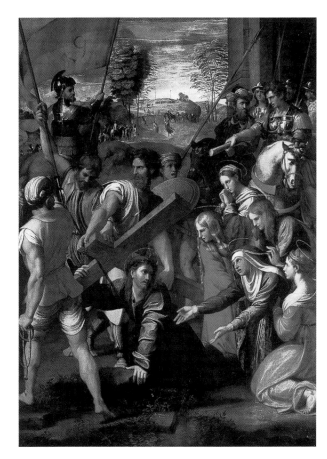

for princes and rulers, works which expressed his immense knowledge, such as the *S. Ceclia* for S. Giovanni in Monte Uliveto in Bologna, the *S. Michele* for the king of France, the *Spasimo di Sicilia*, and the *Transfiguration*. And other works accumulated in addition to these, works that were often excellent, accomplished with competent assistants who had already embarked on their own happy career, such as the *Holy Family* for François I and the *Visitation* for Branconio dell'Aquila, today in the Prado.

But the work in the Stanza dell'Incendio di Borgo and that little bit he was able to do in the Sala di Costantino speak volumes about a changing of the guard already underway.

The supreme master withdrew after having invented a language destined to become petrified in an academic immobility that he never would have wanted to witness.

Hence, works such as the Vatican Loggias or the Loggia of Psyche in the Farnesina do not cease to disconcert today's viewers. Where is the Raphael's hand in the Vatican Loggias, which have entered

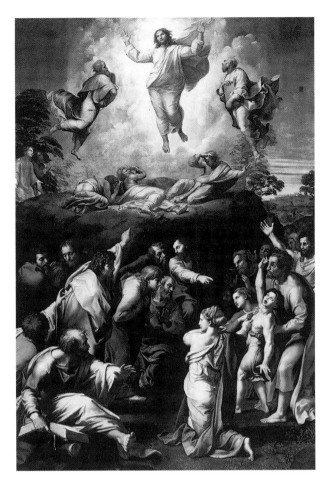

Raphael Sanzio
*The Transfiguration*,
1518-1520
Oil on wood, 405×278 cm
Rome, Pinacoteca Vaticana.

history as "Raphael's Loggias"? How much did the Urbinite actually manage to do in the Farnesina Loggia? How much did he dedicate to his late venture into architecture, which led him to make new proposals, even for St. Peters in Rome, and to design the villa of Cardinal Giulio de' Medici in Monte Mario?

Almost as if the growing Protestant Reformation had induced the master, a Catholic *par excellence* as the Papal painter, to step back, to think of a new turning point which never came about.

The *Transfiguration* celebrates his apotheosis and his limits, as the historians over the course of the centuries have recognized. And they recognized them also in the most singular and at first incomprehensible vacillation regarding the attribution of authorship itself, truly Raphael's last mystery. Some think it was left unfinished at Raphael's sudden death, a death variously recounted in terms that are almost opposites, in keeping with the way things had been throughout his life, some thinking of sexual excesses and others of the pure life

of a new Christ ready for a new martyrdom. Some think of it as the completely finished and perfect expression of the master's hand, a crowning masterpiece and fully his own.

And yet the discrepancies are there by the multitude within this sovereign work. There is the incomparable depth of the true Raphaelesque material, but there are also elements of extreme hardness as seen in the *Incendio di Borgo*. There is the admirable contrast of light and shadow, but there is also a graphic stiffness that had already been seen in the *Trasporto al Sepolcro*.

One truly sees in the figure of Christ ascending that commingling of grace and beauty that Raphael had sought his whole life and that he had brought to its highest expression at the time of the Castiglione portrait (Vasari asserts that the head of Christ in the *Transfiguration* was the very last thing done by Raphael), but there are things which seem excessively forced and unexpectedly harsh, even in the figure of the demon-possessed Child, which is not exceptionally beautiful.

But Raphael must have inspired fear if one thinks that Leo X, feeling the walls of the Papal palace tremble upon the death of the mysterious master, abandoned his rooms in the grip of a genuine terror.

*Pierluigi De Vecchi*

# Difficulty/ease and studied casualness in the work of Raphael

Sometimes the reactions of contemporaries before the work of an artist, expressed in a synthetic manner and, so to speak, translated into formulas by those writing on art in that period, subsequently almost remain incorporated in the work itself, eventually building a kind of filter and wielding a decisive influence on the way the work is perceived even in later centuries: they become a filter which it would in any case be impossible to eliminate completely, but which one has to be aware of, also because it usually offers very useful keys to interpretation. Indeed, if it is true that any work or image is not only the product of a single personality but, at least indirectly, of a wide "cultural field", it is right – and in any case inevitable – that this takes place.

It is therefore not unusual that, something which applies to certain Renaissance artists and in particular to Michelangelo and Raphael, the effort to define the fundamental characteristics of their works, in a comparison which has gradually become a contrast, has produced significant consequences on the use, semantic transformation and even invention of the terminology used by critics in the contemporary artistic literature.

In the vertiginous interrelations, on a lexical level – but also on a conceptual one – that took place in Italy in the 16th century between art literature, treatises on social conduct and treatises on love and female beauty, it would obviously be absurd to expect or claim to find a systematic and constant use, even of only certain "key" terms, that actually sometimes feature different or even contrasting meanings. This is for instance the case of "diffi-culty" and "ease", which have to be seen in the light of their interaction and in specific contexts. Praise for the "difficulty of art" generally concerned, in the Renaissance, what one considered the "scientific" premises of artistic activity: from the theory of proportions to the anatomy, from perspective and foreshortening techniques to the study of antique models. Referring to the panel presented by Brunelleschi at the competition for the second door of the Baptistry in Florence, Manetti admired first and foremost the "difficulty". Also, the presumed greater difficulty of painting or sculpture was an important argument and basis of the reasoning for those participating in the debate on the "primacy of the arts" promoted by Benedetto Varchi in 1546[1]. The unrivalled leader in that field was, according to Vasari, Michelangelo, whose works even appeared to surpass the antique models due to "a certain greater solidity of foundation, a more entirely graceful grace and a much more absolute perfection, executed with a certain <u>difficulty</u>, so <u>easy</u> in its manner, that it is impossible ever seeing anything better..."[2].

The path of Raphael was on the contrary, also in this case according to Vasari, slower and more difficult and he could only attain his objective thanks to the example of Michelangelo, who enabled him to overcome the old "manner" learned from Perugino: "...purified himself and freed himself of the burden of the manner of Pietro in order to learn that of Michelangelo, full of <u>difficulty</u> in every part, almost changing from master to disciple once again"[3]. However, in this aspect he remained inferior not only to Buonarroti but also to Leonar-

[1] Varchi 1960, vol. I, pp. 1-58. The *Lezzione* by Varchi is followed by the letter sent to him on the subject by Vasari, by Bronzino, by Pontormo, by Master Tasso, by Francesco da Sangallo, by Tribolo, by Cellini and by Michelangelo (ed. cit., pp. 59-82).
[2] Vasari (1568) 1976, vol. IV, pp. 11-12.
[3] G. Vasari, "Life of Raphael of Urbino painter and architect", in *The Lives* ed. cit. vol. IV, p. 205.

Raphael Sanzio
*La Belle Jardinière*,
1507-1508
Oil on wood, 122 × 80 cm
Paris, Musée du Louvre.

do, who completes the triad of the three great representatives of the modern manner: "...but regardless of his diligence and studies, he could never surpass Lionardo in some difficulties: while there are many who consider he surpassed him in terms of gentleness and in a certain natural ease, he nevertheless was by no means superior in a certain awesome combination of concepts and greatness of art, in which few have equalled Lionardo..."[4]. However, also in Vasari's writing, difficulty is not always intended in a positive sense. In fact, precisely after having praised Raphael for having refrained from competing with Michelangelo in the "science of the nudes", he criticises those who do not venture on a similar unsustainable confrontation, as by avoiding it, "they would not have exerted themselves in vain, nor would they have painted in a very rigid manner, full of difficulty, without subtlety, without colour and lacking in inventiveness"[5].

With the treatises of Venetians Marco Pino and Ludovico Dolce, the anti-Michelangelesque debate leads to a decisive overturning of criteria. In the *Dialogue on Painting* by Dolce, in reply to Giovan Francesco Fabrini (one of the interlocutors) who claims, invoking the "common judgement", that Raphael "was a great painter, but not equal to Michelangelo", the Aretino (the author's spokesman and source of inspiration) replies that it is a matter of the opinion of those who "without understanding anything else, follow the opinion of others" and adds: "I know well that in Rome, while Raphael lived, the majority, both of men of letters and art experts, considered him superior to Michelangelo as far as painting was concerned. And those who preferred Michelangelo were mostly sculptors: who only focus on the drawing and the awesomeness of his figures, as it appeared to them that the graceful and gentle manner of Raphael was too easy, and consequently not the result of such great skill: unaware of the fact that ease is the principal argument of excellency in any art, and the most difficult to achieve: and it is an art to conceal the art: and that finally, beyond the drawing,

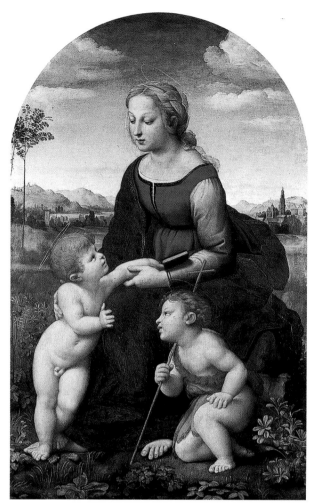

apart from drawing, the painter needs other parts, all of them indispensable"[6].

The search for difficulty becomes virtuosity and is criticised as a lack of "a certain tempered measure and a certain considered convenience, without which nothing can be graceful or look well". Raphael is exalted, in comparison with his rival, precisely due to his ease: "and while it is true that Michelangelo has always pursued difficulty in all his works, what Raphael, in contrast, has sought is ease, something which as I said, is difficult to achieve, and he has obtained it so that it seems as if his works are made without thinking, and without either exertion or ostentation. This is a sign of very great perfection, something which also applies to writers, and that is, the best are the easiest..."[7]. The quotation, on the following lines, of the examples of Virgil and Cicero, Petrarch and Ariosto confirms the identification of specific references in terms of culture and taste, but even more

[4] Ivi.
[5] Idem, p. 206
[6] L. Dolce, "Dialogue on Painting", in *Treatises on the art of the Sixteenth century*, ed. cit., vol. I, p. 149.
[7] Idem, p. 196.

importantly, the fact that it is by now possible to clearly recognise, in the ideal of the ease, the court term of "studied casualness" (*sprezzatura*): a term which Dolce indeed used explicitly in another passage, with reference to "colouring".

It is known for a fact that the term was coined by Baldassare Castiglione. In *The Courtier*, one of the interlocutors – Ludovico da Canossa – replying when asked how someone who is not endowed by nature or by heaven, may acquire "grace", in the absence of which any quality or skill is futile, elegantly backs off, saying he cannot teach how one becomes a good courtier, but only show how a good courtier should be. However, he suggests a kind of imitation, understood as assimilation of the best models, which features close parallels with the debate on imitation, both among men of letters and in the field of the arts. He then adds a "very general rule which I believe applies to all human matters that are done and said, more than any other: avoid whenever possible, and as a very sharp and dangerous rock, <u>affectation</u> and, perhaps saying a new word, use in every thing a kind of <u>studied casualness</u> which conceals the art and demonstrates that, what is done and said, is done without effort and almost without thinking. I believe grace is, to a large extent, due to this: because everyone knows the <u>difficulty</u> of rare and well-made things, consequently when they are done with <u>ease</u> this elicits great marvel; and on the contrary making an effort and, so to speak, force something, leads to great disgrace and very low esteem for every thing, regardless of how great it is. But one may say something is true art, when it does not seem to be art"[8]. The transition from the concept of "studied casualness", from the definition of a model of "courtly" behaviour to the terminology used in writings on art, as well as that associated with literary and musical theory[9], occurred immediately and in a completely natural manner in the *The Courtier* and is subsequently witnessed, among others, by the way Dolce uses it in his treatises, when referring to colouring and the way to "arrange" the figures: "in this it seems to me that a kind of suitable stud-

ied casualness is necessary, so that there is neither excessive vagueness in colouring, nor too great definition in the outlines, but that a pleasant firmness is perceptible in everything. This is why there are some painters who make their figures so completely clean that they appear colourless, with so attentively orderly hairdos that not even one hair is out of place; something which is a vice and not a virtue, because it becomes affectation, which deprives everything of grace"[10].

The conflict between difficulty and ease is thus solved. The fact of overcoming every difficulty without apparent effort is opposed to "affectation" which may, in the arts, be manifested both as a deliberate and flaunted search for difficulty, as exhibited virtuosity, as well as in excessive diligence: the *"nimia diligentia"*, already criticised by Pliny as opposed to *"venustas"*. And Castiglione quotes, from Pliny, the famous example of Protogenes: "it is still said that it used to be a proverb, among some very excellent antique painters, that too much diligence was harmful, and that Protogenes, having been rebuked by Apelles, was unable to take his hands off the canvas /.../What Apelles wanted to say was that Protogenes, when painting, did not know when to stop; and this merely amounted to reproving him for being affected in his work. This virtue is therefore the opposite of affectation, something we from now on will call studied casualness..."[11]. Subsequently, the vicissitude recounted by Pliny was repeated by Ludovico Dolce in a passage of the *Manners of Representation* with explicit reference to Giovanni Bellini: "excessive <u>diligence</u> is also detrimental to the encounter: because, apart from being guilty of <u>affectation</u>, one sometimes worsens matters. This is why Apelles used to reprove the good painter by saying he did not know how to take his hands off the canvas; as one today sees some excellent Painters, who have appeared before us: such as Giovanni Bellini, who, something that was rare in his time, used so much diligence in the things that he made, that they seemed illuminated, and moreover one perceived a very great affectation in the way the hair was arranged, with

[8] B. Castiglione, *The Courtier*, I, XXVI.
[9] On the relations with literary and musical theories see, in particular, P.L. Sohm, "Affectation and Sprezzatura in 16th and early 17th Century Italian Painting, Prosody and Music", in *Kunst, Musik, Schauspiel* (Akten des XXV Internationalen Kongresses fuer Kunstgeschichte – Vienna 1983), Vienna 1985, vol. II, pp. 23-40.
[10] L. Dolce, *Dialogue*, cit., vol. I, p. 185.
[11] B. Castiglione, *The Courtier*, cit., XXVIII.

not even one strand out of place..."[12]. The criticism of the affectation in the rendition of the "minor details" was first and foremost directed at the arrangement of the hair or certain details of the clothes and drapery, but it actually concerned all elements of an "illuminated" style, which by then appeared obsolete, especially in Venice, in comparison with the "manner" of Titian, who had already reached the central stage of his activity.

The manifestation of studied casualness in the work of an artist may therefore be observed "in a single, effortless line, a single brushstroke drawn with ease, in such a way that it seems that the hand, without being guided by any kind of study or art, proceeds by itself to the end point, according to the intention of the painter"[13]. Excessive diligence, which inevitably leads to "restraint", is therefore condemned as negative, just like "sloppiness", even if Leonardo on his part warned, in his "rules of the painter", to learn diligence before learning "easy practice"[14]. Ease and studied casualness are however inseparably linked to difficulty, presupposing that the latter is overcome. And also Vasari, expressing his admiration for the late style of Titian, using words that may be traced to the concept of studied casualness, observed that "this manner has been the reason why many, wanting to imitate and demonstrate practical skill, have painted clumsy paintings: and this occurs because, even if they may seem to have been made without effort to many, this is not really the case, and they are deceived; because it is known that they are redone, and that the colours have been retouched many times, and the effort is visible. And this manner is judicious, beautiful and stupendous, because it makes the paintings seem alive and painted with great art, concealing the efforts"[15].

Referring to Raphael, Vasari, in whose writings, on the other hand, the term "studied casualness" never appears, frequently uses the terms "ease" and "diligence": the latter, depending on the context, in both a positive and, more often, restrictive sense. "Ease", understood precisely as an ability to overcome the "difficulties of art" and conceal every effort, on the contrary becomes one of the essential distinctive traits of the mature work of the artist, to the point of characterising the very creative processes: "Invention was so easy and characteristic of him, as those who see his stories may appreciate, as they resemble the writings..."[16]. As to "diligence", especially in the passages describing Raphael's gradual approach to the modern manner through an imitation of the models of Michelangelo and Leonardo, one on the contrary seems to perceive at least the echo of a judgement on Raphael formulated precisely by Michelangelo and recounted by Condivi, who tells that the Florentine master, "never envious of the efforts of others /.../ always praised everyone universally, except Raphael of Urbino, with whom there had already been some conflict on painting /.../ I have only heard him say that Raphael was not endowed with this art by nature, but through long study"[17]: a judgement of a subtly depreciative tone, implicitly opposing the "ease" of natural talent and disparaging the "difficulty" of long study.

In actual fact, throughout the period of his activity, Raphael regularly practised the study of models in accordance with the principles of "imitation". It is a matter of methods that were singularly congenial to him, as his contemporaries, from Paolo Giovio to Vasari, had already recognised. The brief biography of the artist, written by Giovio just a few years after Raphael's death, opens by praising the "admirable sweetness and alacrity" of his "readily assimilating" talent[18]. Later, in the *Preface* to the third age of the *Lives*, Vasari particularly emphasised this trait of Raphael's personality, writing that "by studying the efforts of old masters and of modern ones, [he] took the best from everyone, and having united them, enriched the art of painting with that entire perfection which the figures of Apelles and Zeuxis had vaunted in antiquity, and more if one could say, or show the works of those for purposes of this comparison"[19]. It is a matter of a method that has sometimes erroneously been interpreted as a sign of an eclectic attitude, while he took inspiration from a "dynamic comparison", by

[12] L. Dolce, *Manners of representation and Chosen and Elegant Voices of the Vulgar Language*, Venice 1564, p. 393.
[13] B. Castiglione, *The Courtier*, cit., I, XXVIII.
[14] Leonardo, *Treatise on Painting*, II, 67.
[15] G. Vasari, *Life of Titian di Cadore painter* in *Le Vite...* ed. by G. Milanesi, Florence 1878-85, vol. VII, p. 452. The passage by Vasari may appear as contradictory but, in actual fact, when he asserts that "one sees the difficulty" what he wants to say is that skilled individuals are able to appreciate the "difficulty of the art" while the concept of studied casualness is contained in the final assertion: "makes the paintings seem alive and made with great art, concealing the efforts". The imitators, authors of "clumsy paintings" commit the error of considering "easy" and without "difficulty" something which on the contrary appears "easy" only thanks to the perfect mastery of the "difficulties".
[16] G. Vasari, "Preface...", in *The Lives...* ed. cit. in note 2, vol. IV, p. 9.
[17] A. Condividi, *Life of Michelangelo Buonarroti*, Rome 1553. The passage is quoted in V. Golzio, *Raphael in the documents, in the testimonials of his contemporaries and in the literature of his century*, Vatican City 1936, p. 294.
[18] P. Giovio, "Raphael Urbinatis vita", in *Writings on art from the Sixteenth Century*, edited by P. Barocchi, Turin 1977 (II ed.), vol. I, p. 13.
[19] G. Vasari, "Preface...", in *The Lives...*, ed. cit. in note 2, vol. IV, pp. 8-9.

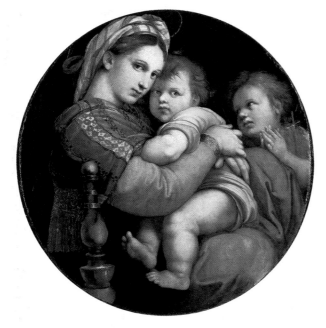

Raphael Sanzio
*Madonna della Seggiola*, 1514
Oil on wood, diam. 71 cm
Florence, Galleria Palatina
di Palazzo Pitti.

no means passive, that he made with the models he studied and in line with the most avant-garde positions to be found within the context of the animated debate on imitation that continued throughout the Renaissance, involving both men of letters and artists.

Raphael's study of models was always characterised – apart from an astonishing rapidity of assimilation, manifest from his first works – by an acute critical awareness, something demonstrated both by the selective confidence of the orientations and by the systematic control of the natural datum, and above all by the continuous effort to "overcome" them: from the "imitation" of works by Perugino during the early years of his activity, to that of the modern manner of Leonardo and Michelangelo, and to a "comparison with the ancients" in his Roman years.

Following the precept formulated by Castiglione's character Ludovico da Canossa, in order to achieve "grace" and perfection in the "manner", the artist had to follow the path of imitation of the best models, like the courtier who has not been endowed with this gift by heaven or by nature, avoiding affectation and practising studied casualness, concealing the effort and making others forget the "long study" through an apparent – but absolute – spontaneity and naturalness in terms of gesture and inventiveness. In light of these considerations,

Michelangelo's opinion of Raphael does not seem, in the final analysis, unfounded: however, it would be impossible to deny that a talent for imitation and assimilation requires a certain natural predisposition which Raphael certainly possessed to a very exceptional extent.

It has been justly observed[20] that the exercise of studied casualness is closely linked to the assertion of a new aesthetic ideal – in relation to the concept of "grace" – the most incisive depiction of which may perhaps be found in a famous passage of the *Preface* to the "third age" of the *Lives*, where Vasari describes the decisive passage to the modern manner, and to what he considered the "perfection of art" made by a group of artists, and in which context he attributed a leading role to Leonardo, Raphael and Michelangelo. The main obstacle preventing the masters of the "second age" to take the decisive step was, according to Vasari, the shortcoming of the "rule" of a "liberty, which, not being the rule, was governed by rules and could exist without creating confusion or damaging the order; something which required inventiveness in all things and a certain beauty extended to every smallest detail, which showed all that order with more ornament"[21]. The overturning of a concept of beauty chiefly understood as "symmetry" – rule, order, measure and proportion – by now seems to be an accomplished fact, in the interrelations between treatises on conduct and love and speculations in the fields of literature, arts and music. In the *Dialogues on love* by Leone Ebreo we read, for instance: "if you consider it carefully, you will find that, regardless of whether one finds beauty in things that are well-proportioned and harmonious, the beauty is beyond their proportions"[22]. The "liberty" referred to by Vasari marks the transition from "commeasured beauty" to a beauty containing ineffable elements that are completely "incommeasurable" and which go beyond "order" and proportions: "a proper judgement was lacking in the measures, without which the figures lacked measurement, had in the measure they were made with, a grace which went beyond the measure. The

[20] See, in particular, A. Blunt, *Artistic Theory in Italy, 1450-1600*, Oxford 1956, p. 97 and P. Barocchi, "Critical note", in *Treatises on art...* cit., vol. I, p. 311.
[21] G. Vasari, "Preface...", in *The Lives...* ed. cit. in note 2, vol. IV, p. 5.
[22] Leone Ebreo, *Love Dialogues* (1535), Bari 1929, p. 320.

drawing fell short of this, because, even if an arm was round and a leg straight, there was no research with muscles and that gracious and gentle <u>ease</u> which appears between seeing and not seeing, as one finds in flesh and living things; but they were crude and flayed, which made them appear <u>difficult</u> and hard in manner...".[23]

The "gracious and gentle" ease, which requires a mastery of more refined abilities of "imitation", implies the overcoming of further difficulties – from a deeper knowledge of anatomy to a more mature and conscious assimilation of the antique models – in the same way as "liberty" presupposes such a confident possession of "rules and measure" as to permit a surpassing of the limits of the norm, with marvellous studied casualness, avoiding the effort and aridity of diligence, as "study renders the manner dry".

Among the characteristics of affectation we must finally mention also a tendency to repeat, as in the case of Perugino, whom Vasari criticised for having reduced his art to "manner" by giving all his figures "the same air". The opposite virtue is "variety" in which context the excellency and near primacy of Raphael was universally recognised, from Vasari to Ludovico Dolce: "...in all his works he used a variety that was so admirable, that no figure resembles, neither in terms of air nor of movement, another to the point that there is no shade of the defect painters today are accused of, the so-called manner, that is bad practice, where one sees forms and faces that are almost always similar"[24]. It appears significant that, almost mirroring this, Aretino (Dolce's spokesman in the *Dialogue*) also claims that "those who see a single figure by Michelangelo, see them all"[25].

The roots in the traditions of Urbino of Raphael's figurative culture is perceptible – precisely in the moment he identifies most with the models of Perugino through a process of "critical imitation" – in particular compositive processes, which enabled him to combine the research of "imitation" with an organisation of the image based on "harmonious" relations, staged, in particular, in the Gavari *Crucifixion* and in the *Wedding of the Virgin*[26]. This web of geometric and mathematic relations dominates the "composition" of the painting according to those laws of "delimitation" and the "mutual correspondence between the lines defining the dimensions" which one considered based on the analogies between the musical and visual harmonious proportions studied by the theoreticians and architects of the Renaissance. In Book IX of *De Re Aedificatoria*, Leon Battista Alberti wrote that "those numbers that have the power to give sounds the concinnity, which is so pleasant to the ear, are the same which may fill our eyes and spirit with admirable joy. Therefore it is precisely from music, which has subjected such numbers to exhaustive investigation, as well as by the objects in which nature has given conspicuous proof of itself, that we will derive all laws of delimitation"[27].

However, while in the elaboration of the theory of harmonious proportions – from Alberti to Piero della Francesca and the "divine proportion" by Luca Pacioli – at this point prevailed on speculations of a metaphysical character, the extension of its application from music and architecture to the practice of "representation" on the part of artists could not but collide with the impetuous development of conventions aimed at an increasingly convincing, in illusory terms, "imitation" of natural appearances. Regardless of whether other kinds of impulses may also have contributed to the crisis of a concept of beauty like "order and measure", what remains in the foreground are the "practical" reasons that eventually legitimated and, more importantly, asserted the need for liberty introduced in the order.

In his Urbino period, Raphael already felt in 1503-04 a pressing need to change "from master to disciple once again" facing, through the exercise of an imitation of the best models, the "difficulties" that lead to a full mastery of the new manner. In the works of Leonardo and Michelangelo – beyond a new repertory of compositive schemes and formal inventions, or a completely new range of movements and attitudes, which a more profound knowl-

[23] G. Vasari, "Preface...", in *The Lives...* ed. cit. in note 2, vol. IV, p. 5.
[24] L. Dolce, "Dialogue..." ed. cit., vol. I, p. 196.
[25] Idem, p. 193.
[26] See, in particular, P. De Vecchi, *The Wedding of the Virgin by Raphael* (Brera Booklets no. 2), Florence 1973 and J. Shearman, "The born architect?" in *Raphael before Rome*, Studies on the History of Art, 17, National Gallery of Art, Washington, 1986, pp. 203-210.
[27] L.B. Alberti, *De Re Aedificatoria*, Book IX, ed. by G. Orlandi and P. Portoghesi, Milan 1966, vol. II, p. 822.

edge of anatomy made it possible to control with a hitherto unseen rigour – he discovered the full realisation of the expressive potentials of the modern manner, along with an amazing naturalness and realism, both in terms of "imitation" and of rendition of the affections and passions of the spirit. And in a few years, driven by the new experiences, his language changed radically. The "difficulty" was then solved through ease and studied casualness, not only in terms of execution, but first and foremost of communication, in the sense of an absolutely natural image: the "natural ease" referred to by Vasari.

An apparently paradoxical aspect has been underlined on various occasions, concerning the reaction of the public to the works of Raphael and, in particular, to his "Madonnas", which have on the one side elicited the greatest admiration on an intellectual level due to their specifically formal characteristics, but which have, on the other, enjoyed equal success at a "popular" level. If we consider, for instance, the groups of the Virgin with the Child and St. John as a child, painted in the years the artist lived in Florence – the *Madonna of the Meadow*, the *Madonna of the Goldfinch*, the *Belle Jardinière* – along with the drawings associated with them, one observes that, on these sheets, the preparatory studies seem to be intertwined in a single research which, with significant progression, from the cartoon of *St. Anne* by Leonardo, aims at recovering, within the monumental pyramidal structure of the composition and through a prolonged play with "variations", the greatest possible naturalness and spontaneity in the attitudes, gestures and movements which, in the paintings, link one figure with the next, in a harmonious relationship with the natural environment: a lawn covered by flowers, a view of hills, lakes and distant villages, under a serene and luminous sky with a few clouds high up. The traditional attributes associated with the Passion - the goldfinch, the robin, the small cross or the scroll usually offered to Jesus by the small St. John, or different types of flowers – are naturally also found in Raphael's paintings, but their symbolic significance does not appear to dominate the general tone of the image. Any disturbance that may be caused by these elements is overshadowed by the representation of tender affective bonds between the mother and the child, or the two children at play the Virgin watches, only slightly absorbed. Therefore, regardless of the studied and very balanced formal structure, the charming immediacy and apparently easy readability of the image that result from a completely "everyday" affective tone, explains their uninterrupted popularity among laymen, as well as the fact that the painting at the Louvre is today still known by the imaginative and poetic name of "belle jardinière" dating from the XVIII century, when the figure was also described a *"Vierge en paysane"*[28]. As a comment in a passage of *The Courtier* acutely points out[29], studied casualness implicit in an excellent action, in itself rare and difficult but which gives an impression of absolute ease when accomplished in such a way as to elicit amazement and admiration without any ostentation, may in actual fact be aimed at two types of public, and its success (or failure) also depends on the reception given to it. Immediately after having spoken about studied casualness and affectation, Ludovico da Canossa adds "but one can call an art true when it does not appear to be an art; nor does one have to study beyond the fact of concealing it: because if it is discovered, it is completely discredited and makes the man disrespected. And I remember that I have already read that there were some very excellent orators in antiquity, whom among other efforts strove to make everyone believe they had no notion of letters; and dissimulating knowledge, they demonstrated that their oration was made very simple, and more boldly depending on whether they presented nature and truth, rather than study and art; which, had it been known, would undoubtedly have inspired in the spirits of the people, the idea of not being deceived by it"[30]. The discovery of the artifice implied in concealing the "difficulty" entails, if the public is competent, a condemnation of "affectation", but on a popular level it al-

[28] J.B. de Monicart, *Versailles immortalisé par les merveilles parlantes*, Paris 1720.
[29] E. Saccone, "Grazie, Sprezzatura, Affettazione in Il Libro del Cortegiano", in *Castiglione. The Ideal and the Real Renaissance Culture*, edited by R.W. Hanning and D. Rosand, London 1993, pp. 45-67.
[30] B. Castiglione, *The Courtier*, I, XXVI.

so means losing the ability to involve and persuade. The ideal is therefore that of a "pure and friendly simplicity, which is so appreciated by human spirits", which may however only be reached, as experts know well, if the "difficulty" has been mastered and concealed.

Closely related to the intention to render the communicative potentials of the image as great as possible, one must also consider the constant tendency of Raphael to interpret the models – and in particular the works of Leonardo and Michelangelo – by translating their formal and psychological complexity in more relaxed rhythms and more unrestrained "naturalness" of presentation, enabling the spectator to enjoy a more direct, cordial and immediate approach, both on a perceptive and on an emotional level. Also in this case it is a matter of an apparently "natural ease" that conceals any artifice to the "non-experts", while the "experts" are able to fully appreciate the "difficulty" translated in ease and studied casualness.

The apparently simple and natural style developed by Raphael, who captures and "persuades" the spectator (as the listener or reader in the case of oratory or poetry), may be retraced, at least in some aspects, to the "devoted manner" of Francia and Perugino who, as Vasari himself witnessed, enjoyed great popularity and vast success before being overshadowed by the success of the "modern manner", to be subsequently "modernised", but in a different way and developing more specifically devotional implications, by Correggio[31].

After Raphael's move to Rome, one of the most mature and eloquent examples of his apparent "natural ease" may be found in the *Madonna with the chair* or the *Sistine Madonna*, two paintings that have enjoyed great popularity over the centuries, something witnessed by the numerous copies and prints and, even today, by reproductions and souvenirs of every kind. As to the *Madonna with the chair*, Ernst Gombrich, author of a masterly analysis focused precisely on the ways the work is perceived, asserts that "it speaks such an evident language that it has been capable of fascinating many persons who have never heard about Raphael", but adds "entire generations of art lovers have considered it an incarnation of artistic perfection"[32]. On the one hand the painting has inspired the popular imagination and is indeed the subject of picturesque and amusing legends[33] and has been interpreted, due to its "naturalness", as a characteristic scene, to the point of being defined, even by a scholar: "a spontaneous and clearly realistic portrait of a woman with her child, alive and vibrant in the hot breath of the Roman sun"[34]. On the other, it unites "order" and "imitation" so masterly in the difficult "metric form" of the round painting that we "do not realise we are facing a compositive tour de force" because "what we admire is an image of serene and unrestrained simplicity[35].

Also the *Sistine Madonna* has sometimes been "interpreted" as an image of – however unsettling – spontaneity and truth. The Virgin descends from the heaven, towards the crowd of worshippers, indicated by St. Sixtus' gesture and the glance of St. Barbaro, and among whom the spectator feels included. Holding the Child in her arms, almost as if she presented it as a sacrificial offer, without halo but circumfused by an aura of light, she steps barefoot on the clouds, with a movement suggested by the drapery of her garments rather than by the articulation of the limbs. The curtains which, on a symbolic level, indicate that the image is a "theophany", are however perceived, along with the balustrade, as the sign of a tangible vicinity to the divine sphere, thus capturing and involving the spectator with "celestial naturalness". Yet the painting, carefully studied in every detail, is presented as a "portrait of an apparition", a fundamental moment of the radical innovation of altarpieces pursued by the artist – from the *Madonna of Foligno* to the *Transfiguration* – both in relation to the formal structure and the perceptive and emotional relationship created with the viewers, and thus by virtue of its very significance as "icon"[36].

In the *Sistine Madonna*, as well as in the *Madonna with the chair*, the eyes of both Virgin and Child

[31] I would like to thank Dr. Giancarla Perini, who is studying this argument in particular, and with whom I had the opportunity of having useful conversations.
[32] E. Gombrich, "The Madonna with the Chair by Raphael", in *Norma e forma. Studi sull'arte del Rinascimento*, Turin 1973, p. 93. The text, published in English in *Norm and Form. Studies in the art of the Renaissance*, London 1966, repeats the content of a conference held in November 1955 at King's College at the University of Durham.
[33] Idem. pp. 95-96.
[34] P. Oppé, *Raphael*, London 1909, p. 189.
[35] E. Gombrich, "The Madonna...", cit. p. 102. It is worth while remembering that J. Burckhardt had already pointed out that the painting reveals "the entire philosophy of the round painting" (text from a conference held in 1866, published in the *Kulturgeschichtliche Vortraege*, Leipzig n.d., Italian translation in *Letters on history and on art*, Turin 1962, pp. 475-488).
[36] As to the latest contributions on this issue, reference is made to P. De Vecchi, "Portrait of an apparition – Sidenotes on the Sistine Madonna", in the papers of the convention *The Madonna for St. Sixtus and the culture of Piacenza in the first half of the Sixteenth century*, Parma 1985, pp. 34-42, and M. Rohlmann, "Raffaels Sistinische Madonna", in *Romisches Jahrbuch der bibliotheca Hertziana* 1995 (30), pp. 221-248.

Raphael Sanzio
*The Sistine Madonna*, 1513
Oil on canvas, 265 × 196 cm
Dresden, Gemäldegalerie.

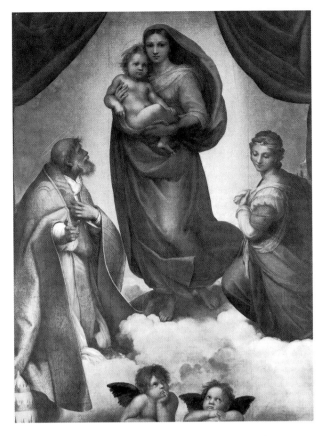

acter. Regardless of whether the glance is oriented towards the eyes of the spectator or not, another element of fundamental importance must also be considered: the creation of precise relationships of an illusory-perceptive nature which identify, through the particular viewpoint chosen, the position of the observer in space with respect to the "painted" image, something which greatly reinforces the effect of "real presence", accentuating the naturalness and apparent spontaneity and immediacy[37].

Previously Leonardo, more than any other, had succeeded in expressing, through the particular organisation of the portrait and the posture of the figure, the specific emotional reaction to the presence of the spectator, in the *Mona Lisa* but also in the *Cecilia Gallerani* (above all on the part of the ermine). Rather than aiming at capturing and expressing the changing "impulses of the spirit" or a particular psychological intensity, Raphael seeks to establish a kind of "communication" with the viewer: *"imago loquitur"*. The image expresses grace and beauty – also physical – in the *Veiled Lady* (en passant, the same "model" as the *Sistine Madonna*) or in the *Bindo Altoviti*: grace, in the sense of the courtly idea of studied casualness, in the case of the portraits of his scholar and Humanist friends, from Pietro Bembo, to Andrea Navagero and Agostinio Beazzano, to Tebaldeo and, above all, to Castiglione.

The suggestion of the "real" presence – both physical and "spiritual" – of the personality in the image perhaps represents the hardest challenge taken on by the masters of the modern manner, within the context of the "comparison" between the evocative potentials of poetry and painting that was reproposed in the Renaissance, in the wake of epigrams from the *Palatine Anthology* expressing the frustration suffered by the artist faced with the inability to express the interior life of the portrayed personalities or, on the contrary, exalted by the ability to render his image "vivacious" and realistic[38]. It appears significant that the superior ability to fascinate of the latter was, in fact, defended by

look towards the spectator, establishing a direct relationship and wielding great charm, both on a perceptive and on an emotional level. Certainly, the expedient of placing a figure with the eyes aimed at the observer had long since been recommended in order to highlight the illusionist effect, but we are here dealing with a dual glance, not of one or more marginal figures but of the "protagonists" and, most importantly, in an image associated with religious rites. The effect is in any case that the onlooker is captured and involved, through the creation of a situation which seems completely natural and ordinary, without any sense of detachment and separation.

The artist pursues the same end in the portraits dating from the last decade of his activity. Also in this context we may assert that one very frequently finds, in Renaissance portraits, works where the glance of the portrayed personality, often appearing distracted and engrossed, rests on the spectator, but the opposite is particularly rare among Raphael's portraits, and always connected – witness those of Julius II and Cardinal Inghirami – to precise reasons of a functional and expressive char-

[37] Fundamental observations in this regard may be found in J. Shearman, *Only connect.. Art and the spectator in the Italian Renaissance*, Princeton University Press 1992.
[38] Idem, pp. 108-112.

Leonardo in particular: "offer a poet who describes the beauty of a woman to her lover; present a painter who portrays her: you'll see where nature will make the enamoured judge turn" and: "and if the poet claims he may incite men to love /.../ the painter has the power to do the same, and to such an extent that when he places the portrait of the loved one before the lover, he often does with it, kissing it and speaking with it, what he would not do with the self-same beauties presented to him by the writer"[39].

Only a complete mastery of the modern manner makes it possible to tackle the awesome "difficulties" of the enterprise – the culmination of the aspiration to "imitation" – with sufficient studied casualness. And Raphael faces this challenge with the greatest "naturalness" in his portraits of his Humanist friends, who shared his ideas on aesthetics and social conduct, through the exchange of glances, which appear even more direct and immediate due to the fact that it is, among other things, based on subtle and precise bonds of perceptive relations between image and spectator.

the apex of this process is probably represented by the portrait of *Baldassare Castiglione*, in part due to the friendship and shared ideals of painter and subject. Castiglione was, for that matter, perfectly aware of the aspirations and achievements of the artist and friend when he, in 1519, on returning to Rome as ambassador of the Gonzaga family, having left his young wife and first child born in August 1517 in Mantua, wrote a Latin elegy, conceived as if it were written to him by his distant wife, containing a clear reference to Raphael's painting in some verses: "*Sola tuos vultus referens Raphaelis imago/Picta many, curat allevat usque meas...*"[40]. Sole alleviation of the suffering caused by the separation, the portrait receives the tender attentions of the wife, who jokes and speaks with it. Sometimes it even seems about to reply her, by hinting or speaking. Even the little son recognises his father, greeting him with infantile babbling. The image created by the artist has almost become a living presence.

Beyond the personality, the painting represents the very ideals of courtly "grace" and "studied casualness", at the same time exalting those values that one considered made life worth living, and it is useful to remember the words written by Vittorio Colonna concerning *The Courtier* and its author, stating that he was by no means surprised that Castiglione had been able to describe the perfect image of the gentleman: "which, merely by holding a mirror in front of himself and considering his internal and external parts, he could describe just as he did"[41].

[39] In *Writings on art from the Sixteenth century*, edited by P. Barocchi, Turin 1978 (II ed.), vol. II *(Painting, Sculpture, Poetry and Music)*, pp. 239-40.
[40] The verses of the elegy that refer to the portrait are reproduced in Golzio, *Raphael in the documents.*, cit., p. 43.
[41] V. Colonna, *Correspondence*, edited by E. Ferrero and G. Mueller, Turin 1889, p. 25 (letter XVIII, dated 20 September 1524).

Konrad Oberhuber

# Raphael's Vision of Women

More than any other painter, the master from Urbino has been praised for the extraordinary beauty of his Madonnas. Reproductions of the *Madonna del Granduca* or of the *Sistine Madonna* were for a long time stock decorations of most households, Catholic or not. Throughout history they have determined the ideal of feminine beauty through the regularity and gentle geometry of their oval faces, a regularity underscored by their simple hairstyles, by their seriousness and simplicity of expression and by their youthful innocence. Their almost canonical character has, in fact, led many to reject those images of the Madonna by Raphael, mostly works of his later years, which do not follow this ideal. The classical artist could not be credited with the great variety of female beauty that he actually produced. When his female portraits corresponded with the two ideals mentioned above, they were admired, but deviations aroused immediate calls for the authorship of Raphael's most famous pupil, Giulio Romano, who was attributed with the more realistic and unusual works. The master of the pure Madonnas was also only rarely allowed to be a master of female nudity. Here too the school was attributed with most of the works once celebrated for their ideal forms and antique qualities worthy of the goddesses of Olympus. This is particularly true of the frescoes in the *Psyche Loggia* of the Farnesina which have recently been cleaned and revealed to everybody; here we find that many more of them are by the master himself than had hitherto been thought. The painting known as the *Fornarina* that combines real-

ism with nudity was particularly vulnerable until recent cleaning again removed all doubts about Raphael's authorship. Yet the Madonnas of the same style are still not accepted by many scholars.

The path that Raphael took in developing his female ideal is indeed extraordinary. One has only to look at the early *Madonna and Child with St. Jerome and St. Francis* from Berlin in this exhibition, with the almost completely abstract oval of its regular face and the geometrically articulated body that follow the idealised language of Pietro Perugino. This influence is also evident in the construction of the body of the Child out of rounded volumes. If one then looks at the *Hertz Madonna* from the Palazzo Barberini painted around 1516, one notices the powerful presence and astonishing realism particularly evident in the completely animated body of the Child with his meticulously observed skin and swelling muscles, but also in the impressive face and head of the Madonna with her large eyes and the almost trapezoid form of the face and large hairdo. Even more astonishing is the bodily presence of the figures in space, where antique dignity and antiquarian concern for dress replace the old generalised and timeless elements of bodies and garments of the Perugino school.

Yet the beginning of the path towards the observation of the body in terms of surface and the undulations of life in its various parts is already obvious only two or three years after the Berlin Madonna in the beautiful body of the *Christ Blessing* from the Pinacoteca Tosio Martinengo in Bres-

cia dateable to around 1504-05. We know from a drawing representing the bust of a St. Sebastian in Hamburg (K.M.O. 97) that at that time Raphael was making black chalk drawings from a nude model, while all nudes in his drawings before that time seem to be derived from other masters. The models which he studied and drew before 1504 or 1505 were figures in studio tights, garments also used in Perugino's studio which gave to the body a kind of geometric abstraction that corresponded to the early ideal in Raphael's work. It suited his search for the rendering of the figures in space, a skill in which he excelled above all other members of the Umbrian school and which had induced even such great old masters as Bernardo Pinturicchio to seek Raphael's help in the design of difficult compositions of figurative poses. From the very beginning Raphael tried to give his figures something like a central axis around which they could turn, an uprightness, which is very apparent in the *Christ Blessing*, but can also be felt in the Saints at the left and the right of the Madonna in Berlin which seem to command their own space behind her sacred, and therefore a little flatter, image. The *St. Sebastian* from Brescia in this exhibition, however, seems to have no space around him and presents himself with powerful frontality. The oval of his face is also more assertively anchored in the picture plane than any ever found in early works by Raphael, where faces and gestures always seem more delicate and tentative and at the same time more filled with inner emotional life. The *St. Sebastian* is a masterpiece by Raphael's teacher Pietro Perugino and can serve as a wonderful comparison to the *Christ Blessing* that has much more individualised features, a mobile stance and space, and the amazing realism in the observation of the hands and skin, so different from the accomplished abstraction of the *St. Sebastian*.

It is at this moment, around 1504, that the faces of Raphael's women become more individual. In a famous portrait drawing of a young girl in the British Museum from around 1502-03 and another

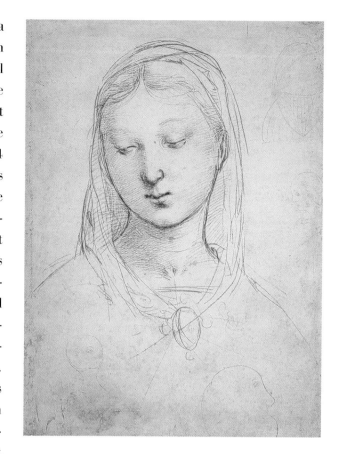

Raphael Sanzio
*Study of the Madonna*
London, British Museum.

one in the Uffizi (K.M.O. 73 and 74), geometric clarity and abstraction seem to prevail over the glimmer of alert individuality that can be felt in the intensity of the eyes. Nonetheless this young woman can be recognised in the Virgin of the *Oddi Altarpiece* in the Vatican, even in the predellas, by her crisp elegance, delicate features and long neck. She may have been among the first beautiful young women whose portraits Raphael drew or painted, perhaps in recognition for their services as model or as a means to study them for his pictures. In the studies of the heads of a young woman (K.M.O. 83 and 85) related to the *Sposalizio* in Oxford of around 1504 – I cannot be certain whether this is the same model slightly later or a different one – and in some other works from that moment, a new gentle softness of animation appears that betrays an awakening sensibility to the expression of emotions in the face but also to the surface of skin and its softness. The bust of a saint in the British Museum (K.M.O. 86), which may portray the same woman, has a questioning gaze above the now much

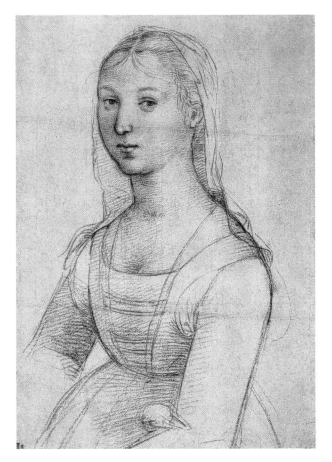

rounder body that almost makes one think of the *Mona Lisa* of which Raphael made a study only a little later in a small silverpoint drawing in Lille on green paper in a group of small sheets. These seem to point to the beginning of his sojourn in Florence and his preparation for the fresco in San Severo in Perugia of 1505.

The delicate female faces of the studies for the *Sposalizio* reappear in the *Three Graces* in Chantilly, the first female nudes that Raphael painted. It seems unlikely that Raphael had studied an actual nude model for this lovely image, which demonstrates a true feeling for the female body, especially in the central Grace seen from behind. Up to this moment young men in tights had posed for the Madonnas to whose bodies Raphael simply transferred female characteristics. In Florence Raphael immediately corrected the gentle and somewhat abstract physical forms of the *Graces*, which he must have observed in real life through what garments might reveal, by drawing Leonardo's *Leda* in a famous study now in Windsor Cas-

tle, possibly from a pen study by the older master himself. Leonardo seems to have been extremely generous in giving the young Raphael access to the material in his studio. Both the swan and the child seem to be drawn in a style close to his way of sketching. In this way the female body gains in ampleness of the hips and grace in the tapering of the legs and becomes closer to the physical truth in the relationship of arms to shoulders and breasts, but the young artist simply absorbs the experience of his much more knowledgeable colleague and master. Raphael was still using the lower part of the Leda's body when he painted Eve in the ceiling of the *Stanza della Segnatura* five years later at a time when, as we shall see, he could already have made nude studies of his own for this figure. When Raphael in Florence actually used a female model to study his Madonnas, the young woman clearly remained dressed. Neither of the studies for Madonnas from the Uffizi here in the exhibition gives any indications of whether a model was used, nor are they of a drawing type for which models have to be used, especially not the study for the *Madonna del Granduca*. Other drawings, in particular various studies for the *Madonna of the Goldfinch*, seem to indicate that there was a female model which might occasionally even have shown her legs to the young artist (see K.M.O. 149). This very graceful woman, variously dressed, seems to have posed for three different female saints in the early version in the Louvre (K.M.O. 193) of the Borghese *Entombment of Christ*. She may also have served as model for the extraordinary *St. Catherine of Alexandria* in the National Gallery in London, which most fully embodies the graceful Leonardesque female ideal achieved by Raphael around 1507. It shows a freedom of movement and an openness of expression which could hardly have been foreseen in 1504. The expressive pose of the head and uplifted eyes are, however, not inspired by the model but derived from Michelangelo's *St. Matthew* which Raphael copied in a drawing in the British Museum (K.M.O. 206). There is

clearly also a male nude study for a Virgin praying under the Cross for a picture no longer extant or never painted, as exemplified in two drawings in the Albertina in Vienna (K.M.O. 138 and 139). In Florence male nudes seem to have been easily available to Raphael and he clearly took advantage of this opportunity rivalling now not only Leonardo but, above all, Michelangelo, whose works he had also come there to study.

While Raphael's frequent male studies remain for the most part unused, since the frescoes in Perugia with historical and mythological scenes that Raphael must have been asked to paint were never executed for reasons we are unaware of, the studies for the Madonnas bear ample fruit in numerous works in which the figure gains in mobility, in amplitude in space, and in expression. The quiet restraint of the early *Madonna del Granduca* becomes fully apparent when one compares it with the *Madonna Tempi* in Munich painted only three years later with an almost spiral movement and an intimacy in the interaction between mother and child gained through incessant study of bodily action be it male or female. Female beauty is especially clearly expressed in the gentle variety of faces of the Florentine Madonnas as Raphael delicately modifies their features, arranging and rearranging their hair, turning their heads and animating their faces in a sequence of different expressions of sweet concern for their lively charge, the baby Jesus. Their basic character, however, seems to follow one single type. While the Madonna in the *Ansidei Altarpiece* painted for Perugia in 1505 still clearly makes full use of the graceful and slender model Raphael had used in that city, the *Terranuova*, the *Madonna del Granduca*, and the *Small Cowper Madonna* all of the same year assume somewhat rounder forms without truly pointing to a new prototype. The *Madonna of the Meadow* of 1506, however, clearly has an ampler chest, a more elaborate hairstyle and a more individual rounded face that reflects the body type of the model mentioned above and which seems to be at the base of all of Raphael's

Madonnas in Florence, however modified their faces may be. The studies in Oxford and in the Metropolitan Museum in New York for the Vienna picture (K.M.O.123,124) seem to show this female model in tight studio garments. As we saw in studies for the *Madonna of the Goldfinch* and in others like the one in the Albertina for a Madonna in half length (K.M.O. 137) or the Louvre study for the *Belle Jardinière*, Raphael could study her legs. While the artist clearly had a variety of older and younger men to study in the nude, the female model seems to have been not only chastely dressed but also to have been the only one. The female nudes in the mythological studies where Raphael at one point groups two nude men with a single clothed young woman, and then two female nude nymphs with one male figure, both in Oxford (K.M.O. 175 and 176), do not seem to be drawn from a live model.

There is also a large portrait drawing of Raphael's model from the Florentine period. It is the gentle and somewhat summary profile study in the Uffizi (K.M.O. 205) that was evidently used for the Magdalen in the Borghese *Entombment* and is close to the preparatory drawing for the picture also in Florence (K.M.O. 202), though it does not seem to be a preparatory study for it. It gives us a good side view of this long-necked young woman with her regular rounded head, the high forehead and the long delicate nose caught in a somewhat melancholy mood. Whether Raphael intended to paint a real portrait of her we cannot know. The study follows, in any case, the type found in the Umbrian period in the sheet in the British Museum mentioned above (K.M.O. 74) but was more quickly and more summarily executed.

Raphael's encounter with femininity in Florence is, in fact, deepened by a number of wonderful painted portraits. The first one is that of *Maddalena Doni* from 1505, still strongly constructed in the Perugino manner, but already with lively hands and a certain individualised observation of the features and the skin, yet far from the Flemish realism observable in her husband. The

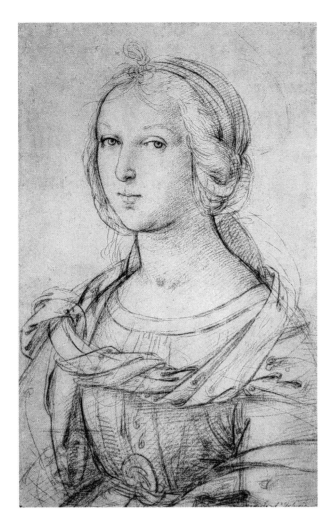

Raphael Sanzio
*Portrait of a Young Woman*
London, British Museum.

work a new dignified and specific presence of the sitter that, in spite of the symbol of Virginity in her lap, makes her a person rather than a bride. Raphael conveys to his sitters, male or female, a stature as individuals more than any of his Central Italian predecessors and he does so through spatial freedom, the uprightness of their pose, and the luminosity of the colour. While these early portraits follow Leonardo and Memling in the landscape behind them, the slightly later pictures referred to as *La Gravida* and *La Muta* are painted in the older Italian tradition of a simple dark background. Their presence and their individuality have become even more powerful and one gains an insight into the social stature and responsibility of these women whose names are unfortunately not known to us. It is amazing how, while following a set pose and a strong geometric ideal in the presentation of their bodies and heads, the artist nonetheless varies the shapes of their faces and chests as well as individualising the form of their hands, so that one can clearly perceive the very different body types, ages and character. There are no male counterparts to these ladies unless one is tempted to date to this later Florentine period the *Male Portrait* in the Getty Museum, which could, however, like the *Portrait of a Young Man* from Budapest, already belong to the beginning of Raphael's phase in Rome, where the young Humanists of the papal court must have begged the artist to do their likenesses. None of them, however, has the strength that emanates from the ladies.

At the very end of Raphael's stay in Florence, when he was preparing for the *Madonna del Baldacchino*, an extraordinary event in Raphael's relationship to women took place. There are two very slight sketches of a face and head that differ decisively in character from the confident roundness of the Florentine model; they show a much lower forehead and more squarish features, and emanate an element of delicacy and shyness as a whole. When the two studies are viewed side by side – they are now separated between the Bay-

grand pose of the *Mona Lisa* is reduced to simple geometry. Yet a year later in the *Lady with the Unicorn* from the Villa Borghese the miracle happens: Raphael no longer constructs but depicts a real person. The blonde young woman with blue eyes affected the looks of many of his Madonnas and the drawing style of the wonderful study for the painting in the Louvre could make one think of Raphael's model especially when one looks at the more finished drawings, only to discover that the Borghese *Lady* differs from the other young woman through the much higher oval of her head and the generally less rounded forms of all the features of her body, especially the strongly tapering shoulders so different from the gentler bent ones of the model and thus of all the Madonnas. While clearly inspired by the *Mona Lisa*, particularly in the feature of the two columns framing the image at the left and right that were once part of Leonardo's picture, we feel in Raphael's

onne and Cambridge, Massachusetts (K.M.O. 253 and 254) – one sees on the verso the same model posing in the nude for a *Venus pudica* slightly and somewhat hesitantly leaning forward (K.M.O. 256). Raphael had finally found a young woman who would pose for him not just dressed and in the religious context, but also in the nude. The even more astonishing fact is that this model's proportions, with the rather tight chest, heavy thighs and lower half of the body but thin and delicate lower legs, a squarish face and low forehead, seem to correspond to those of a model that Raphael still used at the end of his life; in addition, the slightly bent pose of the Venus in the drawing reappears in reverse in a drawing for a *Festa di Venere* formerly in the Schindler collection in New York and now in an Austrian private collection. It was also used by the pupils of Raphael for a fresco in the Villa Madama that has gone through various attributions, amongst them Giovanni Francesco Penni, but which I would like to return to the master as one of his last works, just as it was attributed to him in 1544 when the composition was copied from the chiaroscuro by Ugo da Carpi which it had inspired, by the Master NDB, who inscribed his print (B.XII, p. 109, no. 5) with the name of Raphael as inventor (See: Oberhuber-Gnann, 1999, no. 195). Yet so many other female model drawings, whether dressed or in the nude, show the same shy face and identical body features, amongst them the small drawing in the pose of a *Venus pudica* in Budapest (K.M.O. 545) and studies for the *Psyche Loggia*, that one can only draw one conclusion: This female model, whom Raphael used so many times in Rome, must have already entered his household at the end of his stay in Florence, probably as a servant to do his housework as well as a model for his pictures. This may be the first appearance of the famous *Fornarina*, thought in the 19th century to be the daughter of a Roman baker whose house one even tried to identify. If the observation is true – for the myth of the name was long ago exploded as only appearing in the 18th

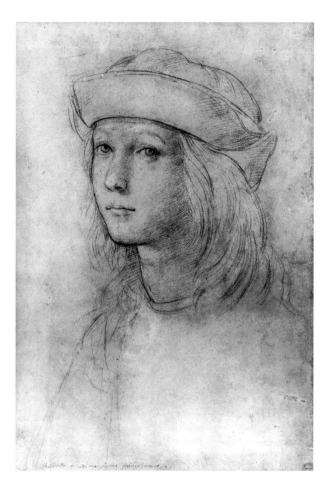

century literature as a humorous name for an unvirtuous woman – then this young lady and, most likely, Raphael's first assistant, the Florentine Giovanni Francesco Penni, had already been hired by the master before he came to Rome.

I have argued in the past that this young model first appeared at the time of the *Disputa* when Raphael drew a *Venus rising from the Sea* on a sheet with a study for a figure in an early design of the fresco in the Uffizi (K.M.O. 284). While this drawing is sketchy and somewhat idealised, we have a more precise record of the young woman's appearance in the studies of her legs for the famous print by Marcantonio Raimondi of the *Massacre of the Innocents* in the Albertina (K.M.O. 344) and in the *Venus* in the British Museum (K.M.O. 358) from the time of the *School of Athens*. There can be no doubt that this is the same person as the nude from Florence. Again she appears in the silverpoint drawing of a nude seated on the ground in Cleveland (K.M.O. 417) that must date from around 1511. It is easy to establish a conti-

nuity of studies of the model in the nude from then on. Around 1512 Raphael draws her as an allegory of Grammar watering a flower in a small drawing in Chatsworth (K.M.O. 455). Around 1513 Raphael made mythological studies, among them a *Toilette of Venus* in the British Museum (Oberhuber-Gnann, no. 34), using the same model who appears nude in the nymphs in the famous print by Marcantonio, the *Judgement of Paris*, which should also be dated to that time (Oberhuber-Gnann, no. 33), while the three goddesses have somewhat heavier forms. It is true that the next appearance of this model in the nude is only in 1516 in the studies for the *Bathroom of Cardinal Bibbiena* and in the early ideas for the *Psyche Loggia* designed for Agostino Chigi, but there are drawings from 1514 and 1515 that show the same model dressed but with facial and body features close enough to ensure the continuity (see K.M.O. 527 and 528). Since 1516, nobody has doubted the identity of the nude models in the drawings for the Farnesina or even the dressed one for the Madonnas or the so-called *Fornarina*, an identity supported by Vasari's tale, stating that by that time Raphael was deeply in love with his model and could not stay away from her, an infatuation, according to Vasari, that ultimately led to his untimely death. Yet it is not sure whether Vasari just invented this to explain the special erotic qualities of Raphael's mythological works, especially of the *Psyche Loggia*, and the general venerean disposition of the artist re-marked upon by other authors, or whether he actually had precise information about this from Raphael's even more erotically inclined pupil, Giulio Romano, whom he knew personally. We shall see later that the bodies of the various nudes in the frescoes and drawings do not all seem to be the same.

One thing, however, is clear from the pictures: that the facial features of the model we know as the *Fornarina* dominate the female imagery in Raphael's work from around 1514-15 onwards, i.e. from the *St. Cecilia with Saints* in Bologna and the *Spasimo di Sicilia* in Madrid, even though the artist continues to vary the facial expressions by altering the hairstyle and other aspects. Occasionally, however, he brings in a totally different facial type even for famous works like the *Madonna with the Rose* or the *Madonna of Francis I*. In fact there are moments, as in the Vienna version of *St. Margaret*, when he uses the head of the model in full unison with the body, while in the Parisian version of *St. Margaret*, he places a different head type with a higher forehead and a more elongated oval face on the body, with the help most probably of Giulio Romano; the head, in fact, is almost a memory of that of the woman we know from the *Lady with the Unicorn*. In the *Hertz Madonna*, seen in the exhibition, one can, on the other hand, clearly see the similarity to the portrait of the *Fornarina*. Raphael has simply painted the hair blonde and made the forehead a tiny bit higher so that it appears a little more triangular.

The situation was quite different before 1514. The model in the figure drawings of clothed women often seems to be the same as that used in the nudes. This is especially evident in the caryatid in the Louvre (K.M.O. 493) for the *basamento* of the *Stanza d'Eliodoro*. From around this time there are some studies for Madonnas where a kind of domestic intimacy becomes apparent, e.g. the two studies, one in Chatsworth and one in Oxford (K.M.O. 444 and 445) with a seated Madonna on a low chair and a rather large child standing next to her. In these works, which relate chronologically to the *Madonna of the Seat* but may have served for an unfinished painting in the Villa Borghese (Oberhuber 1999, fig. 233), one feels a kind of warmth and sweetness emanating from the studies of the nude and foreshadowing feelings one receives from later studies like the caryatid for the *Sala di Costantino* in Frankfurt (K.M.O 588) and from the Louvre's *Study for a female head* here in the exhibition. The most personal of these studies from around 1514 is a little sketch of a sleeping woman seated at a window made on

a preparatory sheet for the ceiling frescoes in the *Stanza D'Eliodoro* and the vaulting system of *St. Peter's* and therefore dating from this time. I feel less certain about the Fornarina model posing for earlier Madonnas, but I would like to consider it possible that the study for the *Madonna Alba* in Lille (K.M.O. 385) combines the type of head similar to that of the nude model with a body that seems to be in conformity with hers; this would then also be the case with the early study in Oxford (K.M.O. 394) for the *Cumaean Sibyl* in *Santa Maria della Pace* or the study for *Sappho* in *Parnassus* in the British Museum (K.M.O. 372). Yet other studies of what might be, but which not necessarily is, the same body have clearly different heads like the later definitive study for the same *Cumaean Sybil* in the Britsh Museum (K.M.O. 393), the study for the *Madonna di Foligno* on blue paper also in London (K.M.O. 427), or the wonderful silverpoint study of the *Madonna dell'Impannata* in Windsor Castle (K.M.O. 425). This fact makes identification of the model less easy. The elegant oval heads seem to fit so well with the slender bodies that one is not really willing to see these studies as combinations of two different women. Did Raphael then have more than one female model in his early time in Rome? When one looks at the *Sybils* in *Santa Maria della Pace*, the *Cumaean Sybil* in its final version clearly represents one type of young woman while the sibyl to the left of the arch actually represents the other type which we know from the Oxford study of the Cumaea whom we have tentatively identified with the *Fornarina*. Meanwhile, the sibyl on the far left is different again in facial type and body, having not only the round face familiar from Florence but also the ample bust and general roundness of the body. In fact there is a study for one of the Muses in *Parnassus* (K.M.O. 375) in the Albertina in Vienna in which the bare-breasted model is shown with the round head familiar from Florence and very slender arms quite unlike the plumper ones of the nude model identified with the *Fornarina*. Features similar to the upper torso of this figure can be seen in the figure of Eve on the *Segnatura* ceiling and whose lower section is derived, as we saw, from Leonardo's *Leda*. These features do not conform to the body we think is that of the model for the *Fornarina*. Even more disturbing is the extraordinary black chalk study in Windsor Castle for *Poetry* on the ceiling of the *Stanza della Segnatura* now with a fully nude torso. Here the thoroughgoing roundness of form and the great beauty of the proportions of this model make it very clear that she cannot be identical to the sweet but more homely other young woman. One could also speculate that the extraordinarily lovely sheet of a Madonna and Child in the Albertina that Raphael drew on the back of a study for the *Disputa* (K.M.O. 310), and which included a love sonnet, was created using the same model, but it is in fact too summary and free to have actually required a model; it is purely the animation of the face that seems to point in that direction. Were the sonnets that speak of a secret love and found on the drawings for the *Disputa* directed to this young lady?

From all these observations it seems that one can assume that Raphael had, in fact, three female models in his early time in Rome and had not only brought the young Fornarina with him from the city on the Arno, but also the earlier model, henceforth called the Florentine model who, in the new situation in Rome, seems to have been freer in her habits of letting the master study her body. This model, whom we will trace in some of the painted Madonnas, may, as we shall see later on, have influenced Raphael even after 1514 when the Fornarina seems to have won out in general over her rivals, especially the lovely one with the oval face whom we shall henceforth call the Cumaea model from the beautiful drawing in the British Museum which seems to characterise her best.. It seems, incidentally, also clear that even in Rome Raphael occasionally used a young man to pose for a Madonna, as in the study for the *Madonna with the Fish* in the Uffizi (K.M.O. 458), which does not seem to show any signs of femininity.

Raphael Sanzio
*The Three Graces*, 1504-1505
Oil on wood, 17 × 17 cm
Chantilly, Musée Condé.
© Photo RMN - R.G.Ojeda.

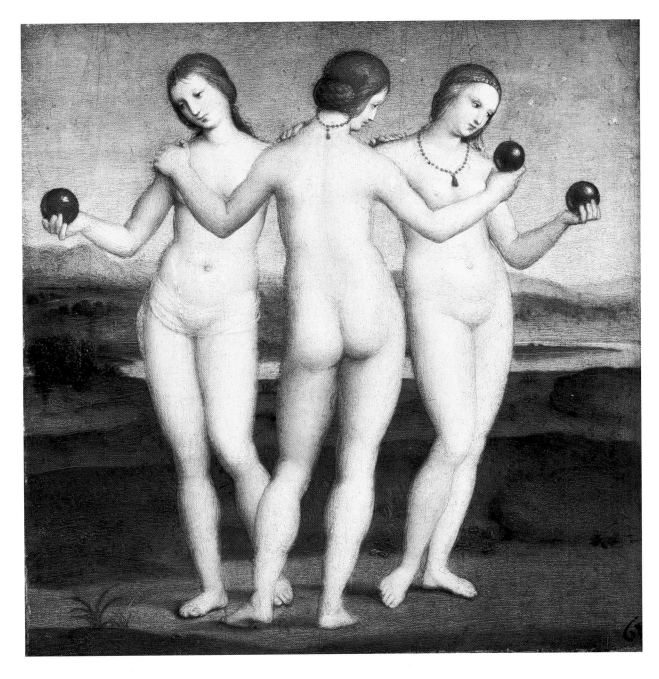

There are many more studies of women in that time not discussed, like the ones for the frescoes of *Heliodorus* (K.M.O 428 – 430) and for various Madonnas where it is even harder to determine a definite body type that can be clearly assigned to one single personality. Maybe more intensive research will help in the future. Again, I would tend to speculate that many of them were made from the Cumaea model. In summary, one could say that in all likelihood between 1509 and 1514 in Rome there were three female models in Raphael's workshop: the first was the round and ample chested girl known from most of the Flo-rentine Madonnas, the women in the Borghese *Entombment* and, above all, from the *St. Catherine*; the second was the model on which the *Fornarina* was based who posed occasionally in the nude but before 1514 only rarely with garments; and the third was the slender model whom we know from the British Museum version of the *Cumaean Sibyl*.

It is evident that Raphael used a considerable variety of different head types in his paintings and frescoes from 1509 to 1514, unlike the period he spent in Florence or after 1514 when he mainly varied one specific type of face and head. One of

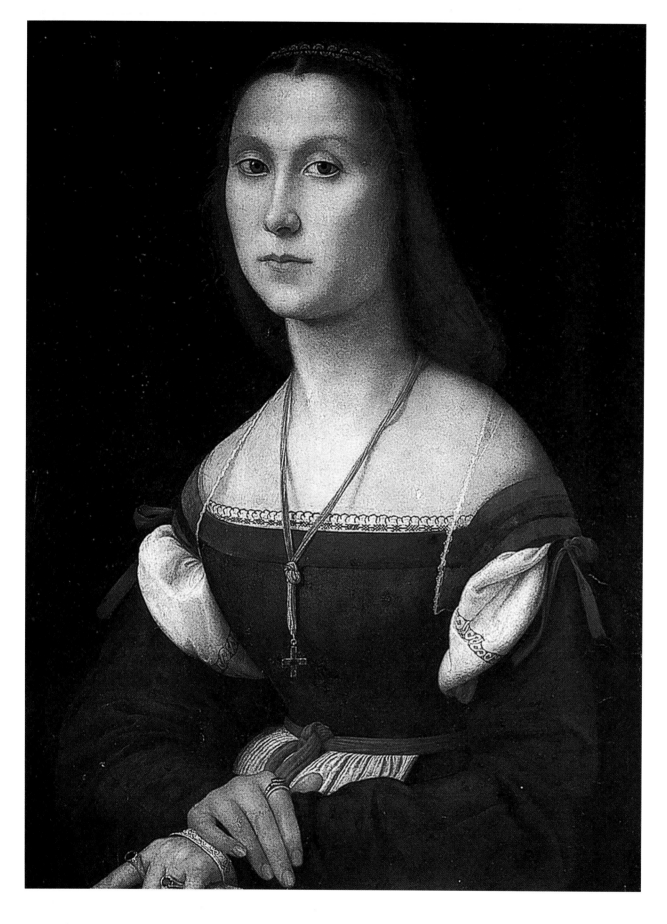

Raphael Sanzio
*La Muta*, 1507-1508
Oil on wood, 64 × 48 cm
Urbino, Galleria Nazionale
delle Marche.

the most charming, the head of a Muse in *Parnassus*, can be studied in a beautiful drawing in this exhibition. Raphael also used this blonde head at a later moment for a woman in one of the tapestry cartoons of around 1509. There is also one small silverpoint study for an early version of the *Aldobrandini Madonna* in the British Museum (K.M.O. 414) that also uses this same young model. Unless one also wants to recognise this young woman in the head of the figure of *Poetry* above this fresco, a figure, which, as we saw, originally had the very different and more expressive head of the Florentine model in the drawing in Windsor (K.M.O. 334), these two probably contemporary drawings must have been prompted by a unique occasion for the artist to study the face of this particularly beautiful young woman, who seems to have consented to pull back her hair in an antique style befitting a Muse quite unlike all the other women that Raphael drew. There is a second study for a Muse in the Colville collection in London (K.M.O. 378) which, while somewhat similar in the high forehead and the oval of the head, seems to have a slightly different expression in its more conscious gaze. One has the feeling that this head belongs to a dark-haired girl rather than a blonde one and that the brunette figure of *Moderation* in the *Allegories of Justice* in the *Segnatura* and the equally dark-haired *Aldobrandini Madonna* in its final execution seem to render this model with the greatest precision in her natural hair colour. This head seems to be, in fact, the one that has furnished the basic type for many of the figures of women in Raphael's early years in Rome, amongst them the *Madonna di Foligno*, the *Madonna with the Fish*, the *Sistine Madonna*, and the *Madonna of the Seat* but also many others. She rules this early period in Rome the way that the Fornarina rules the later part. She is the woman I refer to as the Cumaea model.

The *Madonna Alba* on the other hand, seems to be the one certain case of the use of the Florentine model in a Roman Madonna, unless one considers the unusual face of the *Madonna della Tenda* another example. She may, however, also be the model for a picture up to now little considered in the literature because it was finished at a later date by a Florentine painter, the *Holy Family with St. John* in the Kunsthistorisches Museum in Vienna (Oberhuber 1999, fig. 227). In those early times the model we know as the Fornarina seems to appear only once in a painted Madonna. If I am right, she is the prototype for the *Madonna with the Diadem*, which strangely enough heralds in her antiquarian mode many of the later Virgins in which she truly dominates. *Parnassus* and the allegories in the ceiling and the fresco with the allegories of Justice in the *Stanza della Segnatura* were for Raphael rather special occasions to celebrate varieties of female beauty even though he always sought occasions to include women in his historical compositions, for example, the *Stanza d'Eliodoro* and the *Stanza dell''Incendio*. At a later stage, this constituted one of his claims for superiority over the very strongly male-dominated work of Michelangelo. Yet around 1511, when he also painted the *Sybils* in Santa Maria della Pace and his work could also be admired by the general public, he received particular opportunities for this pursuit. Whichever models Raphael may have used, his presence in Rome led to a somewhat new style in female representation in comparison to Florence. The general physical ideals of the four allegories in the ceiling of the *Segnatura* already reflect the switch that came about at the end of the Florentine period with the *Madonna del Baldacchino*, perhaps affected by the new model that entered the master's workshop. Typical features are their narrower chests and more delicate bodies but also the different manner of dressing. They are clad in the high girdled costumes of antique muses. Again Raphael employs his principle of variation by changing their costumes and hairstyles and slightly varying their heads. Once in the case of *Justice* he still looks back to the serene loveliness of the Florentine Madonnas, while in the case of *Philosophy*, the new Roman dark-haired type of

the Cumaea model so well described in the Colville drawing seems to appear.

She is seen also in the top row on the right in *Parnassus*, with a sisterly variation of her head at her left side and the blonde girl from the study from the Horne Museum right next to them. On the other side of the central tree group we see three muses also with sisterly faces combining the oval roundness of the *Madonna del Granduca* with the more open blonde hairstyle of other Florentine Madonnas, while the heads of the two seated muses seem similar to Raphael's Florentine model who sat for the preparatory drawings. *Sappho*, finally, is closest to Raphael's Roman model, the Fornarina, as we saw when studying the British Museum drawing for the painting.

We already studied the *Sibyls* in *Santa Maria della Pace* where Raphael mainly features the two female types, the dark-haired Roman and the blonde Florentine, one still reminiscent of the *St. Catherine* and even showing some of her physical characteristics, while the third young woman in the group, the one that turns in a kind of spiral movement, is based on a study of the young Fornarina but is not presented through the beauty of her head and face. Here Raphael also includes an old woman in one of the Sibyls, a model he also used for the figure of St. Elizabeth in the *Madonna dell'Impannata* and later on in the *Fire in the Borgo*.

These three extensive series of frescoes allowed Raphael to celebrate the grace of women, presenting them with light bodies, in floating, rippling garments and with highly idealised faces. Leonardo da Vinci's ideals tinged with Peruginesque geometry seem to dominate these creations. The famous *Madonna Alba* in Washington, a *tondo,* is the embodiment of this style in which everything abounds in rhythmical curves. Yet only shortly afterwards, in the *Allegories of Justice*, Raphael's female types have gained heaviness and great dignity as the master struggles with the influence of Michelangelo and makes a big step in his development. *Prudence*, who follows the Florentine model, is still the lightest. *Moderation* is clearly linked through the lovely oval of her head to the Cumaea model, she is much more compact and very similar to the *Aldobrandini Madonna*. The most Michelangelesque and heaviest of all is of course *Fortitude* whose facial features and body forms could possibly be interpreted as transformations of the *Sappho*. Her energy resembles the *Madonna of the Diadem* but her garments are entirely different. With Raphael, this kind of scheme, in which one tries to understand his figure types by setting up various models as we have done here, will never fully work out in the end because he is always free to combine and vary things in his own way.

The *Stanza d'Eliodoro* provided fewer occasions for the presentation of femininity. The *Expulsion of Heliodorus* still has beautiful onlookers who react to the tremendous miracle with the graceful garments and faces we know from *Parnassus*. As in the drawings, the models on which the figures are based are hard to determine even though I suspect that the Cumaea model may be the prototype for the elegant figure prominently placed in the foreground. The much more simply clad, grander and heavier figures on the right of the *Mass of Bolsena* are more reminiscent of the *Madonna with the Diadem* for the standing women and possibly of the Florentine model for the seated one. In any case they already follow the new precepts.

As we have already seen, it is the Cumaea model who fully dominates in the Madonnas, with their lovely oval faces and high foreheads, beginning with the *Madonna di Loreto* and perhaps the *Madonna del Libro* (Oberhuber 1999, fig. 210). Her graceful, very upright and dignified stance compliments her ideal face and leads to the grand and statuary figure walking on clouds of the *Sistine Madonna*, a true new goddess. In contrast, St. Barbara in the same picture still makes one think of the Florentine ideals.

But who then is *Galatea*? Is Raphael's letter to Castiglione to be trusted, where he says that she is

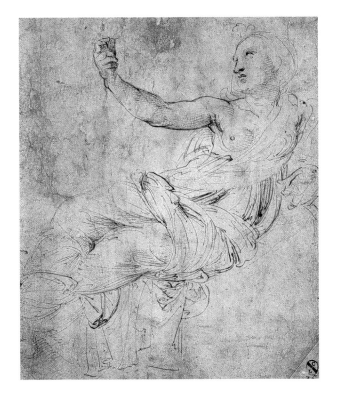

entirely invented because he does not have enough beautiful models to choose the best parts from? Her body clearly corresponds to the seated nude in the drawing in Cleveland (K.M.O 417) and to that of the Venus in the British Museum (K.M.O. 358) whom we have declared above as early embodiments of the *Fornarina*, but her rounded head with the high forehead differs from the model's and seems to combine the roundness and animation of the Florentine model as seen in *St. Catherine* with the delicacy of the Cumaea model. So Raphael may after all have followed the ideas of Xeuxis. The prominent and much more realistically painted nymph riding on her lascivious partner seems to have the fuller torso that we know from the study of *Poetry* made from the Florentine model, but a face in which the low forehead is somewhat reminiscent of the *Fornarina* combined again with a Leonardesque sweetness found in his Florentine work, for instance, in the *Colonna Madonna*. The wonderful floating blonde hair of the third nude, seen from the back, reminds one instead of the blonde girl he once drew, but she certainly did not provide him with a special drawing session for this lovely invention. Raphael's next grand display of women came with

the *Fire in the Borgo* where we also find the old model on the left whom we saw in the *Sibyls* and in the *Madonna dell'Impannata*. The women on the right, especially the one that carries the water jug on her head, are still related to the onlookers in *Heliodorus* through their upright stance and slender bodies and represent the ideal of the Cumaea model combined with elements of the hair and head of the blonde girl from *Parnassus*. The kneeling woman holding a child in the centre, for which there is a beautiful study in the Albertina, is strangely similar to Raphael's Florentine model and even makes one think of the early study for the Borghese *Entombment* (K.M.O. 193) and of the portrait drawing in the British Museum (K.M.O 205). Even the grand lady with outstretched arm whose face is similar to that of the *Madonna della Tenda* may be inspired by the Florentine model rather than by the Fornarina. This makes one wonder whether the old idea that the Fornarina is Raphael's only model from 1514 on can be maintained. Two drawings for the *Madonna of Francis I*, one in the Louvre (K.M.O. 568) and one in the Uffizi (K.M.O 569), invite reflection. The Louvre drawing clearly shows the delicate body and shy face of the *Fornarina*, but the face in the Uffizi drawing appears much more energetic and much closer to the Florentine model, it is a face that is actually closer to the one in the final painting and once again represents a combination. Moreover the fragment of a cartoon for the *Pearl* in Lille (K.M.O 581) shows the beautiful, almost oval, but strongly rounded face and hand which is again the one we know from Florence. It differs strongly in proportions and expression from that in the Louvre for the *Sala di Costantino* here in the exhibition. The face for the *Pearl* is also the alternative face for the *St. Margaret* in the Louvre, which we discussed above, who may on close inspection even also have her body, differing in the more energetic rhythm of movement from that of the Vienna version. Does this continuity explain faces like that of the mother of the possessed boy in works like the *Trans-*

*figuration?* One has to be careful! Raphael obviously had to continue to vary his female protagonists even after 1514 as the famous spandrel *Venus, Ceres and Juno* in the *Psyche Loggia* demonstrates. Here Ceres clearly has the head of the Cumaea model, probably inspired by an earlier drawing, while Venus has the animation of *St. Catherine*, and thus of the Florentine model, which is also visible in Juno's head. Are the great varieties of female heads and body types hitherto easily dismissed in terms of collective participation based on the study of various models or Raphael's freedom in varying that of a single person? One easily recognises the Fornarina in drawings like the ones in Chantilly, in the Teylers Museum in Haarlem, and in Lille (K.M.O. 555, 556, and 557) that are usually attributed to Penni or Giulio Romano. One can also recognise her in the study of Proserpina behind Hebe in the drawing in Haarlem (K.M.O.552), but when one looks at Hebe in the same sheet and at the three Graces in the study in Windsor Castle (K.M.O. 553), the general expression of the body and the facial features seem so different that one is easily disturbed. The same is true for the great difference in expression of Juno and the Psyche in the sheet from the Louvre here in the exhibition. Even the difference in the bodies of the two servants of Psyche, one from Chatsworth (and now in Edinburgh and here in the exhibition) and the other one in the Louvre (K.M.O. 548 and 549), may betray more than two different poses and hairstyles. One seems svelte and energetic, the other slow and languid. The *Psyche carried on Clouds* also from Chatsworth seems the most unusual with her lovely oval face and unusually loose hair taken up in a bun. Again the problem has to be left open and in confusion. Perhaps the notion that came to us from Vasari about the Fornarina as the only female model is not correct even for the period after 1514 when she seems to take over the role of the Cumaea model in the Madonnas of the earlier Roman period, but of course without absolute exclusiveness. In the executed frescoes of the *Psy-*

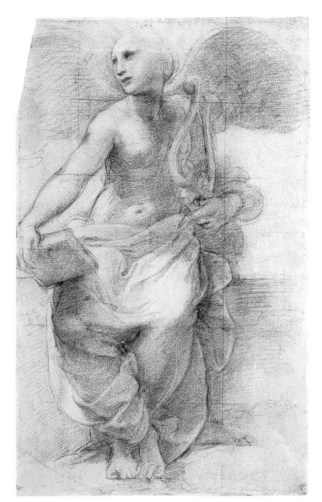

Raphael Sanzio
Study for *Poesia*, ceiling of the Stanza della Segnatura
Windsor Castle, Royal Library.
The Royal Collection
© 2001 Her Majesty Queen Elizabeth II.

*che Loggia* it is absolutely clear that Raphael has to vary his female figures according to the principles that we have observed so far. By now the various hairstyles and facial types have become familiar from many of his previous works and even the bodies seem to follow the variations already observed in *Parnassus* or in the *Allegories of Justice*. For example, in the ceiling fresco of the *Council of God*, the three types, the slender and elegant long-necked Juno, the heavier rounded Venus and the young and svelte Psyche, are deliberately contrasted with each other. The *Three Graces* both in the spandrel and in the *Marriage of Love and Psyche* consciously show sisterly bodies taken in each fresco from one model but not necessarily from the same in both.

The body of drawings of the female nude for the *Psyche Loggia* is the largest in Raphael's work because the nudes also appear in the frescoes. The habit of making nude studies even of the dressed figures was developed in Florence by the great

artists and used by Raphael for the male figures very frequently throughout his career, but it does not seem to have been the case with women. In the famous instance of *Alexander and Roxane*, where all the figures are studied in the nude in the celebrated drawing in the Albertina but are dressed in the executed work, known now only from prints, Roxane, the female nude, also remains nude in the final version (see K.M.O. 539, 540). Till the end Raphael remains delicate with his female models and undresses them only when the work absolutely demands it. Nonetheless Raphael certainly created a breakthrough in the study of female nudes which were spread in prints throughout the world. He could do this only through a private involvement in the lives of the young women, who according to Vasari lived with him in his household like the apprentices and with at least one of whom, the Fornarina, he clearly had a personal relationship, as the depiction of her in the nude as a kind of *Venus pudica* with all the attributes of a virtuous woman and thus as a bride testifies.

Vasari, however, speaks about the other female portrait, the *Donna Velata*, which he had seen in a Florentine collection. The union of these two portraits in this exhibition is clearly its major event, while the meeting of the *Lady with the Unicorn*, the most personal of the Florentine female portraits, and the *Donna Velata*, the most luxuriously painted of his Roman private portraits, provides an extraordinary historical dimension to it. Are the *Donna Velata* and the *Fornarina* the same person, one painted dressed, the other in the nude, as has been surmised? The confrontation in the exhibition will surely provide some clue. The question is of course aggravated by the facts that the two paintings come from different moments in the Roman period, one from before or around 1514, the other from the end of Raphael's life, around 1519-20, and that the former is lightly painted on canvas while the *Fornarina* is heavily painted on panel so that many of the obvious differences can be explained in terms of date and

technique. In fact the *Fornarina* is a product of the time when Raphael worked with very powerful contrasts of light and shade and used them to create a sense of space that isolates the figures from their surroundings while at the same time embedding them into them. This gives the nude a sense of isolation and a detached presence very different from the *Velata* who is much more easily and comfortably connected with the picture plane and her environment. In fact in the *Velata* one still discerns the influence of the *Mona Lisa* while in the *Fornarina* the relationship with Leonardo can no longer be felt even though the prototype for such a nude portrait came from his *Mona Vanna*. One could, therefore, easily argue that the sense of comfortable roundness, the way the Lady's bust unfolds in space and the wonderful and harmonious relationship between head and shoulders underlined by the veil in contrast to the more uncomfortable isolation of the head from the body in the *Fornarina* are all stylistic traits and have nothing to do with the personality of the sitter. Yet there are many more differences, however small, within the general vocabulary of the two female portraits. The *Donna Velata* has a higher forehead, looser and more wavier hair, a less elongated nose and a rounder chin. There is above all one very prominent small element, the ear. The ear of the *Velata* has practically no earlobe but is fully connected to the face at the bottom, while that of the *Fornarina* has a very prominent lobe. In these portraits, where all of a sudden the ears are no longer hidden away by hair as in Florence, the portraitist must certainly have paid attention to this very personal trait. So quite apart from the great difference in style and above all in personal aura emanating from the two women, one sitting in front of us with great serenity and inner confidence, the other rather diffident and shy, there are real physical traits that seem to say they are not the same the woman.

Vasari, however, appeared to say that this was a portrait of Raphael's beloved who lived at his house. The greatest similarity one can perceive

among the drawings by Raphael is the study in the Albertina for the *Fire in the Borgo* and the cartoon for the face of the *Pearl* in Lille, two works in which we saw last reflections of the Florentine model who may also have lived in Raphael's house and who worked for him as a model. The Vienna figure even seems to have an ear like the *Velata*, but this observation should not be exaggerated. I have argued in the past that the *Velata* represented a married woman of high social standing with whom Raphael was in love before he got infatuated with the servant and nude model that lived in his house. I saw reflections of her beauty in the many Madonnas and female figures which I have now related to the Cumaea model. Yet while a certain ideal element seems to connect these faces to that of the *Velata* much more than to the *Fornarina*, the study presented here, based on an analysis of the actual drawings extant, made it evident to me that there was yet another model involved, one who never seems to have undressed for the painter.

I will also admit that to separate the model I have here called the Florentine one from the Fornarina is not easy, especially after 1514, and may even be a mistake, yet I felt compelled to do so before I started to tentatively connect the drawings with the image of the *Velata* and so to find another possible solution to Vasari's statement. Research is always in progress and all I can hope for, is that these lines will stimulate others or even myself to think further about the mysterious relationships of Raphael to women, his love for them, his admiration for their beauty and his high respect for their individuality, which, I think, contributed to make the two extraordinary female portraits from his Roman period so excitingly different.

This study began an exploration of Raphael's vision of women with a glance at his beautiful, idealised Madonnas, which, in the course of the artist's development, incarnated ever more fully beings of flesh and blood and assumed, at the end of his life, a classical Roman dignity and restrained, lonely, and pain-conscious grandeur

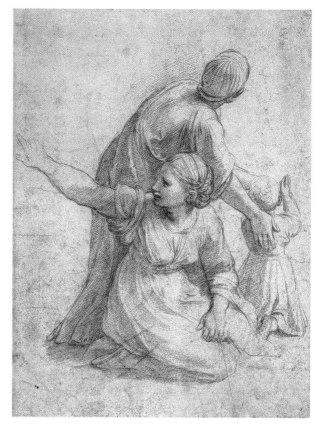

quite unlike the youthful maidenly innocence of the Virgins of the early Umbrian time. We followed the process of their transformation through the more mature and animated liveliness of the Madonnas of the Florentine period, resplendent in their clarity of colour and form, and through the free and open grandeur mixed with intimacy and restraint so characteristic of the early Roman period, to reach their ultimate expression in what was to become Raphael's archetypal work, the Sistine Madonna. In this image of pure, wise and free femininity, it was natural to experience both the goddess-like *grandeur* of the mother of God and the gentle humility of the handmaiden of the Lord. In the Sistine Madonna, divine grace received its ultimate expression in feminine form. We encountered Raphael's first encounters with real women in drawings and portraits, who sat for him to have their likeness rendered. During this process, the artist discovered how he could enter more and more deeply into the personalities of his sitters and bring out their individuality and human presence. This discovery reached its culmination in the early Roman period in the por-

trait of the "Donna Velata", the freest and most natural representation of a Renaissance Lady totally equal in kind and status to the most dignified of men, like Raphael's friend Count Baldassare Castiglione, and as free in bearing and as unencumbered with gender prejudices as the portraits showing those of the men, with whom Raphael had a personal relationship. Here human grace is expressed in feminine imagery in the most dignified manner.

In the *Fornarina*, however, loneliness and exposure even in the context of human love, the problem of modern man, becomes apparent. This leads us to the main theme of our study, the encounter with Raphael's models, a study that still seems incomplete and fraught with problems. It demonstrates the difficulty faced by artists in the Renaissance of how to deal with the social problem of seeing a female body in the nude, a problem later solved by the academies and the collective studies of nude models. Then, however, such impersonal access to the female nude did not exist. At first the problem of the nude was not so urgent for the young Raphael since most of his pictures were religious and consequently of dressed figures, but the Humanist call for mythological paintings and for female allegories exerted pressure, resulting in the urge to study the movements of the body beneath the garments as the artist did for all his male figures as soon as he arrived in Florence. The possibility of studying the physical features of his wife, used by other artists, was not to available to Raphael since he refused to marry, as he seems to have been waiting for the woman of the elevated social status to which he was aspiring. It seems, and this is one of the plausible results of this study, that Raphael had to solve the problem by bringing one or even two models with him to Rome as members of his extended household. However, his artistic exigencies demanded more and different body and facial types which he solved by hiring or engaging other females, albeit not necessarily for study from the nude. The artist's personal relationship with these models seems to have aroused speculation already in Raphael's lifetime, as Vasari's biography suggests. The testimony of the *Fornarina* combining the full features of a bridal portrait, of a representation of the ancient goddess Venus, and the personal expression of a gentle and lonely human being lovingly looking at her partner, evokes another feminine grace, the grace of love in a relationship between two human beings within or without the social context of the morals and habits of its time. The purifying quality of true love gave Raphael's model a special, exposed yet confident dignity which fully foreshadows the problems of love in our time. These were just beginning to emerge in Raphael's days, when the age-old social prejudices and prescriptions in the choosing of partners for marriage began to give way to marriages for love, or even freer unions, as part of the discovery of the individual in modern times.

*Daniel Arasse*

# The Workshop of Grace

Contrary to what one might at first imagine, when Giorgio Vasari mentioned *grazia* as being the most characteristic quality in Raphael's art, he revealed a sense of originality as unexpected as it was conscious. If there was one idea about Raphael that very quickly gained ground, it was that he was the father of *venustà*. From the beginning of the 1520s, Paolo Giovio launched this theme, declaring, in his *Raphaelis Urbinatis Vita*, that none of Raphael's works, in whatever form of painting, was lacking in "venustas", and in 1557, Lodovico Dolce developed this theme brilliantly throughout his *Dialogo della Pittura*: Raphael's paintings possessed "that which the figures by Apelles had, and according to Pliny: *venustà*"[1] However, Vasari never uses this term to describe the artist's manner. For him, Raphael is not the artist of *venustà*, but of *grazia*. The difference may appear slight and even insignificant. The two notions, whose origins lie in Cicero, Pliny and Quintilian[2], are closely associated by the start of the Cinquecento and the writers of the 16th century drew no distinctions between the concepts behind these two words, which they considered synonymous; Giovio explicitly described them as being the same ("venustas [...] quam gratiam interpretantur") and Dolce confirmed the sameness of the terms : "That which you call *venustà*, the Greeks called *charis* and I shall always speak of as *grazia*[3]."

And yet, Vasari knew well what he wrote. Working as a historian, he sought to define the difference between the various manners of the artists; he had therefore to be more precise than a Humanist such as Paolo Giovio, who was able

without a qualm to evoke the *commensuratio* and the *venustas* of Michelangelo's works[4]. The fact that he never used this last term in reference to Raphael suggests that he was discreetly drawing a distinction between the two words which already belonged to the everyday language of the new-born artistic literature. This difference is as subtle as it is precise. If the *venustà* in Raphael indeed cedes its place to *grazia* ("[...] *quella grazia e dolcezza che fu propria di Raffaello*"), it was nevertheless the distinguishing mark of Parmigianino, admired for "*una certa venustà, dolcezza e leggiadria* [...] *che fu sua propria e particolare*". This return to an equivalent formula ("*propria...*", "*sua propria...*"), which has slid from grace to beauty, is not casual since Vasari takes pains to recall "it was said that the spirit of Raphael had passed into the body of Francesco [Parmigianino], because in that young man one could find the rare artistic abilities and affable, gracious manners of Raphael. This all the more because Francesco sought to imitate Raphael in all that he did, and especially in painting"[5]. In view of this calculated choice of words, Vasari thus proposed a different and new nuance between *grazia* and *venustà*, a nuance which, when analysed, shows that in his eyes *venustà* is a *grazia* that manifests itself as such – or, to put it in terms which might have been those of the period, that it is a *grazia di maniera*. The passage from Raphael to Parmigianino and the simultaneous metamorphosis of the *grazia* into *venustà* corresponds to the transformation of the classicism of the Renaissance into the practising of an art that was *di maniera*[6].

[1] Giovio, in Barocchi 1977, I, p. 15; Dolce (1557) 1968, p. 174.
[2] Cf. Pommier 1991, pp. 39-81, and especially, p. 44-45.
[3] Giovio, in Barocchi 1977, I, p. 15; Dolce (1557) 1968, p. 176.
[4] Giovio, in Barocchi 1977, p. 12: "[...] ut nemo commensuratius atque venustius pinxisse censeatur."
[5] Vasari 1984, 6, p. 245.
[6] Cfr. Arasse 1987, pp. 703-714.

Grace is in fact "proper" to the classical Renaissance which places it at the heart of its formal ideal, both artistic and social. It finds its greatest expression in Baldassare Castiglione's *The Book of the Courtier*, which was published in 1528 but written between 1513 and 1524. Its dialogue was supposed to have taken place at the beginning of the century, at the court of Urbino, and thus at the height of the Renaissance and in one of its very centres. In order to express the manifestation of this grace, which governs the aesthetics behind social relationships as it does also in works of art, Castiglione forged a neologism that is practically untranslatable, the *sprezzatura*, that apparent nonchalance, a superior synthesis of what is natural and elegant in art and life, "which hides its artistry and which reveals that what is said and done is arrived at without effort and almost without thinking". For Castiglione, it is from this that "grace above all derives": "the true art is that which seems not to be art, and one must above all else try to hide it". One of his models is the gesture of the painter who, like Apelles and unlike Protogenes, knows how to "take his hands from the board": in his works, "a single line which is not laboured, a single brushstroke made with ease, in such a way that it seems that the hand is completing the line by itself without any effort or guidance, clearly reveals the excellence of the artist"[7].

Fruit of an "art that hides art" in favour of an equilibrium between culture and nature, grace nevertheless presents its follower with a double difficulty. In the first place, as soon as this art (of hiding art) reveals itself, the grace becomes affectation, the worst of faults as far as Castiglione was concerned. In addition and in the same way, it is hard to define, as Vasari discovered when he sought to describe what characterises the *bella maniera* inaugurated by Leonardo da Vinci: "[...] in the rule, a licence which, although not fixed by the rule, yet does not break it [...]; in the measures, the judicious appreciation that confers upon the figures, without their being measured and the size chosen, a grace that exceeds the measure [...]. In the drawing, [...] that facility formed of grace and delicacy, that appears between the seen and unseen [...]. In the manner, a charm that renders all the figures slender and gracious"[8]. The convoluted complexity of these formulae is due neither to clumsiness of expression, nor to a conceptual weakness on the part of the historian. It seeks to arrive at a formal definition of that quality which Agnolo Firenzuola in 1541 in his *Della bellezza delle donne*, and Lodovico Dolce in 1557 more lazily qualified as "*je ne sais quoi*" ('an indescribable something'); this formula was apparently invented by Martial in one of his Epigrams[9] and was destined to be enormously successful.

Given that he wished to make grace a quality distinguishing 16th-century art from that of the 15th century, Vasari could not be content with such an imprecise expression. He therefore adopted the line appearing in the *Libro della beltà e grazia* (1543) by Benedetto Varci – although altering the line of argument in a significant manner. Setting himself the task of answering the double question about whether grace can exist without beauty and which of the two is the more desirable, Varchi skilfully brought together Aristotle and Plato to distinguish between the two types of beauty[10]. The first, "natural, corporeal beauty", depends on the proportions and suitable measurements of the limbs, to which is added the sweetness of their colouring; as such, it can be without grace. The second form of beauty, "spiritual beauty", consists of the virtues of the soul; it blends with grace which springs neither from the body nor from matter, but from "form which gives them all the perfections they contain". In human beings, this form – which "informs" matter – is none other than the soul and it is thus from the soul that "all this beauty which we call grace" emerges, which charms and incites one to love the being who possesses it, and who, according to Plato, is a "ray and a splendour of the sovereign that penetrates and shines throughout the world and

[7] Castiglione 1987, p. 54 (I, 26) e p. (I, 28).
[8] Vasari, 1984, 5, p. 19 (adapted translation).
[9] Cfr. Pommier 1991, p. 45.
[10] Varchi 1960, I, pp. 85-91.

Raphael Sanzio
*Solly Madonna*, 1502-1503
Oil on wood, 52 × 38 cm
Berlin, Gemäldegalerie,
Staatliche Museen zu Berlin.

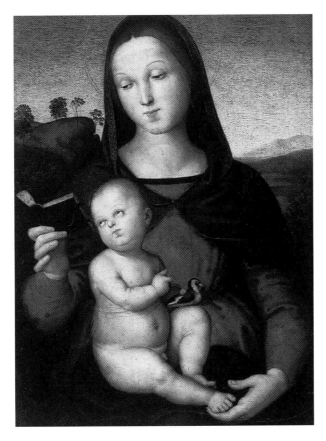

[11] On this point, Varchi picks up the Neoplatonism of Leone Ebreo who, in his *Dialoghi d'amore* of 1535, had written that "grazia, quale per li chiari e spirituali occhi suole entrare e delettare e muovere nostra anima ad amare quello oggetto, qual chiamamo bellezza"; cf. Pommier 1991, p. 74, n. 19.

[12] On this point, see Alain Pons' remarks in his introduction to Castiglione's *Le Parfait Courtisan (Il Cortegiano)* (1987, p. XXI).

[13] Vasari, 1984, 4, 1983, p. 117: "Hanno grandissimo obligo al cielo et alla natura quegli che senza fatiche partoriscono le cose loro, con una certa grazia che non si può dare alle opere che altri fa, né per istudio né per imitazione; ma è dono veramente celeste che piove in maniera su quelle cose, che elle portano sempre seco tanta leggiadria e tanta gentilezza, che elle tirano a sé non solamente quegli ch'intendono il mestiero, ma molti altri ancora che non sono di quella professione." ("They owe a great debt to the sky and nature, those who give birth without difficulty to works endowed with a grace that others cannot achieve either by striving or by imitation; it is truly a celestial gift that flows over these works and confers upon them such a radiation of elegance and charm that they attract other artists and even many people who do not practise it.").

[14] Vasari, 1984, 5, p. 194.

[15] Raffaello, *Lettera...*, (1971), 1979, VII, 1, pp. 1530-1531: "[...] le dico che, per dipingere una bella, [...] io mi servo di certa idea che mi viene nella mente. Se questa ha in sé alcuna eccellenza d'arte, io non so; ben m'affatico di averla."

in all its parts"[11]. Without referring to Aristotelian and Platonic concepts, Vasari used Varchi's distinction to differentiate between the *bella maniera* of the Cinquecento and the simply regular beauty of the Quattrocento, represented in particular by Raphael's teacher, Perugino.

The impact of philosophical reflection, in particular of the Neoplatonic variety, on the notion nevertheless made itself felt in the *Lives*. In the book, grace is in effect doubly demonstrated. It is the consequence of work, of the artist's knowledge whose "art hides the art", in the manner of the courtier's *sprezzatura*, but it is also the fruit of a singular skill, of an innate talent whose origins can only be celestial and which makes the artist, as also the courtier, the link and mediator of a grace that in some way moves through him to touch those around him[12]: an artist endowed with grace can impart this to his figures, which draw to them those who view them. Announced already in the biography of the Florentine sculptor, Desiderio da Settignano (c. 1430-1464), whose works possess the "celestial gift" of "that grace and that simplicity which are liked by all

and are unanimously acclaimed"[13], the theme was picked up once more and orchestrated in the *Life* of the "very gracious Raphael", the opening lines of which must be read: "Heaven sometimes showers upon a single person from its rich and inexhaustible treasures all the favours and precious gifts that are usually shared, over the years, among a great many people. This was clearly the case with Raphael Sanzio of Urbino, an artist as talented as he was gracious, who was endowed by nature with the goodness and modesty to be found in all those exceptional men whose gentle humanity is enhanced by an affable and pleasing manner, expressing itself in courteous behaviour at all times and towards all persons. Nature sent Raphael into the world after it had been vanquished by the art of Michelangelo and was ready, through Raphael, to be vanquished by character as well. [...] In Raphael, [...] the finest qualities of mind are accompanied by such grace, industry, looks, modesty and excellence of character as would offset every defect, no matter how serious, and any vice, no matter how ugly. [...] Artists as outstandingly gifted as Raphael are not simply men but, if it be allowed to say so, mortal gods"[14].

Generally, these lines are taken to evoke Vasari's admiration for Raphael's grace. This mistakenly neglects the other definition of grace, the work and the *savoir-faire* that it also presupposes, both in the social sphere and in the artistic one. Vasari is quite precise about this point too: in Raphael, grace is without any doubt a gift from heaven but it is also the fruit of long, arduous work. Raphael himself pointed this out in the famous letter addressed to Castiglione around 1514: after indicating that in order to "paint a beauty", he would make use of an "idea that would come to mind", he concluded that he did not know if this idea had in itself "some excellence in the matter of art", but that he would strive to obtain it[15]. For himself, having since the introduction to the third part of his *Lives* stressed this work and these efforts hidden in the finished work – "[...] the very gracious Raphael of Urbino [...] studied the works

Raphael Sanzio
*Madonna del Granduca*,
1504-1505 (detail)
Oil on wood, 84 × 55 cm
Florence, Palatina Gallery,
Palazzo Pitti.

Raphael Sanzio
*Madonna del Prato*,
1506 (detail)
Oil on wood, 113 × 88 cm
Vienna, Kunsthistorisches
Museum.

Raphael Sanzio
*Madonna del Cardellino*,
1507 (detail)
Oil on wood, 107 × 77 cm
Florence, Uffizi.

Raphael Sanzio
*La Bella Giardiniera*,
1507-1508 (detail)
Oil on wood, 122 × 80 cm
Paris, Musée du Louvre.

[16] Vasari, 1984, 5, p. 222. This study should, of course, be rounded off with an analysis of Raphael's preparatory drawings, concerning which Middeldorf (1945, p. 16) once showed the considerable work that went into them, whereas the final work possessed "the virtue of ease", concluding that grace is "the mark of Raphael's genius".
[17] This type of analysis was perfectly undertaken in the case of the *Madonna della Sedia*, which in the 18th century became Raphael's most famous work. In 1882, Crowe and Cavalcaselle indicated to what extent Raphael "hides the effort beneath incomparable beauties of form and expression", and more recently, it has been possible to show how this painting finds "the solution to one of the hardest problems of composition taken from Antiquity" and that Raphael resolves it "with a naturalness that is so felicitous that it makes one forget its complexity". cf. *Raffaello a Firenze...*, 1984, p. 157.
[18] For a close analysis, cf. Dalli Regoli 1987, pp. 419-428.

(*fatiche*) of the old masters and those of the modern masters, from each selected the best and, having made his selection, enriched the art of painting with that total perfection that Apelles and Zeuxis possessed in Antiquity" – having then recalled them during each step in the artistic training of the master – studies of Perugino, Leonardo da Vinci, Massaccio, Michelangelo, Fra Bartolomeo –, Vasari lingered over the point in his conclusion "to show with what toil, study and diligence this honourable creator always governed [his work]" (*per mostrare con quanta fatica, studio e diligenza si governasse sempre mai questo onorato artefice*)[16].

This insistence on the part of Vasari on Raphael's work may surprise one since the supreme quality of his art, his grace, consists just in hiding this effort and work. These pages doubtless constitute a lesson aimed at young artists, and they also have the look of a *pro domo* plea of an artist who is master of the art of reference (Michelangelesque rather than Raphaelesque). At all events, they invite one to search for those indications of *fatiche* in the works themselves, hidden beneath the sovereign grace of the paintings. Experts in the painter have for a long time highlighted how the apparent natural disposition of the figures hides the complexity of formal relations that were slowly perfected[17]. From work to work, we can also follow the renewed use of a grouping and its renewed elaboration. We have some chance of discerning the way in which the *graziosissimo Raffaello* used to work[18].

The motif of the virginal face, that of the Madonna, is from this point of view particularly revealing. In the beginning, the *Solly Madonna* (1500-1501), in common with other Madonnas, evidences a reference to the regular model of Peruginesque beauty. The Virgin is rendered sweeter and more present in the *Madonna del Granduca* (1504), in which the light and the relationships between the figures stressed through their movements adds life to the original model. Raphael very quickly moved to a model of *grazia* derived from Leonardo, as in the faces of the *Madonna del Belvedere* (1506) and in the *Madonna of the Goldfinch* (1507). But this period of equilibrium between rule and grace was immediately left behind in *La Belle Jardinière* (1507): in its almost flaunted artifice, the face appears as an extreme of grace at the same time as an extreme of beauty. The singular effect of this face is achieved through a series of minimal transformations of earlier formal elements the re-elaborations of which there would be little point in describing. We would add little about the effect of the image by stating that the contours of the face have changed *a little*, that the nose is *a little* larger, the eyes *a little* more protruding and the figure *a little* plumper. Raphael's research into the Madonna's face continued with his *Saint Catherine of Alexandria* (1508) and, above all, in the *Large Cowper Madonna* (1508) in which the stressing of the "perfect" features, pushed to extremes, has resulted in a beauty of almost strange form. After this fast, coherent development, Raphael nevertheless returned to a more "natural", simple form of grace, apparently less artificial and systematic, the culmination of which is without doubt

the fascinating face of the *Sistine Madonna* (1513-1514), whose strangeness surfaces through an expression that it is hard to define but which suggests a specific spiritual moment or feeling.

This simplification of the Madonna's face after 1508 is not the result of chance. It corresponds with Raphael's move from Florence to Rome. The theme of the Madonna and Child would henceforth only appear relatively infrequently in his work, as he would be more involved with the large-scale projects entrusted to him[19]. In Rome, his greatest work was to be in history painting: the intellectual search regarding combinations of forms was henceforth to be inseparable from studies of figures caught in movement, at the heart of the action, of an *istoria*.

If we look closely, the great Madonnas of the years between 1506 and 1508 already betray this desire to insert grace in a "natural" configuration of figures forming an *istoria*. From the *Madonna del Belvedere* to the *Madonna of the Goldfinch* and hence to *La Belle Jardinière*, the poses of the figures changed according to a precise system of variations which progressively provided a veritable treasure-trove of combinations of possibilities to set against the starting hypothesis. With these three works, to which we must add the *Madonna of the lamb* (1507) and the *Canigiani Holy Family* (1507), Raphael was probably responding to the debate that was active in Florence between Leonardo da Vinci and Michelangelo concerning the unified, contrasting and dynamic grouping of a number of figures engaged in a reciprocal action (the *Saint Anne* and the *Madonna and Child with St John the Baptist* for Leonardo, the *Doni Tondo* for Michelangelo). In the *Madonna del Belvedere*, the Baptist is seen to our left on his knees, outside the Virgin/Jesus group, and he offers his cross to the Christ Child who stands at the centre of the painting, held by Mary. In the *Madonna of the Goldfinch*, the Baptist stands and is part of the group, introduced by the right hand of Mary, and offers Christ the bird that has given the painting its name. *La Belle Jardinière* (pro-

visionally) concludes the research and transformation: Jesus has passed to our left, held by Mary's right hand, whereas St. John the Baptist is kneeling, but to our right and is evidently intimately included in the Virgin's family. Once again, he has his cross, but he no longer offers it to Jesus, who is involved in closing the book from which the Virgin was already turning away in the previous painting. The continuity from one work to the next is beyond dispute, as is also the systematic nature of the variations in the respective disposition of the figures. The last version is provided in 1511 with the *Madonna Alba*. Here, too, we see the "game of the cross"[20] between Jesus and St. John the Baptist, and also the movement of Mary's leg, shown from the very start of the series (*Madonna del Belvedere*); however, the two children are shown on the same side of the Virgin, imparting a more supple fluidity to the group of figures[21].

This very partial series suffices to show how Raphael "*s'affatica*" to arrive at that "*eccellenza*

[19] Raphael produced 19 paintings of "Madonna and Child" between 1504 and 1508; he was to produce only another 8 between 1509 and 1520.
[20] This "game with the cross" might have been suggested to Raphael by Leonardo's *Madonna with the yarnwinder*, cf. Dalli Regoli 1982, pp. 25-31.
[21] Because of their close composition and the sitting pose of the Madonna, the *Madonna della sedia* (1514) and the *Madonna of the curtain* (1514) do not belong to this series.

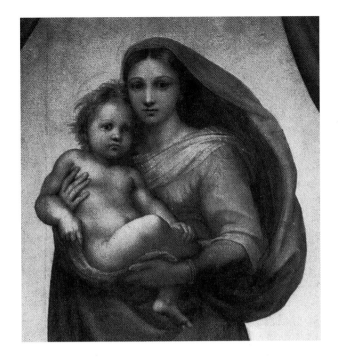

Raphael Sanzio
*The Sistine Madonna*, 1513
(detail)
Oil on canvas, 265 × 196 cm
Dresden, Gemäldegalerie.

[22] For a summary of the dossier concerning the model(s) in the paintings, cf. Mochi Onori 2000, p. 10. The hypothesis of Dante Bernini should be added, according to whom *La Fornarina* is not a portrait; for him (1983, p. 11), the name of Raphael ostensibly inscribed on the figure's bracelet suggests "shamelessly" that she belonged to the artist – which would be hard to imagine if this were a portrait. However, a private destination for the panel could justify this detail, even in the case of a portrait.
[23] Chesne Dauphiné Griffo 1983, p. 17.
[24] Concerning Leonardo's *Monna Vanna* and its relation with *La Fornarina*, cf. Brown, Oberhuber, "*Monna Vanna* and *Fornarina*": Leonardo and Raphael in Rome", in *Essays Presented to Myron Gilmore*, ed. by Sergio Bertelli and Gloria Ramakus, Florence, 1978, pp. 25-86.

*d'arte*" that can provide a visual translation of the "*certa idea*" which lies at the origin of his work. For Raphael, as for Leonardo da Vinci, painting was a *cosa mentale* and the grace that issues from each painting, that ease that is full of *sprezzatura* is, in effect, the result of an art that hides the work that goes into it.

This consideration of Raphael's work, made up of variations based upon a selected number of elements within a similar structure, throws a little light upon two paintings that still leave art historians very divided and puzzled: the two female figures known by the name of *La Velata* and *La Fornarina*.

The pose of the figures and their presentation as a bust has led to both works, which are very similar in size, being referred to as "portraits". This immediately raises the question of the identity of the sitters depicted; some see two different models, whilst others see the same model treated in different ways[22]. Far from being arbitrary or futile, the debate bases itself upon the incontestable fact that the women in the two paintings resemble one other as much as they differ from each other. Their pose is similar, they wear an almost identical jewel in the same place and their physical types are similar. However, their faces are very

different. The colour of the hair changes from one figure to the next (chestnut for *La Velata*, jet black for *La Fornarina*), the evident rosiness of *La Fornarina* is far less apparent in *La Velata*, and *La Fornarina* has far more prominent eyes and a more pronounced, almost large nose. It is therefore permissible to ask whether this double figure is taken from a single model or from two. With the information that is currently available, and in the absence of any precise document concerning these two paintings and of any female portrait clearly identified as such enabling comparison, it is impossible to establish if there was one or two models behind these two panels. Strictly speaking, the debate constitutes a false problem, a problem for which no solution can be found until it can be viewed correctly, and each historian brings to the question his own conviction, interpreting the elements in the paintings in line with this.

The similarity in the two works, founded upon precise differences, is, on the other hand, significant. Whatever the case may be regarding the identity of the models – and without going so far as to declare, with Giuliana Chesne Dauphiné Griffo, that all of Raphael's female faces belong to a series that can be traced to a "single model" or to his idea of this[23] – *La Velata* and *La Fornarina* manifestly constitute two variations, two versions of a *certa idea* of feminine beauty. With these two works painted a few years apart, Raphael provided a response to the last two portraits of women by Leonardo da Vinci, the *Mona Lisa* and the *Monna Vanna*[24]; he provides his own version of dressed and naked beauty – the first beneath a veil and as the image of the spouse, the second as the sensual incarnation of the lover. This idea agrees with the reservation implied by the pose of *La Velata*, whose left arm, parallel to the edge of the image, and the splendid sleeve, maintain the spectator at a distance despite the manifest proximity of the sitter (and the same is done in the *Portrait of Baldassare Castiglione*). The idea also agrees with *La Fornarina*'s ostentatious nudity: the left arm – no longer resting on the edge

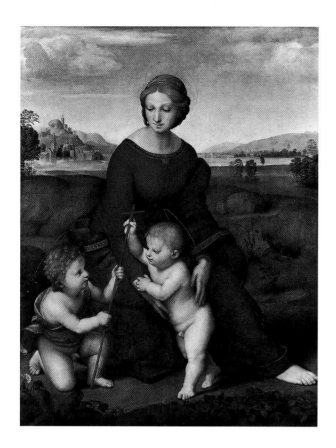

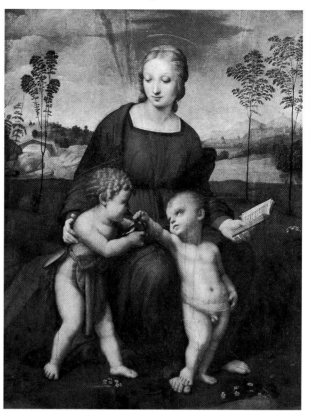

Raphael Sanzio
*Madonna del Prato*, 1506
Oil on wood, 113 × 88 cm
Vienna, Kunsthistorisches
Museum.

Raphael Sanzio
*Madonna del Cardellino*, 1507
Oil on wood, 107 × 77 cm
Florence, Uffizi.

of the panel – does not pose an obstacle to the figure's proximity, while the gesture of the right hand, a little to one side and modified compared to that of *La Velata*, presses gently on the left breast, outlines it and pushes it up a little in front of the spectator; and, unlike the frontal gaze of *La Velata*, she looks slightly off-centre. More than portraits, this work by Raphael makes one see in these two paintings organised variations of a "certain idea" of beauty and of its presentation. Without fearing an anachronism, one might think that what is played out between the two figures is not so far removed from that "obscure object of desire" represented in film and surrealist form by Luis Bunuel.

The association of these two works also throws some light on the reasons for contradictory, paradoxical reactions that *La Fornarina* has roused since its reappearance in 1595-1597. These reactions are subjective, but no less arbitrary for that, and constitute some form of response to the effect desired by Raphael.

Described in 1595 as a "female nude, painted from the life, as a half-bust", by 1597, it had become a "nude Venus, painted as a half-bust"[25]. This difference is, however, not very significant. The term, "Venus", had already for a long time been used both to designate the goddess of love and a "*donna ignuda*" - a female nude. It is significant, on the other hand, that in 1618, Fabio Chigi should see in it only a "mediocre fine painting of a lower-class prostitute" (*Illius sane meretriculae non admodum speciosam tabulam*) and that a quarter of a century later, Teti should be so enthusiastic before this "admirable painting" (*nobilissima tavola*) in which Raphael had painted a "very beautiful woman" (*una donna bellissima*) [...] who "will take your breath away if you gaze upon her incautiously" (*una che a guardarla incautamente ti tolga il respiro*). Negative criticism tended to dominate in the 18th century and led, in the 19th century, to rejections of such violence that still surprise today. In 1897, for example, Giovanni Morelli refused to attribute the painting to Raphael, one reason being the vulgarity of the model, that was "so common and repugnant that one could believe one had before one's eyes a woman in abject condition"[26]. Of course, one

Raphael Sanzio
*La Belle Jardinière*,
1507-1508
Oil on wood, 122×80 cm
Paris, Musée du Louvre.

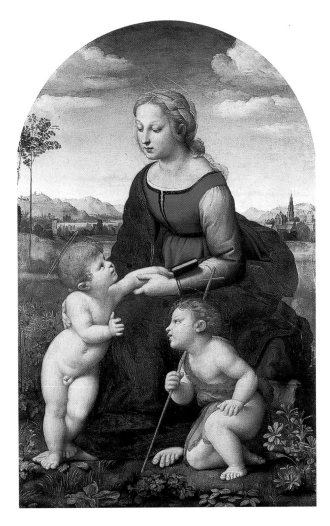

recognises the prudishness that had already led Mark Twain to describe Titian's *Venus of Urbino* as the most "revolting, the vilest and the most obscene in the world"[27]. We would be wrong, however, to stop there. The violence of the reactions provoked by *La Fornarina* is closely linked to the specific elaboration that Raphael had given to his *idea* of feminine beauty – and two writers who are rarely quoted by art historians, President Charles de Brosse and Stendhal, help to clarify the issue.

Going against the current of negative views of the beauty of *La Fornarina* that were then taking hold, the lines that President Charles de Brosse dedicated to the painting in 1739-1740 have an almost contradictory character. After stressing the regular beauty of the face, he progressively moderated his admiration and arrived at an unexpected conclusion: "Admirable, finished and coloured to the greatest perfection. The good lady has extremely regular features, dark skin, black hair, large dark eyes that are too round, tired, verging upon the yellow and Moorish. Although conventionally beautiful, I would not be so mad about her as to kill myself in the service of this Moroccan lady, as did the ill-advised Raphael"[28]. This text is paradoxical because *La Fornarina*'s beauty is certainly not "conventional"; indeed, it was the non-conventionality that explains the criticism then besetting the painting. Charles de Brosse seems aware of this non-conventionality which, for him, is to be explained above all by the "complexion" of the figure and, even more, by the eyes, which are "too round, tired, verging upon the yellow and Moorish". It is also revealing that the fault of these eyes is almost explicitly attributed to the "overly sexual" nature of this "Moroccan lady" for whom he believed, Raphael had killed himself. In the erotic context of the image, the expression "tired eyes" inevitably suggests the tiredness brought on by love (did Stendhal remember this passage when in turn he evoked "the black-rimmed eyes of Raphael's women which makes one think they have spent the night with their lover"[29]?) For Charles de Brosses, this beauty with tired eyes is that of a "good lady", who is expert and sturdy in the matters of love.

A few decades later, in the reflections he dedicated to the painting in his *Idées italiennes*, Stendhal notes the duality of the painting's effect according to whether the whole of the figure or just the face is contemplated: "La Fornarina is shown without clothes, except for a transparent veil. The chest, right arm and head are clearly by Raphael and in his finest manner; one might say that he has done nothing finer than that chest." Then, lingering over the face, the mood changes: "One still often finds in the people of Rome figures like that of La Fornarina, with an overlarge nose that thrusts forward too far and which encroaches on all the surrounding features, leaving too little space between the end of the nose and the chin. The lips pout towards the centre of the

[27] Cf. Rosand 1997, p. 38.
[28] De Brosses 1929, II , p. 52.
[29] Stendhal, *Journal littéraire*, in *Oeuvres complètes*, Geneva, 1970, XXXIII, p. 300.

mouth which, giving them a constant expression, cancels out any expression"[30]. More sensitive to the figure's nose than her eyes, Stendhal echoes the criticisms formulated in the 18th century regarding the physical type of *La Fornarina*. However, he concludes in an original manner: far from condemning this alteration of the ideal, seeing in this the (vulgar) mark of the supposed low-class origins of the model, he regards the (Roman) character of the face as one of the painting's qualities and sees in its "truth" the second pivotal aspect of its extraordinary effect: an ideally beautiful chest, an incomparably true head.

According to Stendhal, therefore, the singularity of *La Fornarina* in Raphael's œuvre lies in its ideal beauty having been rendered special, more "real", through the introduction into the face of an "irregular" (unconventional), distinctively Roman, feature, and it is this that resulted in the work being seen as a portrait. As Rosanna Barbiellini Amidei writes: "the face is less beautiful; it is lacking in that '*certa idea*' because its individualisation is more stressed [...] From '*imitare*', we have moved on to '*ritrarre*'[31] – and this "nude portrait" could thus go from being seen as the mythical lover to that of the physical person for whom the artist killed himself. It is certainly no chance, indeed, if the criticisms regarding the lack of beauty in the figure intensified in the 18th century, just as the painting became the portrait of the woman "for whom he died"[32] in an excess of physical love. Raphael's attack of ideal beauty must be seen within the context of an eroticisation of painting, which suggests that, for him, ideal beauty was not physically desirable and that by laying siege to his idealisation, he was creating a desired representation of beauty[33]. The perfect beauty of the naked body of *La Fornarina* and the individual, less perfect, modelling of her face lead one to see the signs of an eroticisation of the figure as a result of the internal tension in the work. Two details of the deformations subjected to ideal beauty seem to confirm this analysis and feeling. The left hand of the figure and, in particu-

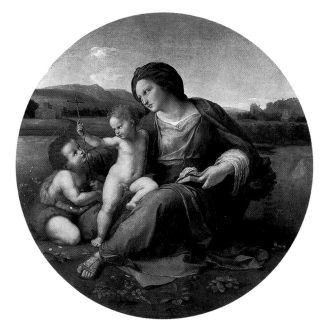

Raphael Sanzio
*Madonna d'Alba*, 1511
Transferred from wood to canvas,
diam. 95 cm
Washington, National Gallery of Art.

lar, the pose of the fingers are clumsy and their relative stiffness is perhaps linked to the positioning of this hand[34]. The deformation subjected to the right arm of the figure is even clearer, given that its outline (the drawing) is extremely irregular – more irregular than would be required by the visual depiction of its appearance alone – through the effect of the transparent veil that covers it, creating areas of shadow. This transparent, deforming veil, which reveals all in hiding, is one of the commonest tools in the eroticisation of the image, a *topos* of erotic appeal. The subtlety of its use in *La Fornarina* lies in the fact that it was not raised; especially as this eroticisation is applied to a part of the body that is traditionally less erotic than the shoulders and chest, which are unveiled and presented as ideally beautiful. This deformation of the veil is seen again, however, and in a highly accentuated manner over the navel, one of the centres of eroticism of the body, as already mentioned in the *Song of Songs*, in which the lover, amongst other things, says to the Shulammite: "The joints of thy thighs are like jewels, / The work of the hands of a cunning workman. / Thy navel is like a round goblet, / Wherein no mingled wine is wanting"[35].

The deformations to which *La Fornarina* exposes ideal beauty thus have an extremely strong implicit coherence. This coherence is that of Eros

[30] Stendhal 1972, XLVII, p. 142-144.

[31] Barbiellini Amidei 1983, p. 14. On the "portrait effect" linked to the presence of a distinguishing mark on the face, I would refer the reader to my study, "Saint Bernardin ressemblant: la figure sous le portrait" in *Atti del simposio internazionale caterinianobernardiniano*, Siena, 1982, p. 311 ff.

[32] Miller (A. Riggs) 1776, III, pp. 80-81, quoted by Englen 1983, p. 31.

[33] Stendhal (1973, pp. 1222-1223) implies nothing else at the end of the page in *Promenades dans Rome* dedicated to the "portraits" of women whom Raphael supposedly continuously inserted in his works. After evoking the beauty "in the manner of Raphael" of a young woman, "absolutely in the manner of the Madonna della Sedia", seen between the Colosseum and the Quirinal, he declared: "Today, I noted that in order to sense beauty properly, one must have absolutely no plans to seduce the woman one is admiring".

[34] For another example of unexpected "clumsiness" corresponding to an erotic charge of the figure, I would refer the reader to my analysis (Arasse 1977, pp. 468-470) of *The Angel incarnate* by Leonardo da Vinci.

[35] *Song of Songs*, 7, 3. The configuration of tissue and the slightly darker curve which, without any anatomical reason, forms an arc over the navel can suggest the form of an eye and eyebrow. Without being able to declare the validity of this perception – it is typical of these allusive configurations that they should be by and large undecidable – regarding the "navel-eye" motif and its erotic value, I would refer the reader to my study, "Le corps fictif de saint Sébastien et le coup d'oeil d'Antonello"(Arasse 1983, pp. 55 ff.), as well as to *Le Détail...*, (Arasse 1992, pp. 224-228)

and not the sublimated Eros that seizes the spectator before the face of *La Velata* – or which in 1749 makes Jean Nicholas Cochin before the *Madonna della Sedia* wrote: "One does not think of desiring nothing: it is an object of admiration"[36]. It is the Eros of a physical desire which has nothing platonic about it. *La Fornarina* has no need to be Raphael's mistress: she is the chestnut-haired Eve, the profane Venus with tired eyes, too worldly in the eyes of the prudes.

But what happens to her "grace" in all this? The criticisms the work collected between its reappearance at the end of the 16th century until the end of the 19th century are enough to indicate that *La Fornarina* is not "gracious": openly erotic, she is not universally pleasing – this irresistible charm, let us not forget, constituting a characteristic of grace. Is this painting, therefore, a failure on the part of the artist, the only one, perhaps, suffered by the "very gracious Raphael"? One might think so, and imagine that it was caused by the excessive complexity of the '*idea*' that the painting was to incorporate, or because of the overly powerful investment of intimacy in the work.

The virulent hostility of the some reactions, however, shows that the rejection of the painting was caused by more confused aspects, by something other that the sole judgement of artistic taste. *La Fornarina* goes deeper: for its detractors, it attacks the very idea they have formed of Raphael, the painter of grace. And thinking about it, their reaction was not without some foundation. If, as André Chastel has written, Raphael is "Eros become painter"[37], the Eros exalted by this "half-bust, nude Venus" is not the platonic Eros which from the 16th century, for Raphael seemed to have represented the triumph "in his life as in his work"[38]; the lover it invites is not the Neoplatonic love in which Baldassare Castiglione saw "a certain desire to enjoy" the beauty of the "fluid that emanates from divine goodness"[39]. Far from this ideal of perfection, at once aesthetic and moral, far from the metaphysical principle of love, *La Forna-*

*rina* is a figure of physical Eros, of sexual desire deriving from physical beauty. A work destined for a private collection, the painting could only shock some spectators when it was offered up to the public gaze. Doubtless it did so anyway, since the '*idea*' that Raphael '*s'affatica*' to accomplish in this figure concerns the complex relation between beauty and sexual desire, a relationship which this painting very clearly shows contradicts the Neoplatonic and Christian ideology of the "desire to enjoy" beauty.

The association between sexual desire and the (relative) uglification of desired beauty is especially unexpected in Raphael who is the incarnation of the gracious apogee of the Renaissance, since it seems to express a similar dialectic to that which Georges Bataille would be the first to render explicit in the pages of *L'Erotisme* dedicated to "*the opposition of purity and taint in beauty*": "The image of the desirable woman [...] should be drab – she would not provoke desire – if she were not to announce, or, at the same time reveal, a secret animal aspect, that is more heavily suggestive [...]. If beauty, the achievement of which rejects animality, is passionately desired, it is because this possession introduces an animal taint. It is desired in order for it to be tainted [...] The greater is the beauty, the deeper is the taint"[40]. One can conceive that a painting in which such a sentiment emerges and which depends for its effect upon such a profanation would have been troubling, and that it would even have been violently rejected. Some find it anachronistic that Bataille should be called upon to help interpret Raphael. However, it can be justified for at least three reasons. Firstly, it is a fact that the structure of the painting, its '*idea*', its specificity within all of Raphael's painted works, insists upon *La Fornarina* closely associating erotic nudity and an "unconventionality" in the figure that render it "less beautiful" than its painted sisters and cousins. In addition, the violent hostility of some reactions liken this figure to that with a vulgar, venal sexuality not redeemed by anything ideally; these can be

[36] Quoted in *Raffaello a Firenze...*, 1984, p. 153.
[37] Chastel 1982, p. 499.
[38] Chastel 1982, p. 497.
[39] Castiglione 1528, IV, quoted by Chastel 1982, p. 495.
[40] Bataille 1957, pp. 158-161.

inspired by nothing other than the work of "tainting" to which Raphael dedicated himself with regard to his ideal type. Finally, in its origins and problems, Bataille's considerations are Christian and his interpretation of the relationship between beauty and sexual taint accords with the statute of sexuality in Christian morality. Far from contradicting Raphael's possible sentiments, this reflection can contribute to clarifying the aspects in the work to which the latter dedicated himself in *La Fornarina* to make of the deformation of beauty the mark of physical desire for this same beauty.

We can now understand why *La Fornarina* should have appeared "disgraceful" and how it could not have had the "grace" to be loved by all. Far from being something of an artistic failure, its singularity accords perfectly with Raphael's work in which he has succeeded in that "*eccellenza dell'arte*" evoked in his letter to Castiglione. For a painter whose life and art passed as a miracle of exquisite sociability and grace, *La Fornarina* in actual fact constituted a work that was as ambitious as it was intimate. For it, he had to renounce his gift and his *savoir-faire*, even his grace. The contrasting effects that the painting has exercised upon its admirers and opponents and the contradictory effect that it can sometimes exert upon a single spectator attest to the success of Raphael's difficult task – which, perhaps it is true, he reserved for his own contemplation.

# *La Fornarina.* Biography of a Painting

*Iconography*

From radiographic studies performed initially by I.C.R. in 1978, repeated on the occasion of the 1983 exhibition and again recently, the female figure appears to be painted against a distant landscape, in which we can make out a river, and in the middle, above the model's head, a bush, presumably the myrtle that appears in the final version, in an arrangement very similar to that in the portrait of Ginevra de' Benci by Leonardo da Vinci (Washington, National Gallery), in which the juniper bush (*ginepro*) alludes to the name of the subject, just as the myrtle in La Fornarina symbolically evokes the image of Venus. The subsequent alteration of the background took place at the same time as the painting of the flesh tones, as revealed during the restoration, and reaffirms that the iconography of the painting refers to the image of Venus: a "half Venus nude", as indicated by the sources. The X-ray clearly reveals the landscape in the upper part of the painting, whereas at the level of the forearm traces of this initial arrangement are lost and the vegetation is painted on a base that does not appear to contain any traces of a prior landscape. Pursuing the analogy with the *Ginevra de' Benci*, one might advance the hypothesis that the landscape was bordered in the original composition. Such a delimitation is seen in Leonardo's painting, to which the first composition with the myrtle bush seems to refer. A computer reconstruction, based on Leonardo's study of hands kept in Windsor, of the part missing from the Washington Gallery painting suggests a position of the arms similar to that of the *Woman with Bouquet* by Verrocchio, in a pose reminiscent of that of *La Fornarina*. The framing of the landscape by the parapet is found in the *Mona Lisa* as well and is directly retraceable to an early layout by Leonardo, which appears to have influenced *La Fornarina*. Raphael had used a delimitation of the landscape with a parapet in the *Small Cowper Madonna* in Washington, whose connections to Leonardo are shown by D. A. Brown through the coeval *Madonna of the Meadow* in Vienna[1]. In the Florentine period, furthermore, Raphael's study of Leonardo is confirmed by the copy of the *Battle of Anghiari*.

The iconographic references to Venus are re-emphasised by the symbolism of the plants that overlie the earlier background landscape – the quince, symbol of carnal love, and the myrtle, sacred to the goddess; and the pose and the detail of the *armilla* [bracelet] – which finds precedents in Classical statues, from the *Medici Venus* to the *Capitoline Venus*. The transposition of a portrait into an image of symbolic value is a feature of Renaissance iconographic constructions, as found in Giorgione's *Laura* (Vienna, Kunsthistorisches Museum), to whose name the laurel bush in the background alludes. The use of the iconography of a particular saint was also frequent; the introduction of these iconographic elements into a portrait of a female sharing the saint's name exalted the virtues of the person painted. Hence, Fischel[2] argues that the name of the woman loved by Raphael had to be Caterina, on the basis of the existence of a version of the Veiled Woman [*La Velata*] in the iconography of *St. Catherine*, engraved by Wenzel Hollar, who stated the name of the model[3]. Additionally

[1] Brown 1983, pp. 9-26.
[2] Fischel (1948) 1962, p. 124.
[3] Reference can be made to the following work from the Barberini Gallery: the *S. Maria Maddalena* by Piero di Cosimo, which is composed like a portrait.

the analyses carried out on the Veiled Woman revealed no traces of a different iconography.

The relation to Leonardo, beyond the reference to the *Ginevra Benci*, is found in the drawing by Raphael of Leonardo's Leda, and the image of the Leda refers back to a portrayal, perhaps spurious, which has made it down to us only through copies, of the so-called "nude Mona Lisa", a portrait of a courtesan or reference to an erotic image, from which was reputedly derived the so-called *Monna Vanna* (St. Petersburg, Hermitage), painted by Salaino, a follower of Leonardo[4]. It should be mentioned that the image of a courtesan is not necessarily in conflict with the image of a loved woman; the so-called "honest courtesans" were women of a cultural level generally higher than that of common women, from whom they were distinguished by their looser morals, and their frequenting of cultured and elite circles. They were often raised to the status of 'official' lover of a powerful man. In addition, the hand placed over the heart, as in *La Fornarina*, is an attribute of "Amity" in the iconography of Cesare Ripa.

The iconography of Venus and the symbolism of the quince befit the portrait of a particularly desired lover for whom the role of bride was apparently not contemplated. In a letter of 1 July 1514 to his dearly beloved uncle, Simone di Battista di Ciarla[5], in Urbino, Raphael talks clearly of marital plans with an eminently practical sense: "I answer [you] that you know that Santa Maria in Portico [Cardinal Bibbiena] wants to give me one of his relatives, and with my uncle the priest's permission and your own, I promised to do whatever his revered Lordship wished, and please know that if Francesco Buffa has any matches that I still have not got, that I will find a fair damsel, as I intend one, of good fame, hers and [her family's], who will give me a dowry of three thousand golden scudi, and [who] live in Rome, because one hundred ducats here are worth more than two hundred there: you can be certain of it" making it understood that he appraised well all the social and economic advantages that might derive from a marriage to Maria Bibbiena, rather than to just any girl. We are a good distance from the romantic interpretation of the relationship with the Fornarina built up in the 19th century literature. Nevertheless, regarding the woman "whom Raphael loved [un]to death", probably the same woman who was living with him in April of 1520, we know from Vasari that before dying "as a Christian he sent the lover out of his house; and left her the possibility to live honestly"[6], after having entrusted her to Baviera, his servant. The small gold ring with stone worn on the ring finger of the left hand on the second joint is a wedding ring. However, this nuptial interpretation of the ring is not accepted by J. Craven[7], who sees in the iconography of the painting a direct reference to a Petrarchan image associated with Raphael's sonnets.

A curious annotation emerging during the process of restoration is that the wedding ring, placed according to the customs of the times on the ring finger of the left hand, turns out to have been originally covered with a coat of flesh-coloured paint, erasing it as if the artist had had second thoughts. As further proof that it could not be seen, the old copies of the painting, such as that of the Borghese, do not contain this detail, which appears only when the original colour has faded somewhat, and hence it is present in the 18th century engravings. The traces left by the original colour led C. Cecchelli to hypothesise that the ring bore traces of the star from the Chigi coat of arms[8] and, in keeping with the hypothesis that the woman was a famous courtesan, that the woman portrayed may have been Imperia, favourite of Agostino Chigi. The woman is also identified with the *Psyche* in the Farnesina or more often with the figure of *Galatea* in the Farnesina. However, the features of the Barberinian model would not seem to correspond to those of the only known portrait of Imperia.

In spite of the continuing tradition, the identification of the subject of the Barberini painting with the so-called Fornarina is not universally shared. A hypothesis formulated by several authors, and echoed by Pedretti[9], is that it is the portrait of a

[4] Pedretti, 1996, pp. 127-128.
[5] In Camesasca 1956, *Raffaello, tutti gli scritti*, p. 34.
[6] Vasari 1550, vol. III, p. 670.
[7] Craven 1994, pp. 371-394.
[8] Cecchelli 1923, II, pp. 9-21.
[9] Pedretti 1982.

courtesan and in particular, with reference to Vasari's citation, of Beatrice Ferrarese, the courtesan who was the lover of Lorenzo de' Medici, duke of Urbino. The iconography of the portrait, and the headdress, which has something of the Ferrarese style of wearing the Roman veil, might lead one to suppose that it is a portrait that Lorenzo had painted of his lover. This hypothesis however would not explain Raphael's signature on the bracelet, clearly indicating to whom the model belonged rather than being a mere signature, nor the complexity of the execution, which denotes the quest for different solutions; above all, the immediacy of the sketch made visible by reflectography makes one think of a live portrait and a close intimacy with the model.

The jewel that adorns the Fornarina's turban appears completely analogous to the jewel that appears on the veil of the *Veiled Woman* in the Galleria Palatina in Palazzo Pitti. As noted by A. M. Pedrocchi[10], it is a jewel which is very stylistically similar to a necklace pendant, but smaller, with a large central stone, a square cut ruby, surmounted by another smaller stone, a sapphire or an emerald, set in an encircling pattern of small volutes. At the bottom it ends with a blister pearl held by a golden thread. The two stones are framed presumably by a twisted gold ribbon with white enamel highlighting. All the painters who adopted the iconography of the painting, from Giulio Romano to Ingres, put an emphasis on this detail. Jewels similar to this one, used as neck pendants, are painted by Raphael in the portrait of *Maddalena Doni* in the Palazzo Pitti or in the Borghese painting of the *Woman with the Unicorn*.

The arrangement of the Fornarina's headdress is typical of the way the veil was worn by Roman women. The fabric of the "Roman cloth" was often made of silk using the characteristic yellowish tones that are found in the *Veiled Woman* or else using a pattern of coloured stripes with the warp often in gold, as in numerous female figures in Raphael's paintings, such as the *Sistine Madonna*, the Magdalen in Santa Cecilia, and especially the "Roman scarf" that wraps the head of the Madonna of the Chair [*Madonna della Seggiola*][11]. Isabella d'Este brought the *capigliara* into vogue at the court of Mantua, a hairstyle where the hair is gathered and held by a net or a veil, which seems to have influenced the way the Fornarina wears her veil: wrapped like a turban and knotted at the nape of the neck, bordered with a thick fringe, fastened to the head with a golden cord and adorned with a jewel very similar to, as has been said, the one that holds the veil to the head of the Veiled Woman.

*The attribution to Raphael*

The new information obtained during the restoration adds fuel to the debate. The first essential point is that the painting does not appear fully finished in terms of the glazing. The face is perfectly completed up to the level of the neck while some brushwork is missing from the skin of the torso, and the treatment of certain chiaroscuro effects confirm it, such as the shadow around the left arm. The vegetation in the background appears not to be wholly completed and certainly more summarily executed. The hypothesis that Giulio Romano, who probably would not have left the final glazing unfinished, made a contribution to the painting is thus rather improbable.

Another important point regards the drawing, or the sketch laying out the painting, which was made visible via reflectography performed with the new instruments at the Istituto Nazionale dell'Ottica, which transfer the data directly into electronic format. When reflectography was performed in 1983, the thick yellowed glaze was not removed, and no appreciable results were obtained.

The sketch reveals, even more clearly than the second thoughts which had already been brought into evidence with the 1983 analyses, that the painting was executed by the painter in a direct and immediate way, probably using a live model. The drawing on the support shows a different position of the arm that was corrected directly with paint. In addition, the type of sketch can be directly related to Raphael's method of work in his very first

[10] Pedrocchi 1983, p. 20.
[11] Chesne Dauphinè Griffo 1983, p. 16.

phases of ideation, often subsequently transposed in drawings by his students, but in this case directly transformed into a painting by the master. An example of this method may be found in the drawing for the tapestry of the *Miraculous Draught of Fishes*. Another of the numerous examples of this method of fixing the images is the back of the sheet, inv. 205 in the Albertina of Vienna, bearing graphic annotations for various paintings.

Analogous analyses of the works of Raphael, especially regarding works from his later period, portraits in particular, may shed further light on this period of the master's painting, when he shifts to a more plastic and chiaroscuro painting, such as that found in the *Transfiguration* in the Vatican Museums. This painting, which is considered to be wholly the work of the master, as affirmed by Vasari, was placed at the head of Raphael's deathbed and exhibited to the mourning populace who saw "him dead and it (the *Transfiguration*) alive". The *Transfiguration* too was not entirely completed at the death of the painter in 1520, as was probably also true for *La Fornarina*.

Raphael's heirs, Giovanfrancesco Penni, nicknamed Il Fattore, and Giulio Pippi, nicknamed Giulio Romano, were very young when the master died and had great difficulty in obtaining as inheritance even the work that was already commissioned, such as the completion of the Sala di Costantino in the palazzi Vaticani[12]. Giulio was around 21 years old and his method of painting and drawing is documented by a famous work in the Galleria Nazionale in Palazzo Barberini, restored and subjected to reflectographic analysis on this occasion: the *Madonna Hertz* (see the information on A. Lo Bianco in this catalogue). The drawing, which appears clearly defined under reflectography, appears very similar to the drawing of *Madonna with Child* in the Louvre and while its attribution to the hand of Pippi is completely convincing, it is a completely different hand and method from those used in the sketch for *La Fornarina*.

Very interesting results were obtained via reflectographic analysis of works by Raphael from a much

earlier period, such as the *Small Cowper Madonna* in Washington, which under reflectographic exam shows a drawing which is more complete than that of *La Fornarina*, but one that shows the same characteristics in summarily defining the fingers and in using multiple thin lines to create the outlines.

The relationship of the Barberini *Fornarina* with the *Veiled Woman* in Palazzo Pitti is also of fundamental importance. The tradition of the Barberini *Fornarina* as a portrait of Raphael's "beloved" is continuous and precise. On the other hand the *Veiled Woman* in Palazzo Pitti, among the numerous portraits which, according to Vasari, Raphael painted of his woman, is the only one that Vasari describes and whose history can be traced all the way back from the modern day. The identities of the two models were called into question at the end of the 19th century and during the 20th century[13], however, it is clear that the model for the two portraits is the same person. Nevertheless, Dussler too[14], with some reservations, and more decidedly Oberhuber[15], saw different people in the two portraits. A psychological difference, moreover, is perceptible within the two images, which could be explained by different phases during the life of the same person. The model in the Florentine painting is seen as the embodiment of sobriety and the composed consciousness of a high social position while the painting housed at Palazzo Barberini emphasises the worldly, sensual, almost lascivious aspects of the model. But it is also worth considering the different intentions behind the paintings: while one was destined for public viewing, the home of the antiquarian Botti in Florence, the other was for absolutely private use, as can be seen in the typology of the image, and remained in the artist's studio.

In recognising the identity of the subject, the critics often imputed the difference to the signs of the passage of time that appear in the body and face of the model in the later Barberini portrait. Oberhuber addresses this topic but in reference to the figure of Galatea in the Farnesina, in which he iden-

[12] For this topic see Fernetti 1997, pp. 133-136, which attributes to Raphael's hand the two details that appear to have been done in oil in the frescoed room, *Justitia* and *Comitas*, of which the latter, mirroring the *Fornarina* iconographically, is reputed to have been completed based on a drawing of the master.
[13] Gruyer 1881, p. 72; Crowe, Cavalcaselle 1891, vol. II, p. 563; Springer 1895, pp. 42-43; Cartwright 1895, p. 85; Checchelli 1923, p. 12; Ravaglia 1923, Filippini 1925, p. 222.12; Dussler 1971, p. 43.
[14] Dussler 1971, n. 43.
[15] Oberhuber, in D.A. Brown, K. Oberhuber, *Monna Vanna...*, 1978, part II.

tifies the same model as in the painting in the Pitti. The thesis that different models are depicted in the Barberini and the Palazzo Pitti paintings, two different loves of Raphael, would be supported by the difference in social status of the two women. The Veiled Woman is portrayed as a married woman of relatively high social status, whereas the Barberini Fornarina wears the veil typical of married women with children. Nevertheless it is to be noted that the turban, or better, the towel, worn by the Barberini Fornarina is nothing other than a form of the Roman veil for married women, as attested to by the Virgin in the *Madonna of the Chair*, with her similar headdress. In addition the iconography and attributes of Venus do not allow the social status of the model to be determined.

Determining the identity of the model and thus whether or not she is the woman loved by Raphael is an important issue in reconstructing the genesis of the painting. The work appears to be the product of an immediate arrangement with a live model and several *pentimenti*. First of all, changes were made to the background, as well as to the turban and the arm. The painting technique shows a careful and protracted construction of the image, with repeated and concatenated elements. The painting does not appear complete in its last renderings. The quality of the brushwork is extremely high and the drawing revealed by reflectography is completely different from the method used by Giulio Romano while completely analogous to that of Raphael. The woman portrayed coincides with the image of the *Veiled Woman*, documented as the portrait of the woman loved by Raphael. Lastly, the iconography of *La Fornarina* was noted and copied by contemporaries of Raphael (the frescoes in Villa Lante, the Borghese copy). All these factors tend to confirm that with all probability the work, as tradition would have it, was a private portrait of the model-lover, a person cited explicitly by the sources, which was left unfinished in the artist's workshop upon his death in 1520, and probably sold with the other works by his students and heirs. Its reappearance in Rome only in 1595 is explained by its being a strictly private portrait (the *Madonna of the Chair*, a painting of private devotion, appears in 1589), in spite of the notoriety of the image documented by the coeval replicas.

### The 19th century misunderstanding

A reliable reference in favour of it being a portrait of the model loved by Raphael comes from Vasari, who stated that Raphael "did portraits of many women and particularly his own woman", "of whom he painted a beautiful portrait, that looked really alive, which is now in Fiorenza in the custody of the *gentilissimo* Matteo Botti, Florentine merchant, friend and family to every virtuous person and especially to painters: kept by him as a reliquary for the love he brought to art and particularly to Raphael"[16].

This portrait is constantly cited [as being] in the Botti house by Borghini[17], by Francesco Bocchi in 1591 and in the edition revisited by Cinelli in 1677[18], notwithstanding the fact that Comolli, in the notes to his *Vita inedita di Raffaello da Urbino* of 1790, identifies the work previously kept in the Botti house with the Barberini painting, which was documented as having remained uninterruptedly in Rome since the late 1500's. Tommaso Puccini, director of the Gallerie di Firenze from 1793, claimed to have identified the painting cited by Vasari as the *Portrait of an Unknown Woman*, now attributed to Sebastiano del Piombo, then located in the Uffizi and dated 1512[19]. Puccini's misunderstanding, as Ridolfo was to clarify in 1891[20], arose from having interpreted documents regarding the inheritance left by Botti to the Grand Duke's house (documents that Puccini would not have personally reviewed, but which he reports as they were referred to him by the historian, Galluzzi) as referring to a bequest to Cosimo I by the son of the merchant, Matteo Botti, a friend of Raphael's. However, it was actually a descendant of the merchant Matteo Botti, the Marchese Matteo Botti, who instituted his heir, Cosimo II, with a testament executed on 15 September 1619. The testament contains a clear

[16] Vasari, 1550, p. 658.
[17] Borghini 1584, III, p. 392.
[18] Bocchi (1677) 1951 p. 172. In citing the painting in the Botti house once again in 1677, a house that no longer existed at that date since the last heir had died, Cinelli merely repeats without revision Bocchi's 1591 description.
[19] Puccini 1825.
[20] Ridolfi 1891, pp. 441-445.

reference to the painting, which refers directly to Vasari's citation, and it is the so-called *Donna Velata* [Veiled Woman], still in the collections of the Palazzo Pitti in Florence, described as: "a painting on canvas portraying a young woman down to her belt, by the hand of Raphael of Urbino, adorned with a walnut frame, a half-arm high, one and one eighth arms wide, with its curtain of red light silk decorated with a silken fringe and cordon of similar silk, found in Palazzo [Pitti], but not assessed"[21]. In any event, Puccini's thesis, up until Ridolfi's clarification, was commonly accepted, even if with some reservations due to differences between the model in the *Portrait of an Unknown Woman* in the Palazzo Pitti and the one in the Barberini painting, for which there was an ironclad tradition of her being Raphael's love.

Melchiorre Missirini was among the first critics of Puccini's thesis, but for completely different reasons. In an 1806 letter to Arrigoni[22], after having recounted, as if it were the historical truth, the liberal invention of an idyllic encounter between the Fornarina and Raphael in a vegetable patch on the banks of the Tiber, he argues that the Barberini painting represents a woman who is too graceless to be the Fornarina, the protagonist of such a tale of love. And in the picture in the Pitti Gallery in Florence, whose author he first hypothesised was Sebastiano del Piombo, based on a drawing by Michelangelo, the woman portrayed would have been another genius's great love, Vittoria Colonna, Marquise of Pescara. He went on to affirm that the portrait of Raphael's love cited by Vasari had been lost.

The same aesthetic refusal of the model in the Barberini portrait would be picked up again some fifty years later by Farabulini in somewhat cruder terms: "This woman is not only gauchely mawkish, but obscenely half nude; and we do not know how Sanzio could have portrayed her this way"[23]. The issue of the "vulgarity" of the portrayal (both for the physical type of woman, and the nudity) often contributes to support the attribution to Giulio Romano and recurs in the criticism of the 1800's. For

Duppa and Quatremère[24] this judgement found confirmation in the dark tones of the painting (also often attributed to a poor job of restoration). For Morelli the issue was decisive; he saw the model in the Barberini painting as being "common and repugnant so that one would say he had a woman of abject condition in front of him"[25]. It was not in fact easy to identify a portrait of the Fornarina that corresponded to the romantic legend that was being woven. In the 1700's, on the other hand, it was the nudity of the model that created no small discomfort to the beholder's morale to bring about analogous judgements.

The painting in the Palazzo Pitti gallery in Florence continued to be copied and known as the portrait of the Fornarina, or at least one of the Fornarinas, who in the meantime seemed to have multiplied. And it should be kept in mind that in the painting *Raphael Dying* painted by R. Morgari in 1880, the model for the Fornarina is that of the woman in the Pitti Gallery[26]. A copy of the Pitti portrait with variations was exhibited in Rome at the Corsini Gallery as *La Fornarina*. In an 1805 guide to the Corsini Gallery, the painting, in Room IV, was indicated as *La Fornarina* and attributed to Giulio Romano, evidently thanks to the fame that the Florence painting had acquired. In the Corsini painting, E. Ravaglia saw a portrait of Beatrice Ferrarese done by Sebastiano del Piombo[27]. Filippini, on the other hand, identifies the "famous Albina, courtesan of Rome"[28]. The Fornarina was also recognised in a painting in Verona then owned by Cristoforo Laffranchini, cited by Gian Battista Persico in his description of Verona as a "celestial work"[29]. Claude Paquin[30], who saw the painting in those years considered it "*supérieure même à celles de la Tribuna et du Palais Barberini*".

In those years there was a spate of discoveries of portraits of Raphael's love. A version is identified in the office of the Duke of Marlborough, a version that Rehberg[31] affirms is the one cited by Vasari and notes the resemblance to the Barberini portrait. The engraving of this work by P. Pieroleri bears the inscription "*Ritiro ed onestà sono i miei*

[21] Archives of Palazzo Pitti, inheritance, no. 398*v*; Ridolfi, 1891, p. 452.
[22] Missirini 1828.
[23] Farabulini 1875, p. 236.
[24] Duppa, Quatremère de Quincy 1870, p. 352.
[25] Morelli (1897) 1991, p. 54.
[26] Florence, Palazzo Pitti, Galleria d'Arte Moderna, inv. n. 337.
[27] Ravaglia 1923, pp. 53-61.
[28] Filippini 1925. 5, pp. 222-226.
[29] Persico, in addition to his 1820 description of Verona, cites the painting in a letter of 5 January 1827 to Benessu Montanari, Quatremère de Quincy (1824) 1829; Gruyer 1881, p. 73 note.
[30] Valery (A.C. Paquin) 1831-1832, vol. IV, p. 308-309.
[31] Rehberg 1824, p. 92.

*pregi*" [discretion and honesty are my virtues] representing the apex of the romantic transposition of the personage. A "Fornarina" is also engraved by Chambras with the title *La Vendèngeuse*. This was a copy of the *Dorotea* by Sebastiano del Piombo in the Berlin Museum and, in any case, the features of the Fornarina are also recognised in the original *Dorotea*. Drawings were also discovered portraying the woman loved by Raphael, such as the one discovered and defended in 1874 by Colbacchini[32] against the opinions of the experts of the Venice Academy.

But alongside the more or less reliable versions one must also keep in mind the copies and the versions from the time of the Barberini *Fornarina*, whose histories are not always easy to reconstruct.

Contemporaneously with the discovery of new versions and copies, the features and body of the Fornarina are identified in numerous female figures of Raphael's works. The most traditional of these correspondences is that with the kneeling woman in the right foreground of the *Transfiguration* in the Vatican Museums; this goes hand in hand with the identification with the figure on the left of the Heliodorus fresco, in which Missirini detects the interest in the figure by another great artist, noting that in the painting "la Fornarina is painted with such agility of movement that I heard Canova say more than once that this was the most beautiful body created by Raphael as a likeness to his woman". On this identification depends the one accepted by Gruyer[33] with the "Portatrice d'Acqua dell'Incendio di Borgo" [the water bearer in the *Fire in the Borgo*].

The other portrayal most widely recognised as a portrait of the Fornarina is that of the Muse Cleo in *Parnassus*. Missirini again sees it as the "truest portrait of the Fornarina, both in her face and person".

Other direct relationships of the Barberini model include the figure of the Magdalen in the *Ecstasy of St. Cecilia* in the Pinacoteca Nazionale di Bologna[34], the *Allegories of Justitia and Comitas* in the Sala di Costantino, hypothesised to have been

the work of Raphael in his late period[35] as well as an often noted correspondence with *Psyche* in the Farnesina[36], and a vaguer relationship with *Galatea*. The identification of a portrait of the Fornarina in the *Madonna of St. Sixtus* in the Dresden Gallery is seen through a greater idealisation of the Palazzo Pitti portrait, just as the identification, asserted by Calzini as early as 1908 with the model for the *Madonna of the Chair* in Palazzo Pitti[37]. Notably forced and probably to be interpreted in a broad sense is the vague identification with the *Belle Jardinière* in the Louvre[38].

The issue of the relationship of the Barberini painting with certain other of Raphael's portraits of women is more complex. The *Portrait of a Woman* in the Musée des Beaux-Arts of Strasbourg has been considered as having a direct relationship with *La Fornarina* (similar gesture, the resemblance of the model and headdress). J. Shearman[39] attributes this painting to Giulio Romano, and Fischel[40] attributes it more generally to the Raphaelian school. Dussler[41] sees the *Portrait of a Woman* in the Hannover Gallery as being based on the same model. Fischel[42] also takes into consideration the problem of the portrait in the Czartoryski Collection in the Krakow Gallery, where, in spite of the ambiguity of the portrayal, like Freedberg[43], he sees the Barberini model.

### The 19th century identification of the model

It is not until the early years of the 19th century that the attempt is made to give a historical dimension to the figure both by examining the sources and forcing the interpretation of the documents. The existence of a specially loved woman is clear from the sources, a woman whom Vasari defines as "his" [Raphael's]. It is also clear that, nonetheless, Raphael was to have married one of Cardinal Bibbiena's nieces and that he was particularly taken by feminine graces, so much so that his biographers attribute his death to an excess of amorous pleasures (and this excess could only have been due to "his" woman). Simone Fornari from Reggio wrote not long after Raphael's death that

[32] Colbacchini 1871; Colbacchini, *A proposito…*, 1874; Colbacchini, *Memoria che può…*, 1874.
[33] Gruyer 1881, p. 85
[34] Morelli 1897, p. 54; Minghetti 1885, pp. 147-151; Fischel 1962, p. 67.
[35] See also note 13; Oberhuber 1978, p. 38; De Vecchi 1981.
[36] Filippini 1925, p. 223.
[37] Calzini 1908, pp. 6-8.
[38] Boucher Desnoyers 1853, p. 24; Schlegel (von) 1973, p. 30 notes in any case "that the Madonna [la Belle Jardinière] in the guise of a beloved woman, is painted in a wholly earthly grace".
[39] Shearman 1966.
[40] Fischel 1962, p. 67.
[41] Dussler 1971, n. 43.
[42] Fischel 1916, pp. 251-261.
[43] Freedberg 1961, pp. 179-180.

the painter had died from an excess of carnal love[44]. This tradition is picked up again in the following centuries, somewhat sketchily, as was reported, in Tetius's description, and explicitly restated in the 1700's. Lady Ann Miller in 1776 cites the painting as a portrait of [Raphael's] "favourite Mistress, for whom he died"[45]. The theme recurs also in the literary transpositions. It finally took medical studies to discredit this tradition and look to a more probable cause for the painter's death, such as pneumonia[46].

The legend opened the way to a romantic reconstruction of the figure. The first attempt to give a historical dimension to the Fornarina is in the thesis elaborated in the early 1800's by Missirini, who affirms in a letter to Arrigoni that "[she was] the so-called Fornarina, daughter of a bailee baker in Rome, who lived across the Tiber near Santa Cecilia"[47]. A hypothetical identification of the name of the model was arrived at later, based on existing documents that cannot be considered historically reliable since they cannot be directly referenced to the woman cited by Vasari.

The reconstruction was based on the 16th century annotations to a 1568 edition of Vasari owned by the notary, Giuseppe Vannutelli, in Rome, in which the proper name of Raphael's woman referred to by Vasari is clearly stated: Margherita[48]. There was also an oral tradition in Rome regarding the houses where Raphael's beloved had lived. R. Lanciani[49], who reported the legend, indicated three of the alleged houses: the first near the corner of Via S. Dorotea and Porta Settimiana, on the ground floor; the second in Vicolo del Cedro (then Via del Merangolo) near the church of S. Egidio in Trastevere; the third was the Palazzetto Sassi in Parione, in Via del Governo Vecchio 48, in whose entryway a memorial tablet was placed in the 19th century, reportedly replacing an older one, with the words *"Raphael Sancti – Quae claruit dilecta – Hic fertur incoluisse"*[50]. In addition to the tradition, supported by the tablet, this last address appears to be the most reliable following the discovery of the indication in the Vatican Archives[51], "[in] a house

owned by Mons. Benedetto Sacco lives Franco, a Sienese baker", an indication immediately connected to the legend of the Fornarina. "Franco", who was "Sienese" like Chigi, and what's more, a *"fornaro"* [baker], could only have been the father of the Fornarina. The identification was strengthened by the discovery of a document published by Valeri[52], who spoke of the presumed retreat of the Fornarina into the Convent of S. Apollonia in Trastevere four months after the death of Raphael: "on the 18th day of August, 1520. Today, Margherita, widow, and daughter of Francesco Luti of Siena, was received into our Conservatory". The timing, the name, the paternity and the Sienese origin all contribute to the definitive attribution of the name Margherita Luti of Siena to the Fornarina. Previously, the only surname attributed to the Fornarina was of literary origin, Goffarelli[53].

*The painting's fortune in the 18th and 19th centuries*
In the 1700's the painting *La Fornarina* was constantly cited by travellers from abroad and indicated in tour guides. It should be noted that the appreciation expressed consistently for this work and for the model was not excessively positive and in some cases reached outright rejection. Edward Wright in 1720[54] describes the painting as "Raphael's mistress painted by himself, with naked Breast and Arm. Upon the Bracelet on her arm is written Raphael Urbinas. The picture has abundance of nature, but represents no great beauty. There is a copy of it above the stairs, by Giulio Romano". At approximately the same time an analogously harsh judgement made by Richardson defined the painting as being disagreeable and the features of the model inelegant, following the Puritanical tendency to reject overly audacious portrayals: "Below, Raphaele's Mistress; the Original. It is much more soft and better coloured than that of Giulio; but at the best is Disagreeable enough; of Dark, Sullen, Brown complexion; Eyes and Hair very Black, and like a Blackamoor; nor are her Features at all elegant"[55]. The comments of President de Brosses in one of his letters (collection of 1739-40) stand

[44] Fornari 1549, p. 514.
[45] Miller (A. Riggs) 1776, see also Comolli 1790, pp. 92-93.
[46] Bufarale 1915, e Portiglotti 1920, pp. 23-26.
[47] M. Missirini, letter to Arrigoni, cf. Quatremère de Quincy 1829, p. 657.
[48] Odescalchi 1836, pp. 108-109.
[49] Lanciani 1907, p. 236.
[50] See also Bessone-Aurelj 1928.
[51] Armellini 1882, p. 62.
[52] Valeri 1897, vol. II, pp. 353-63.
[53] Vedi Poggiali 1889, p. 34.
[54] Wright 1730, p. 292.
[55] Richardson 1754, p. 157.

completely alone in finding in the painting *"autant di suavité qu'on puisse trouver dans l'école vénitiene ou lombarde"*[56]. His fellow Frenchman, the Abbé Jeróme Richard, commenting several years later, shared the opinions of the English travellers: *"Le portrait de la maîtresse de Raphaél peint par lui même. Elle a le teint brun & obscur, les yeux noirs & tristes, les cheveux fort noir & lissés, qui lui accompagnent le visage dans toute sa longueur, le nez bien fait, & quelque grâce dans la bouche, la figure est peu agréable; ce tableau peint sur bois est d'autant mieux conservé, qu'il paroit que Raphael lui même avoit fait ajuster le deux petites partes de bois noir qui l'enferment dans le quadre. Il y en a une copie faite par Jules Romain, d'un coloris beaucoup plus dur, & qui n'a aucun agrément"*[57].

Richard notes the detail of the two doors that closed over the picture and the existence of the copy by Giulio Romano, which he compares unfavourably to the original, an indication that is constantly repeated. It is also interesting to note the placement of the painting, which in the 1700's and 1800's seems to have remained always on the ground floor of the palazzo, where the most important pictures are supposed to be displayed, and precisely in the north wing, towards Piazza Barberini, in the Sala della Fontana dell'Orfeo, where Ridolfino Venuti describes it, "Descending to the other apartment, in the first room painted with forest scenes with a majolica tile floor, one vaguely makes out a fountain, with various waterworks … in the third [room] the portrait of Raphael's female friend, whom he painted himself"[58]. J. De Lalande: *"l'appartement du rez-de-chaussée est composé de neuf pièces, qui toutes contiennent des choses précieuses: une fontaine avec quatre colonnes ioniques de granite, les quelles forment une distribution agréable. Un tableau de Raphaél, rerpresentant sa maîtresse. C'est une belle brune, il l'a peinte en peu découverte, un bracelet au bras, à la manière des antiques, sur le quel Raphaél a écrit son nom; le tableau dont plusieurs hont beaucoup de cas est peint d'une manière trés sèche"*[59]. Nibby, "And last in a separate office one

can observe the portrait of the Fornarina, beloved of Raphael, painted by [the artist] himself, an outstanding work in spite of the fact that the paint has deteriorated to no small extent. Opposite there is a copy of the portrait, which some say was painted by Giulio Romano"[60]. In 1844 the painting was still located on the ground floor, but in the south wing, as indicated by the inventory ordered by Enrico Barberini with all the works remaining in the palazzo after the division with the Sciarra branch of the family.

In the 1700's the image was more widely circulated via engravings. The first was the one done by Domenico Cunego (Verona, 1726 – Rome, 1774); the copper is kept by the Istituto Nazionale per la Grafica, Calcografia Nazionale (inv. no. 980, T XXII). The print was created for the volume *Schola Italica Picturae*, plate 9, published in Rome in 1773, edited and funded by the painter Gavin Hamilton, who wished to present *"tabulae selectae… summorum e schola italica pictorum,"* from Michelangelo and Raphael up to the painters of the 17th century[61], as printed on the title page (the volume has no text). The eight initial plates present four works by Michelangelo and four by Raphael. The inclusion of the *Fornarina* among the four Raphael works is certainly a significant expression of the fame enjoyed by the painting at the close of the 18th century. Equally significant is the caption *"Raphaelis Amasia, vulgo la Fornarina / Extat Romae in Aedibus Barberinis"*. This is the first citation of the name "Fornarina" as the nickname of Raphael's lover and as the title of the Barberini painting, alongside the name Amasia, still used in Rome in the 19th century for lover[62].

A comparison between the 1772 print (ed. Gavin Hamilton) and the copper plate shows that the plate underwent significant modifications, among which the most evident is the veil added to cover the breast. As hypothesised by G. Pezzini Bernini, the alteration may be attributable to the "moralising current" that in 1823 induced the heads of the Calcografia Camerale to destroy "the copper plates held morally offensive … other [works] were

[56] De Brosses 1929, vol. II, p. 449.
[57] Richard 1766, vol. VI, p. 69.
[58] Venuti 1767, p. 226.
[59] De Lalande 1769, vol. III, p. 415.
[60] Nibby 1841, p. 592; see also Titi 1763, p. 333 and Northall 1766, p. 319.
[61] See Bernini Pezzini, in *Raphael Urbinas…*, 1983, pp. 26-27.
[62] Oberhuber 1978.

saved only at the price of disfiguring them with leaves or veils" (C. A. Petrucci, 1934).

The print made four years later by the young Roman, Francesco Rastaini in 1778 is a replica faithfully derived from the Cunego print, and the engraving by Pietro Fontana, dated 1805 in the repertories, still has the breast uncensored by the veil. In 1817 the Barberini *Fornarina* was first on the list of works belonging to the Barberini family subjected to the obligation of the fideicommissum, as indicated by the writing "F 1" on the lower right side of the painting, and it has a pre-eminent place also in the convention of the Italian State with the Barberini heirs, which led to the dismemberment of the historical collection of the princes. The painting became part of the collection of the State following a Regal decree law of 26 April 1934. At the request of the Barberini and Corsini princes, the two branches among which the Barberini fideicommissum was split after 1871, the State agreed to divide the collection into three parts. The first was to become State property, as a donation and as payment of all taxes, including export taxes relating to a second share of the collection. This second share, on the basis of this donation, would remain completely accessible to the princes, who retained the right to freely export and sell the works abroad. A third group of paintings would remain the property of the princes, but subject to certain restrictions and to the laws in force regarding important works of artistic or historic value. In the group that became State property, the most highly assessed painting by far was the *Fornarina*, to which a value of 1.5 million lire was assigned, as opposed to the portrait of *Federico da Montefeltro* at 800,000 lire, the *Uomini Illustri* by Giusto di Gand at 80,000 lire, and the portrait of *Beatrice Cenci del Reni* at 100,000 lire. The *Fornarina* was thus the fundamental piece for the compensation to the State in exchange for the custody of the masterpieces relinquished by the State, and certainly this convention was not unrelated to the fact that the Barberini offered their palazzo as headquarters for the Armed Forces.

After being acquired by the State, the painting was deposited in the Galleria Borghese, where it was displayed in the second room on the first floor together with other works by Raphael already belonging to this gallery[63]. The first act of the Gallery management was to replace the frame around the work, which evidently was no longer the original. The new frame, which is the one we see today, was done "in the Renaissance style" by the artisan Torquato Gaudenzi. The painting was displayed in this period of time at the exhibition on the masterworks of European painting[64] held in 1944 in the Palazzo Venezia and at the "Temporary exhibition of masterpieces of art"[65] held in the Galleria Borghese in 1945. In 1949 Palazzo Barberini was purchased and the building became the headquarters for the Galleria Nazionale. In 1953, after the right wing of the piano nobile was prepared, the *Fornarina* returned to its prior location.

*The 19th century restoration*

The 19th century witnessed the only recorded restoration work on the painting. In the payment notes from the Barberini there are various payments made between the end of 1821 and April of 1822 to "Palmaroli, painting restorer for the restoration of paintings, both freely owned and those subject to fideicommissum"[66]. Among the latter was certainly the *Fornarina*, believed to have been restored by Palmaroli himself in 1820. There was supposedly a layer of grime obscuring the painting so that it was not possible to distinguish it from a copy placed nearby. There is no specific report on the restoration, but much blame has been attributed to it. Whereas Abbé Richard[67] found it still well conserved in the mid-1700's, Quandt[68], around the time of the restoration, found it to be in poor condition, and the notes on the poor preservation of the painting become more and more frequent after the restoration work. In 1838, Nibby[69] noted that the colour had suffered and Pistolesi's guide observed that "the colour has darkened considerably"[70]. Passavant is even more precise on the motivations for the defect he attributes decisive-

[63] De Rinaldis 1935, p. 21.
[64] *Catalogo della esposizione...*, 1944, p. 28.
[65] *Catalogo della Mostra temporanea di insigni opere d'arte appartenenti alle gallerie di Roma, Napoli, Urbino, Milano, Venezia*, Galleria Borghese, Roma 1945, pp. 15-16.
[66] Bibl. Apostolica Vaticana fondo Barberini, Computisteria, vol. 712, f. 1211 e vol. 726, f. 197.
[67] Richard 1766, p. 69.
[68] Quandt, in "Antologia", Firenze 1821.
[69] Nibby 1885, p. 592.
[70] Pistolesi 1856, p. 372.

ly to the restoration work and to the use of bitumen in the paint: *"Les ombres seules ont quelque chose de trop brun, il en est de même du fond. Mais les légers déjauts peuvent aussi être attribués à la restauration avec du bitume"*[71].

Gruyer gives credit to Palmaroli for having made the painting readable, criticising him only for excessive retouching of the head of the figure: *"La tête est d'une coleur moins agréable; les lumières s'y sont éteintes en quelques endroits, tandis qu'en d'autres places les ombres ont pris quelque chose de dur. La faute en est au temps d'abord, aux restaurations ensuite. Le tableau a beaucoup souffert. Il est demeuré longtemps presque inconnaissable sous une épaisse couche de poussière et de noir de fumée. En 1820, Palmaroli l'a très habilement nettoyé; mais sur la tête, qui avait été particulierement atteinte, il a été contraint d'operer des retouches qui ont en partie rompu l'harmonie primitive"*[72]. The text of Crowe and Cavalcaselle, on the other hand, accuses the restoration of having unnaturally accentuated the contrast between the light tones and the dark background of the painting, upsetting the chromatic balance: "Palmiroli completely cleaned the painting in 1820. The worst offended parts are the neck, the breast, the veil, and the hand that rests upon it; the shadows in many areas have suffered greatly as well as the half-tones. The background has gained in tint and become quite dark. The eyes and the forehead are the parts best preserved."[73].

In more recent times, Cecchelli recalls the restoration and the generally good conservation of the painting: "The only restoration which we know anything about is that done by Palmaroli in 1820, which only darkened a bit the overall tonality and patched several moth holes; but one cannot speak of bona fide defects"[74]. Camesasca takes the opposite view and imputes the poor state of preservation to Palmaroli's restoration work: "the poor conservation results from the unequal cleaning done by Palmaroli"[75], noting in particular the darkening of the colours.

It is probable that the annotations of the darkening of the colours made by many critics, above and beyond the yellowing of the glaze, regard the dark tones of the background, which contrast with the luminosity of the figure. Raphael passes from the intricate and open spaces in the background of portraits from the Florentine period to the dark background of portraits such as that of the *Cardinal* in the Prado, *Fedra Inghirami* in the Palatine Gallery, or the *Bindo Altoviti* in Washington, while in the *Veiled Woman* or the portrait of *Baldassare Castiglione* in the Louvre the background space has a lighter and more luminous tint.

The work did not undergo any alterations or suffer any damage in the following years. In an old document dating back to around 1924, when the work still belonged to the Barberini, there is mention of creating a new backing for the wooden tablet, but the work was never done. It is probable instead that one of the supporting crosspieces was replaced.

[71] Passavant (1860) 1882-1891, p. 98.
[72] Gruyer 1881, vol. I, p. 69.
[73] Crowe, Cavalcaselle, *Raphael...*, 1884-1891, vol. III, p. 84.
[74] Cecchelli 1923, vol. I, fasc. 11, p. 11.
[75] Camesasca, *Tutta la pittura...*, 1956, pp. 70-71.

Oil Paintings

# Raphael Sanzio (Urbino, 1483 – Rome, 1520)
## *Saint Sebastian*, 1501-1502

Oil on wood
43.9 × 34.3 cm
Bergamo, Accademia Carrara
(inv. 314)

**Provenance:**
Crema, Collection of the Zurla Counts; Milan, collection of Giuseppe Longhi; Bergamo, collection of Count Guglielmo Lochis, from 1836; Bergamo, Accademia Carrara, from 1866.

**Bibliography:**
Quatremère de Quincy 1829, pp. 7-8, note; Lochis 1858, pp. 147-151; Passavant 1860, II, p. 20, no. 16; Lermolieff, Morelli 1893, III, p. 244; Berenson 1896; Frizzoni 1897, pp. 76-78; Rosenberg, Gronau 1919, no. 9; Gronau 1922, pp. 13, 221; Venturi 1920, pp. 110 ff.; Berenson 1932, p. 479; Longhi 1955, p. 20; Volpe 1956, p. 8; Camesasca 1952, I, tav. 5; Ottino dalla Chiesa 1955, pp. 110 ff.; Fischel 1962, pp. 24 ff., 166 ff.; Dussler 1966, no. 4; Dussler 1971, p. 5, tav. 13; Rossi 1979, pp. 114-115; Cuzin 1983, pp. 20-24, fig. 12; Marabottini 1983, p. 60; Ferino Pagden, Zancan 1989, p. 18, no. 4; *Raffaello e Dante* 1992, p. 258; De Vecchi 1995, p. 202, no. 8; Meyer zur Capellen 2001, pp. 117-119, n. 6, tav. 69.

This is one of the artist's earliest works. It was certainly executed in the very first years of the 16th century, when Raphael was still deeply influenced by the style of Perugino and had not yet attained complete confidence in composition. This is revealed by the young martyr's physiognomy. The face is broad and oval and the features are extremely idealised. In addition, the pose of the hand is mannered; the outstretched gesture of the fingers is somewhat unnatural and the foreshortening is awkward. In addition, the size of the hand is somewhat small for an official of the Roman army, as was Sebastian. These weaknesses demonstrate that the painting was executed in an early phase of the artist's development. Furthermore, the broad landscape silhouetted behind the shoulders of the saint is far from the atmospheric charm already evident in the *Madonna Conestabile* in St. Petersburg and above all from the standard the artist attains after contact with the works of Leonardo. The affinities with other early works and in particular the *Solly Madonna* (Berlin, Gemäldegalerie) are compelling. One can note, for example, similar features in the Berlin work – the wide and subtle ridge of the arching eyebrows, the right hand pose with the book and the portrayal of the barren landscape. The decoration of the embroidery of the garment is very refined, enriched by gold thread designs layered by a close warp knit. This enthusiasm for the preciousness of detail has frequently been attributed to the influence of Pinturicchio (there is a theory that he collaborated with Raphael in the decoration of the Piccolomini Library in the cathedral in Siena). Roberto Longhi in particular supported this interpretation and he included the *Saint Sebastian* in that "slight pintoricchio-style intermezzo" found in the early works of Raphael in order to "create richness and ornamentation". This can also be seen in, among other works, the *Resurrection*, once at Kinnaird a Rossy Priory and now in São Paulo, Brazil (Longhi 1955, p. 20). The charm this small work exerted during the 19th century in particular is fundamentally due to the strong Perugino-style elements in the painting. The sense of grace and composed resignation of the saint, which symbolises his very martyrdom, aroused the enthusiastic admiration of connoisseurs. It is also interesting to note Morelli's appreciation for the "naturalness" of the hand which, he noted with regret, Raphael later abandoned in his mature work (Morelli [1887] 1991, p. 65).

No document exists relating to the circumstances that led the artist to depict *Saint Sebastian*. Rumohr believed that the painting was a fragment of a larger work: this suggestion, rejected by Passavant, found no support (Passavant 1869, II, p. 20). Most probably it was a devotional painting commissioned privately. The painting, originating from the Zurla Collection in Crema, was acquired by the Milanese engraver Giuseppe Longhi for 3000 lire (Passavant 1860, II, p. 20; the Longhi Collection is mentioned by M. Valéry in his *Voyages en Italie*, pp. 185-186; Beretta 1837, p. 97, defines the artist the "supreme connoisseur of Raphael"). In 1836 the painting became a part of the collection of Count Lochis of Bergamo. In fact it is described in the gallery catalogue published by Lochis himself in 1858. In order to certify the authenticity of the work, the author mentions the appraisal of numerous artists and connoisseurs, among them Francesco Hayez, who professed to recognising in the work "the beauties of the divine painter" (Lochis 1858, p. 150; cf. also Frizzoni 1897, pp. 76-78). Following the

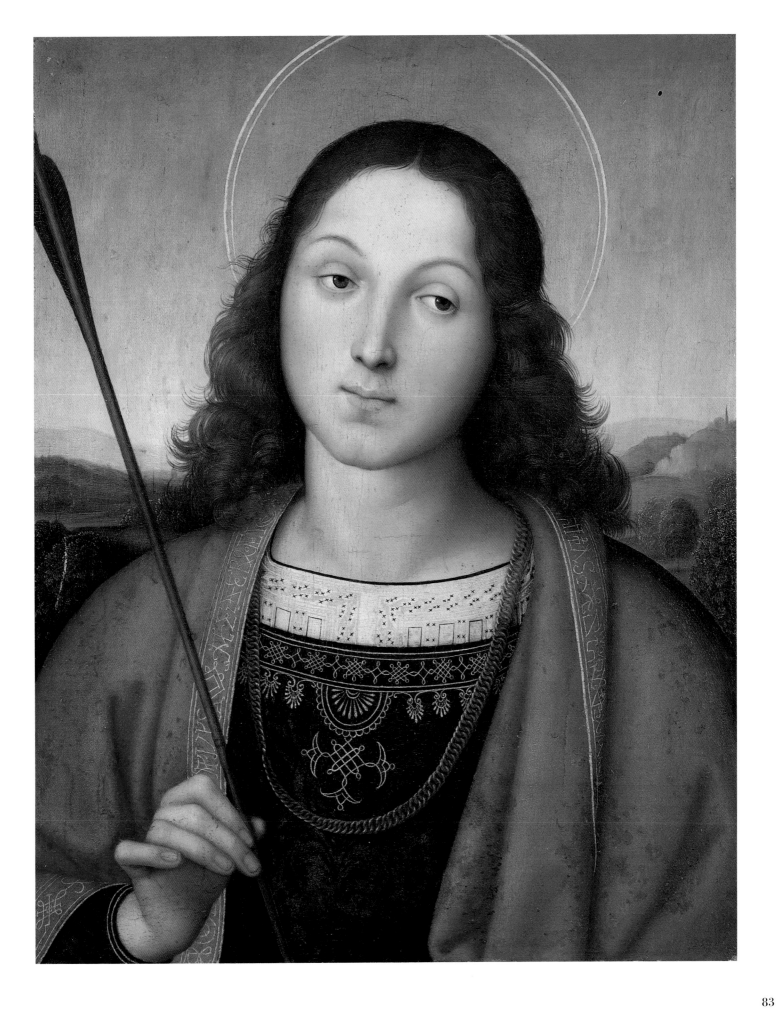

death of Lochis in 1859, the small panel passed by virtue of a legacy to the Accademia Carrara galleries. On this occasion it was again subjected to expert examination, which confirmed its high stylistic qualities and opposed sale overseas. Panzeri sets out the economic value proposed respectively by Giovanni Morelli and by Enrico Scuri (400 gold napoleons for Morelli; 10,000 florins of the Lombardo Veneto Reign for Scuri; cf. Panzeri 1987, p. 239, note 55). In 1896 in the *Gazette des Beaux-Arts*, Berenson made note of the existence of a copy of the *Saint Sebastian* in the Ross collection in New York. The painting ("un peu banale et prétentieuse"), very modest with respect to the Bergamo original, was attributed by the scholar to a painter of the Perugino circle, Giovanni di Pietro Lo Spagno (Berenson 1896, pp. 211-214, fig. at p. 212). In 1971 Dussler noted that the painting could no longer be traced (Dussler 1971, p. 5). An engraving of the work by Giuseppe Mari was published in the Italian edition of the Raphael biography by Quatremère de Quincy (1829). (*I.B.*)

# Raphael Sanzio (Urbino, 1483 – Rome, 1520)
## *Madonna and Child between Saints Jerome and Francis*, 1501-1502

Poplar panel
34 × 29 cm
Berlin, Gemäldegalerie,
Staatliche Museen
Preußischer Kulturbesitz
(inv. 145)

**Bibliography:**
Passavant (1839, Leipzig)
1889, pp. 14-15; Gruyer 1869,
pp. 436-446; Crowe,
Cavalcaselle 1884, pp. 109-
110; Müntz 1886, pp. 66, 85-
89; Venturi 1920, p. 110;
Gronau 1922, pp. XV-XVI, 11;
Gamba 1932, p. 27; Ortolani
1942, p. 15; Fischel 1948,
p. 44; Longhi 1952, p. 46;
Longhi 1955, p. 22;
Camesasca 1956, pp. 33-34;
Dussler 1971, p. 4; Buren
(van) 1975, p. 45; *Catalogue
of Paintings...*, 1978, cat. 145;
De Vecchi 1981, p. 239;
Oberhuber 1982, pp. 28, 186;
Cuzin 1983, pp. 19-20; Knab
1983, pp. 68, 583;
Marabottini 1983, pp. 57-58;
Mitsch 1983, p. 140; Viatte
1983, p. 181; Barberini 1984,
pp. 63-64; Ferino Pagden,
Zancan 1989, p. 20; Miller
1991, p. 348; Birke, Kertész
1992, p. 40; Oberhuber 1999,
p. 32; Meyer Zur Capellen
2001, pp. 115-117.

The group of Madonna with the Child in benedictory pose is placed at the centre front of the composition. The Virgin gently holds Jesus who is sitting on an embellished cushion; beside is St. Jerome in prayer while St. Francis in the background repeats the same gesture as the Child, showing the stigmata on the palm of his hand. There are buildings and bell-towers set in a hilly landscape on the horizon. All the figures look towards the Child who in turn looks towards the observer.

Information regarding the origins of this painting in the Borghese collection, from the 19th century on, is not confirmed in any archival documents. The first precise citation is in Passavant: "it appears to have been painted around 1503; and from Palazzo Borghesi it passes, if memory does not betray us, to the Galleria Aldobrandini" (1889, p. 14). Indicated as being in the collection of Baron von der Ropp, it was purchased in 1829 for the German public collections and is housed today in the new rooms of the Gemäldegalerie together with four other early Madonnas by Raphael.

The authorship of the work, though it has often been judged less than positively – Venturi (1920, p. 110) considered it a "very weak little work" – has never been questioned. The generally accepted chronology places it in the early Umbrian period, the early 16th century, close, moreover, to the *Solly Madonna*, also housed in Berlin, and reminiscent of the work of Perugino and Pinturicchio.

The painting is in fairly good state despite the fact that the panel has been retouched in previous restorations, as had been observed by the expert eye of Cavalcaselle-Crowe: "marks of restoration can be seen on the face and beard of St. Jerome, on the right leg and left foot of the Child" (1884, p. 110) and later by Camesasca: "abundantly retouched on the right side, it has most likely undergone excessively intensive cleaning, which, among other things, has removed the names of the saints written inside the halos" (1956, pp. 33-34).

In the absence of any documentary data, philological analysis can only be carried out from a formal point of view, and comparisons can be made with two drawings critically connected with the painting: the beautiful autograph study of the head of St. Jerome at Lille (Musée Lille, Wicar Collection, inv. 488, 150 × 108 mm) and a drawing in Vienna of a *Sacra Conversazione* with some variants with respect to the Berlin painting (Albertina, inv. 74, 138×114 mm.), once considered to be by Raphael but now attributed to Berto di Giovanni (Viatte 1983, p. 181; Birke-Kertész 1992, p. 40).

In its dimensions and subject the Berlin painting, which appears to have been privately commissioned for a domestic altar, adheres precisely to archaic iconographic models with a simple and consolidated vocabulary. The position of the Virgin, the colour of clothing and headdress, the symbolic embroidered star over the heart and the position of the Child's hands all befit the somewhat provincial religiosity of the Umbria region, as Muntz has observed (1886, p. 88). Although the context could be varied, with the inclusion of angels or saints, the typology of Virgin and Child repeated that of the primitive church, following the Odigitria prototype (Muntz 1886, p. 88; Oberhuber 1999, p. 32). In this type of painting Raphael followed a successful genre, already well established by Perugino during the last years of the 15th century (K. R. Smith Abbott, *Defining a Type: Perugino's Depictions of the Virgin Mary*, edited by J. Antenucci Becherer, in *Pietro Perugino. Master of the Italian Renaissance*, exhibition catalogue, New York 1997, p. 62).

Berto di Giovanni (?)
*Sacra conversazione*
Drawing, 138 × 114 mm
Vienna, Albertina.

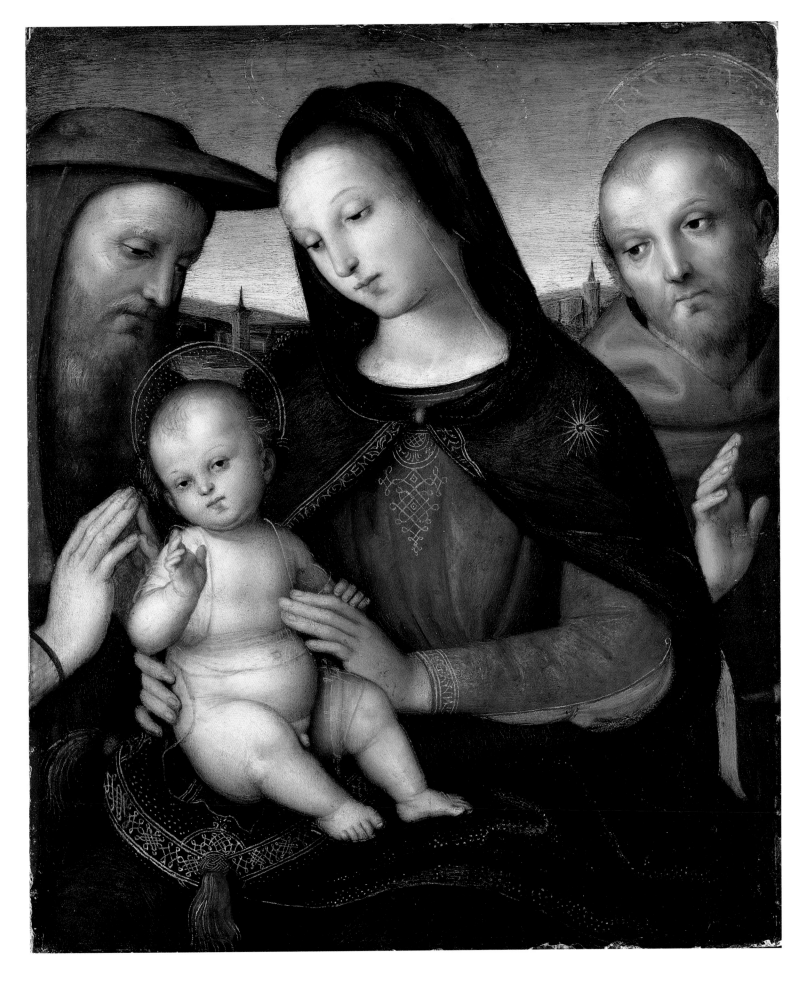

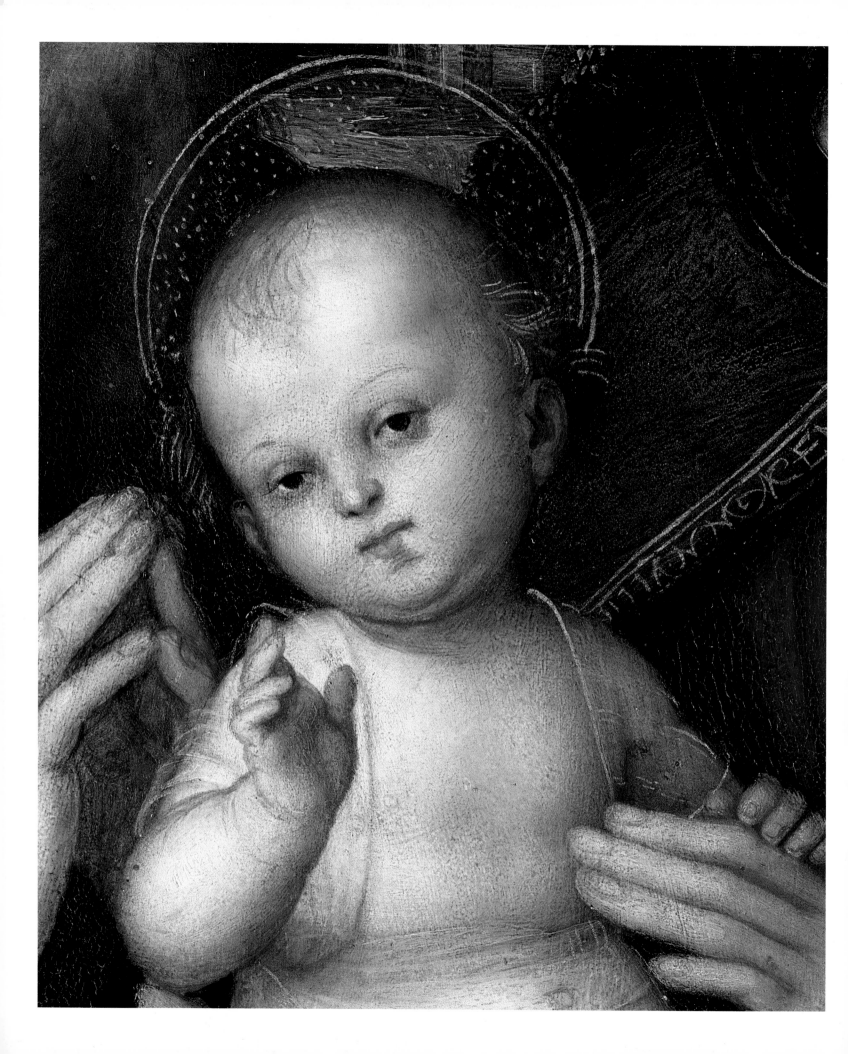

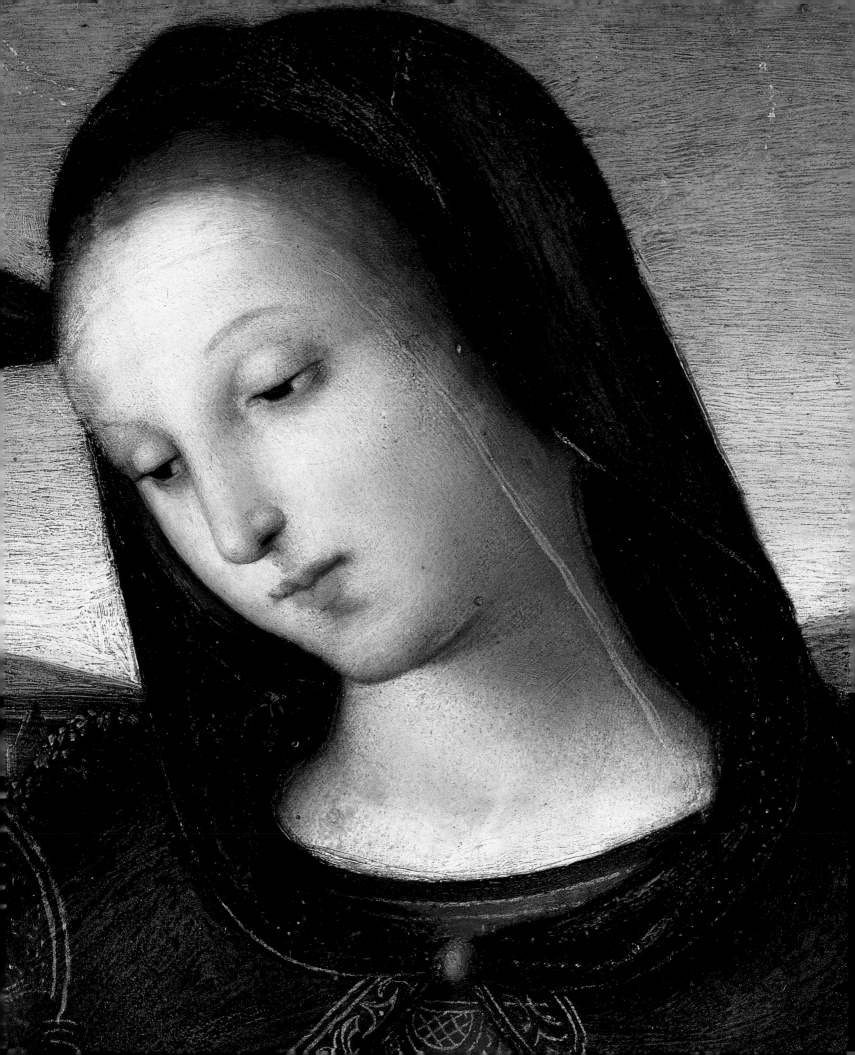

The compositional models were in widespread circulation on sheets or in collections used on the one hand as mere examples for students, on the other as a means of popularising the image (*Disegni umbri del Rinascimento da Perugino a Raffaello*, edited by S. Ferino Pagden, exhibition catalogue, Florence 1973, p. 51). In this context, when placed alongside Raphael's painting, the Albertina drawing shows the originality with which he approached a preconceived scheme even at his first attempts: his technical ability, blending the use of light and chiaroscuro with the depth of colour, suggests an internal feeling that endows the figures with life and communication that goes beyond their plastic definition.

The influence of Pinturicchio is noticeable in the gold decorations of the Virgin's clothing and the cushion on which the Child is seated (Padgen-Zancan 1989, p. 20) can also be traced to the common background of Raphael and Pinturicchio in Perugia, both drawing from the codified repertory of their older master. It is even more evident in the slight twist and inclination of the Virgin's head and the delicate type of facial features and complexion, which were extremely common formal elements in Pinturicchio's Madonnas to be seen at their best in the Fossi altarpiece, now housed at the Galleria Nazionale dell'Umbria (Miller 1991, p. 348 passim).

During the 1950's, Longhi identified another "considerably worn example" in the Grassi collection in Rome, since acquired by the Felix Warburg collection in New York (1952, p. 46; 1955, p. 22); Mayer Zur Capellen (2001, p. 117) also cites three copies in private collections one of which was sold at a Florentine auction (Casa d'Aste Pitti, 18-10-1989) while an 1865 copy by Georg Fr. Bolte is found at the Orangerie in Park-Sanssouci, Potsdam. (*M.C.*)

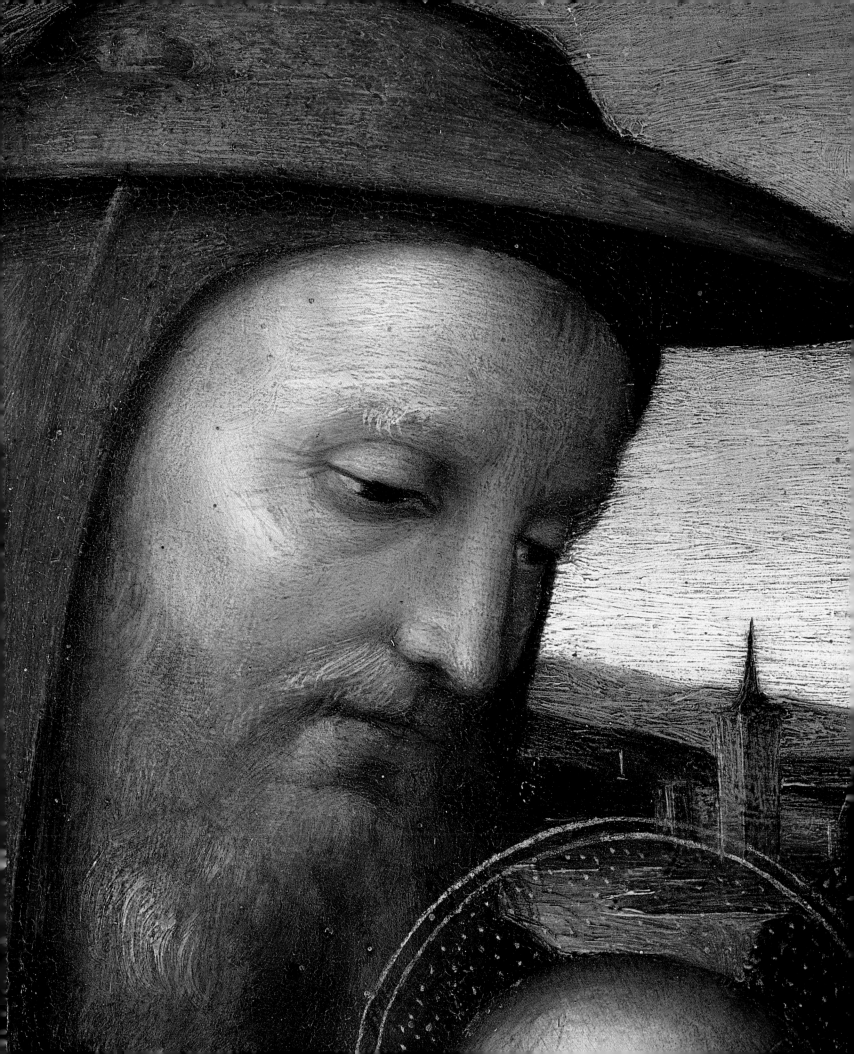

Raphael Sanzio (Urbino, 1483 – Rome, 1520)
*Christ Blessing*, 1506

Tempera and oil on wood
30×25 cm
Brescia, Pinacoteca Tosio
Martinengo

**Bibliography:**
Fischel 1948; Dussler 1971
(with previous bibliography);
De Vecchi 1981 (with previous
bibliography); Oberhuber
1999 (with previous
bibliography).

The original destination of this panel is not known but it was presumably intended for private devotion. What is known is that in 1832 it was purchased by Count Tosio of Bergamo (and from his collection later passed into the museum where it is now kept) from the Mosca family of Pesaro, but there is no basis for thinking it was painted there.

There is no documentary evidence attributing the painting to Raphael, nor is it signed or dated. Nevertheless the wide agreement that it is the work of the Urbino master, given the exceptional quality of the work is apparently well-founded.

As often happens with Raphael, the apparent obviousness and simplicity of the iconography is contradicted by the artist's very particular elaboration. In this case, Christ giving the blessing is neither portrayed as a half figure nor is He looking directly at the observer in accordance with the model consecrated, for example, in the school of Antonello da Messina. The compact, full composition, marked by a terse definition, is very interesting and would tend to date the work around Raphael's first contact with Florence, when the Perugian style of his texture gave way to a more robust naturalism. The vague Leonardesque touch, which can also be seen in the *Canigiani Holy Family* and in the *Galatea* painted in Rome for Agostino Chigi, might lead one to associate the *Christ Blessing* with the new awareness gained by Raphael during his Florentine sojourn starting with his Doni portraits.

The date of the work remains a matter of controversy, with opinions ranging between 1502 and 1505. (*P.D.V.*)

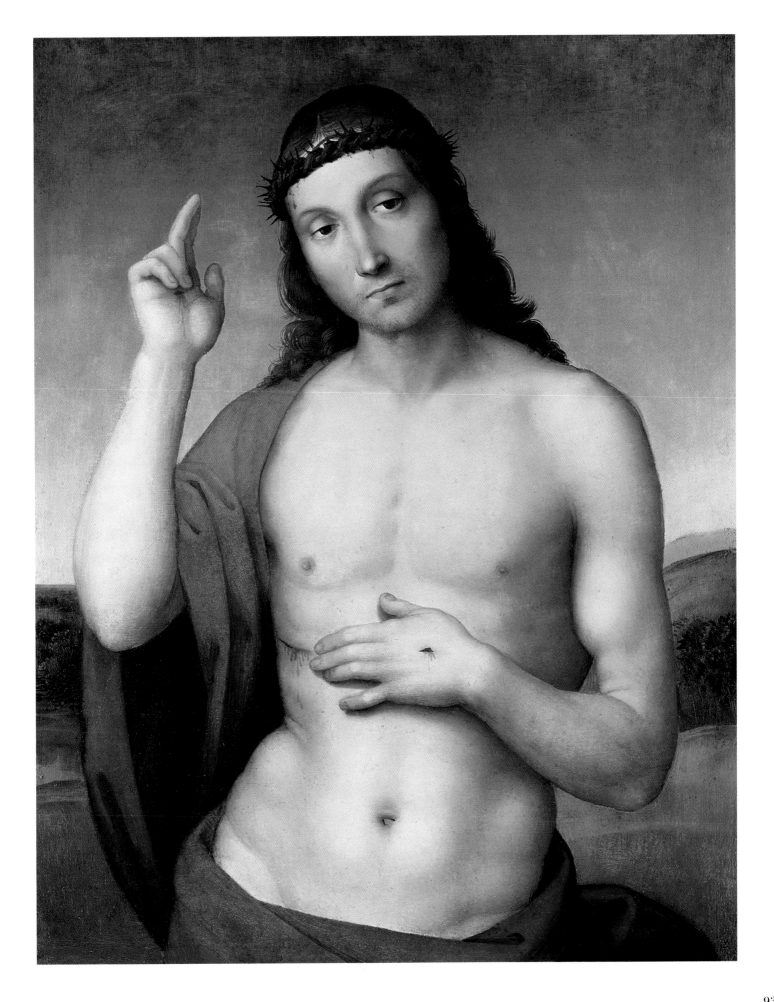

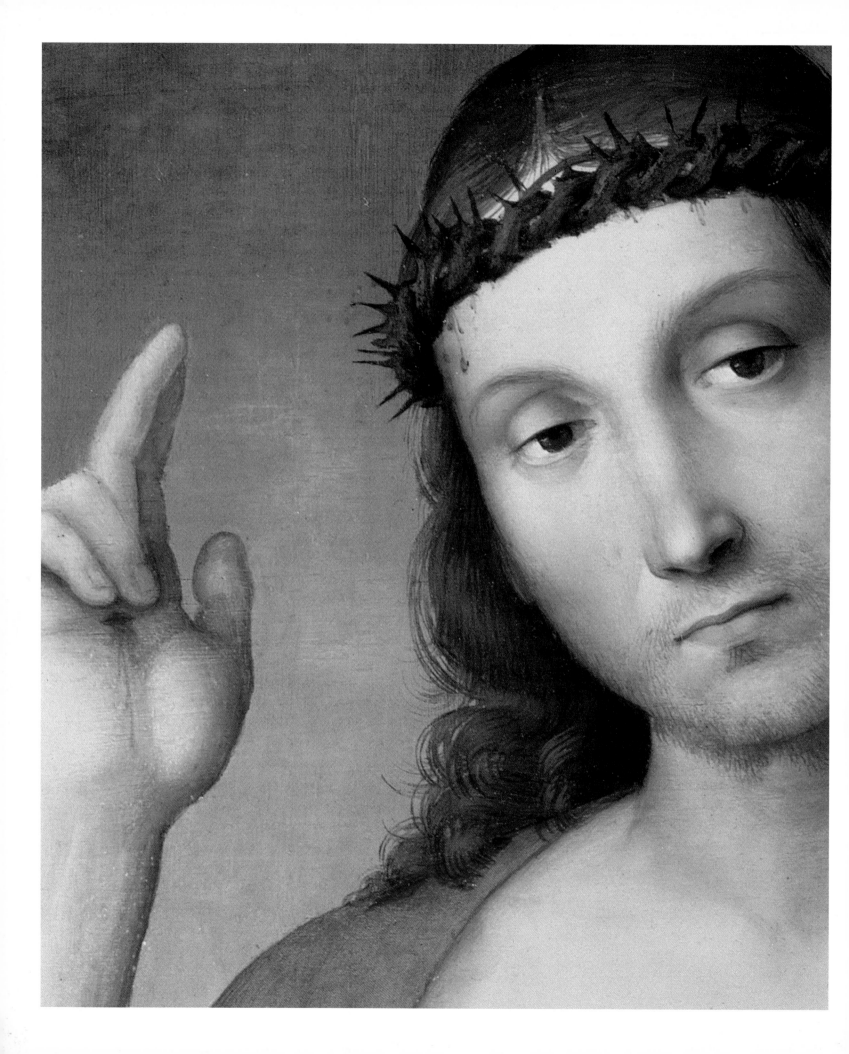

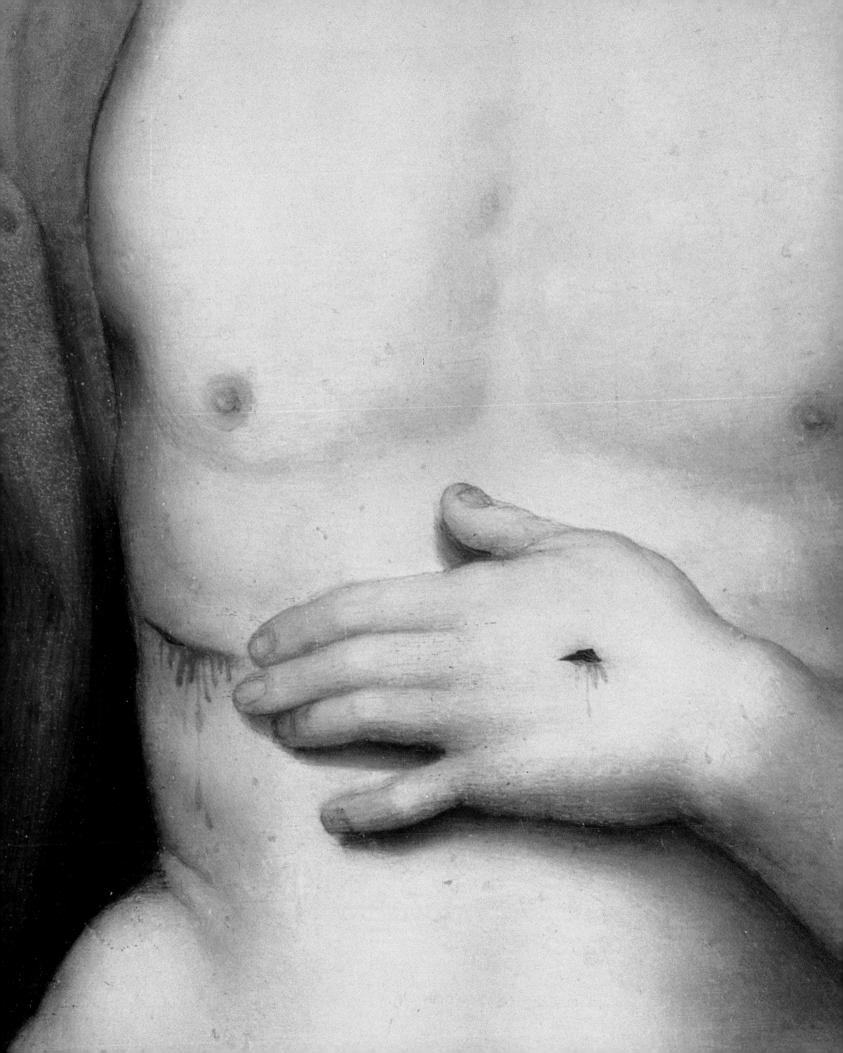

# Raphael Sanzio (Urbino, 1483 – Rome, 1520)
## *Portrait of a Youth*, 1504

Walnut panel on spruce
backing
54×39 cm
Budapest, Museum of Fine
Arts (Szépművészeti Múzeum)
(inv. 72)

**Provenance:**
Rome, Barberini, (1633 (?);
Rome, Maffeo Barberini,
1686 (?); Vienna, Esterházy
von Galántha, 1812; sale of
the Esterházy collection to
the Hungarian state (1870);
transfer of the Esterházy
collection to the new
Museum of Fine Arts (1906).

**Bibliography:**
Viardot 1844, p. 272;
Passavant 1858, III, p. 95;
Frimmel I, 1892, pp. 145, 218
ff.; Venturi 1900, p. 239;
Cust 1916, pp. 202 ff.;
Rosenberg, Gronau 1919,
n. 17; Burkhalter 1932,
pp. 48 ff.; Gamba 1932,
p. 42; Beenken 1935, p. 145;
Nicodemi 1939, tav. XL;
Suida 1941, no. 20; Ortolani
1942, p. 23; Fischel 1948, I,
pp. 56, 358; Schöne 1950,
p. 136, note 43; Camesasca
1956, I, pp. 37 ff.; Brizio
1963, col. 226; Dussler 1966,
no. 16; De Vecchi 1966, no.
29; Pigler 1967, pp. 568 ff.
(bibl.); Becherucci 1968,
p. 36; Garas 1970, pp. 57 ff.;
Fischel 1962, p. 41; Berenson
1968, p. 351; Wagner 1969,
p. 47; Garas 1970, pp. 57 ff.;
Dussler 1971, p. 8 (bibl.); De
Vecchi 1981, p. 262;
Oberhuber 1982, p. 66;
Cuzin 1983, pp. 72 ff.; Garas
1983, pp. 53 ff.; Tátrai 1991,
p. 100; Ullmann 1991, p. 93;
De Vecchi 1995, p. 246;
Oberhuber 1999, p. 83;
Wagner 1999, pp. 263 ff.,
272; Meyer zur Capellen
2001, pp. 282 ff.

The half-bust portrait of a youth arrived at the Museum of Fine Arts from the Esterházy collection in which it was for the first time definitely documented. There is some doubt, however, as to whether it is the same male portrait as that registered in the Barberini inventories of 1633 and 1686[1]. In the Esterházy collection, the painting was recorded as being a portrait of Raphael by Luini; it was attributed to Raphael himself for the first time by Viardot. This attribution was shared by Passavant and since then the majority of writers have accepted Raphael's authorship, with the exception of Berenson who believed it was not wholly autograph[2]. In general, a date from around the Umbrian or early Florentine period has been put forward[3].

The state of preservation of the painting is rather problematic. An X-ray examination has highlighted numerous gaps, especially around the areas of the garments and hair, and also some fairly extensive damage in the sky. The flesh area is quite well preserved. The exterior aspect is, however, badly affected by the dirty varnish in the upper part of the painting. A band running along the edges of the panel has not been painted.

The youth depicted here has several times been identified as a self-portrait of Raphael (most recently by Wagner in 1969) or as a number of individuals, including Pietro Perugino (Viardot), Francesco Maria della Rovere (Passavant) and, finally, Pietro Bembo (Garas)[4]. None of these interpretations is sufficiently documented. The *Portrait of a youth* is an example of a type of half-bust figure with parapet first introduced by van Eyck. The form grew in popularity in Italy especially from the second half of the 15th

century onwards, undoubtedly due in part to the fact that the parapet that mediates between the space of the painting and the real space of the viewer renders plausible the movement or pose of a figure otherwise set in such a fixed manner[5]. The immediate model may have been the portrait of Francesco delle Opere by Perugino, dated 1494[6].

Although no preparatory drawings have survived, some analogies with the *Life drawing of a boy* at the Ashmolean Museum do emerge[7], both as regards the pose and the choice of visual angle, and as regards the accentuated contour and still concise rendition of the physiognomy. In both cases, there is already an attempt to achieve a harmonious union of the individual features. However, in a direct comparison between the two works, the drawing appears more incisive, its composition clearer, more assured and lively. Although some differences can be attributed to the different pictorial genres, the Budapest portrait is to be considered as predating the drawing. It reveals a young artist not yet able to control all the elements in his composition with assurance: face, headgear and long hair of the youth form a balanced whole, but the neck, instead, is too rigid and thick and the hands laid on the parapet are not yet linked harmoniously to the body. Taking into account the compositional layout that is overall still a little shaky, and which is reflected also in the summary description of the background landscape, it is possible to postulate a date from around the end of the Umbrian period, that is, around 1503. The absence of further possibilities of comparison makes a more precise date rather hard to achieve. (*J.M.Z.C.*)

[1] Cf. Garas 1983, p. 54 ff.
[2] Cf. Pigler 1967 and Dussler 1971.
[3] Oberhuber (1999) dates the work to around 1508.
[4] The proposal of Klára Garas (1963, p. 53 ff.), who claims the sitter to be Pietro Bembo, merits especial attention. The author puts the portrait in the context of Bembo's stay in Urbino around 1505-6, during a period in which Raphael could have been occasionally in the same town. Bembo, born in 1470, would have been 35 years old, whilst a much younger man is shown in the Budapest portrait. Moreover, the resemblance with the two medals of Bembo (cf. Hill/Pollard 1967, no. 386 obv. 484b obv.) is rather superficial, as the young man in Budapest does not have the same long, forward-curving nose as Bembo.
[5] As far as the development of the parapet and the relationship between image and frame are concerned, cf. Campbell 1990, pp. 69 ff.; on parapets in van Eyck's work, cf. Pächt 1989, pp. 108 ff.
[6] Cf. Scarpellini 1984, no. 61.
[7] Cf. Parker 1956, no. 515; Knab, Mitsch and Oberhuber 1983, no. 76; Gere/Turner 1983, no. 34; Joannides 1983, no. 9.

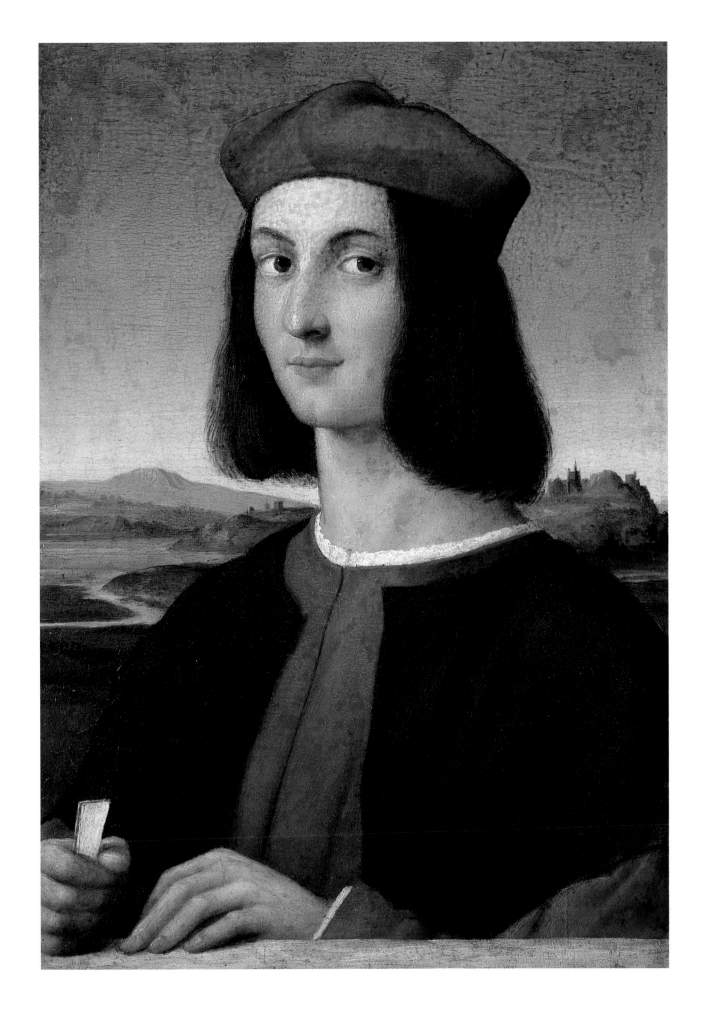

# Raphael Sanzio (Urbino, 1483 – Rome, 1520)
## *Charity, Faith,* (predella of the *Baglioni Altarpiece*), 1507-1508

Oil on poplar wood
16 × 44 cm
Rome, Pinacoteca Vaticana
(inv. 331, *Charity*; inv. 332, *Faith*)

**Provenance:**
Perugia, Church of San Francesco al Prato (to 20 February 1797); from 27 July 1798, Paris, Musée du Louvre (exhibition November 1798, no. 67; 1804, no. 1184); Paris, Musée Napoléon, no. 1141; Vatican City, Vatican Painting Museum.

**Bibliography:**
Orsini 1784, pp. 303-304; Modestini 1787, pp. 28-29; Milizia 1797-1798, p. 276; Quatremère de Quincy 1829, p. 33; Passavant, 1860, II, pp. 61-62; Müntz 1882, p. 253; Crowe, Cavalcaselle 1884, I, pp. 334-337; Berenson 1932, p. 482; Blumer 1936, p. 305; Hauptmann 1936, p. 254; Wind 1938, p. 329-330; Camesasca 1956, I, p. 50; Oettinger 1960, p. 101; Fischel 1962, p. 47; De Vecchi 1966, no. 70; Dussler 1971, pp. 24-25; Knab, Mitsch, Oberhuber 1983, no. 218; Ferino Pagden 1986, no. 5; Ferino Pagden, Zancan, 1989, pp. 61-63; Locher 1994, pp. 79-80; De Vecchi 1995, p. 218; Strinati 1995, pp. 24-25; *Vivant Denon* (1803) 1999, II, p. 1239; Meyer zur Capellen 2001, pp. 241-243.

The two paintings, together with a third not exhibited entitled *Hope,* comprised the predella of the altarpiece commissioned from Raphael in 1507 by Atalanta Baglioni in memory of her son Grifonetto, who was killed in Perugia in July 1500. The altarpiece was divided in the 17th century when the central panel was taken to Rome on 19 March 1608 as a gift from Pope Paul V Borghese to his nephew Scipione. The predella, the decorative part with the *Blessed Eternal Father among the Angels* and the frame of this work by Raphael remained *in loco* in the Church of San Francesco al Prato in Perugia until 20 February 1797 when the three Theological Virtue panels (*Faith, Hope and Charity*) were taken by French troops to Paris (Blumer 1936, p. 305, no. 310). In 1787 Father Modestini described the predella "near the sacristy door" as "three small chiaroscuro figures [...] a work of supreme beauty" (Modestini 1787, pp. 28-29). Contrary to what has been noted in many Raphael monographs, the central panel with the famous *Carrying of Christ* reached France in a very different way to the predella. On the express wish of Camillo Borghese, the painting went to his Paris residence in 1809 (Della Pergola 1959, II, p. 119). The *Carrying of Christ* returned to Italy in 1815 to the Borghese collections, while in 1817 the predella became a part of the Vatican painting museums, never to return to Perugia.

There is no dispute regarding the form and creator of the altarpiece as a whole. Although the decorative work has been attributed to Domenico Alfani, there is substantial agreement among critics that the altarpiece is by Raphael. Indeed, the high stylistic quality of the predella also leaves no doubt that Raphael was the artist, a fact that is only contested by Wind (1938, p. 330).

The sources for the *Baglioni Altarpiece* are complex and difficult. Inspired by a famous work by Perugino, Raphael initially conceived the composition as a *Deposition of Christ.* He then developed this idea in a more dramatic and narrative way, arriving at a formulation of a "history-story", that is, the representation of the *Carrying of Christ*. There are at least sixteen drawings signed by Raphael (Rovigati Spagnoletti 1984; Meyer zur Capellen 2001, with a previous bibliography) that document the development of this compositional path. It is believed that two further important influences determined Raphael's work: inspiration from antiquity (the knowledge of a bas-relief featuring *The Death of Meleager*) and familiarity with the work of a number of earlier important artists (Mantegna).

It appears that the origins of the predella are directly connected with those of the central panel – its iconography appears equally unusual with respect to the tradition of 15th century altarpieces. The preference regarding the decoration of the lower bays of an altarpiece was usually for historical-narrative episodes from the lives of the saints portrayed in the central panels or devotional themes connected with the work's purpose. As observed by Ferino Pagden 1984, pp. 25-26, it is highly probable that the decoration of the predella underwent an inverse process, contemporaneous to the transformation in a narrative sense of the principal scene in the Baglioni altarpiece, passing from an "historical" phase to a "symbolic-allegorical" one. The choice of the three theological virtues, on the other hand, was certainly associated with the reasons that led to the altarpiece's commission, and thus with the grief of Atalanta Baglioni at the tragic assassination of her son. In this context, it is easier to understand why *Charity* has a stronger role in the predella, where it was placed in a central position, between *Faith* and *Hope.* As highlighted by Locher 1994, pp. 79-80, in this way the panel might have the double meaning of a Theological Virtue and as an allegory of Maternal Love. If so, this would link back to the figure of Maria-Ecclesia portrayed in the central panel at the moment of the *Spasimo* and to the personal story of Atalanta Baglioni as *Mater dolorosa.* The use of monochrome emphasises this symbolic element: white ivory-coloured figures emerging from a sombre green background. It has been observed how the adoption of this pictorial technique could derive from contemporary fresco work, for example, the panels painted by

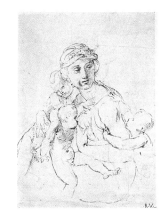

Raphael, *La carità*, pen on silver point drawing, 339 × 242 mm
Vienna, Albertina.

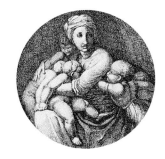

P. Bergeret, *La carità*, 1803, etching, Paris, Bibliothèque nationale de France, Cabinet des Estampes.

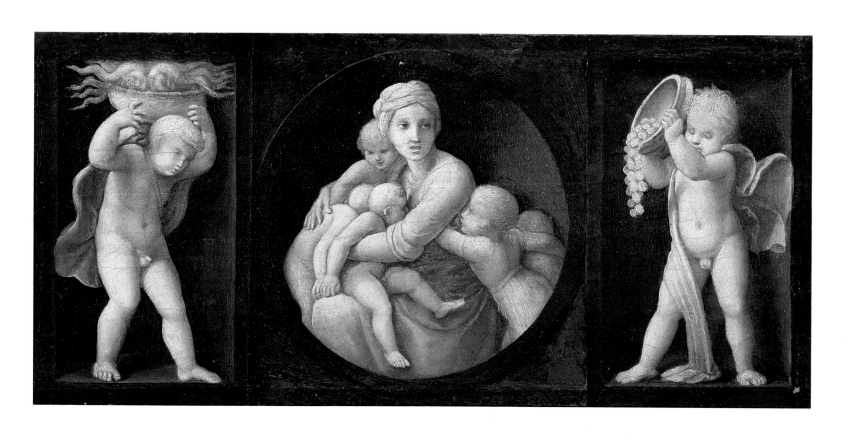

Luca Signorelli in the San Brizio Chapel in Orvieto, but there is no doubt about the innovative significance of this choice for an altarpiece.

As in the *Carrying of Christ*, strong Michelangelesque influences can be seen in the predella, especially in the *Charity* figure inspired by the *Tondo Doni* and, above all, the *Tondo Pitti* in the Bargello. A preliminary drawing preserved in Vienna makes the correlation with Michelangelesque prototypes even more evident (Fig. 1). In addition, Strinati 1995 reveals a deliberation on the figure of the *Delphic Sybil* painted by Michelangelo in the Sistine Chapel, proposing in this way a chronological advancement of the Baglioni predella to the years 1508-1509.

In all probability, the three *Virtue* panels were originally separated and framed in a manner consonant with the decorated frame, which is still preserved, albeit fragmented, in the National Gallery of Umbria. The size of the panels confirms this; together they are 132 cm long, against the 176 cm of the central panel with the *Carrying of Christ* (Rovigati Spagnoletti 1984, p. 49). Long ignored by ancient literature, which nonetheless continued to regularly cite the Altarpiece as among the most beautiful works by Raphael, the predella received renewed attention following its removal to Paris in 1798. In a note dated 1803, Vivant Denon believed the predella was representative of the *"noblesse de composition"* achieved by Raphael *"avant d'avoir consulté l'antique"* (Vivant Denon 1999, II, p. 1239). The three panels were transformed into prints by many French engravers of the time (Meyer zur Capellen 2001, p. 243): among others, Boucher-Desnoyers, Chataigner and Bergeret (Fig. 2). The figures became a model for Raphaelite grace and beauty, to the point of becoming a part of the French figurative lexicon of the 19th century. In 1842 Ingres, among the greatest admirers of Raphael, was inspired by the Baglioni predella for the creation of three preparatory drawings for the stained glass windows of the Church of Saint-Fernand in Paris (Ingres 1967-1968, p. 280, nos. 207-209). Art historiography of the time also appears to have rediscovered the value of the predella: for Quatremère de Quincy "the features of the virtues are heavenly" (1829), while for Crowe and Cavalcaselle (1884) they are defined as being of "incomparable tenderness and serenity" and seem to express "the sweetest grace".

A 16th century copy of the predella held in a private collection in Erlangen was noted by Oettinger (1960). Reference must also be made to the copy by Francesco Appiani (1704-1791) before the piece was removed to Paris (Perugia, National Gallery of Umbria, cf. Locher 1994, p. 25). (*I.B.*)

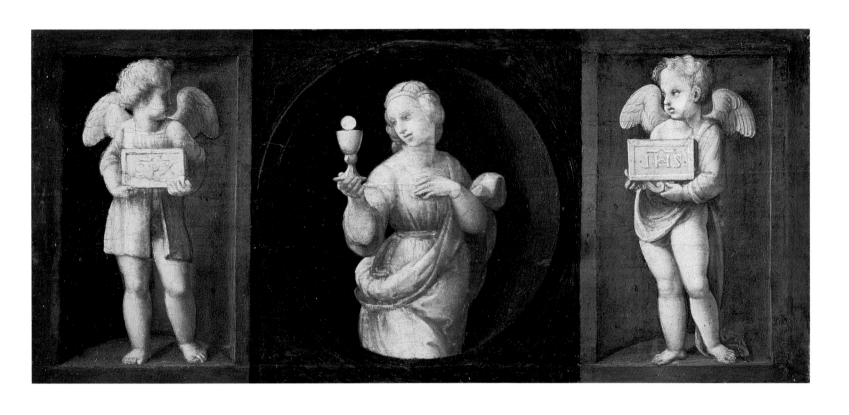

# 6    Raphael Sanzio (Urbino, 1483 – Rome, 1520)
## *Portrait of the Woman*, called *"La Velata"*, 1516

Oil on canvas,
85×64 cm
Florence, Galleria Palatina
(inv. 1912, no. 245)

Bibliography:
*Raffaello a Firenze*, 1984,
pp. 174-182, no. 15.

The painting is now unanimously recognised as being the one described by Vasari in the house of the Florentine merchant, Matteo Botti. It is not known with certainty how the work, probably painted in Rome around 1513 or shortly thereafter, came into this family's possession. Originally from Cremona, the Botti family settled in Florence towards the end of the fifteenth century, becoming Florentine citizens only in 1527. They were well integrated into artistic circles; Vasari, friend of the youngest brother, Simone, praised his qualities as patron and connoisseur. It was the presence of the latter in Rome in the role of the Grand Chancellor to Bishop Paolo Giovio, documented from 1545 to 1547, that fuelled the hypothesis of a direct purchase of the work (*Raffaello a Firenze*, 1984) in the city of the Pope.

Following the Vasari citation, the portrait was recorded as still being in the Botti house by Borghini in 1584 and by Bocchi in 1591. The later sources do not allow us to trace clearly the route the painting took to reach the De' Medici collection until 1891, when Ridolfo made public the testament, dated 1619, by which the last heir of the Botti family, named Matteo after his predecessor, finding himself in serious financial difficulty, was forced to leave all his belongings to Grand Duke Cosimo II in exchange for the payment of his debts and a life annuity.

The transfer of the work to Palazzo Pitti occurred prior to the official assessments of the marquise Botti's inheritance in 1621. The painting is included in the inventory of the Grand Duke's wardrobe on 29 November 1622 with an almost dubious attribution to Raphael ("said to be by the hand of Raphael of Urbino"), giving evidence of the gradual loss of Vasari's records.

Following the year 1622, Raphael's name no longer appears in the inventories, but the movement of the portrait among the rooms of Palazzo Pitti can be easily tracked. The value of the work never went unrecognised; even during the renovation of the Grand Duke's painting gallery during the times of Pietro Leopoldo, a very special position was reserved for the painting in the *Sala di Giove*, alongside the *Madonna of the Chair*, the *Madonna dell'Impannata*, and the portraits of Inghirami and Bibbiena.

The erroneous attribution to Suttermans made at that time, combined with the painting's precarious state of conservation, spared the work from the Napoleonic campaigns of suppression, and it remained at various locations within Palazzo Pitti.

It was certainly the exceedingly high quality of the painting, and perhaps to an even greater degree the subject portrayed, that determined the painting's fate over the centuries. It is not an 'official' portrait, traceable to a commission, but rather an image, more or less idealised, of a young woman, whose mysterious identity has sparked a broad range of hypotheses. According to Vasari, she was Raphael's lover, and he kept her with him in his house until he died. Vasari's records were enriched over the centuries by further details and names, although they have never been supported by any written documents.

The attention of art scholars has been mainly focussed on the resemblance, decisive also for the attribution of the work to the Urbino master, between the face of the *Velata* and those of the *Sistine Madonna*, of the *Sibilla Frigia* in the church of Santa Maria della Pace, and of other figures from Raphael's Roman period. They also compare it with the other celebrated portrait in Palazzo Barberini in Rome known

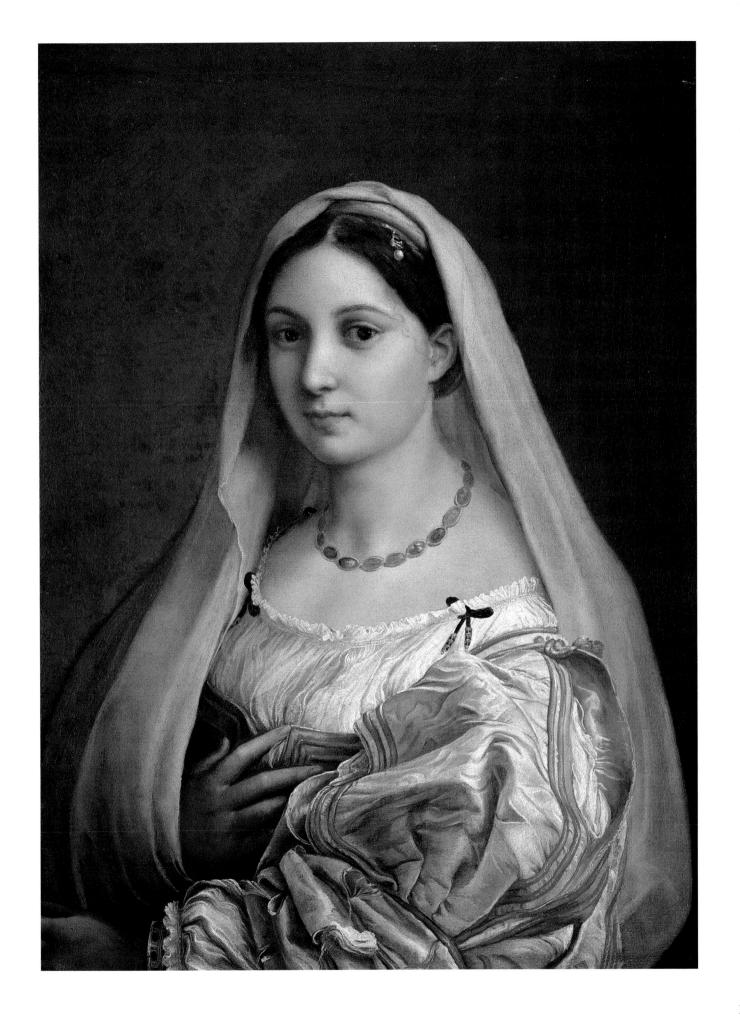

as the *Fornarina*, the comely girl of humble origins for whom Raphael is said to have declined to marry Maria, of noble family and the niece of Cardinal Bibbiena, who is now buried alongside the artist in the Pantheon. According to some (Oberhuber, 1982) they are two different women and the *Velata*, dressed so sumptuously with her head covered by a veil, the prerogative of married women with children, could be an anonymous Roman noblewoman in whose honour the painter also composed verses and whose face, borrowed by various of Raphael's figures, disappears from the works of the master around 1514 at the same time as the appearance of the legendary *Fornarina* in the Barberini painting. Other scholars, identifying a number of similarities in the facial features, in the posture and in the conception, argue that it was the same woman who sat for the two portraits, even advancing the hypothesis that the Florentine version, more than being a portrait, may have been a study for the creation of the image of a saint, perhaps Saint Catherine.

Although she remains without a name, the portrait testifies to the achievement of very important milestones for Raphael. In it he echoes the composition of Leonardo's Mona Lisa, which was the source of inspiration for his portrait of *Maddalena Doni*, the *Gravida*, and the *Muta*, which all preceded the *Velata*, but he overcomes the pyramidal scheme by widening the image and setting it in space with greater ease and freedom. From the lucidity of the forms, thanks to his perfection of drawing in a younger phase, the painter moves on here to plumb the relationship between light and colour with results of unmistakable excellence. The manic sumptuousness of the woman's clothing is the main pretext for this chromatic exercise, which will find expression later in the portrait of Pope Leo X in the Uffizi. In this work there is a similarly preponderant attention to the rendering of the fabrics and to every other detail, such as the engraved silver bell and the illuminated manuscript. Even the expression on the *Velata's* face affirms the artist's choice of an extremely naturalistic execution and not the search for a detached solemnity pursued through simplicity and purity of form, as was typical of fifteenth century portrait painting of mainly Florentine origin. Examples such as this also provide the measure of the variety of suggestions present in Raphael's work and show how the careful study of his painting may have subsequently produced very different interpretations. (*A.P.*)

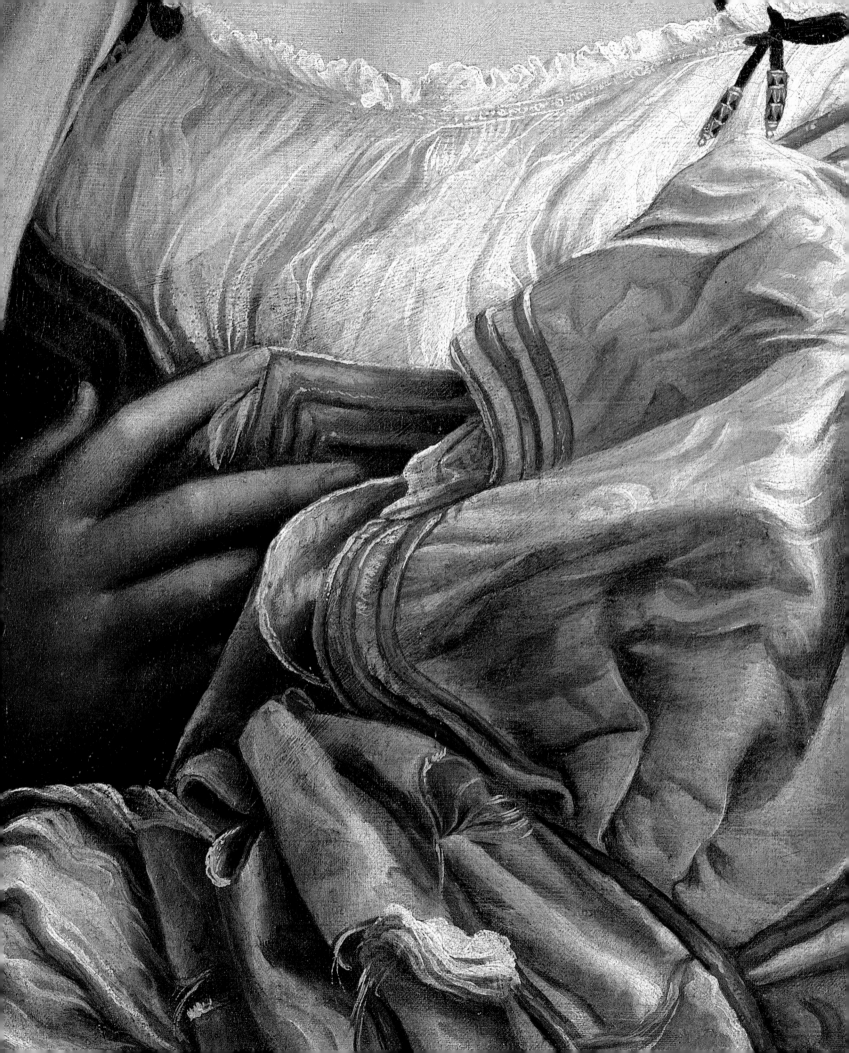

# Raphael Sanzio (Urbino, 1483 – Rome, 1520)
## *Portrait of Baldassare Castiglione, c. 1514-1515*

Oil on canvas
82×67 cm
Paris, Musée du Louvre
(inv. 611)
© Photo RMN - J.G. Berizzi

**Bibliography:**
Beffa Negrini 1606, p. 432;
Von Sandrart 1675, I, p. 55;
Monicart (de) 1720, II, p. 356;
Quatremère de Quincy 1824,
pp. 196-197; Passavant 1860,
II, pp. 154-156; Crowe,
Cavalcaselle 1885, II, pp. 261,
326-327; Golzio, 1936 (ed.
1971), pp. 33-34; Fischel
1948, pp. 115, 325, 365;
Freedberg 1961, pp. 333,
336; Imdhal 1962, pp. 38-45;
Pope-Hennessy 1966, pp. 114,
316; Becherucci 1968, p. 187;
Dussler 1971, pp. 34-35;
Emile-Male 1979, pp. 271-
272; Shearman, 1979, pp.
260-270; De Vecchi 1981, p.
62; Eiche 1981, pp. 154-155;
Gould 1982, p. 480; Laclotte,
Cuzin 1982, pp. 153-160;
Oberhuber 1982, pp. 162,
192; Cuzin 1983, pp. 187-190;
Jones, Penny 1983, pp. 159-
162; Béguin 1983, pp. 84-87;
Ferino Pagden, Zancan 1989,
p. 117; Shearman 1992, pp.
135-137; De Vecchi 1996, pp.
34-35, 38.

Painted for Castiglione, who may have taken it with him to Spain when he was nuncio at the court of Madrid, the portrait was kept in the family palace in Mantua after his death (1529), but in August 1588 it was offered by Camillo, son of Baldassare, to Francesco Maria della Rovere, duke of Urbino. However, it is not known for certain whether the painting actually arrived in Urbino, as the inventory of the ducal palace and the wardrobe of Pesaro (1623-24) only registers an anonymous portrait of Castiglione and no traces of it are found in the inventories of the Medici; following the death of Francesco Maria in 1631, a large part of his collections became the property of the grand duke of Tuscany. The portrait was bought by Lucas Van Uffelen, a friend of Sandrart, who was in Venice from 1616, and later taken to Amsterdam where the Van Uffelen collection was sold to the dealer Alfonso Lopez (1639), and where Rembrandt studied the painting, making a rapid sketch of it (Vienna, Albertina). Lopez' collection was sold in Paris around 1641 and the portrait later became the property of Cardinal Mazzarino (it was not yet registered in the inventory of 1653, while it is described in that of 1661), whose heirs finally sold it to Louis XIV.

The restoration works done in 1975 and 1979 have made it possible to verify that the portrait, painted on canvas mounted on wood, has not been cut in accordance with the original dimensions (especially below), something which had been asserted on various occasions on the basis of comparisons with copies and engravings.

Count Baldassare Castiglione (1478-1529) was a Humanist, poet and man of letters, in particular author of the *The Courtier*, and ambassador in Rome, initially for the court of Urbino and then for that of Mantua; he was subsequently appointed nuncio in Spain by Clement VII. He had been a friend of Raphael since 1504, as witnessed in a letter to his mother dated 7 July of that year, becoming his authoritative counsellor and, in certain aspects, collaborator. Among many things in his papers, the first draft of the famous Letter to Leo I has been rediscovered, in which the artist, appointed by Leo X "*praefectus marmorum et lapidum*" and entrusted with "rendering ancient Rome in drawing", describes his project of surveying the buildings "by regions" on the basis of visible traces and the testimonials of antique texts, presenting a new system of surveying and graphic representation by means of plan, elevation and section. The text – which was almost certainly drawn up by Castiglione, but on the basis of indications given by Raphael – which reveals an intense exchange of ideas as well as the profound affinity of the cultural ideas of the two personalities, above all expresses regret for the acts of destruction perpetrated over the centuries and the loss of the appearance and the very memory of ancient Rome, along with a passionate exhortation, addressed to the pope, to "leave the comparison of the ancients" alive, in order that one may equal and surpass them.

The portrait, painted between 1514 and 1515 during the long period the count remained in Rome as ambassador of the court of Urbino, conveys, at least to the same extent, the profound spiritual concord between artist and subject.

Castiglione is portrayed seated on a chair of the so-called "Savonarola" type, of which we glimpse part of the backrest and one armrest. Under a large cap with frayed edges, decorated by a medal, a pad conceals the receding hairline. He is dressed in winter garments: a black suit edged with thick fur, which opens to reveal a pleated white shirt. The aristocratic sensibility and the

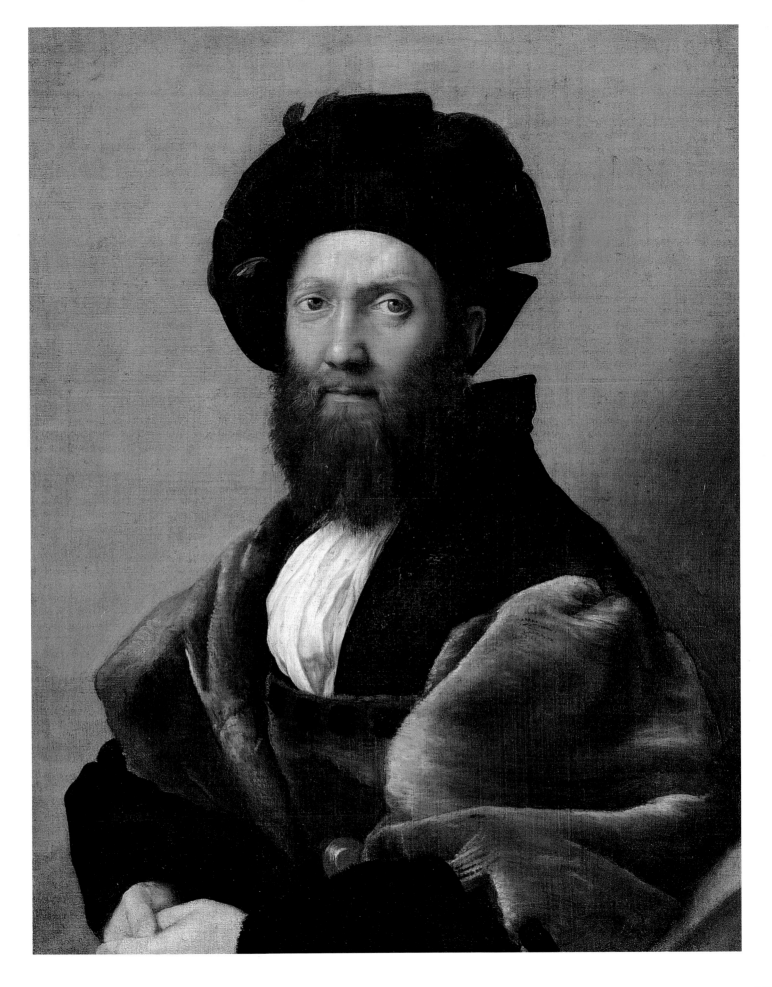

"grace", in the Humanistic sense of the term, of the personality are matched both by the discreet and unostentatious, but very refined, elegance of the clothes and, above all, by the precious chromatic range based on cold dominant hues, delicate shades and nuances of black, from sand grey to greyish browns. The chromatic score is underlined by the soft light. The paint is applied with soft, varied but blended strokes, on a thin priming which makes it possible to achieve effects of subtle vibrations due to the particularly fine web of the canvas.

The traditional scheme of the semi-profile portrait, with the bust placed somewhat diagonally and the face almost frontally, the glance oriented towards the spectator, an arm placed along the lower edge and the hands united in a lower corner, is profoundly innovated due to the very close cut, with the hands only partially visible: this solution is so unusual as to make one suspect the painting had been cut. In fact, the particular framing of the image, along with the height of the viewpoint, fixed on the level of the eyes of the model, suggests both physical and psychological vicinity. The onlooker comes to imagine himself seated next to Castiglione, as if the meeting of glances were to mark a pause in the course of an intimate conversation. And one is reminded of the letter the artist sent his friend and scholar, asking for advice: a letter that attests a long association and sharing of interests, and at the same time reveals, in the last part, a slightly ironic and "courtly" tone which makes it possible to face subjects which undoubtedly had to be very important to both parties with "studied casualness": "Mr. Count, I have prepared drawings in many ways on the basis of Your Lordship's invention and satisfied everyone, unless everyone is flattering, but I am not content with my own judgement, because I fear I will not satisfy yours. I am sending them. Your Lordship may choose some, if some will be found worthy of esteem. Our Lord, honouring me, has placed a great burden on my shoulders. This is the preparation of the building of St. Peter's. I hope I will not collapse under it, and especially because the model I have made is appreciated by His Holiness and praised by many excellent engineers. But I ascend higher with my thought. I would like to find the pretty forms of antique buildings; and neither do I know whether this flight will be like that of Icarus. Vitruvius casts great light for me, but not sufficient. I would have a great master in Galatea, if there were half of the many things Your Lordship writes me; but in his words I recognise the love he feels for me, and I tell you that, to paint a pretty one, I would have to see even prettier ones, on this condition: that Your Lordship was there with me to choose the best. But as there is a shortage of good judgements and of pretty women, I avail myself of a certain idea which comes to my mind. Whether this has some excellency of art in it, I don't know; it takes me great effort to have it...". (P.D.V.)

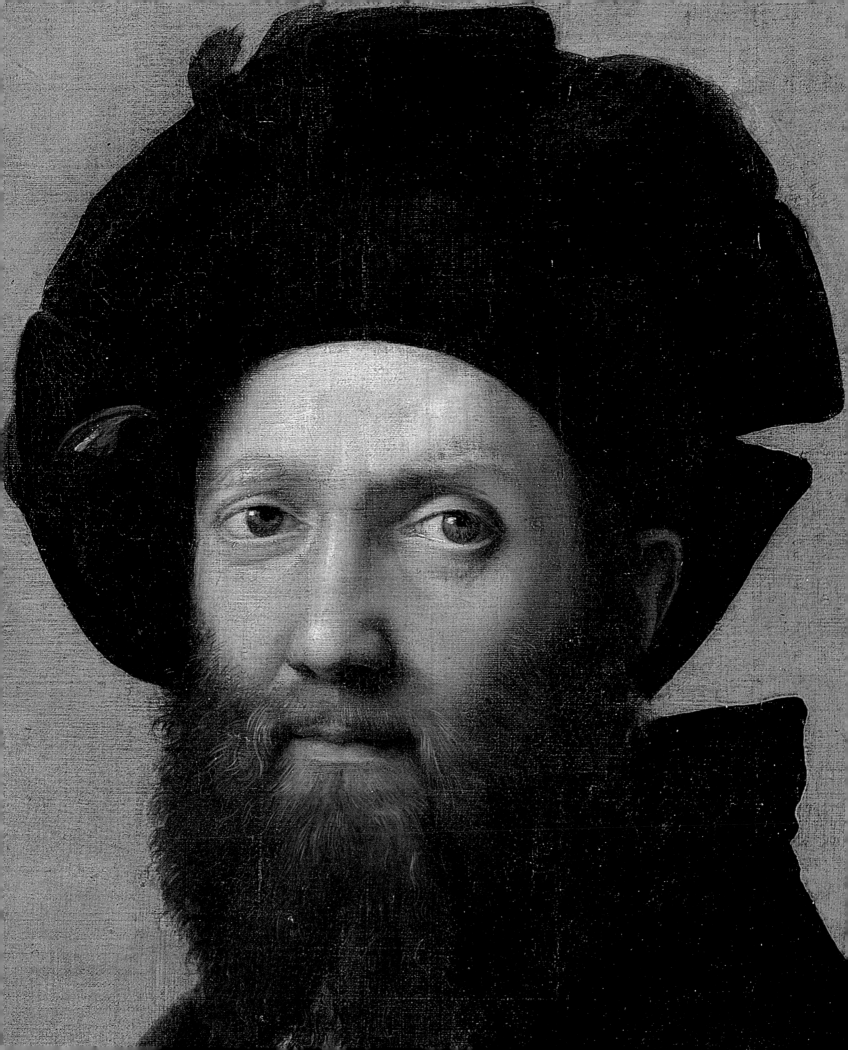

Raphael Sanzio (Urbino, 1483 – Rome, 1520)
*Raphael and friend*, 1518

Olio on canvas
99 × 83 cm
Parigi, Musée du Louvre
(inv. 614)
© Photo RMN - J.G. Berizzi

**Bibliografia:**
Passavant 1882-1891;
Pallucchini 1944; Fischel
1948; Ortolani 1948;
Camesasca 1956; Cunnigham,
in *Wadsworth Atheneum
Bulletin*, 1960, no. 5, pp. 15-
17; Brizio 1963, col. 222-249;
Zampa 1968; Becherucci
1968, pp. 7-198; Matteoli, in
*Commentari*, XX, 1969, fasc.
IV, pp. 281-316; Dussler 1971;
Lichtenstein, in *The Art
Bulletin*, LX, 1978, no. 1, pp.
126-138; De Vecchi 1979;
Lucco 1980; De Vecchi 1981;
Beck 1982; Oberhuber 1982;
Béguin 1983; Cuzin 1983;
Jones, Penny 1983; Pope-
Hennessy 1983; Conti 1988;
Freedberg 1988; Ferino
Pagden, Zancan 1989;
Laclotte, Cuzin 1993;
Strinati, in *Art e Dossier*, no.
97, 1995; De Vecchi 1996, pp.
9-50.

An atmosphere of impenetrable mystery shrouds this surprising masterpiece from Raphael's later years. The circumstances surrounding the commissioning of the painting, its destination and the identity of at least one of the persons portrayed remain matters of conjecture to this day.

The exact provenance of the painting is unknown and there are great uncertainties as to whether it once belonged to the king of France, François I. At the beginning of the seventeenth century mention was made of a double portrait in the Cabinet des Peintures di Fontainebleau (Béguin 1983, pp. 101-104, the reference for all historical information and criticism). Le Brun included it in his 1683 inventory of the collection of Louis XIV and attributed it to Raphael. It was recorded in Versailles in 1695 and entered the Louvre collections in 1792.

After years of hotly contested debate as to its authorship – partly because one of the subjects portrayed was thought to be the artist himself and there were a lot of different opinions as to whose likeness it was, with proposals including Sebastiano del Piombo, Pordenone, Polidoro da Caravaggio, and Luca and Giovan Francesco Penni – art historians today unanimously attribute it to Raphael. Although it is considered to be one of the most extraordinary masterpieces of the late phase of the master's life, the proposed chronology oscillates between 1514 and 1520, with a preference for 1518-1519. During his last, very intense years marked by great emotional suffering, Raphael returned his attention to painting portraits of more than one figure, experimenting with new forms of the complex psychological and narrative game that manifests itself within the image, between the persons portrayed and between the portrayed and the observer. In the celebrated *Portrait of Baldassar Castiglione* (Paris, Musée du Louvre), Raphael succeeded in creating an extraordinary effect of physical and psychological proximity between the portrayed figure and the observer. Thanks to the extremely audacious cut of the image and the raised perspective, the observer is placed at the same level as the portrayed figure, with whom he enters into a more intimate communication.

Once again, in the *Portrait of Andrea Navagero and Agostino Beazzano* (Rome, Doria Pamphili Gallery), the two poets are seated side by side and appear to gaze beyond the canvas at a shared friend, probably Pietro Bembo (Oberhuber, 1982, p. 165), for whom the painting was done, in a very close relationship with the observer.

In the painting in the Louvre, probably the last portrait produced by Raphael, it is the artist himself who steps into the ring. In an audacious invention, he portrays himself in the background, immobile, staring coldly and detachedly at the observer while confidentially resting his hand on the left shoulder of his companion. The companion, turning his head vigorously towards Raphael, is portrayed stretching out his right arm and pointing out of the painting, as if to indicate someone or something outside. Raphael's daring in creating the image is immediately striking and pulls us in, through the decisive gesture of the friend, to the significant centre of the work: Raphael's magnetic and penetrating gaze.

In the past, the sword held by the master's young companion and, perhaps even to a greater degree, "the suggestion of the gesture that seems to 'pierce' the plane of the image" (De Vecchi, 1996, p. 45), had led many scholars to interpret the work simplistically as *Raphael and his fencing master*, which is how the work made its historical debut.

Critics are agreed on the identification of the person in the background as Raphael on the basis of the figure's resemblance to other presumed portraits of the artist, such as the *Self Portrait* in the Uffizi, a medallion at the Villa Lante in Rome, and the engravings of Giulio Bonasone (Bartsh, XV, 347, cited by Pope-Hennessy, 1983, p. 30) and of Marcantonio Raimondi (Bartsch, XIV, 496, ibid.), as well as to other later drawings and engravings (Garas in Béguin, *op. cit.*, p. 102). Compared to these examples, the face of the artist in the double portrait in the Louvre appears leaden, aged and strained. With a gaze full of melancholy, the master seems to presage his approaching end, thus providing the motivation for the attribution of a later date to the work (1518-1519).

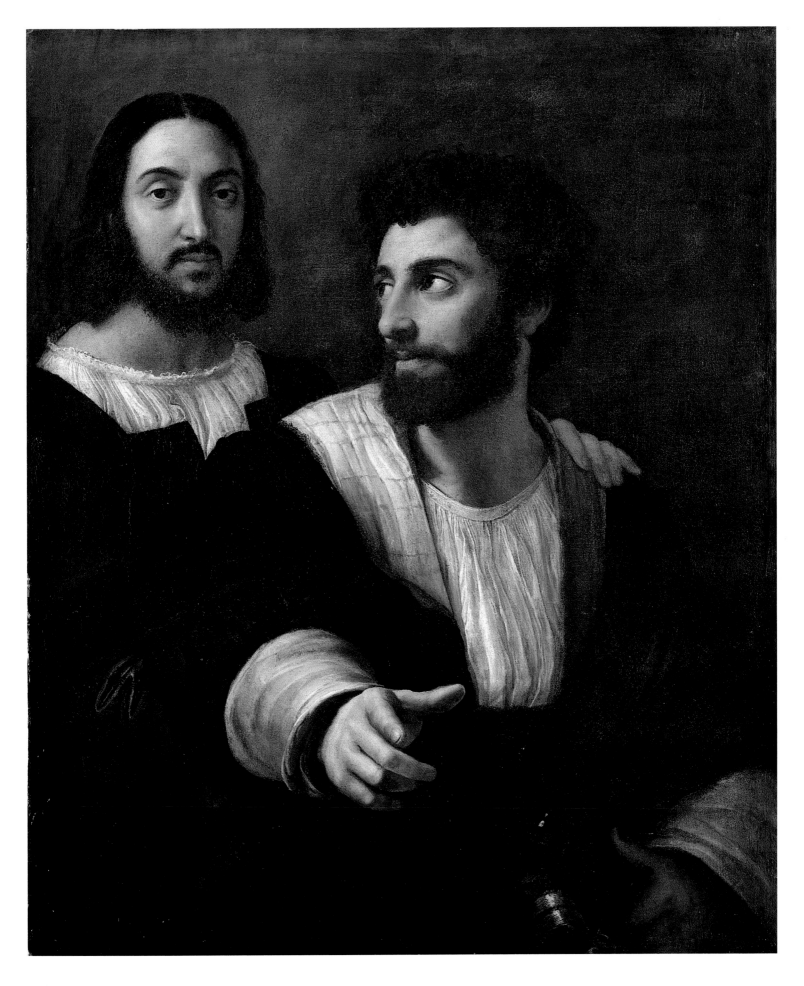

111

None of the hypotheses advanced to identify the young friend have been completely convincing, and over time the names Pinturicchio, Pontormo, Peruzzi, Castiglione, Giulio Romano, Polidoro da Caravaggio, and Giovan Francesco Penni (ibid.) have been proposed. Gould (ibid.) chose to interpret the silent and confidential dialogue between the subjects as being between Raphael and the young Pietro Aretino, with the latter pointing out their common friend and patron, Agostino Chigi, who died before his time in 1524.

According to Strinati, the work is elevated to a "mysterious symbol of friendship" (1995, p. 40), but it is a privileged bond, free from the problematic context of the Roman Curia. Like Shearman (ibid.), Strinati identifies the friend as Giovanni Battista Branconio, the Humanist from Aquila who was Raphael's faithful companion in the last years of the artist's life. Raphael designed a palazzo for him and painted the altarpiece with the *Visitation* for the family chapel in San Silvestro all'Aquila.

Beyond the obvious difficulties in identifying the second character, the painting in the Louvre appears laden with deep symbolism. Iconographically, Raphael intended to allude in his portrait to the conception of the wizard artist and imitator of Christ typical of Dürer, a painter whom he deeply admired. It bears mentioning that in addition to possessing one of Dürer's self portraits (now lost), in 1515 Raphael sent him a drawing for the *Battle of Ostia* (Strinati, *op. cit.*, p. 41). Dürer had already portrayed himself as the *Salvator mundi* in the famous *Self-portrait with fur* in the Alte Pinacothek in Munich (Zampa, 1968, no. 59). Raphael seems to have wanted to re-evoke the atmosphere of thoughtful transcendence clearly evident in the hieratic pose, the rendering of the face, the severe vestments and the symmetry of the lines and colours. With this *Imitatio Christi*, he, like the German artist, places himself outside of his own time and of all time and rises to the value of a symbol.

The affectionate gesture and the tone of deep understanding between the two subjects have induced many to think of a possible religious interpretation of the work, with Christ engaged in conversation with one of his beloved disciples.

From a linguistic point of view, the painting clearly betrays a new meditation on Leonardo and Michelangelo by the master from Urbino, even in this late phase of his career. A strong Veneto influence is also noted, with special reference to Sebastiano del Piombo (Cuzin, 1993, p. 229), to whom the work was once attributed. In reality, Raphael translates the sculpturally simplified volumes and the stark light of the Veneto artist into a softer and more modulated language.

Stylistically, the *Double Portrait* in the Louvre is very close to the cartoons for the tapestries showing the *Acts of the Apostles*, which the Urbino artist worked on in 1516, using concentrated and severe language translated into an austere and exalted classicism (Freedberg, 1988, p. 66). The nature of the companion figure in the foreground also hints at a nearness to the *Transfiguration*, a work in which an element of post-classical tension has already worked its way into the universalistic structure of Raphael's poetics.

Attention should be directed to the perfect synthesis that Raphael obtained between immobility (in the his own passive gaze) and animation (in the active gesture of his friend's hand). The artist draws on a supreme unity, the image of Renaissance man and his new public involvement (Oberhuber, *op. cit.*, p. 160).

According to Cuzin (1983, p. 229) we find ourselves confronted by an allegory of painting, with the young friend who indicates both the mirror in which the two figures are reflected and us, the observers, caught up in this illusory play of images. De Vecchi too (*op. cit.*, p. 47) believes that it is a sort of play of mirrors: the two protagonists find themselves before the canvas, and the friend, turning towards the master, compares the image "of" and "by" the artist with the real features of its author.

Rarely has an artist so strongly focussed on the search for forms so vital and concrete as to suggest, as has been noted, a "snapshot" effect. The concatenation of looks and gestures of the two characters and their complicity succeed in drawing in the observer both emotionally and psychologically, making him a protagonist in the dialogue recited in the scene. And, as though on a stage, the grandiose figures stand out architecturally against the uniform background of the painting. The essential chromatic scheme of the work is based on a highly refined palette of colours ranging from black to sand to pearl, in analogous fashion to the *Portrait of Castiglione*. And, like in the latter painting, the master exploits all the irregularities of the weave of the canvas to achieve extremely subtle modulations of colour and light. (*T.C.*)

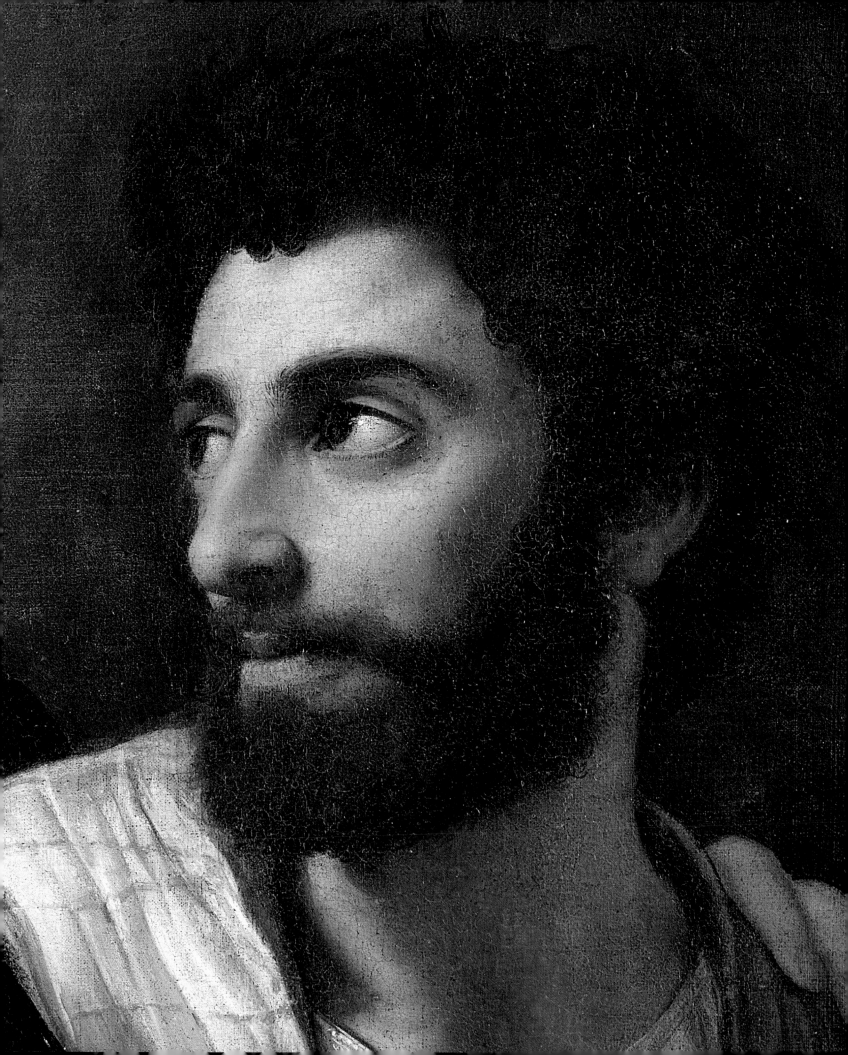

**9** Raphael Sanzio (Urbino, 1483 – Rome, 1520)
*Portrait of a Lady with a Unicorn*, 1505-1506

Oil on canvas transferred
onto panel
67.7 × 53.2 cm
Rome, Galleria Borghese
(inv. 371)

**Bibliografia:**
Rossini 1760, p. 248; Mercurj
1855, p. 10; Crowe,
Cavalcaselle 1884-1891,
pp. 261-262; Piancastelli
1891, p. 291, no. 169;
Cantalamessa 1893, pp. 187-
191; Venturi 1893, PP. 180-
181; Morelli 1897 (1991), pp.
125-128; Giusti 1911, p. 78;
Cantalamessa 1916, pp. 187-
191; Cairo 1922, pp. 165-167;
Longhi 1927, pp. 168-173;
Longhi 1928, pp. 144-159;
Gamba 1932, pp. 46-47;
De Rinaldis 1936, pp. 122-
129; Ortolani 1948, p. 28;
Della Pergola 1950; Longhi
1955, pp. 8-23; Camesasca
1956, pp. 15-16; Volpe 1956,
pp. 3-18; Carli 1959, pp. 36-
41; Della Pergola 1959, pp.
114-116; Pedretti 1959, pp.
155-224; Valsecchi 1960, p.
36; Berti 1961, p. 37; Lucie
Smith 1961, pl. 4;
Castelfranco 1962, p. 16;
Della Pergola 1962, pp. 321-
322; Volpe 1962, pp. 79-85;
Fusero 1963, p. 22; Tea 1963,
p. 22; De Vecchi 1966, no.
51; Becherucci 1968, pp. 7-
197; Bacou 1969, no. 26;
Chevalier, Gheerbrant,
Berlewi 1969, pp. 457-458;
Ferrara 1970, p. 58;
Shearman 1970, pp. 72-78;
Dussler 1971, p. 64; Vasari
1973, pp. 311-416; Rizzatti
1975, pp. 74-75; Castelli
1977, pp. 309-364; De
Tervarent 1977, pp. 281-286;
Ragghianti 1978, pp. 143-151;
Pellizzari 1980; De Vecchi
1981, p. 260; D'Orazio 1982,
p. 338; Oberhuber 1982, p.
64; Cuzin 1983, p. 73;
Forlani Tempesti 1983, pp.
10-11; Joannides 1983, pp.
62-63; Jones, Penny 1983, p.
31; Knab, Mitsch, Oberhuber
1983, no. 125; Licustri 1983,
pp. 169-171; Maltese 1984,
pp. 37-40, 70, 77; Pedrocchi

It is difficult to resist the charm of the celebrated *Dama con liocorno* at the Galleria Borghese, a painting that became famous when it was involved in a curious and intriguing historical-critical incident. The graceful aristocratic lady sits in crystalline purity in an open loggia, a distant landscape behind her, clearly and directly facing the viewer, conveying a sensation of mysterious ambiguity, which is further intensified by the symbolic animal sitting in her lap.

*History and criticism*
The painting came from the inheritance of Olimpia Aldobrandini, the last princess of Rossano, who, after her marriage to Paolo Borghese in 1640, added her superb family collection to that of her husband. The collection was inherited by her family thanks to the passion of Pietro Aldobrandini, Lucrezia d'Este, Duchess of Urbino and the cardinals Salviati and Ippolito d'Este.
The Aldobrandini inventory, published by Della Pergola in 1962 (p. 321), gives the earliest mention of the work: "no. 78. A painting on panel showing a woman sitting with a unicorn in her arms, one palm and a half high circa, a black frame of uncertain authorship, quite damaged as in the above inventory at folio 192 no. 40".
In his fundamental index on the painting, Della Pergola (1959, pp. 114-116) linked this description with the painting, though it offered no details regarding the author and was very approximate about dimensions, specifying only the height (one palm and a half is equivalent to about 35 cm.) over thirty centimetres short of the real height (67.7 cm.). The "black frame" moreover does not correspond to the present one, in carved wood and gilded. On the other hand, the iconography is described precisely, as is the precarious state of the painting, which can be blamed on the iconographic transformation of the painting, after 1682, from "Lady with a unicorn" into "St. Catherine of Alexandria", an identity it maintained until 1935.
But this hypothesis, though convincing, has been challenged in an important study carried out by Bon Valsassina (1984, pp. 20-28), the conclusions of which were shared

by Herrmann Fiore (1992, pp. 262-263). Apart from pointing out the substantial differences in measurement between inventory and painting, Bon considers that the information from 1682 could refer to another painting, since lost, also considering the importance of the theme of a lady and unicorn: the family emblem included a unicorn sitting on the knees of a young virgin.
More recently Costamagna (2000, under *Storia*) revealed a probable correspondence between this painting and one described in the inventory of the Quadreria of Cardinal Scipione Borghese from 1615-1630, numbered 256: "A painting of St. Catherine, walnut frame with gold and gilded olives, height $2\,^3/_4$ width $2\,^1/_4$. Raphael". Converting the Roman palm into centimetres gives measurements closer to the Lady of Villa Borghese than the *St. Catherine* housed at the National Gallery in London, with which this inventory entry has usually been associated. The popularity of this saint can easily be explained by the Cardinal's particular fondness for her, being traditionally connected to the concepts of wisdom and culture.
In 18th century inventories the work is mentioned sporadically and with little certainty, often confused with the aforementioned *St. Catherine* housed in London since 1801. The descriptions found in the guides to Villa Borghese more or less recently (Manilli, 1650, p. 112; Rossini, 1760, p. 248; Mercurj 1854, p. 10; Giusti 1911, p. 78) are very general and imprecise.
Only in the 19th century, apart from a dubious citation in the palace inventory probably dated after 1819 (Bon, *op. cit.*, p. 21), is there a certain description of the painting in the 1833 Fidecommisso inventory: "First room…no. 24. A portrait representing St. Catherine of the Wheel of the Perugia school, $2\,^1/_2$ palms in length; 3 palms in height". (Galleria Borghese Archive, Istituzione Fidecommissaria…1833, cfr. Bon, *op. cit.* p. 21).
These details are repeated in the 1854 descriptions of the palace (Galleria Borghese Archives, *Descrizione dei Quadri della Galleria Borghese*, 1854, in Bon, *op. cit.* p. 21) and in 1872 (De Rinaldis, 1936, p. 123). The

1983, p. 20; Viatte 1983, no.
50, pp. 216-218; Bon
Valsassina 1984, pp. 20-28;
Cecchi 1984, pp. 39-46;
Maltese 1984, pp. 13-15;
Ciardi Dupré 1985, p. 13;
Freedberg 1985, p. 79; Ripa
1986; Vasari 1986, pp. 610-
641; Chastel 1988, p. 100;
Ferino Pagden, Zancan 1989,
no. 26; Marani 1989, p. 187;
Arasse 1990, pp. 11-34;
Cordellier, Py 1992, pp. 92-
95; Herrmann Fiore 1992,
pp. 262-263; Ferino Pagden
1994, pp. 262-266; *Galleria
Borghese*, 1994; De Vecchi
1996, pp. 9-50; Corradini
1998, pp. 449-456;
Costamagna 2000; Moreno,
Stefani, 2000, p. 224.

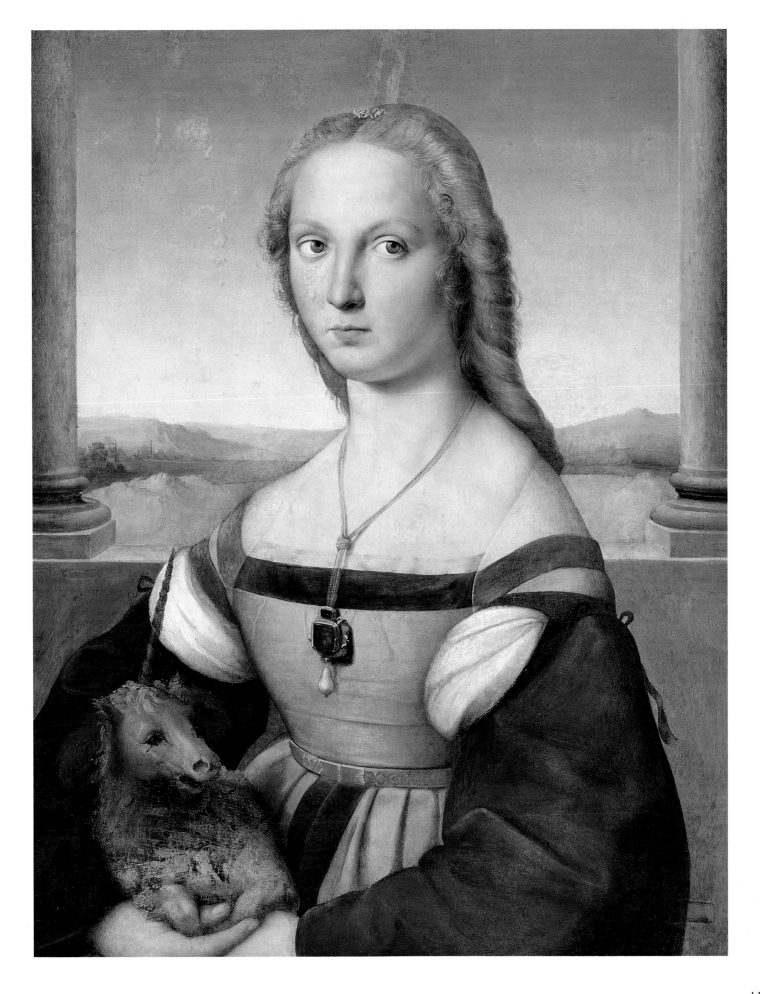

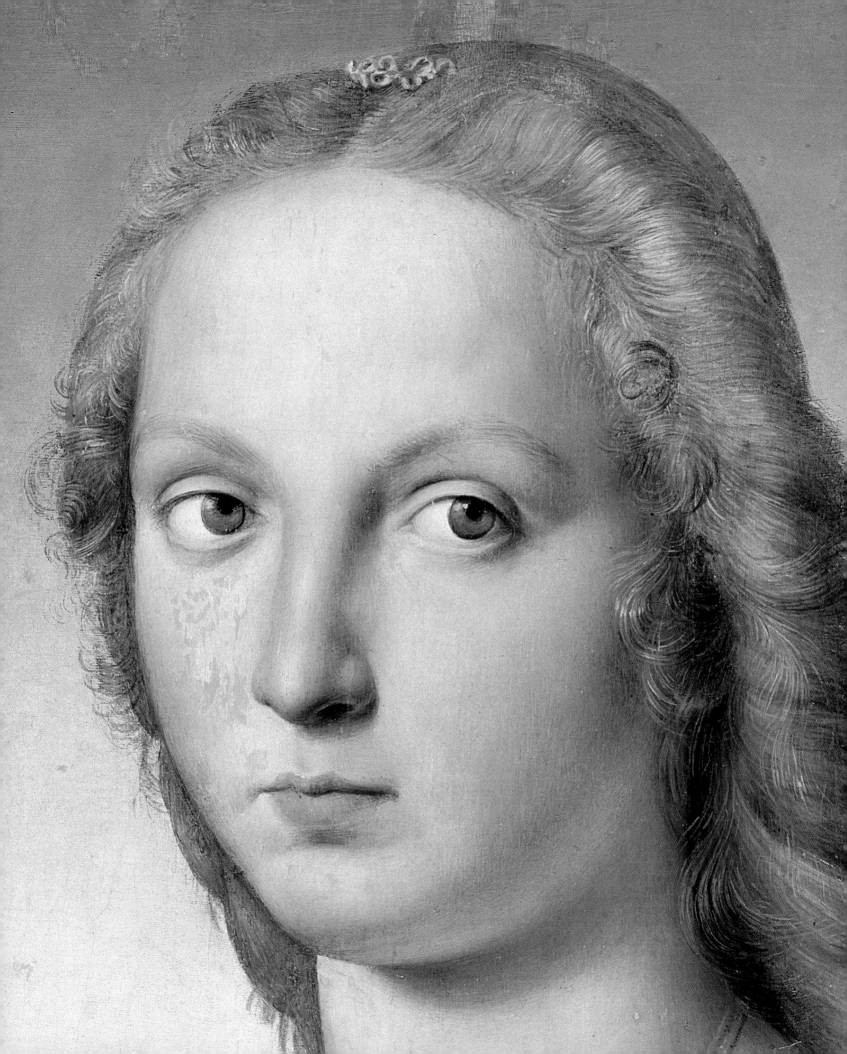

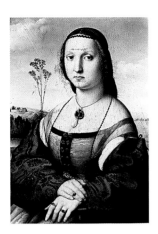

Raphael Sanzio
*Portrait of Maddalena Doni*,
1506
Oil on wood, 65 × 45.8 cm
Florence, Galleria Palattina
di Palazzo Pitti.

authors identify the female figure as being Maddalena Doni, the celebrated wife of the Florentine merchant Agnolo, both immortalised by Raphael in the well-known diptych at Palazzo Pitti.

These citations are the basis for later critical observations by Morelli. In the first edition of his essay on the Galleria Borghese (1875, cit. from De Rinaldis, *op. cit.*, p. 123) he refuses the traditional attribution of the painting to the school of Perugia, and suggests the painting to be Florentine in the manner of Ridolfo del Ghirlandaio. Successively (Morelli, 1897, pp. 125-128, no. 203, pp. 413-414) he considered Granacci, and identified the young lady as Maddalena Strozzi, for which the author would have used the famous drawing by Raphael, now housed at the Louvre (no. 3882). Thus an anomalous double nature was discovered in this painting– a portrait with the attributes of a saint – intended, according to Morelli "perhaps for some relative, or maybe for some respectful admirer of the rosy-cheeked Maddalena, whom the painter transformed into Saint Catherine…" (Morelli, *ibidem*).

Berenson agreed with the Granacci attribution (1925, cit. from Bon, *op. cit.*, p. 23). Piancastelli, on the other hand, moved from the traditional reference to the school of Perugia (Piancastelli, 1888-91, p. 291) to the name of Ridolfo del Ghirlandaio (Galleria Borghese Archive, 1899, Schede Piancastelli, cit. from Bon, *op. cit.*), an opinion backed by Venturi (1893, pp. 180-181), who even noted, though cautiously, some stylistic similarities with the manner of the young Andrea del Sarto. The scholar confirmed the traditional identification of the model as Maddalena Doni and the relationship with the Louvre drawing.

An in-depth analysis of the work was conducted by Cantalamessa, curator of Galleria Borghese from 1906 to 1924. In his notes (1911-12) on the Venturi catalogue, having examined the preceding attributions, he recognised, in the style and composition, the author's *"intention of following Raphael"* (Cantalamessa, in Venturi 1893, *op. cit.*). Subsequently (1916, pp. 187-191) he disputed the traditional identification of the young model as Maddalena Doni and substantiated the existence of two hands, of considerably differing quality, opening the way to Longhi's inspired intuition, who, in two illuminated critical publications (in 1927 and 1928), was the first to recognise the hand of Raphael with his now well-known observation :*"Ille hic est Raphael"* (1927, p. 173). Longhi, starting from Cantalamessa's conclusions, and looking decidedly at the quality of the work, differentiated the original work of Sanzio, of exquisite quality and formal harmony (the head, the neck-line, the corset, the jewels and the landscape) from the "very clumsy

additions" which he attributed to the Florentine painter Giovanni Antonio Sogliani (1492-1544). The insensitive superimposition by the Florentine artist in the second decade of the 16th century affected the area of the hands, the cloak, the red velvet sleeves and the saintly attributes: the martyr's palm and wheel. It is worth while quoting his words: "such a perfect curve as this lady's naked shoulder was certainly not destined to be cloaked so badly in a mantle of painted zinc…" (Longhi, 1927, p. 170). He noted how the figurative scheme adopted by Raphael was derived from the Louvre drawing which has the same landscape background framed by two columns, inspired by Leonardo's Mona Lisa. Thus detaching the drawing from Morelli and his followers' arbitrary attribution to the portrait of Maddalena Doni, and linking it instead to the painting in Villa Borghese, Longhi placed it alongside the great portraits of the master's Florentine period, observing: "the original form of this young lady from Galleria Borghese is raised to the level of excellence of the Doni portrait or the unknown Lady at the Uffizi" (Longhi, 1927, p. 172). The scholar also drew a "conjectural reconstruction" of how the lady's pose and dress originally were under the modifications, a conjecture that, after the restoration, turned out to be exact.

Longhi's courageous interventions prompted Bertini Calosso, superintendent at the time, to act. The panel, already disinfested in 1903 by Luigi Bartolucci and cleaned by Giuseppe Cellini between 1932 and 1933, underwent X-ray analysis (1933) to examine the underlying layers; these revealed the original image of a noble Florentine lady with a small dog in her lap. The Ministry for National Education appointed a commission of scholars consisting of Federico Hermanin, Giovanni Poggi, Roberto Longhi, Aldo De Rinaldis (then curator of the Galleria Borghese) and the restorers Augusto Cecconi Principi and Tito Venturini Papari, to decide on the best means of removing the later modifications. Naturally the discussion was intense. Schmarsow (cfr. Bon, *op. cit.* p. 26) for example, was in favour of removing the wheel and the saint's palm, but not the cloak. In any case the restoration was rapidly approved. The painting was strong and sound on the surface and underneath including the lady's corset. Instead the entire altered parts had "bubbles" where the paint was detaching from the undercoat. Normal fixing however would have consolidated both the original colour as well as the later paint, intensifying the union of the two layers of material. It was decided to destroy the original wooden base and transfer the paint onto another panel of walnut plywood using a very fine canvass as an intermediate medium. The original paint was recovered, almost entirely, by

scraping and peeling the superimposed paint with a scalpel, an operation carried out by Augusto Cecconi Principi. The restorer removed the greater part of the lower part of the painting, the cloak, the hands and the martyr's palm with the exception of the unicorn.

A successive restoration was carried out in al 1959-60 at the Istituto Centrale per il Restauro, then directed by Brandi. The transfer of the painting onto canvas and the scraping and peeling had, in fact, damaged the surface, especially the sky and the seams between the sleeves and the neckline that had been covered by the cloak. The high adherence between the original paint and the paint applied later was confirmation of the fact that not many years had passed between the two interventions. Likewise there could not be more than a century between the first version and the final one as St. Catherine of the Wheel. If the repainting had been post-1682 (as was suggested by Della Pergola) it would certainly have been identified as such by all the important scholars who had dealt with the work, instead they were unanimous in attributing the intervention to a 16th century artist. The X-rays that were done during this restoration confirmed the existence of a dog under the unicorn and also showed an older female face below the present one. However the precarious conditions of the surface made it impossible to undergo an in-depth restoration and it was advised to proceed with a careful cleaning which recovered the ribbon on the left sleeve of the lady's dress. Thanks to this last restoration, the painting recovered much of its original homogeneity and is easier to interpret. The restorer, Nerina Neri, used a collodion solvent for cleansing and removing varnish and retouches from the previous restoration. She also carried out a minor painting restoration and applied protecting varnish.

For the 1984 Raphael celebrations a group of historians, led by Sciuti and Maltese carried out non-destructive analyses of four paintings housed at the Galleria Borghese, including this one. These were XRF (X-ray fluorescence), thanks to which it is possible to identify the characteristic elements of the pigment compositions used (Maltese, 1983, pp. 37-40 and 70, 77 and 1984, pp. 13-15).

A further series of infrared investigations made it possible to see the underlying drawing precisely, underlining small differences with respect to the final version in the hair, the eyes, the nose, the waistbands and the folds in the dress. The pearl was smaller as was the left sleeve.

Modern scholars have expressed widespread agreement as to Raphael's authorship of the painting (Ferrara 1950, p. 58; Rizzatti 1975, pp. 74-75; Carli, 1959, p. 41; Della Pergola 1959, pp. 114-116; Valsecchi 1960, p. 36; Berti 1961, p. 37; Lucie Smith 1961, Pl. 4; Castelfranco 1962, p. 16, no. 18; Tea 1963, p. 22; Fusero 1963, p. 185; Becherucci 1968, pp. 71-71; Oberhuber 1982, p. 50; Cuzin, 1983, p. 73; Ciardi Dupré 1985, p. 13). Freedberg (1985, p. 79) and Dussler (1971, p. 64) have found the attribution to Ridolfo del Ghirlandaio more favourable, dating the painting 1508-1509. Reconciling the two opinions, other critics (Shearman 1970, p. 72; De Vecchi 1981, p. 260; Joannides 1983, p. 62) believe the work to have been begun by Raphael and concluded by another artist, probably Ridolfo del Ghirlandaio.

This extraordinary painting certainly has an important place among the portraits that Raphael painted during his Florentine period. Having overcome the Perugia stereotypes and maintaining the typically Flemish spatial layout, in Florence Raphael had to contend with the work of Leonardo da Vinci which had, as Vasari recalled, a profound influence on him and which he assimilated rapidly. These models, however, underwent an original and highly personal interpretation. Indeed, the celebrated portraits from 1506-7 bear witness, each in different ways, each with its own particular composition, to his profound meditation of the great model of the Mona Lisa.

The compositional formula of the *Lady with the unicorn* and especially the well-known drawing at the Louvre, which is, by now, unanimously recognised as the preparatory drawing for the painting (and not for Maddalena Doni, as was once believed), strongly reiterate the complex issue of the Raphael-Leonardo relationship at that time, also because of the difficulty in dating the Mona Lisa, which still varies between 1500-1501 and 1513-15 (cf. Pedretti, 1959, pp. 155-224 and Marani, 1989, p. 187).

Raphael's drawing is held by many to be decisive proof of the existence of Leonardo's masterpiece prior to 1506. What appears to be evident is Raphael's intention to cite the Leonardo type of half-length female portrait. A three-quarter view, including the hands (given a precise expressive value), and a symbolic animal in her lap (Longhi rightly points out the analogy with the *Dama con l'ermellino* in Krakow), placed before a far-reaching landscape outlined by columns, looking towards the viewers and creating a precise perceptive relationship. As Cuzin has clearly underlined when speaking of this painting, (1983, p. 73), the slightly outstretched arms in a simple posture that offsets the lightly turned head whose gaze captures the spectator, up close recall the portrait of *Ginevra Benci*. The shoulder to the fore is almost eliminated so as to highlight the line that extends from the neck to the arm, a device that Raphael used, infinitely varied, on countless occasions during his long career as a portraitist.

Jones and Penny (1983, p. 31) have clearly shown how Raphael, when adopting Leonardo's prototype, altered the internal proportions between figure, columns and landscape. In the Galleria Borghese painting, the parapet is higher than in the Mona Lisa so that it divides the painting into two equal rectangles, while the landscape element is more rationally framed assuring a clear dominance of the architecture.

Oberhuber has pointed out the fidelity with which Raphael invoked the compositional layout of the Mona Lisa in his drawing, not only are the lady's pose and the columns of the alcove in which she is sitting derived from it, but also "something of the mystery in her eyes and her smile" (Oberhuber, *op. cit.*, p. 50).

Ferino also perceived evidence of an intense relation to Leonardo's Mona Lisa in this painting. If on the one hand Raphael accentuates his strong sense of the "individual", at the same time he underlines the "realistic" element (the detailed, sumptuous dress of Florentine nobility) in contrast to Leonardo's "idealism", though in this painting there is ample "idealism" when compared to the *Maddalena Doni* portrait. She concludes "Raphael was never obsessed with Leonardo's transcendental "mystic naturalism". Even in his maturity he preferred classical rhetoric to Leonardo's cryptic mysticism in nature." (Ferino, *op. cit.*, p. 266). De Vecchi also agrees with this critical outlook. According to him, the comparison of Raphael to Leonardo's models emerges as a sort of "critical consensus". In his portraits the clear, firm architectural structuring contradicts the continuous suggestion of the physical and psychological movement of Leonardo, linking Raphael more to the 15th century Florentine portrait which was "civil and biographic" rather than psychological (De Vecchi, 1996, p. 30).

*Iconology*

The identity of this mysterious lady has brought forward the most varied hypotheses over the years, starting from Morelli, who believed the model to be Maddalena Strozzi, who is very close from an iconographical point of view. Ortolani (1942, p. 26) considered her to be the "real" Maddalena Doni, since the model in the Pitti painting was, he felt, too old to be at the side of her young husband Agnolo. In the wedding portrait of Maddalena Doni, Raphael dwells indulgently on the details of the lady's wedding dress, embellished by an extraordinary jewel, of which the style and choice of stones suggest that it was a wedding gift (Cecchi 1984, p. 112). In the painting of the unknown lady, the type of pendant and the unicorn in the young lady's lap have the connotations of a wedding portrait. Raphael appears to have begun the painting during his Florentine years but left it incomplete "perhaps because of the interruption of the marriage contract, or the sudden death of the lady or her future husband, or simply because of Raphael's definitive departure for Rome" (Costamagna, *op. cit.*, under *Iconologia-significato*). This is probably the reason why the painting was not registered by sources of the time, starting from Vasari.

Recent investigations carried out by the Società Editech Multimedia Art have revealed that in the first version, certainly the work of the master, the lady was painted only to the waist, excluding the sleeves of the dress, with the sky, the landscape and the window included. Subsequently over another drawing (superimposed on the original painting) the columns, the plinths, the sleeves and the dog were added, probably by Sogliani. At this point the painting was of a lady with a small dog in her lap and her hands crossed (without rings) close in typology to the *Portrait of a lady* by Lorenzo Costa at Hampton Court in which the dog was a traditional symbol of marital fidelity. Some decades later, having been damaged, the animal was transformed into a unicorn, changing a civil portrait into an allegory of Chastity or Virginity. This is the period when the left hand was re-painted and the right added. The last intervention transformed the woman into St. Catherine of Alexandria, with the addition of the cloak, the palm and wheel. Oberhuber (*op. cit.*, p. 64) is in agreement with the wedding iconography, as would be suggested by the existence of the dog under the unicorn.

But this graceful young lady has evaded all attempts at identification with any noble lady married to any Florentine patrician known to Raphael in those years, likewise there are no dogs or unicorns in the emblems of any of the aristocratic families with whom he was associated. However, it is worth considering that the artist was also active in other cities (Costamagna, *op. cit.*, under *Iconologia-lettura*).

Another particular detail in this painting is the absence of rings on the lady's hands, they are to be found in other portraits by Raphael from this period. Apart from the symbolic connection between the fingers and the astrological cycle, it is worth noting, according to the scholar, that when female figures are portrayed without rings they are to be linked with mythology or Christian tradition.

The young lady wears a dress that was very fashionable in 16th century Florence, called the "gamurra", which is very similar to that of Maddalena Doni, in a colour somewhere between unripe green and oil yellow, bordered with bands of purplish-red velvet. The low-cut neckline reveals the shoulders lightly covered by a veil. From the seams of the velvet sleeves "like dark sour cherry" (De Rinadis, *op. cit.*, p. 128), ample and heavy,

held by ribbons or "*agugelli*", the blouse "in exquisite material" emerges puffed up abundantly, it also appears lightly crimpled above the neckline. The bodice and skirt are separated at the waist by a tight rigid leather, gold-sealed belt. Also the hairstyle, with a long plait called "*coazzone*", is typically Florentine.

With extraordinary naturalness, the precious pendant hangs around the young woman's neck resting on her pearly breast. The jewel is held by a series of slender gold chains tied in a knot at the centre. Its manner is very similar to that of *La Muta* and the *Portrait of Maddalena Doni*, the latter bound (most significantly) by a gold unicorn. The Galleria Borghese's pendant is composed of a large square ruby mounted in gold, standing out and framed by a gold curled and twisted garland supporting an emerald above and large baroque pearl "in the shape of a tear" (De Rinaldis, *op. cit.* p. 128). The jewel, defined by Longhi (1927, p. 172) as "a tiny pictorial cosmos", can be considered the soul of the painting and the key to its interpretation. We know of the thaumaturgical, magic and esoteric powers that precious stones were considered to possess during the Renaissance following ancient traditions. The choice of ruby, emerald and especially pearl, which, with its elongated form recalls the pure oval countenance of the young lady, implies extreme watchfulness. Emeralds were the precious stones most often given to brides as a wedding gift. This gift was considered to be a good omen for happiness and the success of the marriage. Moreover, as well as magic powers, emeralds had the virtue of making people chaste, keeping evil spirits away and warding off demonic illusions. According to lapidarians, the ruby had the virtue of delivering man from sin, lust and inner sadness, granting strength and prosperity and helped attain spiritual well-being. The pearl, on the other hand, was the usual symbol of purity, chastity and beauty of the soul: traditionally an attribute of Venus herself, then of the Virgin and of virginity. The association between pearl and purity came from the Song of Songs where the bride is compared to a pearl.

It is highly significant that the colours of the jewel worn by the lady with the unicorn – white, red and green – are also the fundamental chromatic values of the entire painting.

Finally, another small jewel in the form of a four-leafed diadem sits on top of the young lady's hair.

The particular value that Raphael wished to give to the symbolic animal, so clearly placed in this work, has not gone unnoticed. The fantastic unicorn, a horse with a long sharp twisted horn protruding from the forehead, with a goat-like beard and a lion's tail, has always been extremely popular since its Far Eastern origins and also in the classical world where it was a symbol of chastity. In the religious field it was a symbol of the revelation of God, of God's penetration into living beings, and in Christian iconography signified the Virgin made fruitful through the Holy Spirit. It enjoyed vast popularity in the Middle Ages, being connected with the concept of courtly love: there is a well-known episode in which the indomitable beast could only be tamed by a virgin of perfect physical and moral integrity. The theme was exploited in numerous late Gothic and Renaissance tapestries. The animal now visible in this painting is very much anomalous when compared to the splendid specimens to which we are accustomed in Raphael and his school, it is also compromised by the poor quality of the paint, both in the coat and the paws which reveal those of the underlying dog.

Alongside the much mentioned Louvre drawing (no. 3882), this painting can be linked to the drawing known as *Portrait of Raphael's sister* (British Museum, 1895-9-15-612) and the subsequent one in Lille (Pl. 649) (cf. Ferino, Zancan, 1989, p. 44, no. 26).

As can be seen from this short exposition, the debate about this lady in the Galleria Borghese is still open, in the hope of new illuminating contributions that may reveal her fathomless mysteries. (*T.C.*)

# Raffaellino del Colle
## (Colle Sansepolcro, late 15th century – Sansepolcro, 1566)
### *La Fornarina Borghese*, 1530 c.

Tempera in oil on canvas, transferred from panel and applied to a new panel
83 × 57 cm.
Rome, Galleria Borghese
(inv. 355)

**Bibliografia:**
Missirini 1828; Quatremère De Quincy 1829, p. 191 note; Nibby 1841, II, p. 601; Mündler 1869, III, p. 810-921; Barbier De Montault 1870, p. 360, no. 65; Bode Burckhardt, Von Zahn 1892, p. 679; Venturi 1893, p. 173; Longhi 1928 p. 211; Hartt (1958) 1981; Della Pergola 1959, vol. II, pp. 121-122 (complete bibliography up to 1959); Entry OA, edited by S. Pellizzari, 1980 (complete bibliography from 1959 to 1980), Soprintendenza per i BAS di Roma, ufficio catalogo; Mochi Onori 1984, pp. 62-63; Herrmann Fiore 1992, pp. 261-262; Herrmann Fiore 1997, p. 70.

*History*

A paper label affixed to the rear echoes the information from the fideicommissary list: "*Iscrizione fideicommissaria del dì 3 giugno 1834 / nota 1 lett. A / Camera delle Veneri Num. 7 / Fornarina di Raffaello, di Giulio Romano / largo palmi 2 onc. 6 1/3 alto palmi 3 onc. 8 1/3 in tavola [in ink] sa 2 no. 65 [in pencil]*". This label, together with the fideicommissary list of 1833, constitutes the sole written historical information about the work of which we can be certain. In the Borghese inventories known today, including the 18th century ones, it is impossible to find any certain trace of it. However, the painting was certainly in the Borghese collection, at least from 1826, when it was noted by Missirini, followed by Longhena (who quotes him, citing a letter from Filippo Agricola, in the Italian translation of the history of Raphael written by Quatremère de Quincy).

Its provenance, therefore, cannot be known, although it is possible, as hypothesised by Mochi Onori (1984), that "*the work was already in the possession of the Borghese family, taken on with the Roman palace and then included in the fideicommissary list with the increase in interest that appeared at the start of the century around the figure of the Fornarina…a possible purchase of the copy by the Borghese should also be seen in this context.*" In the 1626 inventory of Olimpia Aldobrandini "*a portrait of a naked woman on a large panel by Raffael d'Urbino under no. 185*" is described which Paola Della Pergola (1959) has shown incontrovertibly to be Giulio Romano's *Woman with a Mirror* (inv. 2687 in the Pushkin Museum, Moscow, Fig. 8), and which for a time was to be found in the Doria Pamphili collection, following the division of Olimpia's collection between her two sons, Giovan Battista Borghese and Giovan Battista Pamphili (1682).

The Borghese *Fornarina*, on the other hand, is mentioned in the years immediately after 1833, still in the *Stanza delle Veneri* (for example, in the catalogues printed in 1833/35 and in the *Classificazione per epoca dei pittori di cui sono le opere nella Galleria Borghese* – 1837 – by Pietro Rota).

Subsequently, in the *Descrizione dei quadri della Galleria Borghese*, printed in 1842-1843, the painting is reported as being located in room XXII at number 10.

Attributions during the 19th century give the work to Giulio Romano, as did Nibby (1841) and Barbier de Montault (1870). At the beginning of the 20th century, with the passing of the entire collection to the state, the *Fornarina* copy was moved to room IX, its present location. The attribution to Giulio Romano was rejected, amongst others, by Mündler (1869), Bode (1892) and Venturi (1893), who all proposed Sassoferrato, but it was reproposed in 1928 by Roberto Longhi, who considered the Borghese copy "*excellent and without doubt from the 16th century, as a result of which the old attribution to Giulio Romano appears to us to be much closer to the truth*". Della Pergola (1959), instead, speaks of "*a not very noble hand*" though he dates it to the 16th century.

Hartt (1958 and 1981), with whom Herrman Fiore has recently agreed (1992) on the basis of stylistic considerations, advanced the hypothesis of Raffaellino dal Colle (Colle Sansepolcro, late 15th century – Sansepolcro, 1566), a collaborator of both Giulio Romano and Raphael.

Finally, Mochi Onori (1984) attributes the work more generically "*to a Roman hand in the middle of the century*", and compares it to the numerous copies of the famous original by Raphael (Rome, Galleria Nazionale d'Arte Antica in Palazzo Barberini) painted at the time.

The panel, transferred to canvas and laid on a modern walnut panel in 1934 (at the same time as some restoration work on the original Barberini, under the control of Hermanin, Poggi, Venturini, Papini, Longhi, Cecconi Principe, De Rinaldis), was recently (1997-98) submitted to restoration by Laura Ferretti. The restoration essentially consisted in renovating the modern wooden backing. On the occasion of the presentation of the work at Palazzo Barberini (December 2000), the painted surface was cleaned and the heavy varnishes of the previous operation removed as these had oxidised badly over the years.

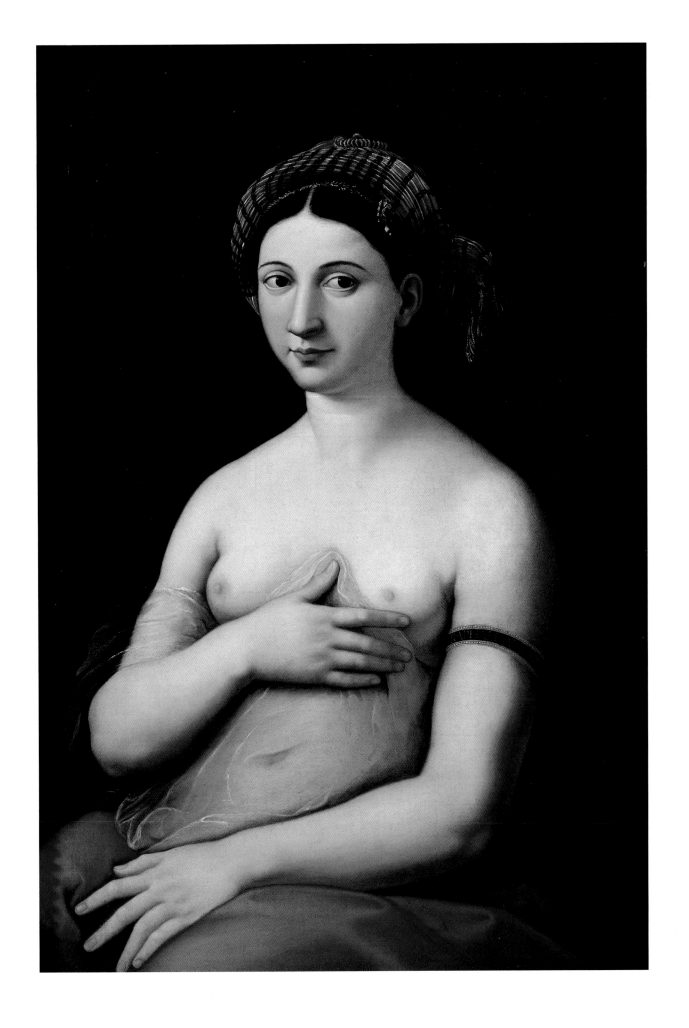

*Iconography*

A young woman with chestnut-coloured hair is seated with bare shoulders, breasts and arms, and with a thin veil over her stomach and elbow. A red cloth covers her flanks and thighs, and the illuminated figure stands out from the dark backdrop of lanceolate laurel and quince leaves (symbols of eternity, conjugal faithfulness and fertility, virtue and love).

On the head: a ribbon in gold thread topped by a sort of dark silky velvet turban in bands of white and peacock blue, decorated with a terminal fringe and a gold pendant adorned with a ruby, four small lateral pearls and a blister pearl. On the arm, a blue enamel bracelet is worn in the classical manner and inscribed "RAPHAEL URBINAS" in gold (the same colour as the two dotted bands that run along the edge of the bracelet).

*Iconology*

The image corresponds to that of the famous portrait of the Fornarina, considered to be Raphael's lover, in the painting preserved in the Galleria Nazionale d'Arte Antica in Palazzo Barberini; it constitutes an archetype that was widely imitated in the 16th and 19th centuries.

*Style*

Diagnostic investigations have made the imprint of the canvas and the thick layers of pigment visible. There are no *pentimenti* at the level of general composition, unlike in the Barberini *Fornarina* (with a river landscape on the right and arches on the left outlined beneath the present painted surface – these emerged in the non-destructive studies carried out in 1983 – and with the "drawing" found during the present operation in the lower part of the painting). However, in the Borghese panel, a partial drawing seems visible beneath the veil and under the hand supporting the breast.

As in the Barberini example, the foliage is painted in relief but, unlike the archetype, the Borghese Fornarina appears thinner in her proportions and more slender, to the point that all the fingers on her left hand are visible.

In the Borghese painting, the striving for formal simplification is made explicit by the reduction of the space surrounding the main figure and by the elimination of a decorative detail that was evidently no longer of relevance in terms of its symbolic value. I refer here to the ring set with a gem that sits on the second joint of the second finger on the left hand of Raphael's Fornarina; in the slightly later Borghese version, this has disappeared as it no longer bears any meaning.

Clearly, Raphael's famous painting had immediately become a figurative "emblem", an example of "style", thanks to the particular fame of both sitter and artist, as well as for the symbiosis of antique and contemporary elements (in the clothing and jewels). It was almost quoted from memory, alone or in other contexts (cf. the numerous copies in Rome in the Gallerie Collona, Sciarra, Albani, Doria Pamphili, and the *Donna allo specchio* by Giulio Romano, today in Moscow's Pushkin Museum, as well as the head of a woman, again by Giulio Romano, included in the Louvre's *Circumcision*).

The evident stylistic affinities between the Borghese *Fornarina* and the works by Raffaellino del Colle during the years he worked in the Villa dell'Imperiale in Pesaro (1529-32), a period in which he was still heavily influenced by Giulio Romano, confirm Hartt's proposed attribution. For a direct comparison, refer to a red chalk drawing by Raffaellino (presently in a private collection), which constitutes the graphic version in a mirror reflection of the woman's head in the Borghese painting.

The text has been taken from the digital file compiled during the "clinical sheet" project undertaken by the Galleria Borghese. (*A.C.*)

Roman School (Sebastiano del Piombo?)
(First half of the 16th century)
*Portrait of a woman* (known as *La Fornarina* or *Vittoria Colonna*)

Oil on panel
73×54.5 cm
Rome, Galleria Corsini
(inv. 221 F.N. 611)

**Inscriptions:**
On the back, in pen and
partially cancelled, the
number "188".

**Provenance:**
A version in the Uffizi;
another copy appeared in a
Christie's auction in London
on 5 November 1965, (no. 31)
and on 4 August 1977 (lot
23); 19th century copy signed
L. Desideri and dated 1895 in
Sotheby's auction on 16
January 1974, (lot 26); Lucco
1980, p.103, no. 36

**Restored:**
1834, Minardi Beretta; 1922;
1996, Ikonos Restorers

**Bibliography:**
Ravaglia 1923, pp. 53-61;
Düssler 1942, p. 131, no. 15;
Pallucchini 1944, p. 158;
Garas 1954; di Carpegna n.d.,
p. 6, no. 18; Lucco 1980, p.
103, no. 36; De Vecchi 1966,
p. 108, no. 99; Lucco 1980,
p. 103, no. 36; Alloisi 2001,
pp. 122-124.
*Documents*: A.S.R.,
Inventario 1827, no. 188;
A.S.R., Archivio Ovidi, b. 8,
fasc. 58; Magnanimi 1980, 8,
p. 80 [37] e p. 96, [9]; Papini
1998, p. 175, [205], p. 193,
[193].

The painting was first exhibited at Palazzo Venezia, then at Tivoli, Villa d'Este, and was returned to the Gallery at the end of the '80s. A slightly different version, which appears to be of better quality, is in the Uffizi. This painting is dated 1512 was attributed to Raphael in the 19th century and only later to Sebastiano del Piombo. It appears that at the beginning of the 19th century Tommaso Puccini, the director of the Uffizi Gallery, attributed the work to Raphael and identified the woman depicted as La Fornarina (the name by which the painting is still referred). On the other hand, Melchiorre Missirini (as cited by Lucco) was of the opinion that the subject was the poetess Vittoria Colonna and that the painting was the work of Michelangelo.

There appears to be no dispute as to the attribution of the version in Florence to Sebastiano, with the single exception of Garas (1953) who again puts forward Raphael, while many doubts continue to remain on the identity of the subject. The hypothesis of La Fornarina is to be firmly repudiated, but in the case of Colonna it is impossible to be certain. The identification is based on similarities – more iconographic and stylistic than related to physiognomy – with the painting in the National Gallery of Washington. The latter painting was recently studied again on the occasion of an exhibition on Colonna held in Vienna, and it tends more to identify the image as a depiction of the *Wise Virgin*.

In the biographical sketches of this exhibition, however, it is noted that, at least from the 17th century (as demonstrated by an engraving by Wenzel Hollar) the painting was identified as the portrait, noted by Vasari, of the famous poetess who was a friend of Michelangelo, and thought to have been executed by Luciani.

The painting in question was commented on by Cavalcaselle (1871) and judged in various ways. The most critical opinion was made by Carpegna (n.d., p. 6, no. 18) who considered it "a late and mediocre replica of the portrait in the Uffizi", while the most enthusiastic was by Hermanin (1924, p. 42) who judged it to be "older" than the Florentine version and was perhaps influenced in this

by Ravaglia (1923). Going against the current, Garas (1953) attributed the painting to Giulio Romano and claimed that Raphael was the artist of the version in Florence. All the others, Dussler (1942) Pallucchini (1944), De Vecchi (1966), Lucco (1980), and Hirst (1981), agree that it is an old copy or at most a replica.

The old inventories, starting from those of Cardinal Andrea Corsini from the late 18th century, attribute the painting to Giulio Romano and this lends some substance to Garas' hypothesis. Only inventories of the 19th century identify the subject as La Fornarina, confirming by implication the earlier cited theory.

X-ray examinations taken during a recent cleaning of the work show a supporting structure on the lower right hand side of the painting and this was also noted in an old photograph probably taken during restoration in 1922. On that occasion the object was erased, covered and the lower area was largely repainted. Ravaglia (cit., p.55) claims that the reworking of the painting dates from the 1800's and was executed in order to change the subject into a Mary Magdalene. This, though, is almost impossible as the cleaning did not eliminate the lowest areas and also because during that time it was claimed the subject was La Fornarina. Interesting results appear when a comparison is made between what is visible and the infrared photograph in which the face appears softer and of a clearly superior quality but with features closer to a hypothetical portrait. In the same photograph, a veil is clearly identifiable that partially covers the hair held back in a braid with bands falling to the neck at the side, even though the colour is heavily grazed. This is very different to the version in Florence where the head is adorned with a small crown of leaves and the hair falls loose at the back of the head. Some trace of the veil can be discerned, perhaps, in certain highlights that show through to the naked eye. Only with difficulty can this be justified as a particular rendering of the hair.

In addition, the X-rays reveal, if not true *pentimenti*, significant corrections in the course of the work, above all in the posi-

Radiographic image.

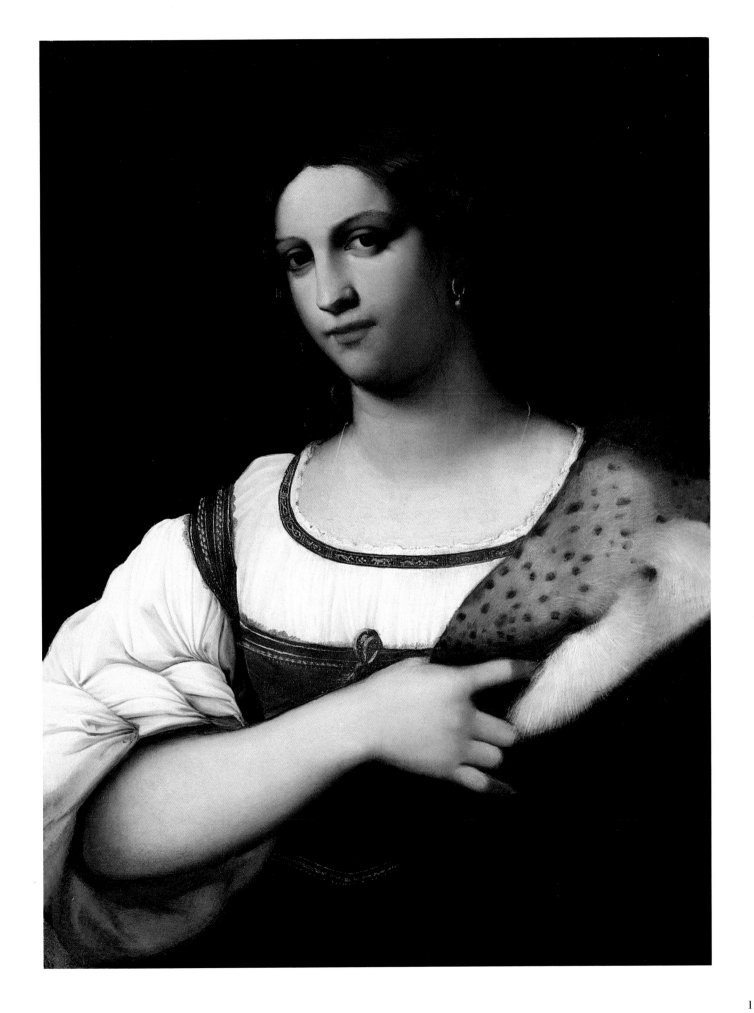

Infrared photograph.

tion of the forearm originally more inclined, and in the gradual refinement of its proportions. The drapery of the sleeve also appears to have received the same treatment with the lower part applied in thicker brushwork. The rendering technique of the decoration of the collar and straps of the bodice also appears to do little to justify the claim that it is a copy. These were executed after the shirt was completed, and this can be easily noted by the traces of the folds under the dark colours, marking firstly the outlines of the borders and then refinishing. In the first version the fur appeared thicker, longer and more irregular: indeed, a tuft behind the shoulder was even misconstrued in an earlier restoration, probably in the 19th century, and as a result was erased. The face shows broad radio-opaque areas possibly due to the presence of various layers of veil and an important correction to the profile of the nose on which the artist nonetheless insisted even in later phases. The X-rays also reveal many predominantly horizontal brushstrokes in the background, traces of which can be seen with the naked eye on the observer's right

hand side. This could be evidence of a background that was perhaps eliminated during execution of the work.

If a conclusion can be drawn from the examination, it tends towards a compositional technique of a Veneto type rather than a central Italian one, and that most likely we are dealing with an original. It is not possible to clarify a relationship with the Florentine version. However it is clear that on several occasions the aim was to adjust the image to the Florentine model by eliminating all those elements that differed from it, either because they were damaged or misconstrued, to the point of heavily retouching the face.

In the opinion of the writer, it appears very probable in the light of what has emerged that the work is an original by the young Sebastiano del Piombo. This will become clearer if we have the courage to clean the work to reveal what has been exposed by the infrared photographs.

The painting is listed among the works restored in 1834 by Giovanni Battista Beretta under the direction of Tommaso Minardi. (S.A.)

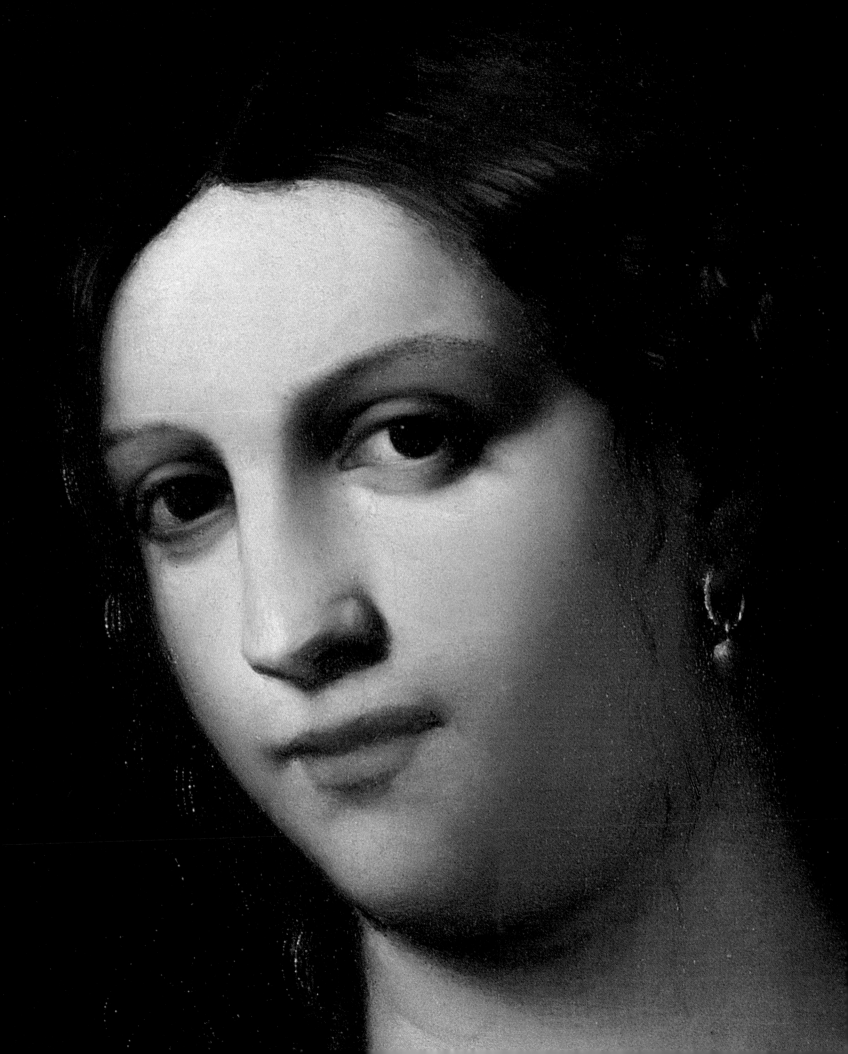

Raphael Sanzio (Urbino, 1483 – Rome, 1520)
*Double portrait* (Andrea Navagero and Agostino Beazzano?), 1516

Oil on canvas
77 × 111 cm
Rome, Galleria Doria
Pamphilij (inv. FC 130)

The sixteenth century man of letters Marcantonio Michiel wrote about the "painting on wood of the portraits of Navagiero and Beazzano ... by the hand of Raphael of Urbino" that he saw at the Paduan house of Cardinal Pietro Bembo[1]. The cardinal, in a letter to Bibbiena, recalls the trip to Tivoli taken in 1516 together with the two Venetian literati, Baldassarre Castiglione and Raphael. The work is reported to have been ceded to Beazzano in 1538.

Old doubts persist regarding the iconography and authorship of the canvas in the Doria Pamphili gallery, however its seventeenth century history can be retraced with complete certainty. It came into the hands of its current owners through the marriage (1647) of Camillo Pamphili and Olimpia Aldobrandini. It was mentioned in several of the Aldobrandini family painting inventories, starting with the lists of the possessions of Cardinal Pietro, drawn up in 1603 by Giovan Battista Agucchi, where the author of the list speaks of "Two portraits both by the hand of Raphael of Urbino"[2]. The issue regarding the identity of the persons portrayed had already surfaced here, one which would later be debated at length, while Raphael's authorship is peremptorily asserted.

The first doubts raised in that regard came up in the subsequent list of the pictures of Cardinal Ippolito Aldobrandini, drawn up in 1638: "Two portraits together said to be by the hand of Raphael, on canvas, approximately three spans high with gilt frame", f. 879v, no. 97. That "said to be" reveals a trend opposing an automatic and perhaps hasty attribution of the work, a practice which in general ends up inexorably attributing the products of any historical dimension to those few artists blessed with fame. Such reservations were later explicated in one of the fundamental texts in the history of modern art literature, Passavant's *Catalogue Raisonné*, where the canvas is demoted to being a Veneto copy[3]. Since then various scholars have been sceptical of Raphael's authorship for reasons of form, and because of the fact that in the first document the work was said to be on wood. Nevertheless, in an inventory of Olimpia Al-

dobrandini Pamphili's belongings, which appears to have been made prior to the year 1665, the list includes "A painting on canvas over wood of Bartolo and Baldo with a gilt frame three and a half spans high, four spans wide, by the hand of Raphael of Urbino..."[4]. The passage provides two pieces of information. First of all, it states that the support of the double portrait, like other sixteenth century canvases, was reinforced by a wooden panel, whose presence was probably either misunderstood or summarily described by Michiel. This is without doubt the most likely explanation for the eventuality of a bleeding through of the colour, rather improbable judging from the condition of the painted surface. Secondly, the portrayed subjects are described as being Bartolo and Baldo. This is an interpretation proposed at around the same time by Bellori (1664)[5] and echoed for years to come, perhaps due to the desire of the owners to believe they posses the images of the two esteemed jurists whose writings were kept and consulted in the Pamphili library. A sort of red herring was thrown into the ring shortly thereafter with the faces being attributed to Luther and Calvin and authorship bestowed on Giorgione, a rather far-fetched but ultimately comprehensible assertion[6]. The work is similarly catalogued in an inventory taken upon the death of Camillo the younger in 1750, in which, however, the canvas is reported in what appears to be its current frame[7].

This bizarre mechanism of iconographic transference should not be overly surprising and is more common than one thinks. The most intimate characteristic of the portrait genre is marked by a recurrent paradox. Although one of the main motivations of the sitter lies in the need to leave something personal to posterity, this attempt quite often fails due to a strange tendency. Trusting in the social position they enjoyed in life, many of the commissioning parties considered it superfluous to attach their name to the image, the result being that a surprisingly great number of portraits today show faces whose identity is a mystery, if indeed they have not been rechristened as a result of fallacious interpretations.

[1] M. Michiel, *Notizie d'opere di disegno...*, ed. by J. Morelli, Bassano 1800, p. 18.
[2] No. 2; cf. C. D'Onofrio, "Inventari del cardinale Pietro Aldobrandini compilato da G.B. Agucchi nel 1603", in *Palatino* 1964, 8, p. 17.
[3] J.D. Passavant, *Raphael d'Urbin et son père Giovanni Santi*, ed. Paris 1860, II, p. 238; cf. P. De Vecchi, *Raffaello. La Pittura*, Firenze 1981, p. 251, no. 73.
[4] Cf. C. D'Onofrio, *ibidem*, p. 17, no. 2.
[5] G.P. Bellori, *Nota delli musei...*, Roma 1664, p. 61. Cf. F. Cappelletti, in *I capolavori della collezione Doria Pamphilij....*, exhibtion catalogue, Milan 1996, no. 2.
[6] Cf. J. Garms, *Quellen Aus dem Archiv Doria-Pamphilij zur Kunsttätigkeit in Rom unter Innocenz X.*, Rome-Wien 1972, p. 320. Inventari di Giovan Battista Pamphili del 1684 e del 1709/10; ADP scaf. 86.33, p. 665. At that time the work was kept in the Palazzo al Corso.
[7] ADP scaf. 86.36, c. 166v: "Altro de quattro palmi per traverso rapp.te due ritratti del Giorgione, cornice dorata come sopra" (model of Salvator Rosa).

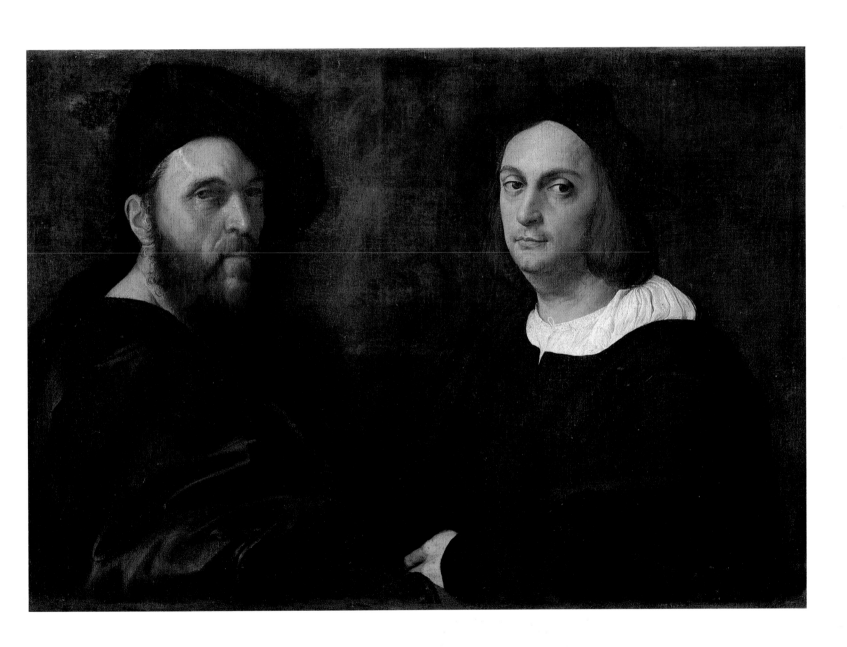

Most critics over the last decades have accepted this work as part of Raphael's *corpus*. The Doria Pamphili canvas would seem to be one of his autographed texts even though it has some singularities, among which is the strange internal division. The face on the right denotes the syntax typical of Raphael: the harmonious relaxation of the body, evident in the posture of the shoulders, as opposed to the muscular Florentine tension; and certain characteristic facial features, such as the protruding eyes. The other figure is written and structured in a completely different way. The more aggressive effect of the light, illuminating the forehead, and the folds of the dark mantle hanging forward into the foreground, are indicative of the desire to create a rather pronounced dramatic effect. This sector of the picture and the green of the background, denoting some lack of homogeneity, show a greater reliance on the Veneto component, something that has been recognised by critics for over a century and a half. It is a dynamic of illumination that brings to mind the language of Sebastiano del Piombo rather than that of Lotto, who has been repeatedly called into question regarding several parts of the Heliodorus Room. Such an internal evolution in the painting would seem to be further testimony to Raphael's extraordinary aptitude for reflection and his quest to embellish the major impulses absorbed from his world. This is a human and professional characteristic that makes his genius something substantially different from an "autogenous" and more banal talent exalted by the romantic ideal. This type of separation within the painting is indirectly echoed by the fact that of the two persons portrayed there exists the same number of completely autonomous copies at the Prado[8].

The painting is well conserved. In this case it is of particular interest to consider how the diagnostic analyses were carried out, as much to reach a more complete judgement in this respect as to acquire information on such a mysterious document. (*A.D.M.*)

[8] *Inventario General de Pinturas. I. La Collección Real*, Madrid 1990, nos. 901, 909, inv. 304-305, the portrait of Beazzano measures 79 × 60 cm., that of Navagero, 68 × 57 cm.

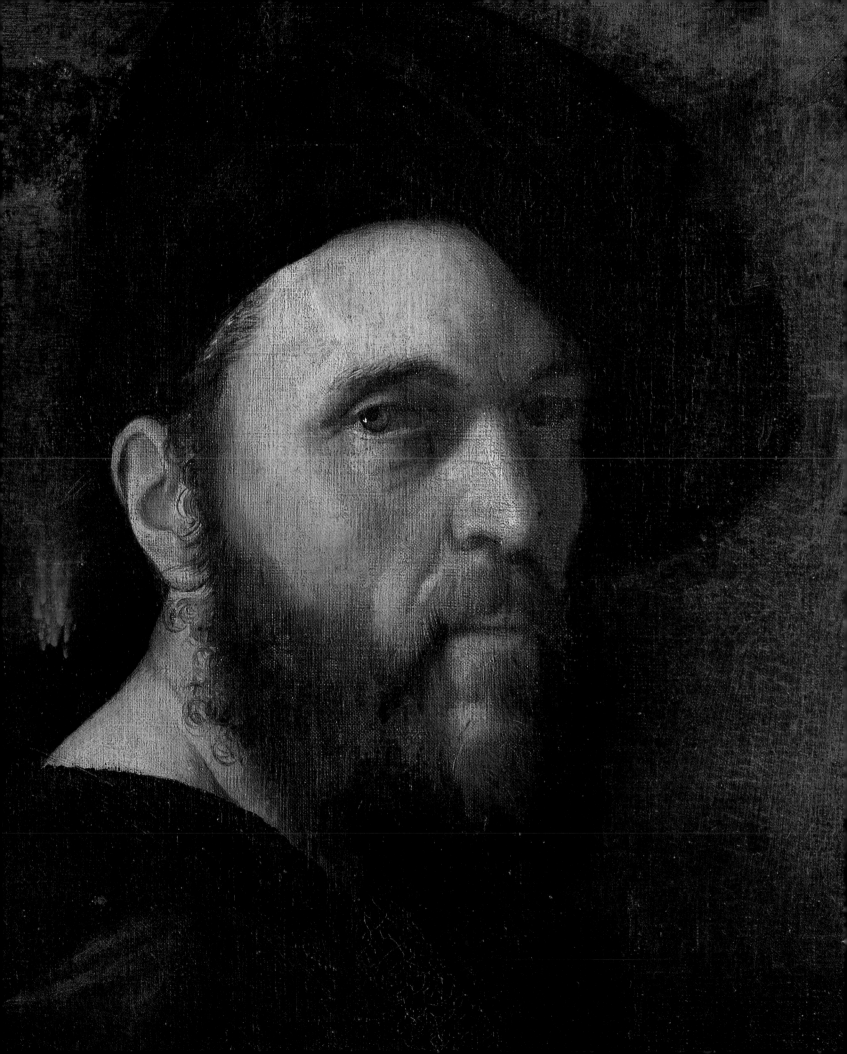

**13**   Raphael Sanzio (Urbino, 1483 – Rome, 1520)
*La Fornarina*, 1518-1519

Oil on panel
87 × 63 cm
Rome, Galleria Nazionale
d'Arte Antica di Palazzo
Barberini (inv. 2333)

**Bibliografia:**
Bembo 1538, pp. 192-246;
Fornari, 1549, pp. 513-514;
Vasari 1550, pp. 635-673;
Borghini 1584, III, p. 392;
Tetius 1642, pp. 153-154;
Scannelli 1657, p. 166;
Bocchi 1677, p. 172; Il
Mercurio errante,1693, p. 56;
Wright 1730, p. 292; Valentini
1750, p. 298; Richardson
1754, p.157; Titi 1763, p. 333;
Northall 1766, p. 239;
Richard 1766, p. 69; Venturi
1767, I, p. 226; De La Lande
1769, pp. 458-539; Miller (A.
Riggs.) 1776, pp. 80-81; Von
Braun 1815, pp. 279-280;
Puccini 1817, pp. 4-6;
Touriseus 1819, p. 212; Miller
1822, pp. 93-94; Fea 1824, p.
398; Nibby 1824, p. 272;
Quatremère de Quincy 1824;
Rehberg 1824, p. 114;
Pungileoni 1829, p. 232;
Knowles 1831, p. 128; Lanzi
1831, p. 175; Von Rumohr
1831, pp. 116-117; Valery,
(Antoine Claude Pasquin)
1831-1832, pp. 308-309;
Odescalchi 1836, pp.108-109;
Nibby 1841, p. 592;
Raczynsky 1846, p. 548;
Missirini 1847, pp. 163-187;
Mundler 1850, p. 181;
Campori 1852, pp. 29-39;
Boucher Desnoyers 1853, pp.
24, 192; Dumesnil 1853, pp.
51, 545-551; Dumesnil 1854,
pp. 180-181; Pistolesi 1856, p.
372; Friedrich 1859, p. 131;
Passavant 1860, pp. 98-99;
Barbier de Montault 1870, pp.
334-350; Campori 1870, pp.
3-15; Urlichs 1870, pp. 50-51;
Gherardi 1874, p. 69;
Farabulini 1875, pp. 232-257;
Cugnoni 1878, p. 46; Cugnoni
1879, pp. 62-63, 486-487;
Farabulini 1879, pp. 5-11;
Grimm 1879, p. 372; Milanesi
1879, pp. 355-357; Das
portrait der Fornarina im
Palazzo Barberini, 1880, p.

The earliest reliable information about the painting is found in a letter from the Vice chancellor Coradusz in Rome to the Emperor Rodolfo II in the year 1595. The painting is described as "a nude woman painted half length from a model by Raphael" and is cited together with other painted works belonging to the countess Caterina Sforza di Santa Fiora (Englen, 1983, p. 30). Coradusz's interest grew out of his efforts in Rome to increase the refined collections of his lord in Prague.

A short time later another hunter of artworks, Ludovico Cremasco, noticed the painting, this time on behalf of the Duke of Mantua, Vincenzo I. Cremasco sent a letter to Mantua in 1597, signing it as the "utterly humble and devoted servant" of the duke, giving a more precise description of the painting as "a half Venus, nude with black eyes and hair, whose left arm bears a bracelet with the inscription Raphael Vrbinas" (Bertolotti, 1885, pp. 28-30). Cremasco was instructed to acquire the painting, noted as a work of Raphael's, without "concern for price".

The painting later passed into the house of the Buoncompagni following the marriage of the only daughter of Caterina Sforza to Giacomo Buoncompagni (Reumont, 1880, pp. 233-235).

Fabio Chigi admired the painting in the Buoncompagni collection and cited it in his commentaries from the year 1618 in the chapter "Praecipua quaedam de Raphaele Sanctio": "Ilius sane meretriculae non admodum speciosam tabulam ab ipso effictam vidimus Romae in aedibus ducis Boncompagni, figura iustae magnitudinis, revincto sinistro brachio tenui ligula, in eaque aureis literis descripto nomine Raphael Vrbinas" (Cugnoni, 1879, pp. 62-63). Fabio Chigi was the first to reveal the identity of the model, although he referred to her portrait as "meretriculae", as Raphael's beloved, the woman that Agostino Chigi had to bring to the painter so that he would finish the frescoes in the Farnesina. For the first time the painting is linked to a specific moment in the life of Raphael: to the period when he was working in the villa of Agostino Chigi, with a direct reference to the work of Vasari for whom Raphael "could not attend so much to his work because of the love he carried for a woman, [causing] Agostino to become desperate, [and availing himself of all means at his disposal], managed to arrange that this woman of [Raphael's] ended up being with him all the time, which was the reason why the work was completed" (Vasari, 1550, vol. III, p. 666). Chigi thus defines Raphael's beloved as "meretricula", whereas in her subsequent romantic idealisation, the identification of the painting as a portrait of a courtesan (in particular, of Beatrice Ferrarese or Imperia) is rejected, since the moral aspects of such a figure would seem not to befit the woman whom according to Vasari Raphael "loved to death", and thus her character tended to acquire an aura of greater nobility. In the 18th century, although reservations are often expressed as to the beauty of the model in citing the picture, due to the tastes of the time, attention is centred on the painting itself as the portrait of a figure who has already become a legend.

However, up until the 18th century the name of the woman portrayed is never mentioned; the nickname Fornarina appears to enter into common use at the end of the 1700s. Oberhuber reveals that the first to use it is Cunego at the bottom of a 1773 print and argues that the meaning of the name is symbolic and not literal (Oberhuber, 1978). The name, Fornarina, does not appear to derive from any written historical tradition, but given the way it was used by the late 18th century one can suppose that it had been in the oral tradition already for some time. The image of the woman portrayed in the Barberini painting has a well defined tradition supporting the thesis that identifies her with Raphael's beloved model. The first iconographic citation of the image is part of a fresco in one of the medallions that decorate the ceiling of a room in the Villa Lante al Gianicolo, the building commissioned by Baldassare Turini to Giulio Romano, dating to the late 1530s. The other medallions contain female heads based on paintings or engravings attributed to Raphael, even though the frescoes are not

356; Reumont 1880, pp 233-
235; Gruyer 1881, pp 52-89;
Armellini 1882, p. 62; Colvin
1882, pp. 1-3; Minghetti
1883, pp. 228-267; Müntz
1883, pp. 60-61, 107; Toscani
1883, pp. 43-46; Burckhardt
1884, II, p. 704; Cavalcaselle,
Crowe 1884-1891, II, pp. 225-
227, III, pp. 80-85; Minghetti
1885, pp. 147-151; Nibby
1885, p. 265; Luzio 1886, p.
550; Carcano 1887, pp. 95-
104; Welker 1888, pp. 17-24;
Morelli 1890, pp, 55, 68;
Ridolfi 1891, pp. 441-445;
Anselmi 1892, pp. 31-32; De
Koch, 1892, p. 704; Marcotti
1892, p. 67; Rosa 1892, pp.
736-738; Fiocchi Nicolai
1893, pp. 10-12; Cartwright
1895, pp. 55-56; Springer
1895, pp. 41-42; Federici
1897, pp. 479-489; Valeri
1897, pp. 353-363; Corsini-
Sforza 1898, pp. 273-278;
Venturi 1901-1940, IX, 2,
1926, p. 275; Vanzolini 1902,
pp. 41-45; Durand-Greville
1905, pp. 313-318; Lanciani
1907, pp. 231-244; Calzini
1908, pp. 6-8, nos. 1-2;
Gronau 1909, p. XXVIII;
Fischel 1916, pp. 251-261;
Chiappelli 1920, pp. 209-224;
Levi 1920, pp. 6-7; Lualdi
1920, pp. 198-208; Oppo
1920; Portigliotti 1920, pp.
23-26; Rambaldi 1920, pp. I-
XVIII; Ricci 1920, pp. 123-
125; Scherillo 1920, pp. 198-
208; Tarchiani 1920, pp. 4-5;
Cecchelli 1921, p. 332; Serra
1922, pp. 109-110; Cecchelli
1923, pp. 9-21; Ravaglia 1923,
pp. 53-61; Venturi 1924, pp.
27-29; Filippini 1925, pp.
222-224; Wanscher 1926, p
138; Zazzaretta 1929, pp. 77-
88, 97-106; Lattanzi 1930, pp.
269-305; De Brosses 1931, II,
p. 449; Gamba 1932, p. 119;
Schlosser, Magnino 1935, pp.
537-538; Golzio 1936, p. 358;
Gronau 1937, pp. 93-104;
Fusero 1939, pp. 165-178;
Nicodemi 1939, p. 51; Bertini
Calosso 1941, pp. 1-2;
Esposizione dei capolavori
della pittura europea XV-XVII

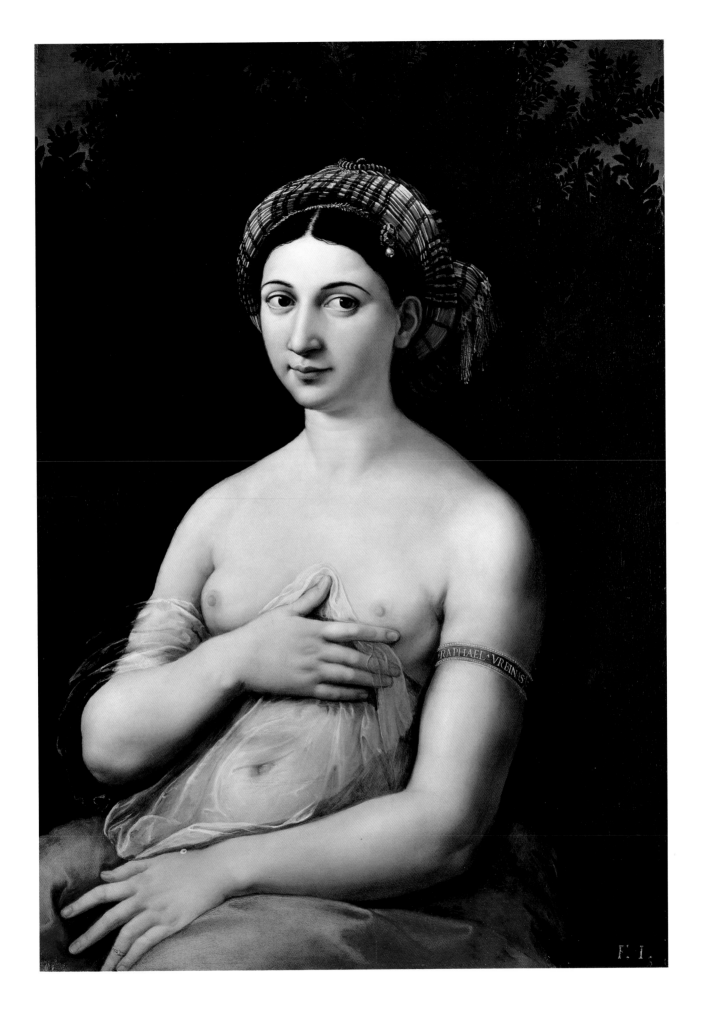

secoli, 1944, p. 28; Hartt 1944, p. 93; Mostra temporanea di insigni opere d'arte appartenenti alle gallerie di Roma, Napoli, Urbino, 1945, pp. 15-16; Hess 1947, pp. 73-106; Ingres, 1947, p. 11; De Vigny 1948, pp. 992-993; Ortolani 1948, p. 64; Friedmann 1949, pp. 213-220; Marrini 1951, pp. 67-68; di Carpegna 1953, pp. 52-53; Pittaluga 1955, p. 25; Bertini 1959, p. 361; Camesasca 1956, I, pp. 70-71; Blunt 1958, pp. 2-20; de Tervarent 1958, pp. 281-282; Carli 1959, p. 18; Noé 1960, pp. 18-19; Bernini 1961, pp. 1-19; Freedberg 1961, pp. 179-180; Fischel 1962, pp. 67, 93, 137, 227, 234; Gnudi 1962, p. 21; Oberhuber,1962, pp. 43-44; Oberhuber 1962, pp. 116-149; Shearman 1962, pp. 13-47; Gould 1963, p. 512; Hartt 1965, pp. 90-91; L'opera completa di Raffaello, 1966, p. 119; Laclotte, 1966, p. 198-245; J. Shearman 1966, p. 63; Ponente 1967, pp. 124, 126; Walter 1967, p. 4; Becherucci 1968, I, pp. 185-186; Golzio 1968, II, pp. 609-646; Golzio 1968, pp. 603-604; Tatarkiewícz 1969; Lavin 1970, 3, pp. 207-226; Pope-Hennessy 1970, p. 11; Düssler 1971, p. 43; Weil-Garris 1972, pp. 342-374; Schlezel 1973, p. 30; Frommel 1975, pp. 184-185; Lavin 1975, p. 17; Dacos Crifò 1976, pp. 46-51; Lotti 1976, p. 72; Méry 1976; Brown, Oberhuber 1978, pp. 25-86; Anderson 1979, pp. 153-158; Bellosi 1980, pp. 39-46; Brandi, 1980, p. 287; Lepp 1980, pp. 365-373; Partrige, Starn 1980; Lilius 1981, pp. 291-298; Pozzi 1981, pp. 309-341; Gould 1982, pp. 478-487; Mostra La galleria Palatina. Storia della Quadreria Granducale di Palazzo Pitti, 1982, p. 32; Ferino 1989, pp. 74, 79; Mochi Onori 1989, pp. 46-47; De Vecchi 1995, pp. 248, 216-217; De Vecchi 1996, pp 38-41; Pedretti 1996 p. 126; Buck, Hohenstatt 1998, pp 99-100; Mochi Onori 1998, pp. 34-35; Oberhuber 1999, pp.208-209; Barbieri s.d., pp. 440-445; Golzio, s.d., p. 70; Missirini, s.d., pp. 252-256.

well preserved and thus difficult to decipher. In an adjacent room there are frescoed medallions on the ceiling with portraits of poets, among whom Dante can be recognised, and a portrait of Raphael himself that corresponds to the self portrait which is part of the double portrait in the Louvre (Raphael and his fencing teacher). Traditionally, the room with the portraits of women was indicated as the room of Raphael's loves (Lotti, 1976, p. 72) but the frescoes of the women, attributed to Tamagni by Dacos (1976, pp. 46-51) and to an anonymous artist, with the same date, by Ferino (1989), are not considered to represent historically distinct personages. They would be a purely iconographic representation, along the lines of the "Amorosa visione" of Boccaccio (Lilius, 1891, p. 298), as opposed to the portraits of actual historical poets in the nearby room. The female figures would all have been obtained from models in paintings with no reference to the identity of the persons portrayed.

It has recently been asserted that the Barberini painting contains a Petrarchan allegory, referring to Raphael's poetry (Craven, 1994, pp. 371-394).

The figure of La Fornarina is identified as well in the fresco discovered in 1822 in the Dominican convent in Rieti, a version that sparked interest for its allegorical meaning. The woman portrayed full length is placed in the fresco representing Universal Judgment on the side of the chosen. The fresco, now known to be the 1556 work of Lorenzo and Bartolomeo Torresani, was attributed upon its discovery, certainly at least partially due to the presence of this figure and the attention focussed upon it, to Giulio Romano himself (Ricci, 1824; Sacchetti Sassetti, 1932).

The portrait of the Fornarina then passed into the collection of the Barberini family, who were eager to assemble a collection worthy of their princely family after the rise to the papal throne of Maffeo Barbarini in 1623 as Pope Urban VIII. An accurate description of the painting is found in a text by Teti, Aedes Barberinae ad Quirinalem, of 1642. Teti described the painting as one of the masterpieces in the collection of his lords, the Barberini, with all the enthusiasm it deserved. Translated, his text reads: the "highly noble [wooden] tablet on which [Raphael] painted an extremely beautiful nude woman half length, animated by an art so perfect in its lines and colours that it would truly seem that from the painting a living person could emerge, nay, if you regard her unguardedly she takes your breath away; and in comparison to her you would not even deem preferable the famous Campaspe painted by Apelle".

The painting is then regularly cited in the inventory of the house of Barberini, always as a work by the hand of Raphael. In the inventory of the cardinal Antonio in April 1644, "a painting on wood with a portrait of a nearly nude woman, by the hand of Raphael of Urbino, set in a walnut frame with gold highlights" (Lavin, 1975, p. 170). A protective structure was added to the tablet consisting of "two doors", as would be written in subsequent inventories. In the inventory compiled after the death of Maffeo Barberini in 1686 the description of the painting is more precise: "A portrait on wood of a Woman holding one hand to her breast and the other between her Nude Thighs, with a red cloth about 4 inches high and 2.5 inches wide, with a walnut frame carved into arabesques with golden highlights with its similarly carved walnut doors, by the hand of Raphael" (Lavin , 1975, p. 408)

The painting was cited again in the 17th century in the Microcosm of Painting by Francesco Scannelli (Scannelli, 1657, p. 166), published in 1657, and described as: "a half-length portrait of a woman au naturel in the gallery of the most eminent Antonio Barberino, painted according to the tastes of the paintings found in Ghisi, and believed to be the portrait and particular model of [the artist's] beloved, a painting which contains above and beyond the very adequate sufficiency of [his] art, an extraordinary mellowness and great and clearly evident naturalness."

The sources do not call into question the attribution of the painting to Raphael before the end of the 18th century. The first to advance such reservations was P. Della Valle in the notes to the 1799 edition of Vasari, asserting that the colours of La Fornarina were closer to those typical of Giulio Romano. In the 1800s the critics are divided: Missirini in 1806, recognises the signature but calls into question its authenticity; Quatremère attributes the work completely to Giulio Romano, and Von Rumhor to Raphael's students; Pungileoni and Passavant, and later Gruyer, uphold the attribution to Raphael, whereas Duppa and J. Cartwright, and especially Morelli, argue for the hand of Giulio Romano. Minghetti considers the painting to have been the work of Raphael's students after his death. Muntz, Cavalcaselle and Crowe all attribute the work to the master, and Berenson himself did not initially accept the work into the Raphael catalogue, but later reconsidered.

In the 1900s divisions among the critics become even more complex. Along with numerous sustainers of the hand of Raphael (Venturi, Filippini, Di Carpegna, Della Pergola, Prisco, Schearman, Ponente, Oberhuber, et al.) and those leaning towards Giulio Romano (Ricci, Carli, Dussler, Brandi, et al.), there is a third group that maintains an intermediate position arguing that in the Barberini Fornarina, to a perhaps un-

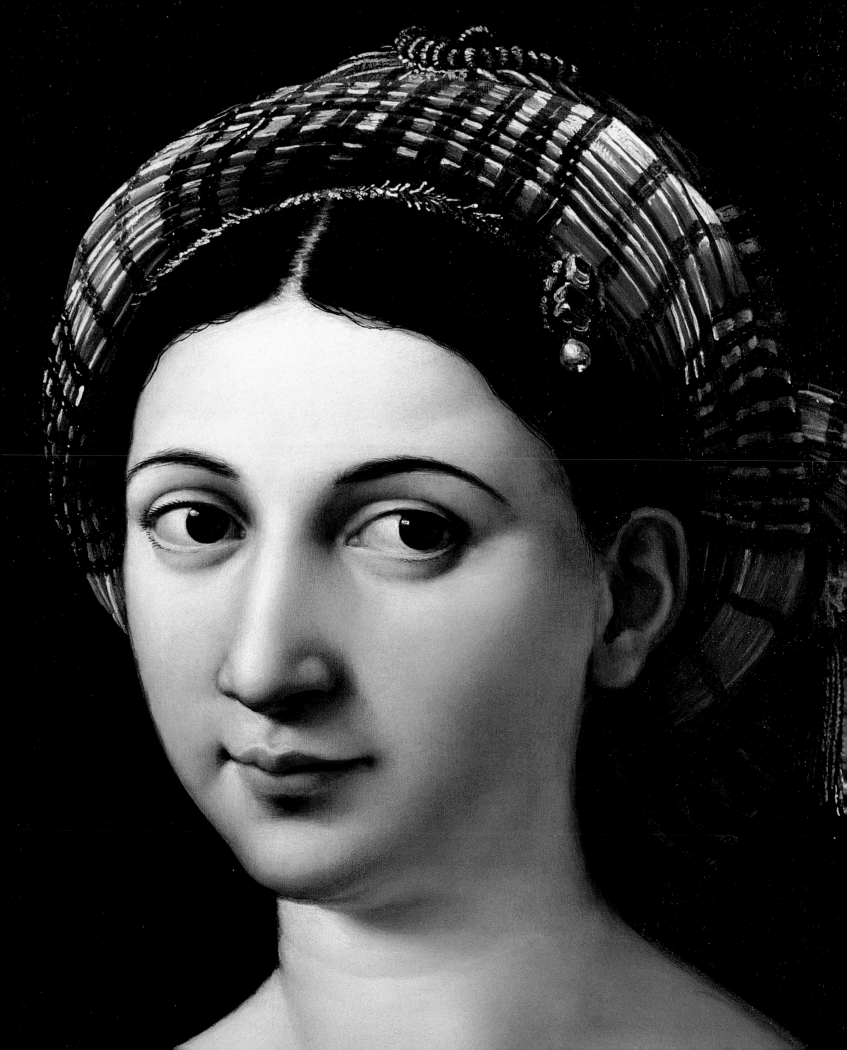

completed first rendering by Raphael, the work of Giulio Romano was added. This thesis is supported by S. Ferino, who sees in the painting a small contribution to the background by Giulio Romano. Today Raphael's sole authorship appears fully documented by new information gained during restoration work and by analyses performed on the painting.

There are numerous copies and versions of the Barberini *Fornarina* whose history cannot always be easily retraced.

Edward Wright (1730, p. 292), writing around 1720-21, had noted the presence of a copy by Giulio Romano in the Palazzo Barberini. Richardson (1754, p. 157) also noticed it and compared it unfavourably to the original. Abbé Richard also fails to make favourable mention of it "Une copie faite par Jules Romain, d'un coloris beaucoup plus dur, qui n'a aucun agrément" (1766, vol. VI, p. 69), when placed next to the original painting. Nibby mentions it in the same place in 1838, attributing it to Giulio Romano (1841, vol. IV, p. 590). This copy does not appear in the list of the Barberini *fideicommissum* of 1817 and neither is it included in the list of works that were the objects of the compromise with the State in 1934. It was part of the works transferred to the Galleria Sciarra Colonna at the time of the division as per the agreement of 1811 regarding the division of the Barberini *fideicommissum* among the two houses represented by the two children of the last heir, the princess Cornelia Costanza Barberini, wife of Giulio Cesare Colonna di Sciarra. In the Sciarra collection a copy of *La Fornarina* is indicated by Longhena in the notes to his translation of Quatremère in 1829. There is also a copy in the Villa Albani in Rome brought there from the palazzo Albani alle Quattro Fontane (Mochi Onori, 1985) after its purchase by Alessandro Torlonia in 1866. A copy of *La Fornarina* is also found in the Galleria Borghese (see the information by A. Costamagna in this catalogue).

A painting in the Museum of Moscow is considered to be another version of the Barberini *Fornarina*. The painting had previously been at the Hermitage and before that in the collection of Olimpia Aldobrandini, princess of Rossano, in whose inventory of 1626 it is described as "a portrait of a nude woman on a large wooden tablet by Raphael d'Urbino" (della Pergola, 1959, pp. 121-122). In the Hermitage catalogue, according to Crowe and Cavalcaselle (1891) the work is indicated as a portrait of Lucrezia Borgia, duchess of Ferrara. The work was probably in the Doria Pamphilij collection in the 1800s (the collection of the princess of Rossana was divided between the Pamphilij and the Borghese), where a copy of the Barberini *Fornarina* is cited up until the 19th century. The painting would have passed, before arriving in Russia, through the Lambruschini collection in Florence and the Noè collection in Brussels (Gruyer, 1881, p. 76.)

According to Crowe and Cavalcaselle, a copy of the Barberini *Fornarina* was also present in the Capitoline Museums "with the no. 150" (Markova, 1989, p. 274). Cavalcaselle has also left us an interesting drawing with annotations of the Barberini painting.

Longhena, in his notes to the translation of Quatremère (A.C. Quatremère de Quincy, trans. Longhena, p. 329) speaks about a copy of the Barberini *Fornarina* present in the house "of a certain sig. Celli, private citizen", information communicated to him "by letter from the distinguished painter sig. Filippo Agricola" (who also references the Sciarra and Borghese copies). Another copy is mentioned by Pungileoni in the Gallery of the Marchese Letizia in Naples, "which may be one of the many copies made by the disciples" (1829, p. 156).

(*L.M.O.*)

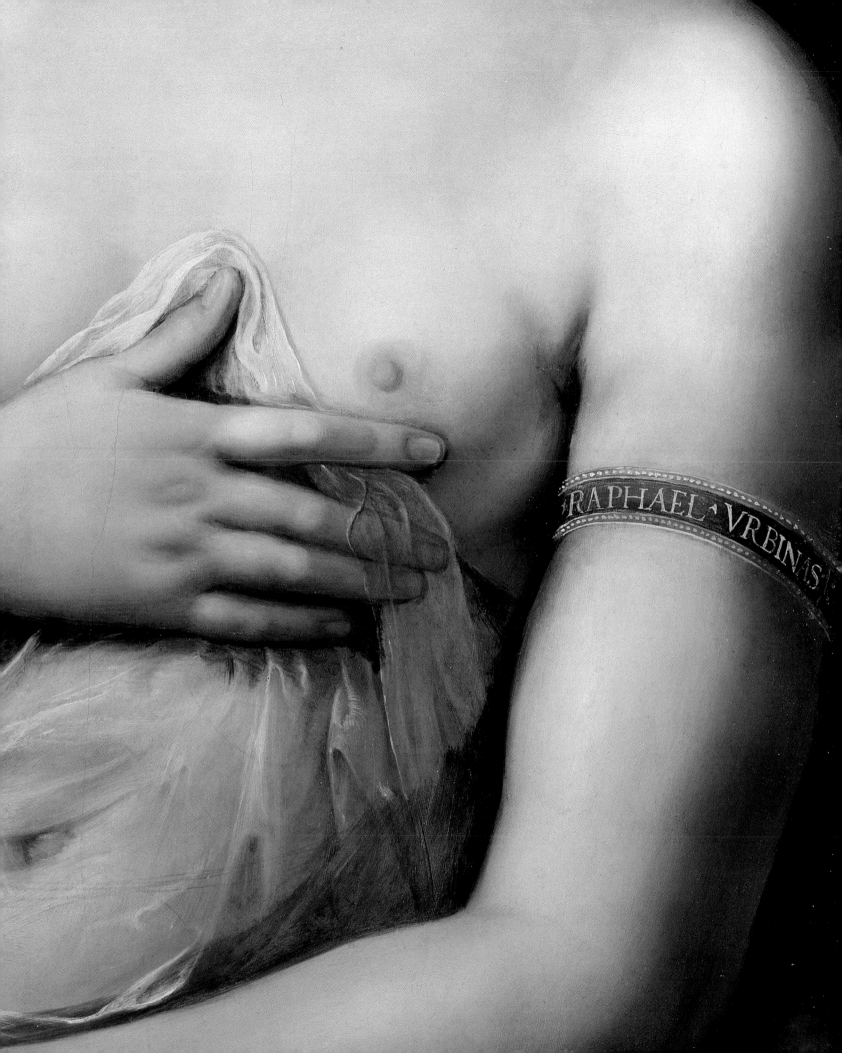

# Giulio Romano (Rome, 1499 – Mantua, 1546)
## *Madonna and Child* (known as the *Hertz Madonna*)

Oil on wood
36 × 30.5 cm
Rome, Galleria Nazionale
d'Arte Antica (inv. 1661)

**Bibliography:**
*Guida generale delle Mostre
retrospettive in Castel
Sant'Angelo*, Rome 1911,
p. 194; Venturi 1926, IX, 2,
p. 358; Richter 1928, p. 39;
Hartt 1944, p. 89; Hartt
1958, p. 54; Nicco Fasola
1960, p. 66; Gould 1982,
p. 480; Lo Bianco 1984,
p. 97; Lo Bianco 1988,
p. 124; Ferino Pagden 1989,
pp. 74 e 270; Oberhuber
1992, p. 25; Young, Joannides
1995, p. 732; Oberhuber
1999, p. 237; Oberhuber
1999, cat., pp. 21 e 250.

This painting came from the collection of Henriette Hertz who bought it at auction in Cologne at the end of the nineteenth century (Oberhuber 1999, p.250). It became part of the Galleria Nazionale collection in 1915; there is no earlier information on the history of this painting.

The composition is both refined and complex. The Madonna, sitting frontally in the centre in accordance with the *Odegetria* prototype, holds the Child in maternal fashion on her lap, the Child's right hand is raised in benediction. The detailed background shows the carved wooden edge of a bed with a heavy canopy. Delimiting the space towards the front is an open chest and almost totally in the foreground a small stool covered with a light cushion, a virtuoso lesson in folds. In the background to the right an open door reveals, in a somewhat mannered fashion, yet another door, also open and partially showing a Savonarola-type chair. The Madonna's dress is extremely detailed, the cloak is tied by a knot on the shoulder and the complex folds of her hair fall in two bands softly framing her face.

Attribution of this painting to Giulio Romano was unanimous. The first doubts were raised by K. Oberhuber in 1992 in a short note where he pointed out that this work was considerably different from the artist's early works such as the *Five Senses* or the *Madonna of the Cat* and belonged to "that category of very refined paintings commissioned for princely courts". Oberhuber returned to this matter when writing about the painting in the 1999 exhibition catalogue. Here he goes into more detail: underlining the strongly Raphael-like character of the painting he links it to other paintings of the Madonna by that artist from the 1515-16 period such as the *Madonna of Divine Love* at Capodimonte in Naples. Apart from the general approach he stresses the emphasis on rich colours, unusual for Giulio Romano, who employed colder, more metallic colours. If it is true that the prototype was from Raphael, as sustained by Richter who named it as the *Madonna della Seggiola*, I believe that another work, the *Sistine Madonna* is more clearly the model, adopting the frontal pose and

countenance as well as the Child, who is totally enveloped by his Mother. The dark, almost wide open eyes of this model, the wavy hair seemingly tossed by an imaginary wind, and the soft folds of the Infant's stomach are precisely reproduced. This deeply innovative work from 1513-14 must have been a reference for the young Romano who had just began his apprenticeship in the master's studio.

Though the evidence put forward by Oberhuber is convincing, I cannot accept his thesis, because, within the strong imprint of the original, Romano also stands apart with a strong personal interpretation, rich in references to a different figurative vision that recurs and is clearly documented as belonging to his output.

As regards iconography, the nearest reference to be found is the *Madonna of the Cat*, where the same background details appear, even the two doves, typical of the contrived naturalism cultivated by Romano and completely foreign to Raphael.

As for issues regarding the date of the work and the role played by Raphael, an important element lies in the hypothesis that the model is the same used by the master in *La Fornarina*, clearly placing the work in the period of collaboration between master and disciple.

There is indeed a certain similarity in the features: the same perfect oval face, the high forehead, the arched eyebrows, the well-defined mouth and rounded chin, and the same hair with the same parting in the centre, though dark in the case of *La Fornarina* while light and ethereal in the *Hertz Madonna*.

The actual model, though ennobled, appears to have been surpassed by a personal interpretation that leaves her character intact while changing her appearance with complete individual freedom. The artist seems to have carried out a double re-evaluation of the subject: on the one hand moving towards a more domestic, everyday reality and on the other towards emphasis on the more refined elements conveying elegance through details in the languid expression and transparency of the subjects. It appears that Romano did not have a live model but

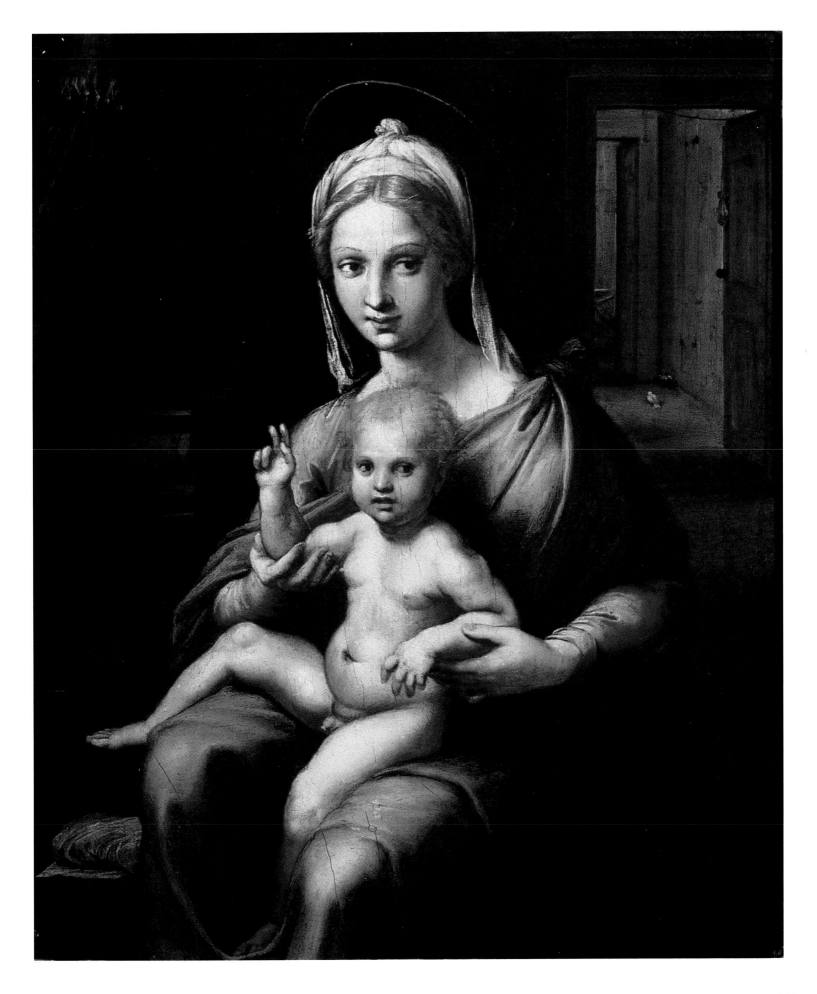

based his work on originals by Raphael, tracing countenances that he tended to repeat in search of an abstract, polished and opalescent beauty, as is found in the *Madonna of the Pearl* or the *Madonna of the Cat*, of which this painting can be considered contemporary or slightly earlier.

Hartt has pointed out a similarity between the Virgin and the *Portrait of Isabella d'Este* (Hampton Court Palace). I feel, however, that beyond any particular analogy, the full sweet face with large eyes and slightly frowning mouth, also seen in the Child, became a typical aspect of the artist's female and infant figures.

The recently concluded restoration by Antonella Docci has shed light on the extremely refined nature of the work by revealing a series of sophisticated details. Among these is the golden hair of the Child, which creates His halo by being illuminated at the sides. The colour, weighed down by oxidisation, is now silvery and metallic with the iridescent tones of the pearly canopy and the drapes strewn on the bed and stool.

During the restoration, a reflectogram was performed on the painting which revealed the underlying preparatory drawing of the entire painting in a full, solidly executed drawing perfectly defining the composition. It was not limited to mere outlines but included preordained and completed details to be repeated in colour. Indeed the shading of facial features is visible, for example, on the nose and eyelids, which brings them out strongly from the background.

The stroke, moreover, is firmly concentrated on the fullness of heads, legs and the whole composition of the image. A close affinity is noticeable with the equally firm and finished drawing of the *Madonna with Child* by Giulio housed at the Louvre (Département des Beaux-Arts, Inv. no. 3607), which Oberhuber, in 1999, attributed to Raphael. During restoration of *La Fornarina*, a reflectographic analysis was made that revealed a totally different procedure in the preparatory drawing by Raphael, in that it was much freer and only formed a preliminary grid rather than a sketch of the entire composition.

It should also be noted that Young and Joannides have published a preparatory drawing of the *Hertz Madonna* from a private collection. (A.L.B.)

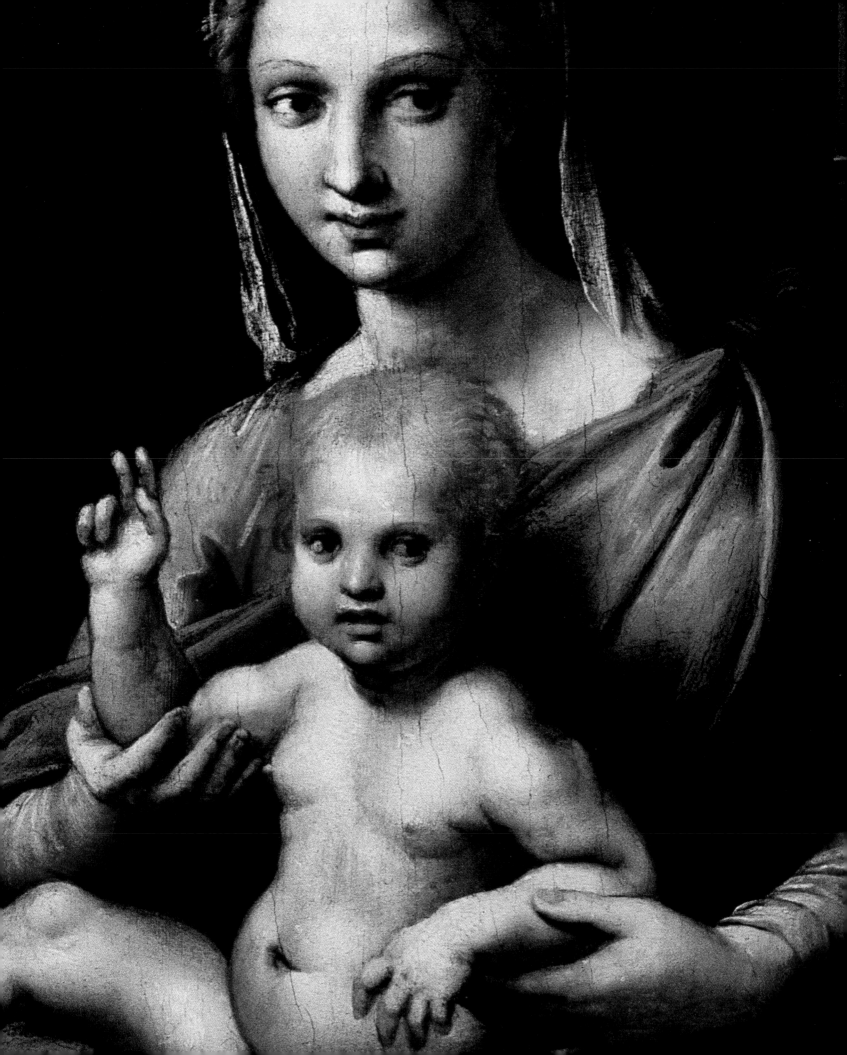

Drawings

Raphael Sanzio (Urbino, 1483 – Rome, 1520)
*Nude woman kneeling to the right in profile*, 1517-1518

Sanguine, with later retouchings in charcoal
278 × 186 mm
Edinburgh, National Gallery of Scotland, inv. D 5145

**Provenance:**
Peter Lely collection (stamp, Lugt 2092); William, second Duke of Devonshire (stamp, Lugt 718); by descendancy to the eleventh Duke; sold to the National Gallery of Scotland in Edinburgh in a secret deal (1987).

**Bibliography:**
Crowe, Cavalcaselle 1890, p. 300, note 1; Popham 1931, pp. 236-237, no. 743; Fischel 1948, I, p. 104; II, Fig. 98; Shearman 1964, p. 70; Oberhuber 1972, no. 480; Gere, Turner 1983, pp. 201-202, Fig. 161; Knab, Mitsch, Oberhuber 1983, no. 548; Joannides 1983, p. 239, no. 420; *Disegni degli Alberti*, 1983, pp. 167-179, n. 108; Oberhuber 1986, pp. 195-196; *Raphael, the Pursuit...*, 1994, n. 47; Jaffé 1994, p. 181, n. 310.

The drawing was part of the illustrious graphic collection of the Duke of Devonshire up to 1987 when it passed into the hands of the National Gallery of Scotland in Edinburgh.

The critics have generally recognised the authorship of Raphael in this harmonious female profile. Fischel (1948) underlines the unmistakable vital impulse and indicates it as possibly the last sanguine drawing done by Raphael. Joannides (1983) takes as his points of reference the fluid line and the lightness of the border.

Opinions regarding the destination of the drawing are more varied. While Crowe and Cavalcaselle (1890) regard it as a work for the scene of the *Fire in the Borgo*, Fischel (1948) thought it was an idea for the drapery figure found at the extreme left on the wall of the *Mass at Bolsena*. Popham, had already suggested in 1931 the more evident connection with the other works associated with the decoration of the *Psyche Loggia* in the Farnesina, a hypothesis more widely accepted also by recent criticism (Joannides 1983; Jaffé 1994). Following Shearman's (1964) reconstructive and iconographic hypotheses regarding the *Psyche Loggia*, the figure represented here could be part of the scenes meant to narrate the episodes of the story of Psyche on earth planned for the upper lunettes, which were never realised. Joannides (1983) points out a parallel with the drawing in the Louvre (*Nude standing female*; M.J. 1120v, sanguine on stile, 362 × 252 mm) which was a study for a group of *Psyche with servants* that was never executed. This comparison had already been suggested by Shearman (1964), who also pointed out the relationship to an engraving by Giulio Bonasone in which a woman, seated in a similar ammner but turned towards the left, is being approached by three handmaidens.

A recent finding in the Farnesina villa of an album of drawings that once belonged to the Alberti family (see H. Fiore, 1984) and which contains a pen and ink sketch of the same group, reversed with respect to the print, provides further support for establishing the chronology of this drawing, placing it alongside the group of studies for the *Psyche Loggia*, dated 1517-1518 (Jaffé 1994). Oberhuber (1986) hypothesises a precise chronology for the different groups of drawings meant for the *Psyche Loggia*: this drawing from Chatsworth is, in this sense, united with nude studies for the *Ostia Battle* (Vienna, Albertina) and chronologically placed between the first realised studies. (*A.F.*)

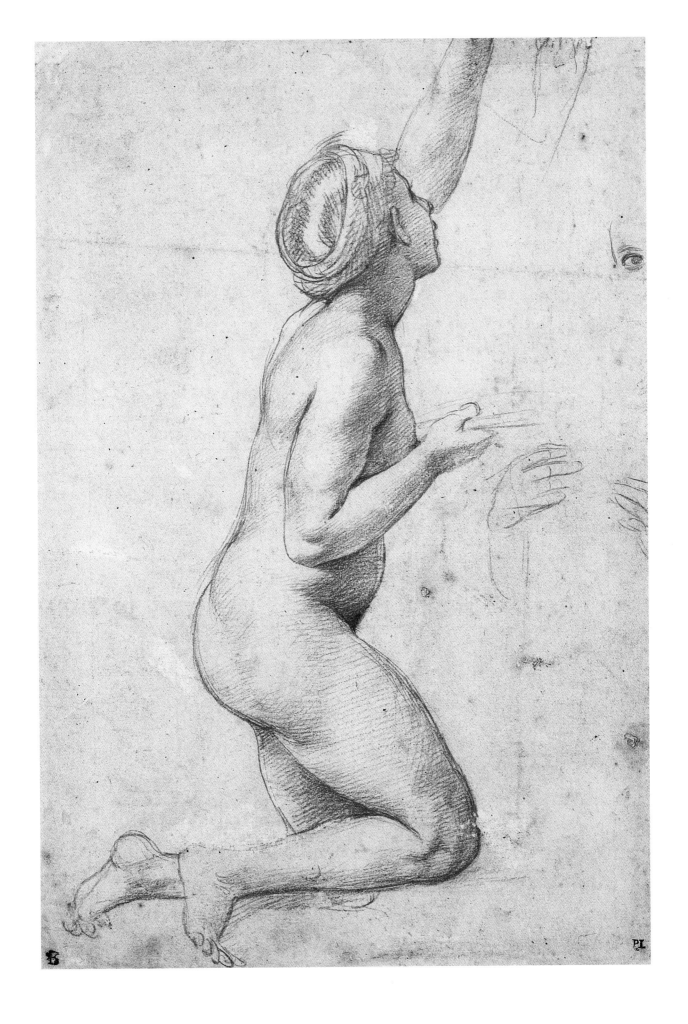

149

# Raphael Sanzio (Urbino, 1483 – Rome, 1520)
*Head of the Muse Thalia, almost in profile to the left*

Black pencil on rather darkened white paper
267 × 209 mm (maximum measurements)
Florence, Fondazione Horne (inv. 5643).

Traces of black and gold ink along the margin marking old framing (back).
Proprietary stamp for the Fondazione Horne, Florence (Lugt n. 1266c)

**Inscriptions:**
signs of old glue and minor restoration (front). In pen on the reverse, written in eighteenth century handwriting: "B G no 35", "B740", and in different hands in pencil "19", "9", "2", "L.rdo Da Vinci.", "from M [...] Sale", in pen "3740".

**Bibliography:**
Fischel 1913-1941, pp. 265-266, no. 254; Gamba 1961, p. 50; Dussler 1966, p. 85; Rossi 1966, p. 169; Forlani Tempesti 1968, p. 385, and note 127 p. 425; Dussler 1971, p. 76; Shearman 1972, p. 99, fig. 53; Oberhuber 1978, p. 55; Joannides 1983, no. 244, p. 193; Jones, Penny 1983, p. 74, fig. 84; Oberhuber 1983, no. 379; Ames-Lewis 1986, p. 98, fig. 117; Morozzi 1988, note 77, p. XXVII; Oberhuber 1999, p. 105, fig. 96.

Since Fischel, specialised experts have always attributed this drawing to Raphael. This study by the master from Urbino is for the beautiful face of the Muse who holds a book as she stands beside Apollo in the *Parnassus* fresco, his third fresco in the *Stanza della Segnatura* at the Vatican, which dates from late 1510 to early 1511.

Comparing drawing and fresco, the model in the drawing already has the outlines of the red cloak and dress of the fresco, the profile is more gracefully poised and almost turned in a three-quarter view thanks to a slight arching of the neck. The model's hair in the fresco is embellished with a gold ribbon.

The "classical" tone of this ideal head, which has already been discussed (cf. S. Ferino Pagden in Florence 1984, p. 340), has usually been explained by Raphael's interest in models of ancient sculpture during the graphic elaboration of the *Parnassus*. This can also be observed in the peculiarity of the soft graphic medium used for this study: thanks to the effect of a strong light source to the left, the features of the Muse become decidedly plastic with subtle chiaroscuro effects and much attention is given to rendering their purity with absolute distinctness. It might also be pointed out that the rapid movement of the pencil as it softly traced the image tended to lose the meticulous expertise seen in other parts, thickening and becoming layered and sketchy in places, for example, in the heavily shaded locks of hair around the ear.

This carefully made drawing, which is in scale with the fresco, can be considered a preliminary study carried out before the preparatory cartoon (cf. Ames Lewis 1986, p. 99).

Raphael probably made use of this study on other occasions, as has been observed in the case of the cartoon made for the tapestry of *The Healing of the Lame Man*, as well as some other works dating from after 1514 (cf. Shearman 1972, p. 99, pl. 20; cf. Oberhuber, in Brown, Oberhuber 1978, p. 55).

The thickness of the paper used for this drawing, quite unusual when compared to the types of paper used in the early sixteenth century, could be explained by the large quantity of glue applied to the back of the sheet (stated verbally by Maurizio Boni, restorer at the Gabinetto Disegni e Stampe at the Uffizi Gallery, 1999).

A later copy of the drawing, attributed to Francesco Furini, is housed at the Kupferstichkabinett in Berlin, (inv. KdZ 16303; 234 × 168 mm, red pencil and grey chalk on white paper). (*C.G.*)

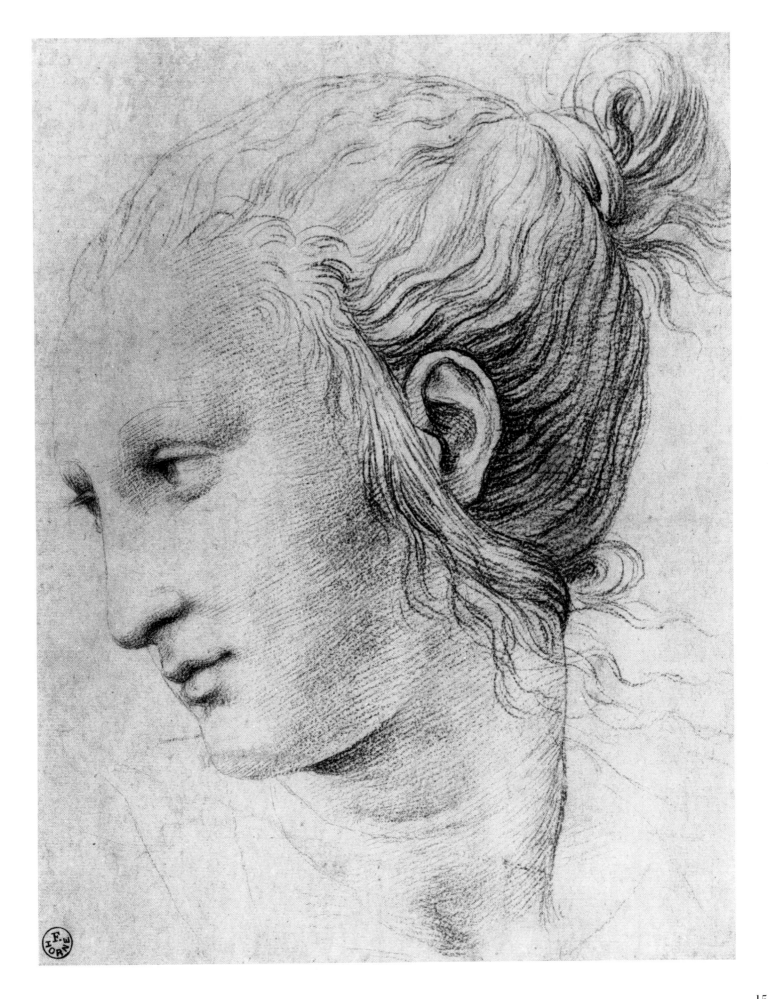

151

**17**

# Raphael Sanzio (Urbino, 1483 – Rome, 1520)
## *Two-thirds figure of Madonna with Child*
## (study for the *Madonna of the Grand Duke*)

Black pencil, stump, traces of stylus on somewhat darkened white paper
213 × 184 mm (maximum dimensions)
Florence, Uffizi, Gabinetto dei Disegni e delle Stampe (inv. 505 E)

Missing some fragments and criss-crossed by small lacerations along the borders; recovered.

**Inscriptions:**
On the back there are traces of old pencil annotations; on the lower left in pen, in old-style script: "Franciabigio". Proprietary stamp for the Gabinetto Disegni e Stampe degli Uffizi (Lugt n. 930)

**Bibliography:**
Ruland 1876, IV, p. 55, no. 7; Crowe, Cavalcaselle 1882-1885, I, p. 249; Ferri 1890, p. 201; Morelli 1892-1893, c. 161; Fischel 1898, no. 42 (with former bibl.); Frizzoni 1912-1921, series III, fasc. 2, n. 6; Fischel 1913-1941, no. 105; Fischel 1962, p. 34; Pouncey, Gere 1962, no. 289; Forlani Tempesti 1968, pp. 343, 421, note 77, fig. 40; Pope Hennessy 1970, p. 184, fig. 170; Dussler 1971, p. 18; Petrioli Tofani, De Vecchi 1982, pp. XIII-XX (with further bibl.); Brown 1983, pp. 130-131; Forlani Tempesti 1983, tav. XVI; Joannides 1983, no. 105; Quednau 1983, pp. 150-152, fig. 22; Ferino Pagden 1984, pp. 354-355 (no. 42); Incerpi 1984, pp. 92-93; Petrioli Tofani 1986, p. 227; Ferino Pagden, Zancan 1989, p. 42 ; Cordellier, Py 1992, p. 51; Chiarini 1995, pp. 37-38, fig. 38; De Vecchi 1995, p. 210 (no. 23); Meyer zur Capellen 1996, pp. 157, 160, 162, fig. 99; Clayton 1999, pp. 54, 56; Meyer zur Capellen 2001, p. 208, fig. 24/I.1.

The study addresses the *Madonna of the Grand Duke* (Florence, Palatine Gallery in Palazzo Pitti) and documents Raphael's experimentation with painting formats: initially the artist leaned towards the round or oval before opting for a horizontally oriented rectangle. The drawing was sketched with a stylus and then lightly gone over with black pencil, intensified in the accentuated chiaroscuro. The option of adding a landscape to the background was contemplated by the artist, as shown by recent radiographic tests on the painting, which reveal the original enclosed setting beneath the dark background. The space opened up behind the Virgin into a landscape seen through an arched window (cfr. the information sheets on the painting, its restoration and diagnostics in *Raffaello a Firenze...*, *op. cit.*, pp. 88-98, 247-249). The enfolding and softly shaded light created from the interplay of the two sources of illumination, of a more mature Leonardesque conception, led several scholars to date the painting to 1506, rather than the generally accepted 1504-05 (cfr. Camesasca 1962, p. 42; Ragghianti 1978, p. 149; Oberhuber 1982, p. 42; Jones-Penny 1983, p. 22; G. Incerpi 1984, pp. 92-93).

Raphael resorted to an analogous solution of including a view of a landscape seen from an interior in his *Madonna* in Leningrad and in the Aldobrandini and Bridgewater Madonnas, the latter presenting today, as in the Pitti painting, a uniform background deriving from the subsequent opaque coatings (cfr. S. Ferino Pagden, in *Raffaello a Firenze...*, 1984, p. 352).

The neutral background in the *Madonna of the Grand Duke* could be attributed, according to Chiarini (1995, pp. 42, 44), to an intervention by the artist himself, rather than to posthumous modifications. By replacing the domestic interior with a dark background, "suggestive of a universal dimension" and a feature of the portraits done in the same period, the artist would have achieved the final rendition of the painting during its execution, in keeping with normal working practice. Even the small differences perceptible in the poses of the two characters in the painting and in the drawing, where the relationship between mother and child is less idealised and more natural, have been interpreted in terms of a deeper immersion into the theme in the process of going from the first sketch to the final realisation (cfr. Ferino Pagden 1982, pp. 106-107).

Brown (1983, p. 132) argues that this study may be derived from the *Cowper Madonna*, given that the drawing presents closer formal relationships with the American painting than with that in the Palazzo Pitti. As was rightly observed by Ferino Pagden, it is possible that Raphael worked out the two compositions simultaneously, compositions which are also united by ideas similar to other Madonnas ascribable to the same period, as shown by various studies with analogous contents (cfr. Ferino Pagden 1984, pp. 352-353; cfr. Clayton 1999, pp. 54-56).

For his choice of composition, the artist would have had to draw inspiration from a three-dimensional prototype, indicated by Pope Hennessy (1970, p. 184) as being one of Della Robbia's low reliefs, and by Ferino Pagden as being the contemporary Urbino sculpture, where the same motif of the Child sitting on the mother's arm is found (*op. cit.*, 1984, p. 352, Fig. 128).

A copy of the drawing, ascribed to Timoteo Viti, is kept in the British Museum (Pouncey-Gere, 1962, no. 289, plate 273). (*C.G.*)

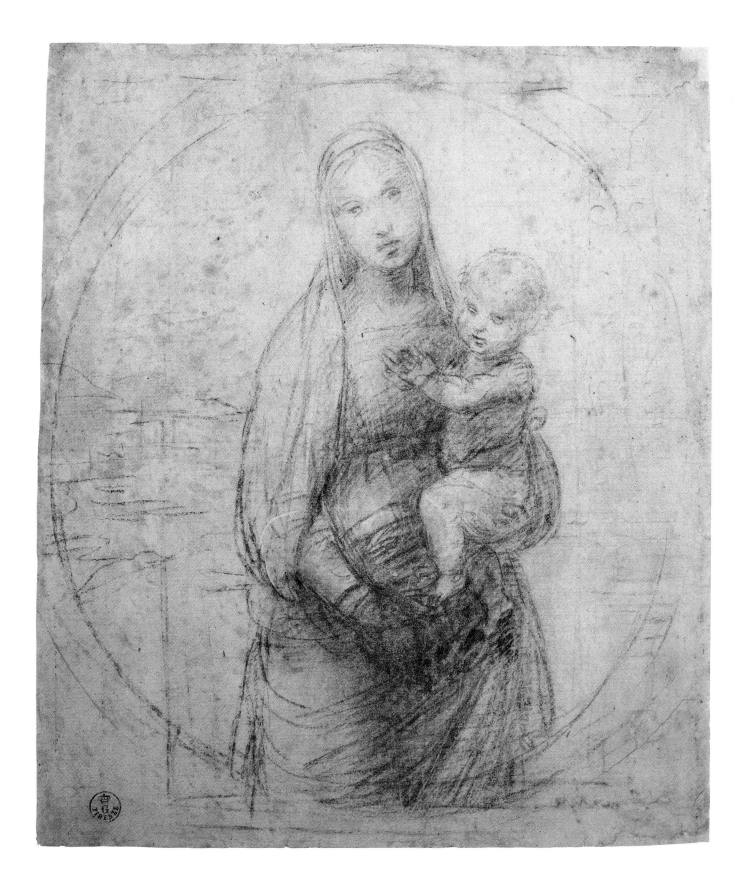

153

Raphael Sanzio (Urbino, 1483 – Rome, 1520)
*Madonna with Child and John the Baptist holding a lamb*

Pen and brown ink on somewhat darkened white paper
160 × 133 mm (maximum dimensions)
Florence, Uffizi, Gabinetto dei Disegni e delle Stampe (inv. 515 E)

Small tears and gaps along the margins, repaired during restoration

**Inscriptions:**
On the back in old-style calligraphy with charcoal: "4". On the lower left in old-style calligraphy with pen: "Di Rafaello", partially cut from the lower border of the sheet.
Proprietary stamp for the Gabinetto Disegni e Stampe degli Uffizi (Lugt 930).
Watermark similar to Briquet no. 7855, cut from right margin.

**Bibliography:**
Quatremère de Quincy 1829, p. 425, no. 6; Passavant 1839, II, p. 483, no. 118; 1860, II, p. 419, no. 117; Ramirez di Montalvo 1849, no. 13; Ruland 1876, XXV, p. 93, no. 1; Crowe, Cavalcaselle 1882-1885, II, p. 339; Ferri 1890, p. 201; Morelli 1892-1893, c. 161; Fischel 1898, no. 416 (with previous bibl.); Fischel 1913-1941, n. 127; Petrioli Tofani, De Vecchi 1982, no. 9; Joannides 1983, n. 170; Oberhuber 1983, no. 146; Petrioli Tofani 1986, p. 231; *Musée du Louvre* 1992, p. 51 (no. 39), p. 214 (no. 294).

During his Florentine sojourn, Raphael had occasion to experiment with the potentials of drawing with pen and ink, the graphic medium best suited to the rapid annotation of his first thoughts, often destined, as in this case, to the development of a theme on which the artist often exercised himself in those years, as documented by the numerous studies we have of Madonnas.

In the drawing, dated by Ferino Pagden to around 1506-07, the rather close formal relationships with the study for the *Madonna of the palm tree* and with the cartoon and drawings for Leonardo Da Vinci's *Saint Anne* were rightly identified (cfr. Forlani Tempesti 1980, p. 184, no. 436), from which the motif of the lamb derives, present also in the studies for *La Belle Jardinière* and in the *Holy Family* in the Prado (cfr. Ferino Pagden 1984, pp. 355-356; cfr. Lehmann 1995-96, pp. 15-27 regarding the origins and developments of this theme).

The various rethinkings in the drawing displayed here, which also characterise other contemporary studies of Madonnas, are significant not only of the attention dedicated by Raphael to his live models, portrayed in the spontaneity of their gestures, but also and particularly of the artist's working methodology, aimed at the search for the most suitable figurative form to which to entrust the idea conceived in his mind and developed through a series of concatenated studies, addressing in this case a composition of complex structure, for which a round frame was probably chosen (cfr. Ferino Pagden 1984, pp. 279-280, 355-356).

A copy of the drawing by Edouard Manet is kept in the Louvre (cfr. Cordellier-Py 1992, no. 294, p. 214). (*C.G.*)

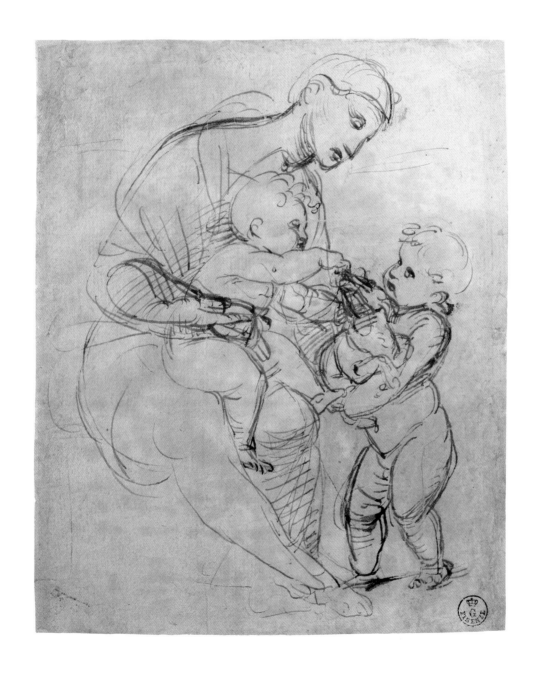

**19**  Raphael Sanzio (Urbino, 1483 – Rome, 1520)
*Child running towards the right with arms outstretched*
(study for the *Madonna of François I*)

Red pencil, traces of stylus on somewhat darkened white paper
270 × 209 mm (maximum dimensions)
Florence, Uffizi, Gabinetto dei Disegni e delle Stampe (inv. 534 E)

Small gaps along the margins repaired during restoration. Ink stains

**Inscriptions:**
Illegible writing on back and traces of red pencil.
Proprietary stamp for the Gabinetto Disegni e Stampe degli Uffizi (Lugt 930)

**Bibliography:**
Scotti 1832, c. 51; Passavant 1839, II, p. 482, no. 114; 1860, II, p. 419, no. 113; Ramirez di Montalvo 1849 (Raffaello), no. 23; Ruland 1876, p. 79, XXXVIII, no. 9; Crowe, Cavalcaselle 1882-1885, II, p. 400; Ferri 1890, p. 203; Morelli 1892-1893, c. 160; Fischel 1898, no. 323 (with previous bibl.); Fischel 1913-1941, no. 378; Hartt 1958, p. 28 e no. 19; Freedberg 1961, pp. 351 sgg.; Oberhuber 1962, p. 63; Forlani Tempesti 1968, pp. 406-407; Dussler 1971, p. 48; Petrioli Tofani, De Vecchi 1982, pp. XIII-XX; Joannides 1983, no. 395; Monbeig Goguel 1983, p. 296 (no. 107); Oberhuber 1983, n. 570; Knab, Mitsch, Oberhuber 1984, no. 570; Petrioli Tofani 1986, p. 239; De Vecchi 1995, p. 239 (no. 84); De Vecchi, Baldini 1999, pp. 30, 33, fig. p. 38; *Roma e lo stile classico...*, 1999, p. 152 (no. 91).

The sheet contains the preparatory study for the figure of the Child running into his mother's arms in the *Madonna of François I* (Paris, Louvre), a work signed and dated 1518. Commissioned from Raphael by Pope Leo X as a gift to the queen of France, the painting was delivered to her by the nephew of the pontiff, Lorenzo de' Medici, duke of Urbino, husband of the daughter of François I, Madaleine de la Tour d'Auvergne (cfr. in *Hommage à Raphaël...*, Paris 1983-84, pp. 93-95).

The painting, which depicts the Holy Family with the Baptist as a child, Saint Elizabeth and two angels, was executed in the period from late March to late May 1518, as attested by the contemporary correspondence (Dussler 1971, p. 48). During work on the prestigious commission, Raphael certainly must have relied on the assistance of pupils, a hypothesis supported by the results of recent cleaning. To varying degrees of agreement, the specialists attribute the figures of the Madonna, the Child and Saint Joseph to the master, whereas the other figures are attributed to Giulio Romano, Penni, Raffaellino del Colle and Giovanni da Udine (cfr. in *Hommage à Raphaël...*, op. cit., p. 95; cfr. Ferino Pagden, Zancan 1989, p.137).

The study of the Child on display, which does not differ substantially from the painting, was sketched with a stylus and then gone over with red pencil for a soft chiaroscuro effect. The same graphic technique was used for the other two preparatory drawings kept in the Louvre (inv. 3862; *Hommage à Raphaël...*, op. cit., no. 107) and in the Uffizi (inv. 535 E; *Raffaello a Firenze...*, op. cit., Fig. 154). In the former, the pose assumed by the Madonna hugging the Child is derived from a live model, dressed in an ample gown in the second sheet, where the artist dedicated painstaking attention to the study of the elaborate folds of cloth. The differences presented by the three sheets on the stylistic level have been traced to the different function fulfilled by each drawing (cfr. Ferino Pagden 1984, pp. 366-368). The attribution of the two studies for the Madonna either to Giulio Romano or to Raphael is still a matter of controversy (cfr. Monbeig Goguel 1983-84, p. 296; cfr. Clayton 1999, pp. 17, 132; cfr. Gnann 1999, p. 152). After approximately sixty years, a copy of the *Madonna of François I* (painting on canvas, 127 × 157 cm; Zurich, priv. coll.) has recently resurfaced, reduced to the two figures of the Madonna and the Child. For the execution of the work, already noted by Fischel, who attributed it to Penni, it has been hypothesised that the artist resorted to the same cartoon used for the original painting (cfr. De Vecchi – Ubaldini 1999, pp. 30-34), whose fragments are kept in the National Gallery of Victoria in Melbourne and in the Musée Bonnat di Bayonne (cfr. Cordellier-Py 1992, p. 504). (*C.G.*)

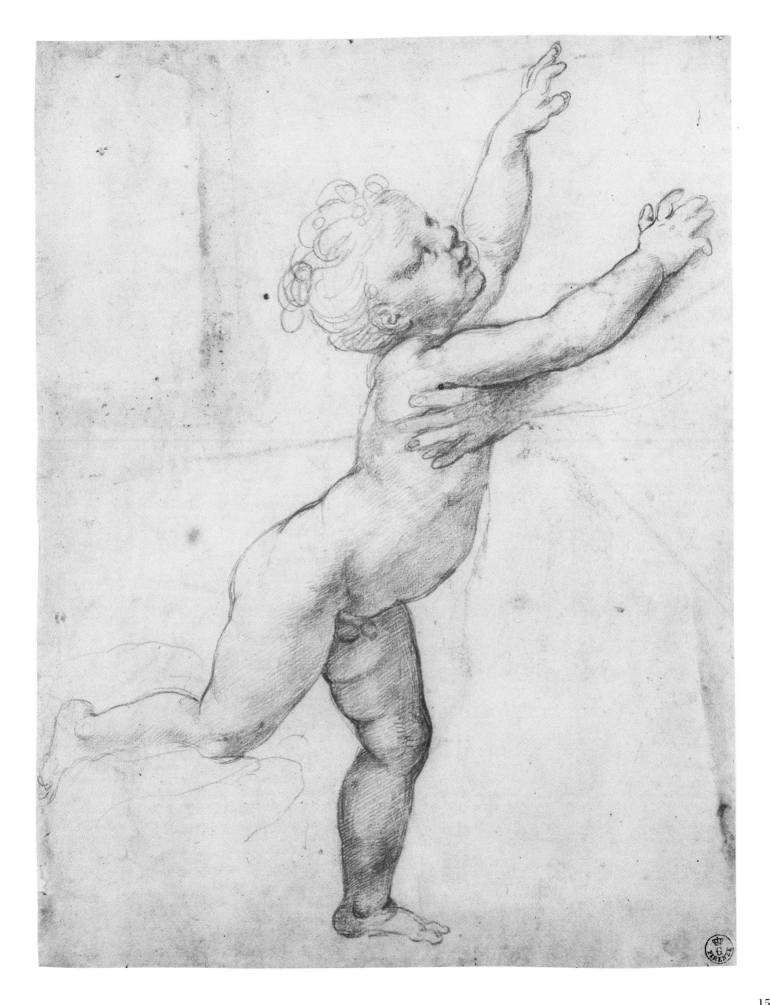

157

# Raphael Sanzio (Urbino, 1483 – Rome, 1520)
## *Moses before the burning bush*

Charcoal with traces of white lead highlighting on 23 sheets of paper with different formats plus three fragments of nineteenth century paper repainted with tempera, later removed and replaced during the recent restoration
1400 × 1380 mm
Naples, Museo e Gallerie Nazionali di Capodimonte
(inv. 86653 I.G.M.N.)

**Provenance:**
Farnese collection

**Bibliography:**
Mori 1837, class II, Div.IV; Niccolini 1857, vol. XVI, pl. XVI, pp. 1-7; Niccolini 1959, pp. 1-24; Passavant 1860, vol. II, p. 130; *Guida...* (1871), p. 62; de Nolhac 1884, p. 443, n. 61; Crowe, Cavalcaselle 1884, II, pp. 153 e 168; De Rinaldis 1911, p. 553; no. 681; De Rinaldis 1928; pp. 367-368; Ortolani 1942, p. 38; Molajoli 1957, p. 69, no. 400; Castelfranco 1962, p. 21, n. 57; Redig de Campos 1965, p. 34; Frommel 1967-1968, pp. 72-73; Oberhuber 1972, n. 411; Forlani Tempesti 1983, no. XLIV; *Le collezioni...* 1982, p. 54, no. 27; Knab, Mitsch, Oberhuber 1983, p. 627, n. 488; Muzii 1987, no. 4; Bambach Cappell 1989, p. 366, no. 265; Ferino Pagden 1990, pp. 195-204; Muzii 1993, pp. 12-22; Hochmann 1993, p. 86; Jestaz 1994, no. 4311; Muzii, in *La collezione Farnese...* 1994, pp. 309-311.

The cartoon corresponds exactly in composition and dimensions to the figure of Moses in the frescoed scene with the burning bush in one of the four side compartments in the ceiling of the Heliodorus Room in the Vatican, over the parietal story of *The expulsion of Heliodorus from the temple* on the east wall, whence the name of the room.

The other biblical episodes in the vaulted ceiling include *God's apparition to Noah*, *The sacrifice of Isaac*, and *Jacob's dream*.

The decoration of the ceiling, previously frescoed by Peruzzi with allegoric figures done in grisaille and battle scenes in eight compartments, is behind the parietal decoration and was begun in 1511 during the pontificate of Julius II and finished in 1514 after the election of Leo X to the papal throne.

The cartoon, perforated along the outline of the figure, is a preparatory cartoon to be used with a dusting bag in a technique often used by the artist.

The figure, in the format of the remaining fragment, was drawn from a live model and possesses a completely different vigour from the one in the fresco that has been compromised by earlier restoration work. Stylistic novelties, clearly assimilated from Michelangelo's ceiling of the Sistine Chapel, are present here: the tension of the form modelled through strong chiaroscuro effects is original, as are the emphasis on the outlines and the gigantism of the figure.

With the work on Michelangelo's ceiling uncovered during the early phases of work, in October 1512, Raphael inevitably had to face up to a new yardstick and extract new stimuli for his figurative work. Above and beyond the vigorous rendition that characterises the style of the drawing, the accent is placed on the emotional tension, on the drama and intensity of the miraculous event, captured in the gesture of the prophet protecting his eyes (Exodus, 3, 6).

The attribution to Raphael and the chronological placement of the frescoes were not uncontested events, however, the later date of the decoration of the Heliodorus Room and the authorship of the drawing are now completely certain. The work dates back to the beginning of summer 1514, a thesis earlier advanced by Oberhuber and Shearman, and newly affirmed by Ferino Pagden, supported by the findings of a study of the ceiling in the National Museum of Stockholm (Ferino Pagden 1990). The date 1514 (the last payment to Raphael is recorded as being made on 1 August of that year) is included in the inscription on the architrave of the window between fake tablets, on the wall with *The liberation of St. Peter*.

The sheets remaining in the Uffizi (Ferino Pagden in *Raffaello a Firenze* 1984, pp. 317-319, no. 20), in the Ashmolean Museum of Oxford (Gere, Turner 1983, pp. 178-179, no. 145) and in the National Museum of Stockholm confirm the process of careful elaboration of the biblical scene with sketches and preliminary studies for the final cartoons, a technical prerogative of the artist's pupils. In a graphical technique analogous to this Neapolitan one, the two fragments of cartoons were done for the heads of the angels in the *Expulsion of Heliodorus from the temple* (*Raffaello e i Suoi* 1992, pp. 168-169, nos. 60 and 61) and for the head of the horse in the same scene (Gere, Turner 1983, p. 177, no. 144). The degree of perfection achieved by the artist leads one to suppose his desire to affirm the autonomous value of these instrumental drawings as works of art in their own right, sought out and conserved by the more aware collectors of the time.

Raphael himself was accustomed to donating to princes and patrons some of his cartoons for the frescoes in the Vatican and also for paintings.

In the seventeenth century, the Neapolitan cartoon had already become part of the excellent collection belonging to Fulvio Orsini, the erudite archaeologist and bibliophile who worked in the service of Cardinals Ranuccio and Alessandro Farnese. The collection already contained such masterworks as Michelangelo's cartoon for the Paoline Chapel with the *Group of Armigers*, the drawing by Sofonisba Anguissola with *The boy pinched by the crab*, and paintings by Mantegna, Sebastiano del Piombo, El Greco and Giulio Clovio as well as valuable antiquities. The collection was willed by Orsini in his testament of 31 January 1600 to Cardinal Odoardo Farnese, and thereafter, through Charles Bourbon's inheritance from his

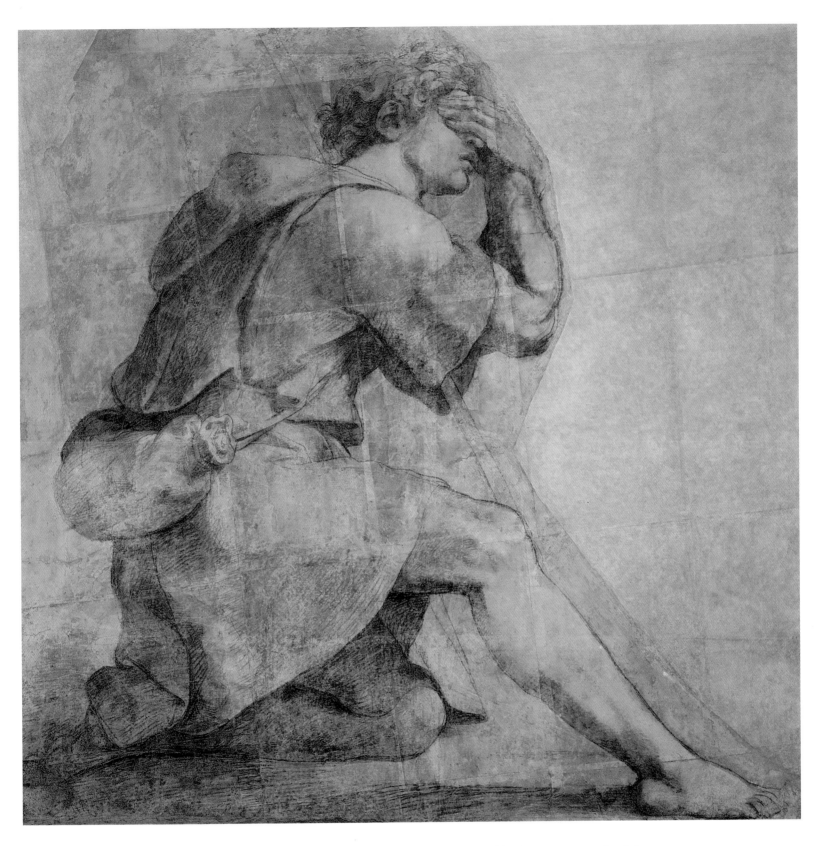

mother, Elisabetta Farnese, it reached Naples.

In 1759 the work was sent from the Palazzo Farnese in Rome to the Palazzo di Capodimonte, the new home of the museum for the Farnesian treasures. Fortunately, the risk of the work being sent to France was foiled at the last minute when it was already packed into a crate with other cartoons and paintings from the collection. The cartoon was moved from the Real Museo Borbonico, later named Museo Nazionale di Napoli, to the Museo di Capodimonte, where it has been on display since 1957.

The cartoon underwent restoration work in 1989-90. (R.M.)

# Marco Dente da Ravenna (Ravenna, 1493 c. – Rome, 1527)
## *The Judgement of Paris*, 1516-1518

Engraving
292 × 443 mm
Paris, Bibliothèque nationale
de France

**Monogram:**
MAF

**Inscription:**
RAPH. URBI. INVEN /
SORDENT PRAE FORMA
INGENIUM VIRTUS REGNA
AURUM

**Bibliography:**
Bartsch 1813, XIV, p. 198, no.
246; Passavant 1864, VI, pp.
70, 46; Delaborde 1887, p.
160; *The Engravings…*, 1981,
pp. 190-191, no. 65; Rodari,
Mason 1984, pp. 51-52, no.
60.

The *Judgement of Paris* by Marcantonio Raimondi (Bartsch 1813, XIV, nos. 197, 245; Passavant 1864, VI, nos. 25, 137; Delaborde 1887, no. 114; Shoemaker 1981, p. 146, no. 43), undoubtedly produced on the basis of a drawing supplied by Raphael, was an enormously successful engraving for the broad influence it exercised, thanks partially to the very particular technique used in making it. By means of an ingenious treatment of the virgin plate with pumice stone, Raimondi gave the scene a uniform background with an atmospheric effect that exalted the refined compositional fabric of his fine lines.

Marco Dente da Ravenna, of whom we have very little biographical information (except that he died in 1527 during the Sack of Rome), was from 1515 one of a group of engravers (with Agostino Veneziano and later with Ugo da Carpi) that coalesced around Marcantonio in Raphael's study. The group did not have a disciple relationship with Raimondi but rather took on the engraving of Raphael's works as equals (Massari, p. 13).

Following the magisterial work of Raimondi, Marco Dente indicated his vocation to be a copier without, however, succeeding in achieving all the tonal and atmospheric effects that Raimondi was able to deliver. Shoemaker (1981) made a ruthless analysis of his work along these lines. Dente's modelling of such figures as Venus appears angular, losing the subtle Raphaelesque grace of Raimondi's female forms, while the emphasis placed on the facial profiles ends up impoverishing the dynamic rendition of the bodies. Marco Dente's engraving technique did not include the prick punch and was often composed of rather hard lines that fail to conserve the vital aspect of the forms, rendering them rather flat and static. Raimondi's vibrant atmospheric suggestions are rather limited in Dente's work because he resolves the chiaroscuro effects using an overly stark contrast between a brilliant white and a metallic darkness of the shadows. And the subtle psychological investigation of the subjects, that characterises Raimondi's work in the expressive rendition of such elements as the eyes, is also beyond the young Marco's reach. The work was made very soon after Raimondi's *Judgement of Paris*, dated around 1513-14, and thus was made during the years of the explosion of antiquarian tastes in Raphael's studio. (*A.F.*)

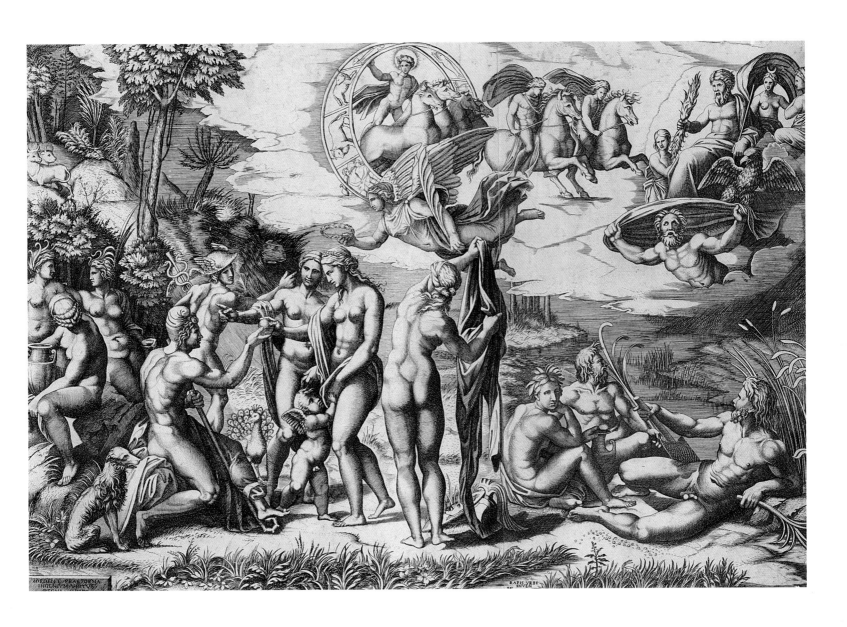

# Marcantonio Raimondi (1480 c. – *ante* 1534)
## *Venus and Eros*, 1514-1515

Engraving
204 × 109 mm (second
version)
Paris, Bibliothèque nationale
de France

**Inscription:**
in pen and brown ink on the
base below the figure of Eros:
MAF

**Bibliography:**
Bartsch 1813, XIV, p. 234, no.
311; Passavant 1864, VI, p.
26, no. 142; Delaborde 1887,
p. 163, no. 116; Beets 1936,
p. 157, fig. 8; Bianchi 1968,
p. 658, fig. 21, pp. 662-663;
Oberhuber 1978, I, p. 311,
no. 311; Jean-Richard 1983,
pp. 330-331, no. 7;
Oberhuber 1984, p. 335;
*Raphael Invenit...*, 1985, p.
243, no. 7.

*Venus and Eros in a niche* is one of the most noted works in Marcantonio Raimondi's early Roman work. The engraving was made by direct contact with a silver-point drawing done by Raphael (London, British Museum 1895-9-15-629) comprising two irregularly cut overlapping sheets (Knab, Mitsch, Oberhuber 1983, no. 358; Joannides 1983, p. 204, no. 286; Pouncey, Gere 1962, pp. 23-24, no. 27). The drawing was made using the same technique seen in the sketches on pink paper and in the larger studies of the *School of Athens*, and portrays Venus in a position inspired by classical statues, together with Eros, whose head and arm are just perceptible. On the basis of this compositional characteristic, Pouncey and Gere (1962) reject the direct derivation of an engraving of such well-defined character from the London drawing, hypothesising instead the existence of a more complete model by Raphael. Actually, even if not immediately visible, it is precisely the uncertain adaptation of the engraving to the compositional module of the drawing in the British Museum that provides the proof of such a direct derivation (Bianchi 1968). The twisting of the body and the off-balance pose of Venus do not correspond to a uniform distribution of weight between her two feet (one of which should be held further back and slightly raised, as suggested on the sheet superimposed over the lower part of the drawing), and the head of the small Eros, which in the drawing emerged from under Venus's left arm, disappears under the right hand and arm of the goddess. The elastic strength suggested by the accentuated curve of Eros's small back seems, furthermore, to lose itself in the void.

On the other hand, the technical quality of the engraving is noteworthy. Fine, curved lines model the bodies and create tonal juxtapositions while the pointillism and the dense concentration of crossed cuts define the depth of the niche and create its shadow. Luca di Leida created a *Lucrezia* inspired by this figure of Venus (Beets 1936) in 1514-15 prior to the creation of the engraving. Oberhuber (1984) sees the engraving as being in relationship to the antiquarian culture which began its development in Raphael's studio in the years of the *Stanza della Segnatura* and the *Sybils* in the church of Santa Maria della Pace. In this sense, Bianchi (1968) excludes the relationship with the *Apollo citaredo nella nicchia*, an engraving by Raimondi based on a lost drawing by Raphael for a simulated statue that appears in the background of the *School of Athens*. In spite of the similarities, the niche shows differences in its structure and decoration. Bianchi thus rejects the hypothesis that on the basis of such a relationship there had been an exchange of the figures of Venus and Minerva, which currently occupies the other sculptural niche visible in the background of the fresco (Pouncey, Gere 1962; Knab, Mitsch, Oberhuber 1983). Indicating in this *Venus* a possible first compositional idea for the same figure in the subsequent *Judgement of Paris*, Bianchi (1968) affirms a link with the creation of the noted engraving by Marcantonio Raimondi, also making reference to the *grisaille* of the same subject created on the embrasure of the window under the *Parnassus* in the Stanza della Segnatura (dated 1512-13). (*A.F.*)

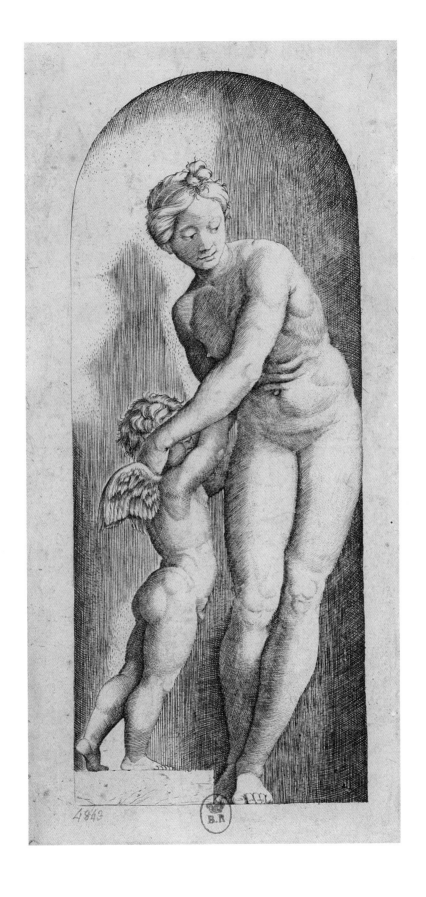

**23** Marcantonio Raimondi (1480 c. – *ante* 1534)
*Apollo*

Engraving
222 × 180 mm
Parigi, Bibliothèque nationale
de France

**Bibliography:**
Bartsch 1813, XIV, pp. 251-
252, nos. 334-335; Delaborde
1887, p. 152, no. 107; Bianchi
1968, p. 663; Oberhuber
1978, II, p. 28, nos. 334-335;
Oberhuber 1984, p. 335;
Weill-Garris Brandt 1984,
p. 229.

The engraving is thought to be based on a lost drawing by Raphael believed to have been a study for the fake statue in a niche in the architectonic background of the *School of Athens*. Placed alongside other engravings such as *Venus and Cupid* and *Parnassus*, this work reflects Raimondi's antiquarian taste and his early Roman years, in keeping with the spirit of Raphael's creative work in the period of the *Stanza della Segnatura* and the *Sybils* in the church of Santa Maria della Pace (Oberhuber 1984). Subjects such as this *Apollo* contribute to a hardened and illuminated, almost sculptural image for the engraving, and to recounting Raphael's views on sculpture (Weill – Garris Brandt 1984, p. 229).

This *Apollo citaredo in una nicchia* has been associated with Raimondi's engraving of *Venus and Cupid in a niche*, but the apparently common motif of the niche is actually indicated as differing in terms of both structure and decoration. Bianchi (1965) picks up the line previously argued regarding *Venus and Cupid* in rejecting the hypothesis of an exchange between Venus and Minerva as statues to be portrayed in the niche of the *School of Athens* parallel to that of Apollo. (*A.F.*)

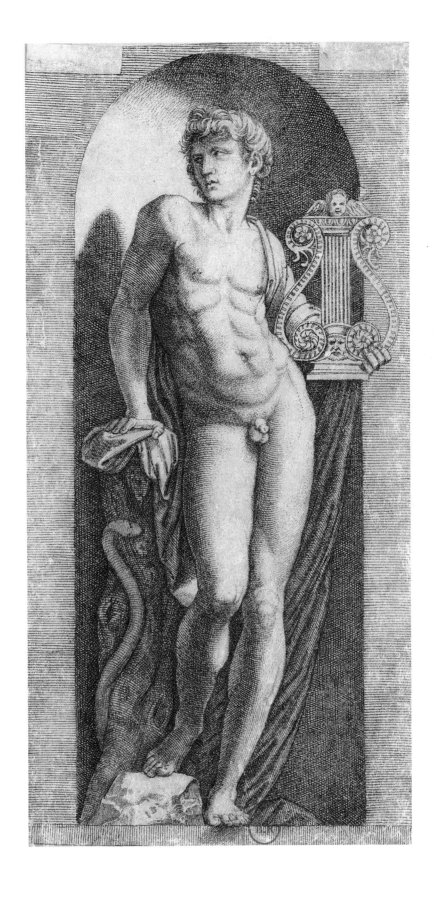

165

# Marcantonio Raimondi (1480 c. – *ante* 1534)
## *Parnassus*, 1515-1520

Engraving
358 × 471 mm
Paris, Bibliothèque nationale
de France

**Monogram:**
MAF

**Inscription:**
*Raphael pinxit in Vaticano*

**Bibliography:**
Bartsch 1813, XIV, p. 200, no.
247; Passavant 1864, VI, p.
24, no. 128; Delaborde 1887,
pp. 156-157, no. 110; Crowe,
Cavalcaselle 1890, II, pp. 85-
86; Shearman 1965, pp. 157-
158; Bianchi 1968, p. 661 e
fig. 19; Oberguber 1978, I, p.
244, no. 247; Shoemaker
1981, pp. 155-157, nos. 48 a-
b; Jean-Richard 1983, pp.
348-349, no. 28; Oberhuber
1984, p. 340; Ginevra 1984,
pp. 53-54, n. 63.

The work is one of the best known to have emerged from the close collaboration on engravings between Marcantonio Raimondi and Raphael. The reconstruction of the visual sources directly associated with the genesis of the plate for *Parnassus* (or *Apollo on Parnassus*) illuminates our understanding of the relationship between the artist and the engraver throughout the various phases in the creative process. The relationship between the compositional scheme of the engraving and the frescoed lunette in the *Stanza della Segnatura* is as evident as the elements that distinguish the two works. With respect to the fresco, the rectangular, non-curved framing of the print allows the inclusion above of a boisterous group of five little cherubs wearing laurel crowns and a less structured distribution of the groups of figures. Apollo is playing the lyre instead of the viola while the two figures of Sappho and Pindar found in the foreground of the fresco are missing from the print.

Delaborde (1887) argued that *Parnassus* was engraved on the basis of a hypothetical lost preparatory study by Raphael made during an early phase of the elaboration of the subject for the *Stanza della Segnatura*. Shoemaker (1981) echoes the hypothesis and provides more precise indications as to which of Raphael's drawings it would refer to. Two of these drawings, kept respectively in Oxford (Ashmolean Museum, inv. P II 639; see Joannides 1983, p. 84, Fig. 21) and in Paris (Louvre, inv. 3982), are actually old copies and according to Shoemaker were an intermediate step between the development of the scheme of the engraving and the final layout of the fresco. As noted by Bianchi (1968) as well, these drawings, and particularly the study of the nude figure in Oxford (also recorded by Crowe, Cavalcaselle 1890 as a copy), share elements with the fresco that are lacking in the engraving, such as Apollo playing the viola and the nymph Erato with a lyre in her hands instead of a book.

Two other studies signed by Raphael, on the other hand, are indicated by Shoemaker as being directly linked to the work of Raimondi: the first is *Man standing: Study for Parnassus* (London, British Museum), which corresponds in terms of posture, but not in the draping of the clothes, with the figure on the right with his arms raised (later reversed in the fresco in the right-hand part of the *Disputa del Sacramento*; see Joannides 1983, p. 191, no. 235r); the second study is a splendid drawing for *Melpomene* (Oxford, Ashmolean Museum, inv. P II 541), repeated again in the engraving in profile albeit with the softness of the folds of clothing being more rigidly drawn (see Joannides 1983, p. 84, no. 26). Along with these drawings, Fischel had included two other studies as being directly related to Raimondi's engraving: the figure of *Virgil* (Oxford, Ashmolean Museum, inv. 541; Fischel 1924, V, pp. 262-263, n. 248; Joannides 1983, p. 192, no. 238r), which also in the engraving is shown in full figure, later reduced to a half-figure in the fresco; and that of *Erato* (Vienna, Albertina, Bd. V, 220; Fischel 1924, V, pp. 263-264, n. 251; Joannides 1983, p. 192, no. 239).

As Shoemaker also indicates, the hypothesis proposed by Shearman (1965) that Raimondi's engraving was based on a *model*, or rather on a first complete study of *Parnassus*, later revised, appears convincing. According to Shearman, Raphael developed his project all the way to its final version (*model*), and only then would completely redo it if he was not satisfied with the results. This hypothesis would explain the richness of detail and the landscape elements in the engraving.

The engraving is generally dated by the critics to between 1517 and 1520. Fischel, and later Dussler (1971), point out the stylistic similarities of the flying cherubs with the *Prophets* of the Chigi Chapel in the church of Santa Maria della Pace (1514), whereas the severe compositional technique and the mature sculptural emphasis also orient Shoemaker to indicate a date just before 1520 and prior to the later influence on Raimondi of Giulio Romano's work. Oberhuber (1984) too adheres to this thesis when he describes these years as a moment of intense demand for new drawings by the group of engravers who operated in Raphael's orbit (in addition to Marcantonio there were Marco Dente da

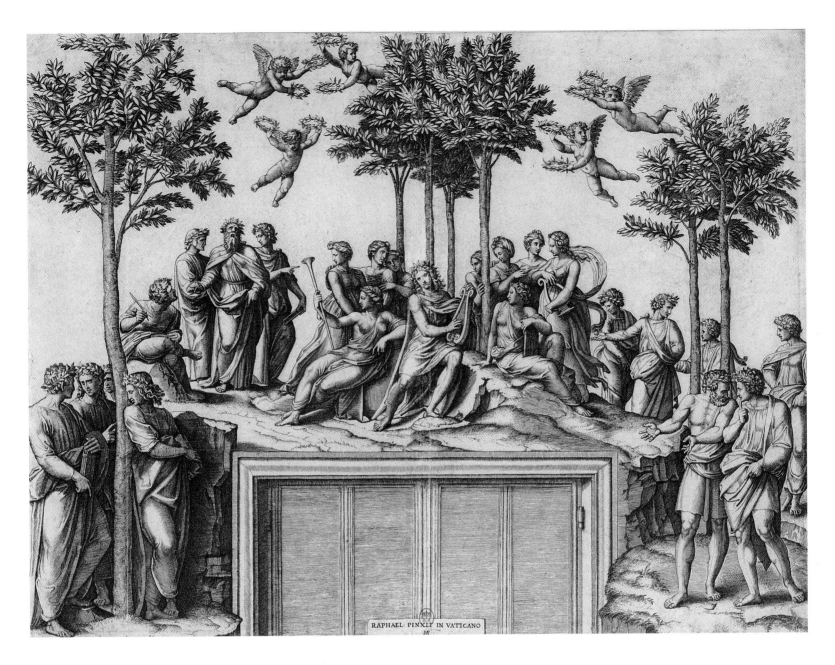

RAPHAEL PINXIT IN VATICANO

Ravenna, Agostino Veneziano and Ugo da Carpi). As there was no longer enough new work, the master decided to recover the older or never-used studies, and it is from this recovery, according to Oberhuber, that Marcantonio's ambitious *Parnassus* had its origin.

Bianchi (1968), on the contrary, prefers to indicate a date previous to that of *The massacre of the Innocents* (done by Marcantonio in two versions in 1511 and 1515) highlighting the less evolved use of the burin in *Parnassus*.

Shoemaker's hypothesis merits mention in which he saw the possibility of another artist's contribution to *Parnassus*. This argument was supported by the publication in his monograph of a first unfinished version of the plate, in which the presence of fainter and less precisely drawn figures is noted in the lower right (such as the figure almost "stuck" between two trees), which might indicate the intervention of one of Raimondi's assistants. (*A.F.*)

Raphael Sanzio (Urbino, 1483 – Rome, 1520)
*Head of a female*, 1519-1520

Black pencil and stump, relief in white lead, preparatory sketch done with stylus on beige paper 230 × 161 mm. Fully glued. Paris, Musée du Louvre, Département des Arts Graphiques (inv. 10 958) © Photo RMN - Michèle Bellot

Fully glued.

**Provenance:**
E. Jabach (Jabach Inventory, II, no. 588, as by Raphael). Presence of initials on remounted drawings (Lugt 2961, on recto); entered the Cabinet du Roi in 1671. The stamps of the Museum Commission (Lugt 1899) and the Conservatoire ( Lugt 2207) are found at the bottom.

**Bibliography:**
Passavant 1860, II, p. 474; Crowe, Cavalacaselle 1890, III, p. 349 (copy); Oberhuber 1972, pp. 196-197, no. 480, tav. 78; Bacou 1983, p. 29, no. 23 (Bottega di Raffaello, forse Penni); Knab, Mitsch, Oberhuber 1983, p. 639, no. 590; Gere, Turner 1983, no. 148; Joannides 1983, p. 246, n. 454; Quednau 1986, p. 249; *Musée du Louvre...*, 1992, pp. 314, 570, nos. 134, 967; Gnamm, Oberhuber 1999, p. 220.

The drawing was identified by Oberhuber (1972) as a study by Raphael for the face of *Charity*, the allegorical figure placed to the right of *Pope Urban I* in one of the fake niches frescoed on the wall with the *Victory of Constantine* in the room of the same name in the Vatican. Oberhuber also identified another drawing by the hand of Raphael, kept in Oxford (Ashmolean Museum, inv. P II 665, charcoal with white highlighting, 228 × 103 mm; Oberhuber 1972, pp. 195-196, no. 479; Knab, Mitsch, Oberhuber 1983, p. 639, no. 589; Joannides 1983, p. 246, no. 133) and associated with this drawing in the Louvre, as a full-figure study for the same *Charity*. The process of attributing authorship of the Louvre drawing at times involved the study in Oxford. Jabach, to whose illustrious collection the drawing belonged prior to its passing into the Cabinet du Roi in 1671, attributed it to Raphael in his inventory. Later it was also catalogued as being the work of the anonymous Italians (Oberhuber 1972; Bacou 1983). Crowe and Cavalcaselle (1890) attribute the Oxford drawing to Penni, and indicate that "a copy" exists in the Louvre. Even Passavant (1860) had spoken of Penni regarding *"deux esquisses pour la figure de la Charité"*, which he indicated as being in the Louvre collections (but they were described as two full-figure studies, with similarities to the composition of the Oxford drawing). Roseline Bacou (1983) has reanimated the debate in modern times arguing that it is difficult to identify the hand of Raphael in the uncertain rendering and the stark outline of several elements of the drawing in question, such as the ear, the shoulders, and the hair. Quedneau (1986)

remains undecided, but still chooses to recognise Raphael's originality in the ideation of the overall decorative scheme. Even if there is agreement with the observations expressed recently regarding a certain weakening of the inclination of the face with respect to the Oxford drawing (see Gnamm, Oberhuber 1999, who also point out that this is thought to be an auxiliary cartoon for the fresco, as already stated in Knab, Mitsch, Oberhuber 1983), the spontaneity of execution that characterises the high quality of this drawing, in which the expressive characterisation of the figure strikes a balance between regal elegance and maternal affection, must also be recognised, as sustained by Joannides (1983).

For the *Room of Constantine*, one of Raphael's later projects, the artist took up the black pencil again after four or five years of working mainly with the sanguine (Joannides 1983). The rendering of the chiaroscuro effect through particularly accentuated shadows is very notable. The image thus takes on an almost sculptural relief, which is a mark of this late creative phase of Raphael. The intense light is concentrated on the face and hair, an effect achieved through the masterly exploitation of the capacities of white lead.

Both Joannides and Oberhuber see a close resemblance between the face of *Charity* drawn here and the features of the Virgin in the painting known as *The Pearl* (Madrid, Museo del Prado), a work whose attribution was once a matter of controversy and today is generally accepted as having been done by Giulio Romano (Ferino Pagden – Zancan 1989, p. 150, no. 96). (*A.F.*)

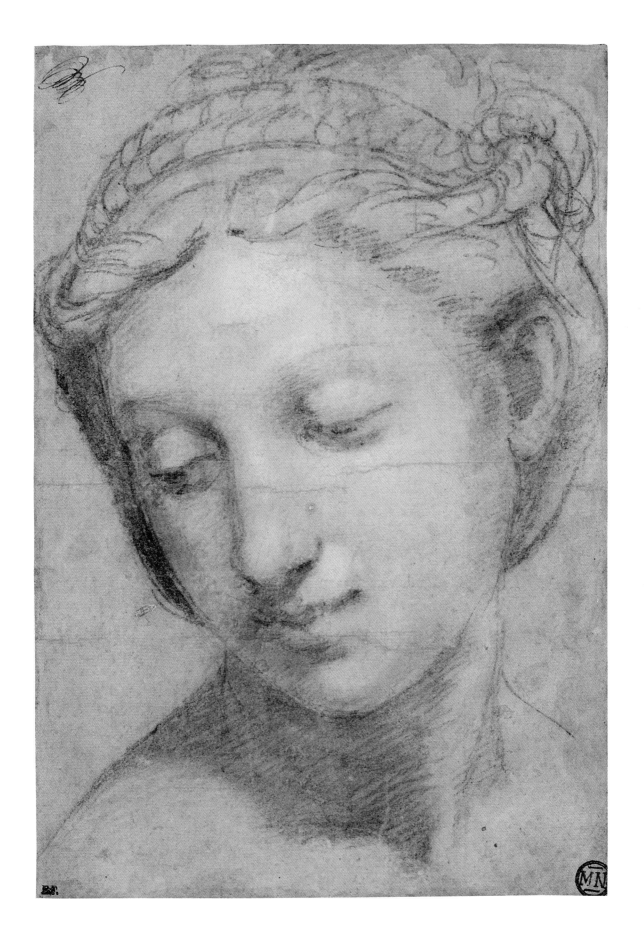

# Raphael Sanzio (Urbino, 1483 – Rome, 1520)
## *Psyche and Venus*, 1517-1518

Sanguine, preparatory sketch done with stylus
264 × 198 mm.
Paris, Musée du Louvre, Département des Arts Graphiques (inv. 3875)
© Photo RMN - Michèle Bellot

Fully glued.

**Inscriptions:**
Annotation in pen and brown ink at lower right: "4".

**Provenance:**
C. Malvasia (as per the note by Mariette on the mounting); Boschi family, inheritors of the Malvasia collection; P. Crozat collection from 1714; auction of the P. Crozat collection in Paris on 10 April 1741: the drawing is part of lot no. 117 (Raphael); acquired by P–J. Mariette (see stamp Lugt 1852). The fragment on the central part of the mounting relates to Mariette with the inscription: *Fuit Comitis C. Malvasia deinde D* ' [Defuncti?] *Crozat nunc P.J. Mariette 174[.?]*, and scroll: Psychen divinae formosit. *Pyxidē / Veneri afferentem / Discipulis sui in oedibus Aug. Chigi Roma / exprimendam, / RAPHAEL URB. DELINEABAT* (Lugt 2998). Sold in Paris on 15 November 1775: the drawing is part of lot no. 669 (Raphael) (reproduced by Gabriel de Saint-Aubain in the margin of his sales catalogue [Boston, Museum of Fine Arts]); acquired on that occasion for the Cabinet du Roi. The Museum (Lugt 1899) and the Conservatoire (Lugt 2207) stamps are found at the bottom.

This is a splendid autographed sketch related to the decorative cycle narrating the story of Psyche and Eros ideated by Raphael for the loggia over the garden of Villa Chigi (Farnesina). Note, in particular, the encounter of Venus and Psyche described in the eighth spandrel on the wall giving onto the garden.
Raphael's authorship of this drawing has virtually never been called into question: reviewing the relative historical criticism, only Fischel (1948) and Harrt (1981) allowed the possibility of Giulio Romano having done the figure of Venus and Raphael that of Psyche. The different definition of the two figures is actually indicative of a creative process still in development: while Venus has already taken on her definitive posture and there only remains to carefully delineate her soft forms, Raphael studies a more certain position for Psyche (note the numerous revisions to the left leg) nevertheless paying great attention to detail in drawing her (Oberhuber 1986; Monbeig, Goguel 1983; Forlani, Tempesti 1998). Clearly evident is the tendency in those years to confer a statuary solidity to the figures utilising the elements of classic sculptural relief (see also the drawings for the decoration of the *Stanza dell'Incendio*) and translating them into an absolutely sure drawing. This is in contrast to the work of his pupils, Giulio Romano and Gian Francesco Penni, who, though following his technique to the letter, created rather hard, cutting and harsh graphics (Joannides 1983). Furthermore, observing the drawing one notices certain particulars characteristic of Raphael, such as the use of the stylus for the preparatory work, a technique little used by his contemporaries (Marabottini 1998; Forlani, Tempesti 1998).
The drawing describes the encounter between Venus and Psyche, the latter portrayed in the act of presenting the surprised goddess with an ampulla containing water from the Styx, the river in Hades guarded by monstrous dragons. This was the solution to one of the difficult tests Venus required of Psyche to accede to the realm of the gods, as narrated in the *Golden Ass* by Lucius Apuleius, the iconographic sources for the decorations on the Loggia di Agostino Chigi (Shearman 1964; Schwarzenberg 1977). Nevertheless it is not clear if the ampulla actually contains a beauty potion obtained in Hades from Persephone, as required by another of Venus's test.
The iconography chosen to describe this encounter is resolved in a dynamic composition that draws on the interplay of the two bodies and finds its focal point in the narrative heart of the scene, i.e., the ampulla and Psyche's hand that holds it out. The figure of Venus emerges imposingly and her upraised arms widen the narrow spatial plane. The sculptural effect is at once highlighted and softened by the chiaroscuro, and delineated with fine, parallel broken lines that reveal Raphael's technical capacity in the more or less accentuated sanguine, typical of his later graphic work.
Joannides (1983) underlines the deliberate exaggeration of the expression on Venus's face in connection with the light and ironic tone that generally characterises the decoration of the Loggia.
A pen sketch over sanguine in Oxford (Ashmolean Museum, inv. P II 655, 105 × 80 mm) was indicated as being preparatory for the composition in question: the forms are just barely mentioned and there are numerous evident rethinkings regarding the position of Psyche's head (Knab, Mitsch, Oberhuber 1983, no. 542; Joannides 1983, no. 413; Gere, Turner 1983, pp. 199-200, no. 159).
(*A.F.*)

**Bibliography:**
Passavant 1860, II, p. 469, no. 336; Crowe, Cavalcaselle 1890, III, pp. 140-141; Fischel 1948, p. 184, fig. 215 (Giulio Romano for *Venus* and Raffaello for *Psyche*); Harrt 1958, pp. 32-33, 288, no. 23, fig. 39 (Giulio Romano for *Venus* and Raffaello for *Psyche*); Shearman 1964, pp. 80-81, fig. 81; Marabottini 1968, p. 283, note 76; Dussler 1971, pp. 97-98; Schwarzenberg 1977, p. 124; Monbeig-Goguel 1983, 298-300, no. 110; Knab, Mitsch, Oberhuber 1983, p. 634, no. 550; Joannides 1983, p. 237, n. 414; Michel 1989, pp. 62, 164, no. 36; *Musée du Louvre...*, 1992, pp. 222, 372, n. 548; Forlani Tempesti 1998, p. 414.

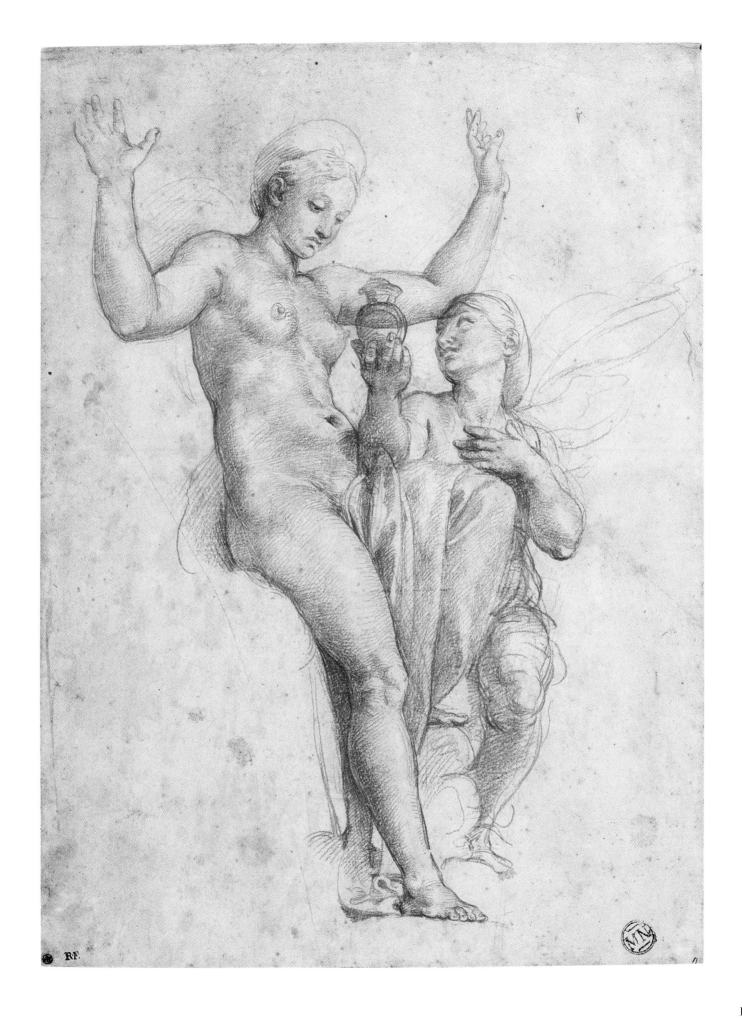

**27**    Pietro Fontana (Bassano, 1762 – Rome, 1835)
*La Fornarina*, 1805

Engraving
320 × 226 mm
Rome, Istituto Nazionale per
la Grafica (Calc. 1723/52)

**Inscription:**
at lower left: *Raffaello Sanzio
d'Urbino dip*. Centre:
*Francesco Fontana dis*. Right
side: *Pietro Fontana inc. in
Roma*; Lower centre: *La
Fornarina di Raffaello / A
Sua Eccellenza La Contessa di
Jersey/ nata Fane, dei Conti
di Westermoreland ecc. ecc. /
Pietro Fontana D.D.D.; Pietro
Aureli vende in Roma*

**Bibliography:**
Le Blanc 1850-1858, I, pp.
244-245; Passavant 1889, II,
p. 115; Petrucci 1953, p. 63,
n. 1723-1752; Bernini Pezzini
1983, p. 26, fig. 13; *Raphael
Invenit...*, 1985, pp. 231, 784;
*Raffaello. La Fornarina*,
2000, p. 15, fig. 12, p. 16.

As a pupil of Volpato in Rome with Pietro Bonato and Giovanni Folo, Fontana learned from the master the technical possibilities of rendering tones in engravings, which marked his aspiration in this new print dedicated to the *Fornarina*. With a more refined methodology for the fine lines, the artist was able to create a softer aspect and also one less subject to an overly cold and sculptural rendering of the woman's flesh tones. Thanks to the original iconography of the nude breast in this engraving dated 1805 by Le Blanc, a later date can be established for the moralistic practice (indicated around 1823 by Petrucci 1953) whereby the Calcografia Camerale would destroy or retouch all those copper plates not deemed morally proper. This is the treatment suffered by the Domenico Cunego plate, which today shows the figure with an added veil. (*A.F.*)

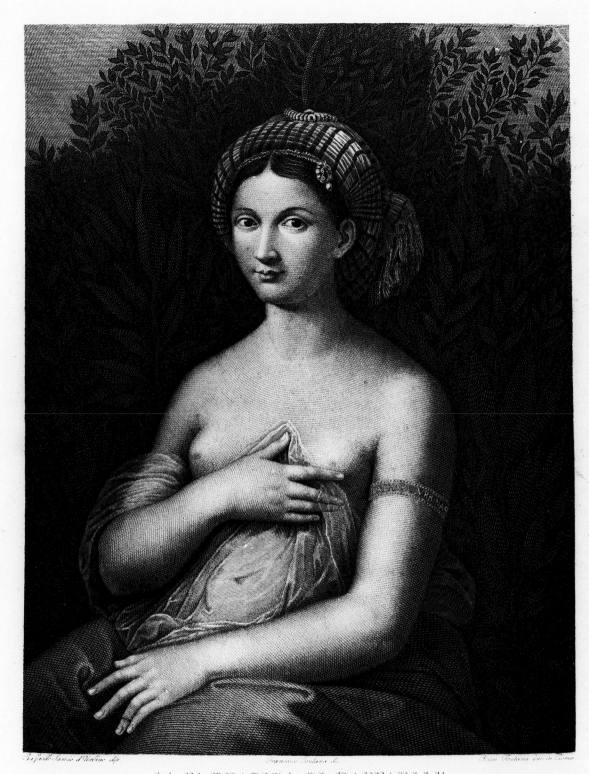

LA FORNARINA DI RAFFAELLE

**28**  Francesco Rastaini (Rome, 1730 c. – 1784)
*La Fornarina*, 1778

Engraving
274 × 175 mm
Rome, Istituto Nazionale per
la Grafica (Calc. 930)

**Inscription:**
at the lower right: *Franciscus
Rastaini del. Sculp. Roma
1778.* In the centre: *Raphael
Pinxit / La Fornarina*

**Bibliography:**
Le Blanc 1850, III, p. 287;
Passavant 1889, II, p. 115;
Petrucci 1953, p. 104, no.
930; Bernini Pezzini 1983, p.
26, fig. 12; *Raphael
Invenit…*, 1985, pp. 230,
784; *Raffaello. La Fornarina*,
2000, p. 15, fig. 11.

The engraving tradition linked to the painting of *La Fornarina* originated in 1772 with the print by Domenico Cunego (Verona 1726 – Rome 1774), whose copper plate is kept at the Istituto Nazionale della Grafica, Calcografia Nazionale (inv. no. 980, T XXII). Used to represent Raphael (together with three others of his works) in the volume *Schola Italicae Picturae* edited by Gavin Hamilton and published in Rome in 1773, the print bore the caption *Raphaelis Amasia, vulgo la Fornarina / Extat Romae in Aedibus Barberini*. For the first time the word "Fornarina" was used alongside "Amasia" to indicate Raphael's lover.

On the heels of the re-established notoriety of *La Fornarina*, promoted also thanks to Cunego's print, Rastaini exemplifies in that engraving the work that four years later he would dedicate to Raphael's painting. The new engraving appears slightly hardened in its outlines with respect to the more graded tones in Cunego's work, even though it maintains the use of the fine line. Under Rastaini's hand, the woman's white veil also loses the effective and luminous transparency achieved in the work of the Veronese engraver. (*A.F.*)

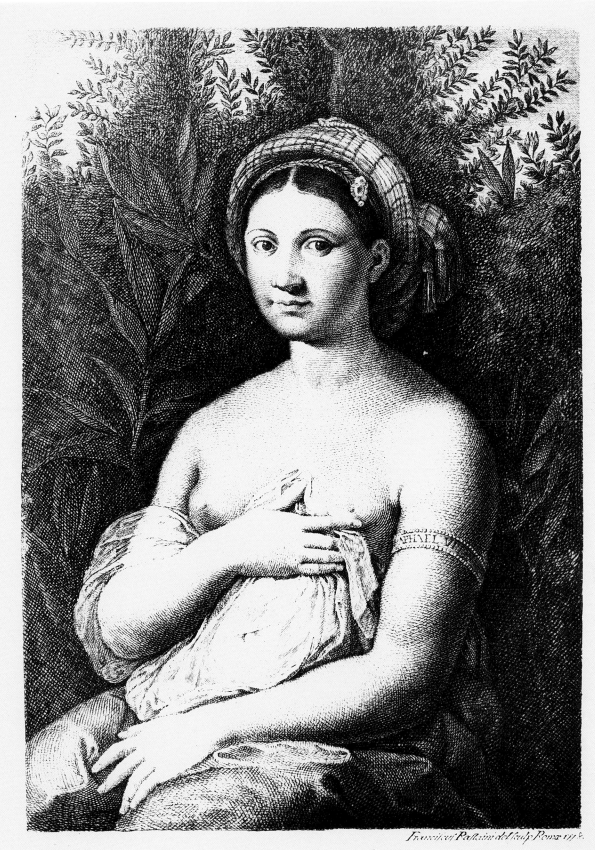

Franciscus Pastrini del sculp Roma 1778.

Raphael Pinxit

Mauro Gandolfi (Bologna, 1764 – 1834)
*Saint Cecilia*, 1833 (engraving); 1835 (posthumous publication
by the son, Democrito)

Acquafortis and burin
810 × 496 mm (wecond
version, with open letters)
Rome, Istituto Nazionale per
la Grafica (F.C. 52774, vol. 41
H 17)

**Provenance:**
Fondo Corsini; Calcografia
post 1850 (retouchings by L.
Lelli and P. Proja)

**Inscriptions:**
On the left under the painted
figures: *Raffaello Sanzio
dipinse*; on the right: *Mauro
Gandolfi dis. et inc. Ultima
sua opera / S. Cecilia /* At the
sides of the coat of arms:
TUTTA INFIAMMATA DI
SIDEREO ZELO / LA
VERGINE CANTAVA E LE
BEATE ANIME / / DEL SUO
CANTO INNAMORATE /
VENIVANO IN TERRA E SI
CREDEVANO IN CIELO. *Cav.
Maffei / A.S.A.Y il Serenis.°
Pr.ᵖᵉ e Signore RANIERI
VICERE' del Regno Lombardo
Veneto / Principe I.ˡᵉ ed
Arciduca d'Austria, Pr.ᵖᵉ R.ˡᵉ
D'Ungheria e Boemia Cav. Del
Toson d'Oro, Gran Croce
dell'Ord.ᵉ R.ˡᵉ di S. Stef.°
d'Ungheria /e dell'Ordine I.ˡᵉ
Austriaco di Leopoldo I.ˡᵉ R.°
Generale d'Artiglieria e
Proprietario del Regg.ᵗᵒ di
Fanteria n° II ec. ec. ec. ;* at
the lower left: *L'Originale
esiste nella Pinacoteca di
Bologna /* Centre: *Luigi Bardi
impresse /* Right: *Democrito
Gandolfi figlio dell'Incisore
D.D.D.*

**Bibliography:**
Nagler 1840, V, p. 9; Le Blanc
1850, II, p. 267, no. 6;
Passavant 1889, II, p. 172,
no. 107; Morini 1926, pp.
172-173; *L'Estasi...*, 1983, pp.
195-196; *Raphael Invenit...*,
1985, pp. 218-219, 766.

Four different versions of the plate have been traced. The first is cited only by Nagler and by Le Blanc and was said to have been produced without any dedication. The article by Morini (1926) dedicated to Gandolfi's engraving of Saint Cecilia states that the artist worked on this plate in 1833, shortly before his death. It was to be his son, Democrito, as attested by the inscribed dedication, who published the posthumous work in 1835 (Passavant 1889) though there was to be no lack of hereditary feuding with the faithful typographer, Zecchi. The second and third versions of the plate correspond to the prints of the Fondo Corsini at the Istituto Nazionale della Grafica: the second keeps open the letters of the inscription while in the third the same letters are closed. The fourth and last version, however, corresponds to the retouching done to the plate after its acquisition from the Istituto Nazionale della Grafica in the late nineteenth century by L. Lelli and P. Proja: traces of abrasion linked to the inscribed dedication are visible.

In elaborating the engraving, Gandolfi worked from a life-sized watercolour based on the painting before it was transferred from wood to canvas; this operation was carried out in 1803 in the Paris workshop of Laurent-Peronville where Gandolfi was temporarily established in the opening years of the century (Bologna 1983).
A mixed technique between etching with acquafortis [nitric acid] and with burin was used that allowed the artist to create telling pictorial effects, especially with the use of fine undulating and irregular marks and the *"pointillé"* learned from his father, which together confer a certain vibrancy to the atmospheric nature of the whole.
The artist has demonstrated a certain faithfulness to the model: what really drove him, however, was the desire to refine each individual expressive quality and technical potential of creating a pictorial work through engraving.
The additions to the fourth version by L. Lelli and P. Proja add vivacity by accentuating the contrasts (Rome 1985). *(A.F.)*

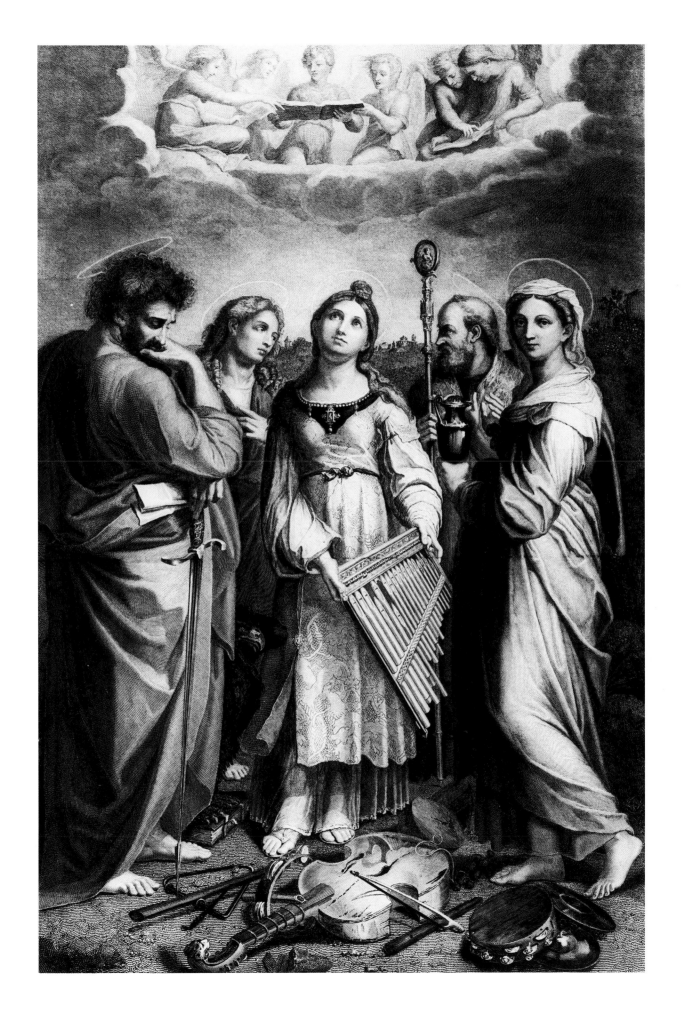

# Raffaello Morghen (Naples, 1758 – Florence, 1833)
## *Portrait of Bindo Altoviti*, 1800-1808

Engraving
303 × 220 mm (first version)
Rome, Istituto Nazionale per
la Grafica, F.C. 50903, vol. 40
H 19

**Provenance:**
From 1840 property of the
copper engraver Luigi Bardi
of Florence; Rome, Istituto
Nazionale per la Grafica,
Fondo Corsini

**Inscriptions:**
On the left under the
portrayed figures: *Raffaelle
Sanzio se stesso dipinse*;
Right: *Raffaelle Morghen inc.
in Firenze*. Below on either
side of a coat of arms:
*All'Ornatissimo Sig. Cav. Gio.
Batista Baldelli / Nicolò
Palmerini questa opera del
benemerito suo Maestro in
attestato di vera stima dedica
e consacra*. In the ribbons of
the coat of arms: *Nocturnus
in lucem prodeo*.

**Bibliography:**
Gandellini, De Angelis 1813,
p. 259, no. CXXXI; Nagler
1840, IX, p. 475, no. 26;
Passavant 1889, II, p. 136;
*Raphael Invenit…*, 1985, pp.
228, 780.

The inscription *Raffaelle Sanzio se stesso
dipinse* mirrors an erroneous but long es-
tablished reading of the phrase by Vasari
*"a Bindo Altoviti fece il ritratto suo quan-
do era giovane"* [for Bindo Altoviti he did
his portrait when he was young]. It was this
phrase that induced people to see a self-
portrait of Raphael in that painting. This
was an opinion that was reconsidered and
corrected only starting in the 1920s (see
Crowe, Cavalcaselle 1890, II, p. 200).
Niccolò Palmerini, faithful pupil of Morghen
who signed the dedication in the inscrip-
tion and was probably directly involved in
the printing of this plate, edited a catalogue
of the works of his master in 1810. Contrary
to observations made by Bernini Pezzini in
a sheet relative to the work (Rome 1985) –
where it was observed that the work in ques-
tion was not on the list – Palmerini's list,
as transcribed by Gandellini, De Angelis
(1813), ascribes the number LXXXI to the
*Ritratto di Raffaello Sanzio da Urbino* (see
Nagler 1840, p. 475, no. 26, which contains
the third edition of the Palmerini catalogue,
dated 1824).
In a second version of the plate, also kept
at the Istituto Nazionale della Grafica (F.C.

50902, vol. 40 H 19, 303 × 220 mm), re-
garding the reproduced painting, the in-
scription further specifies: *"The original is
kept at the Altoviti house in Florence"*. But
the *Portrait of Bindo Altoviti* by Raphael re-
mained in the hands of the heirs only up
to when the request for expatriation of the
work was made in 1808 in order to permit
its sale to Ludwig I of Bavaria.
A date prior to 1808 can thus be established
but also one plausibly later than 1800 if it
is considered that the burin employed here
was only used in Morghen's later work, who
for a long period had favoured acquafortis.
The work is distinguished for its high tech-
nical quality, especially in the masterly and
refined use of chiaroscuro which is partic-
ularly successful thanks to the excellent
rendering of the tones. Indeed, Morghen
obtains a solid construction of the com-
position and its spatial configuration
through the use of tonalism. At the same
time, he obtained an intense pictorial and
descriptive effect of the details, thanks once
again to tonalism (Bernini Pezzini in Rome
1985 underlines in particular the rare vir-
tuosity seen in the rendering of the hair).
*(A.F)*

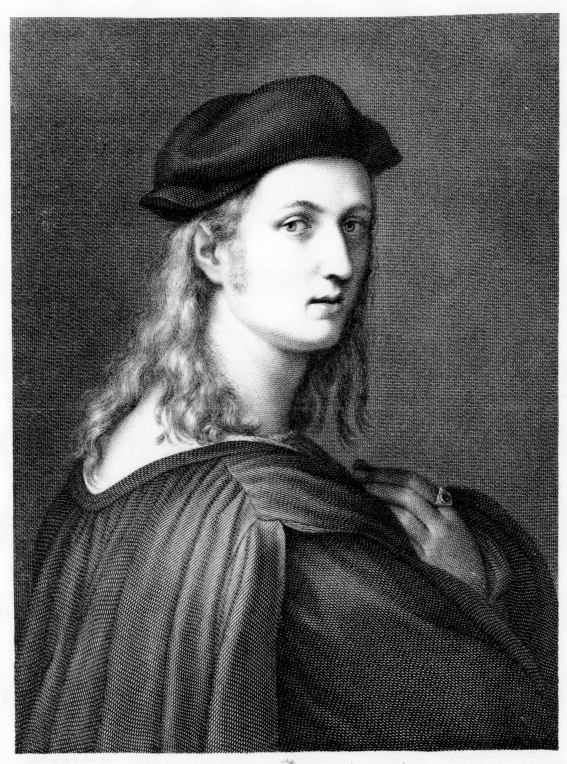

179

# Bibliography

**A**

Alazard J., *Le portrait florentin de Botticelli à Bronzino*, Paris, 1924.

Alberti L.B., *De Re Aedificatoria*, Libro V, IX, edited by G. Orlandi et P. Portoghesi, vol. II, Milan, 1966.

Aleardi A., *Raffaello e la Fornarina*, Verona, 1858.

Ames Lewis F., *The draftsman Raphael*, New Haven-London, 1986.

Anderson J., "The giorgionesque portrait: from likeness to allegory", in *Giorgione. Atti del Convegno internazionale di studio per il V centenario della nascita in Castelfranco Veneto*, Castelfranco Veneto, 1979, pp. 153-158.

Anselmi A., "La vera Fornarina di Raffaello", in *Nuova Rivista Misena*, V, 1892, pp. 31-32.

Arasse D., "Deux notes sur l'invenzione' chez Raphaël", in *Symboles de la Renaissance*, Paris, 1990.

Arasse D., "Le corps fictif de Saint Sébastien et le coup d'œil d'Antonello", in *Le corps et ses fictions*, Paris, 1983.

Arasse D., *Le Détail. Pour une histoire rapprochée de la peinture*, Paris, 1992.

Arasse D., *Léonard de Vinci, Le rythme du monde*, Paris, 1977.

Arasse D., "Raffaello senza venustà e l'eredità della grazia", in *Studi su Raffaello*, edited by M. Sambucco Hamoud and M.L. Strocchi, Urbino, 1987, pp. 703-714.

Arasse D., "San Bernardino assomigliante: la figura sotto il ritratto", in *Atti del simposio internazionale caterinianobernardiniano*, Siena, 1982, pp. 311-332.

Armellini M., "Un censimento della Città di Roma sotto il Pontificato di Leone X", in *Gli Studi in Italia*, IV-V, 1882.

**B**

Bacou R., *Autour de Raphaël. Dessins et peintures du Musée du Louvre*, exhibition catalogue, Paris, 1983.

Bacou R., en collaboration de F. Viatte, *I grandi disegni del Museo del Louvre. Scuola italiana*, Milan, 1969.

Balsamo Crivelli R., *Cammin breve. La vita di Raffaello da lui stesso illustrata*, Milan, 1952.

Bambach Cappel C., *The tradition of pouncing drawings in the Italian Renaissance Workshop. Innovation and derivation*, 2 vol., Yale, 1989.

Bandecchi F., *Raffaello Sanzio da Urbino*, São Paulo, 1920.

Barberini M.G., in *Raffaello nelle raccolte Borghese*, exhibition catalogue, Rome, 1984, pp. 16-19, 63-64.

Barbiellini Amidei R., "L'iconografia: la figura", in *Raphael Urbinas. Il mito della Fornarina*, exhibition catalogue, Milan, 1983, pp. 13-15.

Barbier de Montault X., *Les Musées et Galeries de Rome*, Rome, 1870, pp. 334-350, 360.

Barbieri G., *Annotazioni su quattro dipinti della insigne galleria Pitti*, Rome, n.d., pp. 440-445.

Barocchi P., *Scritti d'Arte del Cinquecento* (Turin, 1977), Turin, 1978.

Barocchi P., *Trattati d'arte del Cinquecento fra Manierismo e Controriforma*, vol. 1-3, Bari, 1960.

Bartsch A., *Le Peintre-Graveur*, Vienne, 1802-1821.

Bataille G., *L'Érotisme*, Paris, 1957.

Becherucci L., "Raffaello e la pittura", in *Raffaello. L'opera. Le fonti. La fortuna*, presentation by M. Salmi, I, Novare, 1968, pp. 7-197.

Beck J.H., *Raphael* (New York, 1976), It. transl., Milan, 1982.

Beenken H., "Zu Raffaels frühesten Bildnisschöpfungen", in *Zeitschrift für Kunstgeschichte*, 4, 1935, pp. 145 ff.

Beets N., "Alberto Dürer, Luca di Leida e Marcantonio Raimondi. Un triumvirato nel regno dell'incisione", in *Maso Finiguerra*, 1936, fasc. I, pp. 149 ff.

Beffa Negrini A., *Elogi storici di alcuni personaggi della famiglia Castiglione*, Mantova, 1606.

Béguin S., "Raphaël et un ami", in *Les peintures de Raphaël au Louvre*, Paris, 1984, pp. 58-61.

Béguin S., "Raphaël, un nouveau regard" and "Raphaël: Balthazar Castiglion" and "Raphaël et un ami", in *Raphaël dans les collections françaises*, exhibition catalogue, Paris, 1983, pp. 53-66; no. 7, pp. 84-87 and no. 13, pp.101-104.

Bellori G.P., *Descrizione delle imagini dipinte da Raffaello d'Urbino*, Rome, 1695.

Bellori G.P., *Nota delli musei, librerie, galerie et ornamenti di statue e pitture né palazzi, nelle case e né giardini di Roma*, Rome, 1664.

Bellosi L., "Il ritratto fiorentino del Cinquecento", in *Firenze e la Toscana dei Medici nell'Europa del Cinquecento*, I, Florence, 1980, pp. 39-46.

Bembo P., *Epistolarium Leonis decimi Pont. max. nomine scriptarum Libri*, XVI, Lyon, 1538.

Berenson B., *Italian Pictures of the Renaissance*, Oxford, 1932.

Berenson B., *Italian Pictures of the Renaissance. A List of the Principal Artists and Their Works with an Index of Places: Central Italian and North Italian Schools*, 3 vol. (London, 1963), London, 1968.

Berenson B., "Les peintures italiennes de New York et de Boston", in *Gazette des Beaux-Arts*, XV, 1896, pp. 195-214.

Beretta G., *Della vita, delle opere ed opinioni del Cav. G. Longhi*, Milan, 1837.

Bernini A., "La Trasfigurazione e l'ultima evoluzione della pittura di Raffaello", in *La critica d'arte*, VIII, 1961, pp. 1-19.

Bernini D., "Introduzione", in *Raphael Urbinas. Il mito della Fornarina*, exhibition catalogue, Milan, 1983, pp. 11-12.

Bernini Pezzini G., "Le incisioni "in *Raphael Urbinas. Il mito della Fornarina*, exhibition catalogue, Rome, 1983, pp. 26-27.

Berti L., *Raffaello*, Bergamo, 1961.

Bertini A., "L'Esordio di Giulio Romano", in *La critica d'arte*, VI, 1959, pp. 361-374.

Bertini Calosso A., "La formazione umbra dell'arte di Raffaello", in *Celebrazioni marchigiane*, part 2, Urbino, 1935, pp. 119-148.

Bertini Calosso A., *Ritratti e Madonne di Raffaello*, Novara, 1941.

Bertolotti A., *Artisti in relazione coi Gonzaga signori di Mantova*, Modena, 1885.

Bessone Aurelj A.M., *Chi era la Fornarina?*, Albano, 1928.

Bessone Aurelj A.M., *Influenze femminili su tre immortali*, Rome, 1948.

Bianchi L. "La fortuna di Raffaello nell'incisione", in *Raffaello: L'opera, le fonti, la fortuna*, Novara, 1968.

Birke V., Kertész J., *Die italienischen Zeichnungen der Albertina*, I, Vienna-Köln-Weimar, 1992.

Blumer M.L., "Catalogue des peintures transportées d'Italie en France de 1796 à 1814", in *Bulletin de la Société d'Histoire de l'art français*, 1936, pp. 244-348.

Blunt A., *Artistic Theory in Italy, 1450-1600*, Oxford, 1956.

Blunt A., "The legend of Raphael in Italy and France", in *Italian Studies*, XIII, 1958, pp. 2-20.

Bocchi F., *Le bellezze della città di Firenze* (Florence, 1677), Florence, 1951.

Bode V., Burckhardt J., von Zahn A., *Der Cicerone*, 1892.

Bombe W., "Raffaels Peruginer Jahre", in *Monatshefte für Kunstwissenshaft*, IV, 1911, pp. 296 ff.

Bon Valsassina C., *Raffaello Sanzio. Ritratto di giovane donna con unicorno*, in *Raffaello nelle Raccolte Borghese*, exhibition catalogue, Rome, 1984, pp. 20-28.

Bonora E., *Sulla critica e l'estetica del Cinquecento*, Turin, 1963.

Borghini R., *Il riposo di Raffaello Borghini in cui della pittura e della scultura si favella, de' più illustri pittori e scultori e delle più famose opere loro si fa menzione*, III, Florence, 1584.

Boucher Desnoyers A., *Appendice à l'ouvrage intitulé: Histoire de la vie et des ouvrages de Raphaël par M. Quatremère de Quincy*, Paris, 1853.

Brandi C., *Disegno della pittura italiana*, Turin, 1980.

Brizio A.M., "Raffaello, ad vocem", in *Enciclopedia Universale dell'Arte*, XI, Venise-Rome, 1963, col. 222-249.

Brosses (de) C., *Lettres familières écrites d'Italie en 1739 et 1740*, II, Paris, 1931.

Brown D.A., "Raphael's creativity as shown by his painting in America", in *Raphael and America*, exhibition catalogue edited by D.A. Brown, Washington D.C., 1983, pp. 109-164.

Brown D.A., "Raphael's Small Cowper Madonna and Madonna of the Meadow: their technique and Leonardo sources: Their technique and Leonardo Sources", in *Artibus & Historiae*, 8, 1983, pp. 9-26.

Bruni B., "La Deposizione della Croce di Raffaello nel S. Francesco al Prato in Perugia", in *Miscellanea Francescana*, LXXIII, 1973, pp. 191-196.

Buchner E., *Das Deutsche Bildnis der Spätgotik und der Frühen Dürerzeit*, Berlin, 1953.

Buck S., Hohenstatt P., *Raffaello Santi known as Raphael 1483-1520*, Köln, 1998.

Bufarale T., *Sulle cause della morte di Raffaello*, Urbino, 1915.

Burckhardt J., *Der Cicerone. Eine Anleitung zum Genuss der Kunstwerke Italiens Bearbeitet von Wilhelm Bode*, II, Leipzig, 1884.

Burckhardt J., *Eine Anleitung zum Genuss der Kunstwerke Itailens*, Basel, 1855 (It. transl., *Guida al godimento dell'arte in Italia*, edited by F. Pfister, Florence, 1952).

Burckhardt J., *Letture di storia e arte*, Turin, 1962.

Buren (van) A.H., "The Canonical Office in Renaissance Painting: Raphael's Madonna al Nones", in *The Art Bulletin*, LVII, 1, 1975, pp. 41-52.

Burkhalter, M., *Die Bildnisse Raphaels*, Laupen (Berne), 1932.

**C**

Cairo G., *Dizionario ragionato dei simboli*, Milan, 1922.

Calvi E., "Gli amori di Raffaello", in *Circolo Marchigiano di Roma*, special number for the IV centennial since his death, Rome, 1921.

Calzini E., "La donna velata di Raffaello e la Madonna della Seggiola", in *Rassegna bibliografica dell'arte italiana*, XI, 1908, nos 1-2, pp. 6-8.

Camesasca E., *Tutta la pittura di Raffaello. I quadri*, Milan, 1952.

Camesasca E., *Raffaello. I quadri*, I, Milan, 1956.

Camesasca E., *Raffaello. Tutti gli scritti*, Milan, 1956.

Camesasca E., *Tutta la pittura di Raffaello*, Milan, 1956.

Camesasca E., *Tutta l'opera pittorica di Raffaello. I quadri*, Milan, 1962.

Campbell, L., *Renaissance Portraits: European Portrait-Painting in the 14th, 15th and 16th Centuries*, New Haven-London, 1990.

Campori G., *Notizie e documenti per la vita di Giovanni Santi e di Raffaello Santi da Urbino*, Modena, 1870.

Campori G., *Notizie inedite di Raffaello da Urbino, tratte da documenti dell'archivio palatino di Modena*, Modena, 1863.

Campori G., *Racconti artistici. Raffaello e la Fornarina*, Florence, 1852.

Cantalamessa G., *Archivio e Galleria Borghese. Note manoscritte (1911-12)*, in A. Venturi, *Il Museo e la Galleria Borghese*, Rome, 1893.

Cantalamessa G., "Un ritratto femminile nella Galleria Borghese", in *Rassegna d'Arte*, XVI, 1916, no. 9, pp. 187-191.

Cantoni A., *Raffaello (1483-1520)*, Milan, 1932.

Cappelletti F., *I capolavori della collezione Doria Pamphilij*, exhibition catalogue, Milan, 1996, p. 34, no. 2.

Cappuccio L., *Raffaello Sanzio*, Milan, 1939.

Carcano G., *Poesia*, in *Atti del IV Centenario della nascita di Raffaello*, Urbino, 1887, pp. 95-104.

Carli E., *Raffaello* (Milan-Florence, 1951), Milan, 1959.

Carli E., *Raffaello. Armonia e splendore del Rinascimento*, Milan, 1983.

Carotti G., *Le opere di Leonardo, Bramante e Raffaello*, Milan, 1905.

Carpegna (di) N., *Catalogo della Galleria Nazionale di Palazzo Barberini*, Rome, 1953.

Carpegna (di) N., *Villa d'Este. Tivoli, La Quadreria*, Rome, n.d.

Cartwright J., *Raphael in Rome*, London-New York, 1895.

Cartwright J., *The early work of Raphael*, London, 1907.

Castelfranco G., *I grandi maestri del disegno. Raffaello*, Milan, 1962.

Castelfranco G., *Raffaello*, Milan, 1962.

Castelli P., "Le Virtù delle gemme. Il loro significato simbolico e astrologico nella cultura umanistica e nelle credenze popolari del Quattrocento. Il recupero delle gemme antiche", in *L'orefi-ceria nella Firenze del Quattrocento*, exhibition catalogue, Florence, 1977, pp. 309-364.

Castiglione B., *Il Cortegiano*, Venice, 1528.

Castiglione B., *Le Parfait Courtisan (Il Cortegiano)*, tiré d'A. Pons, Paris, 1987.

*Catalogo dell'esposizione di capolavori della pittura europea dei secoli XV-XVII*, Rome, Palazzo Venezia, 1944.

*Catalogue of Paintings 13th-18th Century*, II ed., transl. de L.B. Parshall, Berlin, 1978.

Cecchelli C., "La Psyche della Farnesina", in *Roma*, I, 1923, no. 2, pp. 9-21.

Cecchelli C., "Le pubblicazioni del IV centenario raffaellesco", in *Archivio della Società Romana di Storia Patria*, XLIV, 1921, pp. 332-347.

Cecchi A., "Raffaello fra Firenze, Urbino e Perugia (1504-1508)", in *Raffaello a Firenze*, exhibition catalogue, Florence, 1984, pp. 39-46.

Chambers F.P., *The history of taste*, Westport, 1971.

Chastel A., *Art et humanisme à Florence au temps de Laurent le Magnifique. Études sur la Renaissance et humanisme platonicien*, Paris, 1982.

Chastel A., *L'illustre incomprise Monna Lisa*, Paris, 1988.

Chesne Dauphiné Griffo G., "L'iconografia: l'abbigliamento", in *Raphael Urbinas. Il mito della Fornarina*, exhibition catalogue, Milan, 1983, pp. 16-19.

Chevalier J., Gheerbrant A., Berlewi M., *Dictionnaire des symboles*, Paris, 1969.

Chiappelli A, "Raffaello nei poeti stranieri", in *Nuova Antologia*, 55, 1920, pp. 209-224.

Chiarini M., "Il Granduca Cosimo III dei Medici e il suo contributo alle collezioni fiorentine", in *Uffizi: quattro secoli di una galleria*, Atti del convegno, edited by P. Barocchi et G. Ragionieri, Florence, 1982, I, pp. 319-329.

Chiarini M., "La Madonna del Granduca di Raffaello", in *Critica d'Arte*, LVIII, no. 1, 1995, pp. 37-46.

Ciardi Dupré M. G., *Raphael*, London, 1985.

Clark K., *The nude. Study of ideal art*, London, 1956.

Clayton M., in *Raphael and his Circle. Drawings from Windsor Castle*, exhibition catalogue edited by M. Clayton, London, 1999, pp. 54-56, 121.

Cochin C.N., *Voyage d'Italie*, Paris, 1758.

Colbacchini G., *A proposito di un giudizio emesso dalla R. Accademia di belle arti di Venezia sopra un disegno originale di Raffaello*, Venice, 1874.

Colbacchini G., *Memoria di Giuseppe Colbacchini che può servire a conclusione a due opuscoli riguardanti un disegno originale di Raffaello*, Venice, 1874.

Colbacchini G., *Nuove osservazioni critiche di Giuseppe Colbacchini intorno al disegno rappresentante la donna amata da Raffaello*, Venice, 1874.

Colonna V., *Carteggio*, edited by E. Ferrero and G. Mueller, Turin, 1889.

Colvin S., "La donna velata", in *The Art Journal*, 1882, pp. 1-3.

Comolli A., *Vita inedita di Raffaello da Urbino*, Rome, 1790.

Condivi A., *Vita di Michelangelo Buonarroti*, Rome, 1553.

Conestabile G., *Sulla vendita della Madonna del Libro di Raffaello*, Perugia, 1871.

Conti A., *Storia del restauro e della conservazione delle opere d'arte*, Milan, 1988.

Corradini S., "Un antico inventario della quadreria del Cardinale Borghese", in *Bernini scultore. La nascita del barocco in Casa Borghese*, exhibition catalogue edited by A. Coliva and S. Schütze, Rome, 1998, pp. 449-456.

Corsini Sforza L., "La collezione di Caterina Nobili Sforza contessa di Santafiora", in *L'Arte*, I, 1898, pp. 273-278.

Costa F., *Amore ed arte; ossia l'ultima decade di Raffaello Sanzio in Roma*, Montecassino, 1887.

Costamagna A., *Raffaello, Dama con liocorno, Scheda clinica* (CD-ROM), Rome, 2000.

Craven J., "Ut Pictura Poesis: a new reading of Raphael's portrait of the Fornarina as a Petrarcan allegory of painting, fame and desire", in *World & Image*, vol. 10, no. 4, October-December 1994, pp. 371-394.

Crowe J.A., Cavalcaselle G.B., *Raphael: his Life and Works*,

2 vol. (London, 1882-1885), It. transl. Florence, 1884-1891, II e III.

Crowe J.A., Cavalcaselle G.B., *Storia della Pittura in Italia*, Florence, 1884-1891.

Cugnoni G., "Agostino Chigi il Magnifico", in *Archivio della Società Romana di Storia Patria*, II, 1879, pp. 37-83.

Cugnoni G., "Note al Commentario di Alessandro VII sulla vita di Agostino Chigi", in *Archivio della Società Romana di Storia Patria*, II, 1879, pp. 209-226.

Cunnigham C.C., "Portrait of a Man in Armor by Sebastiano del Piombo", in *Wadsworth Atheneum Bulletin*, Hartford, 1960, no. 5, pp. 15-17.

Cust L., "Notes on Pictures in The Royal Collections", in *The Burlington Magazine*, XXIX, 1916, pp. 203-209.

Cuzin J.P., *Raphaël, vie et œuvre*, Fribourg, 1983.

**D**

D'Onofrio C., "Inventari del cardinale Pietro Aldobrandini compilato da G.B. Agucchi nel 1603", in *Palatino*, 1964, 8, pp. 15-20, 158-162, 202-211.

D'Orazio M.P., *Raffaello Sanzio, Ritratto di giovane donna con unicorno*, in *Garibaldi. Arte e Storia*, exhibition catalogue, Rome, 1982, p. 338.

Dacos Crifò N., "Vincenzo Tamagni a Roma", in *Prospettiva*, 1976, no. 7, pp. 46-51.

Dalli Regoli G., *Leonardo intorno al 1501: il tema del gioco*, in *Leonardo dopo Milano. La Madonna dei fusi (1501)*, Florence, 1982, pp. 25-31.

Dalli Regoli G., *Non... da natura, ma per lungo studio: Riferimenti, citazioni e rielaborazioni nelle Madonne di Raffaello*, in *Studi su Raffaello*, edited by M. Sambucco Hamoud and M.L. Strocchi, Urbino, 1987, pp. 419-428.

De Brosses Ch., *Le Président de Brosses en Italie, lettres familières écrites d'Italie en 1739 et 1740*, Paris, 1929.

De Koch E., *Storia delle cortigiane celebri di tutti i tempi e di tutti i paesi*, Milan, 1892.

De Lalande J.J., *Voyage d'un français en Italie fait dans les années 1765 et 1766*, III, Paris, 1769.

De Nohlac P., "Les collections de Fulvio Orsini", in *Gazette des Beaux Arts*, XXXIX, 1884, pp. 427-436.

De Rinaldis A., "Il restauro del quadro n. 371 della Galleria Borghese", in *Bollettino d'Arte*, XXX, 1936, pp. 122-129.

De Rinaldis A., *Museo Nazionale di Napoli*, Naples, 1911.

De Rinaldis, *La R. Galleria Borghese in Roma*, Rome, 1935.

De Rinaldis, *Pinacoteca del Museo Nazionale di Napoli*, Naples, 1928.

De Vecchi P., Baldini U., "Una nuova versione della Madonna con il Bambino nella Sacra Famiglia di Francesco I e l'atelier di Raffaello", in *Critica d'Arte*, LXII, no. 3, 1999, pp. 27-44.

De Vecchi P., *L'opera completa di Raffaello* (Milan, 1966), Milan, 1979.

De Vecchi P., "Lo Sposalizio della Vergine di Raffaello" (*Quaderno di Brera*, no. 2), Florence, 1973.

De Vecchi P., "Raffaello e il ritratto 'di naturale'", in *Raffaello e il ritratto di Papa Leone. Per il restauro del Leone X con due Cardinali nella Galleria degli Uffizi*, texts by A. Del Serra, P. De Vecchi, V. Guazzani, A. Noldi, Florence, 1996, pp. 9-50.

De Vecchi P., *Raffaello. La mimesi, l'armonia e l'invenzione*, Florence, 1995.

De Vecchi P., *Raffaello. La Pittura*, Florence, 1981.

De Vecchi P., "Ritratto di una apparizione. Appunti in margine alla Madonna Sistina", in *La Madonna per San Sisto e la cultura piacentina della prima metà del Cinquecento*, Atti del convegno, Parma, 1985, pp. 34-42.

Delaborde H., *Marcantonio Raimondi*, Paris, 1887.

Della Pergola P., *Galleria Borghese. I dipinti*, 2 vol., Rome, 1959.

Della Pergola P., "Gli Inventari Aldobrandini: l'Inventario del 1682", in *Arte Antica e Moderna*, 5, 1962, pp. 321-322.

Della Pergola P., *La Galleria Borghese a Roma*, Milan, 1950.

*Disegni degli Alberti*, exhibition catalogue edited by K. Herrmann Fiore, Rome, 1983.

*Disegni umbri del Rinascimento da Perugino a Raffaello*, exhibition catalogue edited by S. Ferino Pagden, Florence, 1982.

Dolce L., *Dialogo della Pittura intitolato l'Aretino* (Venice, 1557), New York, 1968.

Dolce L., *Dialogo della Pittura*, in P. Barocchi, *Trattati d'arte del Cinquecento*, vol. I, Bari, 1960.

Dolce L., *Lettere di diversi eccellentissimi Homini... tra le quali se ne leggono molte non più stampate*, Venice, 1559.

Dolce L., *Modi Affigurati et Voci Scelte et Eleganti della Volgar Lingua*, Venice, 1564.

Dumesnil A.J., *Raphaël*, Paris, 1854.

Dumesnil A.J., *Histoire des plus célèbres amateurs italiens*, Paris, 1853.

Duppa R., *Appendice contenente l'elenco delle pitture ad olio di Raffaello*, n.p., n.d.

Duppa R., Quatremère de Quincy C., *The lifes and works of Michael Angelo and Raphael*, London, 1870.

Durand-Greville E., "Un portrait indûment retiré à Raphaël: la pseudo Fornarina du Musée des Offices", in *Revue de l'Art Ancien et Moderne*, XVIII, 1905, pp. 313-318.

Dussler L., *Raphael. A critical catalogue of his Pictures, Wall-Paintings and Tapestries*, London-New York, 1971 (orig. title: *Rafael. Kritisches verzeichnis der gemälde, wandbilder und bildteppiche*, Munich, 1966).

Dussler L., *Sebastiano del Piombo*, Basel, 1942.

**E**

Eiche S., "The return of Baldassar Castiglione", in *The Burlington Magazine*, CXXIII, 1981, no. 936, pp. 154-155.

Emile-Mâle G., "Restauration du tableau (Baldassarre Castiglione)", in *Revue du Louvre et des Musées de France*, 1979, no. 4, pp. 271-272.

Englen A., *Le vicende storiche: le fonti*, in *Raphael Urbinas. Il mito della Fornarina*, exhibition catalogue, Milan, 1983, pp. 30-31.

Eroli G., *La coronazione di M.V. del Ghirlandaio e la Madonna del Libro di Raffaello*, Narni, 1880.

*Esposizione dei capolavori della pittura europea XV-XVII secoli*, Rome, 1944.

**F**

Falcaneri C., *Memorie intorno al ritrovamento delle ossa di Raffaello con breve appendice sulla vita di lui*, Rome, 1833.

Farabulini D., "Raffaello e la Fornarina", in *Il Raffaello*, IX, 1879, pp. 5-11.

Farabulini D., *Saggio di nuovi studi su Raffaello d'Urbino*, Rome, 1875.

Fea C., *Descrizione di Roma*, II, Rome, 1824.

Federici V., "Della casa di Fabio Sassi in Parione", in *Archivio della Società Romana di Storia Patria*, XX, 1897, pp. 479-489.

Ferino Pagden S., "Giulio Romano pittore e disegnatore a Roma", in *Giulio Romano*, exhibition catalogue, Milan, 1989, pp. 65-95.

Ferino Pagden S., *I Raffaello dei Borghese*, in *Galleria Borghese*, edited by A. Coliva, Rome, 1994, pp. 262-266.

Ferino Pagden S., "Iconographic demands and artistic achievements: the genesis of three works by Raphael", in *Raffaello a Roma. Il convegno del 1983*, Biblioteca Hertziana Musei Vaticani, Rome, 1986, pp. 13-29.

Ferino Pagden S., in *Raffaello a Firenze. Dipinti e disegni delle collezioni fiorentine*, exhibition catalogue, Florence, 1984, pp. 354-355, no. 42.

Ferino Pagden S., "Raphael's Heliodorus vault and Michelangelo's Sistine ceiling: an old controversy and a new drawing", in *The Burlington Magazine*, CXXXII (1990), 1044, pp. 195-204.

Ferino Pagden S., Zancan M.A., *Raffaello. Catalogo completo dei dipinti*, Florence, 1989.

Fernetti F., "Gli allievi di Raffaello e l'insolito utilizzo di un cartone del maestro nella Sala di Costantino", in *Prospettiva*, no. 87-88, 1997, pp. 133-136.

Ferrara L., *Galleria Borghese. Roma*, Novara, 1970.

Ferri P.N., *Catalogo riassuntivo della raccolta di disegni antichi e moderni posseduta dalla R. Galleria degli Uffizi di Firenze*, Rome, 1890.

Filippini F., "Raffaello a Bologna", in *Cronache d'Arte*, II, 1925, no. 5, pp. 222-224.

Fiochi Nicolai G., *Le Madonne di Raffaello*, Urbino, 1893.

Fischel O., "Der Raffael Czartoryski", in *Jahrbuch der Königlich Preuszischen Kunstsammlungen*, XXXVII, 1916, pp. 251-261.

Fischel O., *Raphael* (London, 1948), Berlin, 1962.

Fischel O., *Raphaels Zeichnungen*, 8 vol., Berlin, 1913-1941.

Fischel O., *Raphaels Zeichnungen. Versuch einer Kritik der bisher veröffentlichten Blätter*, Strasbourg, 1898.

Focillon H., *Raphaël*, Paris, 1926.

Fomiceva T., "K voprocu o datirovke 'Madonni Konestabile' Rafaelja", in *Soobscenija, Hermitage*, XXXIV-XXXV, 1973, pp. 3-5.

Forlani Tempesti A., *I disegni*, in *Raffaello, l'opera, le fonti, la fortuna*, presentation by M. Salmi, 2 vol., Novara, 1968, pp. 307-429.

Forlani Tempesti A., in *Il primato del disegno. Firenze e la Toscana dei Medici nell'Europa del Cinquecento*, exhibition catalogue, Florence, 1980.

Forlani Tempesti A., *Raffaello. I disegni*, Florence, 1983.

Fornari S., *Spositione sopra L'Orlando Furioso*, Florence, 1549.

Freedberg S.J., *La Pittura in Italia dal 1500 al 1600*, Bologna, 1988.

Freedberg S.J., *Painting of the High Renaissance in Rome and Florence* (Cambridge, Mass. 1961), New York, 1985.

Freedberg S.J., *Painting of the High Renaissance in Rome and in Florence*, 2 vol., Cambridge, Mass., 1961.

Friedmann H., "The plant symbolism of Raphael's Alba Madonna in the National Gallery of Arts, Washington", in *Gazette des Beaux-Arts*, 1949, 36, pp. 213-220.

Friedrich J.B., *Die Symbolik und Mythologie der Natur*, Würzburg, 1859.

Frimmel, T., *Kleine Gemäldestudien*, I, Bamberg, 1892.

Frizzoni G., *I Disegni della R. Galleria degli Uffizi in Firenze. Disegni di Raffaello*, s. 3ª, fasc. II, Florence, 1912-1921.

Frizzoni G., *Le Gallerie nell'Accademia Carrara in Bergamo*, Bergamo, 1897.

Frommel C.L., *Baldassarre Peruzzi als Maler und Zeichner*, Vienna-Munich, 1967-1968.

Frommel C.L., "Raffaello e il teatro alla corte di Leone X", in *Bollettino del centro internazionale di studi di architettura A. Palladio*, XVII, 1975, pp. 184-185.

Fusero C., *Raffaello*, Milan (1939) 1963.

## G

*Galleria Borghese*, edited by A. Coliva, Rome, 1994.

Gamba C., *Pittura umbra del Rinascimento. Raffaello in Storia della pittura italiana*, Novara, 1949.

Gamba C., *Raphaël*, Paris, 1932.

Gandellini G.G., De Angelis L., *Notizie degli Intagliatori con osservazioni critiche raccolte da vari scritti*, Siena, 1813.

Garas K., "The So-called Piombo Portrait in the Museum of Fine Art", in *Acta Historiae Artium Academiae Scientiarum Hungaricae*, 1954, pp. 135-148.

Garas, K., "Die Bildnisse Pietro Bembos in Budapest", in *Acta historiae artium*, vol. 16, 1970, pp. 57-67.

Garas, K., "Sammlungsgeschichtliche Beiträge zu Raffael: Raffael-Werke in Budapest", in *Bulletin du Musée Hongrois des Beaux-Arts*, 60-61, 1983, pp. 41-81, 183-201.

Garms J., *Quellen Aus dem Archiv Doria-Pamphilj zur Kunsttätigkeit in Rom unter Innocenz X*, Rome-Vienna, 1972.

Gere, J., Turner N., *Drawings by Raphael from the Royal Library, the Ashmolean, the British Museum, Chatsworth and Other English Collections*, London, 1983.

Gherardi P., *Della vita e delle opere di Raffaello Sanzio da Urbino*, Urbino, 1874.

Giovio P., *Elogia virorum doctorum ante 1527*, Venice, 1546.

Giovio P., *Illustrium virorum vita*, Florence, 1557.

Giovio P., *Raphaelis Urbinatis Vita*, in P. Barocchi, *Scritti d'arte del Cinquecento*, Turin, 1977, 1, pp. 13-19.

Giusti G., *La Galleria Borghese e la Villa di Umberto I in Roma*, Città di Castello 1911.

Gnann A., "I giovani artisti a Roma dalla morte di Raffaello al sacco di Roma (1520-1527)", in *Roma e lo stile classico di Raffaello, 1515-1527*, exhibition catalogue edited by K. Oberhuber et A. Gnann, Milan, 1999, pp. 31-59.

Gnudi C., Saggio introduttivo, in *L'ideale classico del Seicento in Italia e la pittura di paesaggio*, exhibition catalogue, Bologna, 1962.

Golzio V., *Il Palazzo Barberini e la sua Galleria di pittura*, Rome, n.d.

Golzio V., "La vita. (Raffaello e la Fornarina, ispiratrice dei suoi sonetti) e La fortuna critica", in *Raffaello. L'opera, le fonti, la fortuna*, Novara, 1968, II, pp. 603-604 et 609-646.

Golzio V., *Raffaello nei documenti, nelle testimonianze dei contemporanei e nella letteratura del suo secolo*, (Vatican City, 1936), 1971.

Gombrich E., "La Madonna della seggiola di Raffaello", in *Norma e forma. Studi sull'arte del Rinascimento*, Turin, 1973, p. 93.

Gould C., "Raphael versus Giulio Romano: the swing back", in *The Burlington Magazine*, 124, 1982, pp. 478-487.

Gould C., "The High Renaissance in Rome and Florence", in *The Burlington Magazine*, CV, 1963, pp 512-513.

Grimm H., *Leben Michelangelo's*, Berlin, 1879.

Gronau G., *Documenti artistici urbinati*, Florence, 1936.

Gronau G., *Raffael. Des Meisters Gemälde* (Stuttgard-Leipzig, 1909), Stuttgart-Berlin, 1922.

Gronau G., "Some portraits by Titian and Raphael", in *Art in America*, XXV, 1937, pp. 93-104.

Gruyer F.A., *Les portraits de la Fornarina par Raphaël*, Paris, 1877.

Gruyer F.A., *Les Vierges de Raphaël et l'iconographie de la Vierge*, III, Paris, 1869.

Gruyer F.A., *Raphaël peintre de portraits, fragments d'histoire et d'iconographie sur les personnages représentés dans les portraits de Raphaël*, I, Paris, 1881.

Gualazzi E., *Vita di Raffaello da Urbino*, Milan, 1984.

*Guida del Museo Nazionale di Napoli e dei suoi principali monumenti illustrati*, Naples, 1871.

*Guida generale delle Mostre retrospettive in Castel Sant' Angelo*, Rome, 1911.

## H

Hartt F., "A drawing of the Fornarina as the Madonna", in *Essay in honour of Walter Friedlaender*, New York, 1965, pp. 90-91.

Hartt F., *Giulio Romano*, 2 vol. (New Haven, 1958), New York, 1981.

Hartt F., "Raphael and Giulio Romano with notes on the Raphael School", in *The Art Bulletin*, XXVI, 1944, pp. 67-93.

Hauptmann F., *Der Tondo*, Frankfurt, 1936.

Heinse J.J.W., *Ardinghello und die glückseeligen Inseln*, Lemgo, 1794.

Hermann Fiore K., *Guida alla Galleria Borghese*, Rome, 1997.

Hermann Fiore K., "Raffaello, Ritratto di dama con liocorno, e Raffaellino del Colle, La Fornarina Borghese", in *Raffaello e Dante*, exhibition catalogue, Milan, 1992, pp. 261-263.

Hess J., "On Raphael and Giulio Romano", in *Gazette des Beaux Arts*, 32, 1947, pp. 73-106.

Hill G.F., Pollard G., *Renaissance Medals from the Samuel H. Kress Collection at the National Gallery of Art*, London, 1967.

Hochmann M., "Les dessins et les peintures de Fulvio Orsini et la collection Farnèse", in *Mélanges de l'École Française de Rome*, CV, 1993, 1, pp. 49-91.

## I

*Il primato del disegno. Firenze e la Toscana dei Medici nell'Europa del Cinquecento*, exhibition catalogue, Florence, 1980.

Imdahl M., "Raffaels Castiglione Bildnis im Louvre zur Frage seiner ursprünglichen", in *Pantheon*, XX, 1962, 1, pp. 38-45.

Incerpi G., in *Raffaello a Firenze. Dipinti e disegni delle collezioni fiorentine*, exhibition catalogue, Florence, 1984, nos 6, 7, 13, 15.

Ingres J.A.D., *Écrits sur l'art*, Paris, 1947.

*Ingres*, exhibition catalogue, Paris, 1967.

*Inventario General de Pinturas. I. La Colección Real*, Madrid, 1990.

## J

Jaffè M., *The Devonshire Collection of Italian Drawings. Tuscan and Umbrian Schools*, London, 1994.

Jean Richard P., in *Raphaël dans les collections françaises*, exhibition catalogue, Paris, 1983, pp. 330-331, no. 7.

Jestaz B., *L'inventaire du Palais et des propriétés Farnèse à Rome en 1644*, Rome, 1994.

Joannides P., *The drawings of Raphael with a complete catalogue*, Oxford, 1983.

Jones R., Penny N., *Raphael*, New Haven et London, 1983.

**K**

Kelber W., *Raphael von Urbino. Leben und Werk*, Stuttgart, 1979.

Knab E., *La nascita del disegno autonomo e gli esordi di Raffaello*, in E. Knab, E. Mitsch, K. Oberhuber, *Raffaello, I disegni*, in collaboration with S. Ferino Pagden, edited by P. Dal Poggetto (Stuttgart, 1983) Florence, 1984, pp. 19-75.

Knab E., Mitsch E., Oberhuber K., in collaboration with S. Ferino Pagden, *Raffaello, I disegni* (Stuttgart, 1983), It. edition edited by P. Dal Poggetto, Florence, 1984.

Knackfuss H., *Raffael* (Leipzig, 1895), 1898.

Knowles J., *The Life and Writings of Henry Fusely*, III, London, 1831.

Koopmann W., *Einige weiniger bekannte Handzeichnungen Raffaels*, in "Jahrbuch der Königlich Preussischen Kunstsammlungen", 12, 1891, pp. 40-49.

Kustodieva T.K., *Italian Painting. Thirteenth to Sixteenth Centuries*, in *The Hermitage. Catalogue of Western European Painting*, Moscow-Florence, 1994.

**L**

*L'Estasi di Santa Cecilia di Raffaello da Urbino nella Pinacoteca Nazionale di Bologna*, exhibition catalogue edited by Bernardini C., Zarri G., Emiliani A., Bologna, 1983.

*La Galleria Palatina. Storia della Quadreria Granducale di Palazzo Pitti*, exhibition catalogue, Florence, 1982.

La Lande (de) J., *Voyage d'un français en Italie fait dans les années 1765 et 1766*, Paris, 1769.

Laclotte M., Cuzin J. P., *Musée du Louvre. La peinture européenne*, Paris, 1982.

Laclotte M., Cuzin J.P., *The Louvre. European Paintings*, Paris, 1993.

Laclotte M., *Le XVIe siècle européen. Peintures et dessins dans les collections publiques françaises*, Paris, 1966.

Lanciani R., *The Golden days of the Renaissance in Rome*, London-Boston-New York, 1907.

Landon C. P., *Vie et œuvre complète de Raphaël Sanzio*, Paris, 1805.

Lanzi L., *Storia pittorica dell'Italia dal Risorgimento delle belle arti fin presso al fine del XVIII secolo* (Milan, 1831), edited by M. Capucci, 3 vol., Florence, 1968.

Lattanzi G., *Raffaello*, Milan (1929), 1930.

Lavin I., "On the sourcers and meaning of the Renaissance portrait bust", in *The Art Quarterly*, XXIII, 1970, 3, pp. 207-226.

Lavin M.A., *Seventhenth-century Barberini Documents and Inventories of Art*, New York, 1975.

*Le Beau Idéal ou l'art du concept*, exhibition catalogue edited by C. Michel, Paris, 1989.

Le Blanc Ch., *Manuel de l'amateur d'estampes*, Paris, 1850-1858.

*Le collezioni del Museo di Capodimonte*, edited by R. Causa, Naples, 1982.

Leone Ebreo, *Dialoghi d'amore* (1535), Bari, 1929.

Lepp H., "The portrait in art theory of the Renaissance", in *Kunstgeschichtliche Studien zur Florentiner Renaissance*, I, 1980, pp. 365-373.

Levi C., "La fortuna di Raffaello nel teatro", in *Il Marzocco*, 4 aprile 1920, pp. 6-7.

Levi D., *Cavalcaselle. Il pioniere della conservazione italiana*, Turin, 1988.

Lichtenstein S., "The Baron Gros and Raphael", in *The Art Bulletin*, LX, 1978, 1, pp. 126-138.

Licustri S., "Raffaello, Ritratto di giovane donna con liocorno", in *I Luoghi di Raffaello a Roma*, exhibition catalogue, Rome, 1983, pp. 169-171.

Lilius H., "Villa Lante al Gianicolo. L'architettura e la decorazione pittorica", in *Acta Instituti Romani Finlandiae*, X, 1981, no. 1, pp. 291-298.

Lippmann F., "Raffaels Entwurf zur Madonna del Duca di Terranuova und zur Madonna Staffa-Connestabile", in *Jahrbuch de königlich preussischen Kunstsammlungen*, 2, 1881, pp. 62-66.

Lo Bianco A., "Giulio Romano", in *Aspetti dell'arte a Roma prima e dopo Raffaello*, exhibition catalogue, Rome, 1984, pp. 93-109.

Lo Bianco A., "La Madonna della gatta di Giulio Romano: precisazioni e ipotesi", in *Scritti di Storia dell'arte in onore di Raffaello Causa*, Naples, 1988, p. 124.

Locher H., *Raffael und das Altarbild der Renaissance: die "Pala Baglioni "als Kunstwerk im sakralen Kon*, Berlin, 1994.

Lochis G., *La Pinacoteca e la Villa Lochis alla Crocetta di Mozzo presso Bergamo con notizie Biografiche degli Autori dei quadri*, Bergamo, 1858.

Lomazzo G.P., *Idea del tempio della pittura*, Milan, 1590.

Longhi R., *Da Cimabue a Morandi*, Milan, 1973.

Longhi R., "Percorso di Raffaello giovine", in *Paragone*, 65, 1955, pp. 8-23.

Longhi R., "Precisioni nelle Gallerie Italiane (Precisione aggiunta)", in *Vita Artistica*, août-septembre 1927, II, nos 8-9, pp. 168-173.

Longhi R., *Precisioni nelle gallerie italiane. I, R. Galleria Borghese*. Rome, 1928 and 1929.

Longhi R., "Quadri italiani di Berlino a Sciaffausa (1951)", in *Paragone*, 33, 1952, pp. 39-46.

Lores E., *Raphaël et Margarita*, Paris, n.d.

Lotti L., "La villa Lante già Turini, al Gianicolo", in *Alma Roma*, XVII, 1976, nos 1-2, pp. 68-79.

Lualdi A., "Musica e teatro intorno a Raffaello", in *Emporium*, marzo-aprile, 1920, pp. 198-208.

Lucco M., *L'opera completa di Sebastiano del Piombo*, Préface de C. Volpe, Milan, 1980.

Lucie Smith E., *Raphael*, Novara, 1961.

Lugt F., *Les marques des collections de dessins et d'estampes*, Amsterdam, 1921 (supplement Gravenhage, 1956).

Luzio A., "Federico Gonzaga ostaggio alla corte di Giulio II", in *Archivio della R. Società Romana di Storia Patria*, Rome, 1886, pp. 509-583.

**M**

Magnanini G., "Inventari della Collezione dei principi Corsini", in *Bollettino d'Arte*, 7,
1980, pp. 91-128 e 8, pp. 73-114.

Maltese C., "Per una scheda integrata delle opere di pittura", in *Raphael Urbinas. Il mito della Fornarina*, exhibition catalogue, Milan, 1983, pp. 37-40 et 70, 77.

Maltese C., "Resoconto sommario di analisi sematometriche e chimico-fisiche non distruttive eseguite su quattro dipinti di Raffaello e della sua cerchia", in *Raffaello nelle Raccolte Borghese*, exhibition catalogue, Rome, 1984, pp. 13-15.

Malvasia C.C., *Felsina pittrice*, Bologna, 1678.

Mancinelli F., *Primo piano di un capolavoro. La Trasfigurazione di Raffaello*, Cité du Vatican, 1979.

Mancini F.F., *Raffaello in Umbria. Cronologia e committenza. Nuovi Studi e documenti*, Perugia, 1987.

Marabottini A., "I collaboratori", in *Raffaello, l'opera, le fonti, la fortuna*, Novara, 1968.

Marabottini A., "Raffaello fino all'ottobre 1504", in *Raffaello e Città di Castello*, exhibition catalogue, Città di Castello, 1983.

Marani P.C., *Leonardo. Catalogo completo dei dipinti*, Florence, 1989.

Maratta C., *Ritratti di alcuni celebri pittori del secolo XVII*, Rome, 1731.

Marcotti G., "La vera Fornarina di Raffaello", in *L'Illustrazione Italiana*, XIX 1892, no. 5, p. 67.

Marenco L., *Raffaello Sanzio*, Milan, 1873.

Mariotti F., *La legislazione delle Belle arti*, Rome, 1982.

Marrini F., "Fortuna storica di Raffaello nel Cinquecento", in *Rinascimento*, 2, 1951, pp. 67-68.

Matteoli A., "La ritrattistica del Bronzino nel 'Limbo'", in *Commentari*, XX, 1969, fasc. IV, pp. 281-316.

Mercurj F., *Nouvelle description de Rome et des environs d'après les ouvrages de Nibby, Vasi*, Rome, 1855.

Méry J., *Raphaël et la Fornarina*, Paris, 1976.

Meyer zur Capellen Y., *Raphael in Florence*, London, 1996.

Meyer zur Capellen Y., *Raphael. A Critical Catalogue of His Paintings*, I, *The Beginnings in Umbria and Florence ca. 1500-1508*, Münster, 2001.

Michiel M., *Notizia d'opere di disegno nella prima età del secolo XVI...*, edited by I. Morelli, Bassano, 1800.

Middeldorf U., *Raphael's Drawings*, New York, 1945.

Milanesi G., *Commento a Le vite di Giorgio Vasari*, Florence, 1879, IV, pp. 355-357.

Milizia F., *De l'art de voir le Beau dans les Beaux-Arts*, trad. del generale Pommereuil, Paris, 1797-1798.

Miller (A. Riggs), *Letters from Italy*, III, London, 1776.

Miller Ch., *The travels of Theodor Ducas*, I, London, 1822.

Miller M.J., "A Madonna and Child from Pinturicchio's Sienes Period", in *The Art Bulletin of the Cleveland Museum of Art*, 78, 1991, pp. 326-359.

Minghetti M., *Raffaello*, Bologna, 1885.

Minghetti M., "Ultimo periodo di Raffaello (1517-1520)", in *Nuova Antologia*, 1883, pp. 228-267.

Missirini M., *Notizie intorno alla Fornarina sul vero ritratto della stessa dipinto da Raffaello; e congettura intorno alla verità di quelli della casa Barberini in Roma e della Galleria di Firenze* (n.p., 1847, IV), Milan, 1828.

Missirini M., *Piacevole raccolta di Opuscoli*, III, n.p., n.d.

Mitsch E., *Raphael in der Albertina*, Vienna, 1983.

Mochi Onori L., "I ritratti della Fornarina e Le vicende storiche: la storiografia", in *Raphael Urbinas. Il mito della Fornarina*, exhibition catalogue, Milan, 1983, pp. 22-26, 32-33.

Mochi Onori L., "La copia Borghese della Fornarina", in *Raffaello nelle raccolte Borghese*, exhibition catalogue, Rome, 1984, pp. 62-63.

Mochi Onori L., "La Fornarina nella quadreria Albani", in *Committenze della famiglia Albani. Note sulla villa Albani Torlonia*, Rome, 1985, pp. 245-251.

Mochi Onori L., "La Fornarina. Biografia di un dipinto", in *Raffaello. "La Fornarina"*, exhibition catalogue, Roma 2000, pp. 5-18.

Mochi Onori L., "Raffaello, La Fornarina", in L. Mochi Onori, R. Vodret, *Capolavori della Galleria Nazionale d'Arte Antica Palazzo Barberini*, Rome, 1998, pp. 34-35.

Mochi Onori L., *Raffaello, La Fornarina*, in L. Mochi Onori, Vodret R., *Regesto delle didascalie*, Rome, 1989, pp. 46-47.

Modestini G. M., *Descrizione della chiesa di S. Francesco dei P.P. Minori Conventuali della città di Perugia*, Perugia, 1787.

Molajoli B., *Notizie su Capodimonte*, Naples, 1957.

Monbeig Goguel C., *Raphaël à Rome*, in *Raphaël dans les collections françaises*, exhibition catalogue, Paris, 1983, pp. 153-156.

Monicart (de) J.B., *Versailles immortalisé par les merveilles parlantes*, II, Paris, 1720.

Morcelli P., *Description de la Villa Albani*, Rome, 1869.

Morelli G. (Ivan Lermolieff), *Kunstkritische Studien über Italienische Malerei. Die Galerie zu Berlin*, Leipzig, 1893.

Morelli G., (Ivan Lermolieff), *Kunstkritische Studien über italianischen Malerei in den Galerien Borghese und L. Pamphili in Rom*, Leipzig, 1890.

Morelli G., *Della pittura italiana. Studi storico critici*, edited by J. Anderson, Milan, 1991.

Morelli G., "Della Pittura Italiana. Studi Storico-Critici: Le Gallerie Borghese e Doria Pamphilij" in *Roma* (Milan, 1897), Milan, 1991.

Morelli G., "Handzeichnungen in italienischer Meister", in *Kunstchronik*, N.F., IV, 1892-1893, pp. 1-9, 499, 503.

Morelli G., *Italian Painters. Critical Studies of Their Works*, 2 vol., London, 1892-1893.

Moreno P., Stefani C., *Galleria Borghese*, presentation by C. Strinati, introduction by A. Costamagna; texts by A. Coliva, K. Herrmann Fiore and P. Moreno, Milan, 2000.

Mori F., *Ricordi di alcuni rimarchevoli oggetti di curiosità e Belle Arti di Napoli ed altri luoghi del Regno*, Naples, 1837.

Morini N., "L'Incisione della Santa Cecilia di Raffaello per opera di Mauro Gandolfi", in *Il Comune di Bologna*, March 1926, pp. 172-173.

Morozzi L., *Le carte archivistiche della Fondazione Her-*
bert P. Horne: inventario, Milan, 1988.

*Mostra di disegni dei grandi maestri*, exhibition catalogue edited by G. Sinibaldi, Florence, 1960.

*Mostra internazionale raffaellesca*, exhibition catalogue, Urbino, 1897.

*Mostra temporanea di insigni opere d'arte appartenenti alle gallerie di Roma, Napoli, Urbino, Milano, Venezia*, exhibition catalogue, Rome, 1945.

Mündler O., "Beiträge zum Burckhards Cicerone", in *Jahrbuch der Kunstwissenschaft*, III, 1869, pp. 810-921.

Mundler O., *Essai d'une analyse critique de la notice des tableaux italiens du Musée National du Louvre*, Paris, 1850.

Müntz E., *Les historiens et les critiques de Raphaël, 1483-1883*, Paris, 1883.

Müntz E., *Raphaël. Biographie critique*, Paris, 1901.

Müntz E., *Raphaël, sa vie, son œuvre et son temps*, Paris, (1881) 1886.

*Musée du Louvre. Inventaire Général des Dessins Italiens. Raphaël. Son atelier, ses copistes*, V, edited by Cordellier D., Py B., Paris, 1992.

*Musée du Louvre. La Collection de François I<sup>er</sup>*, catalogue edited by J. Cox-Rearich; préface de S. Béguin, Paris, 1972.

Muzii R., in *La collezione Farnese. La scuola emiliana: i dipinti. I disegni*, Naples, 1994, pp. 12-22.

Muzii R., *I grandi disegni italiani nella collezione del Museo di Capodimonte a Napoli*, Milan, 1987.

**N**

Nagler G.K., *Neues allgemeines Künstler-Lexicon*, Munich, 1840.

Nibby A., *Itinerario istruttivo di Roma e delle sue vicinanze compilato già da M. Vasi* (Rome, 1824), Rome, 1885.

Nibby A., *Roma nell'anno 1838*, Rome, 1841.

Nicco Fasola G., "Giulio Romano e il Manierismo", in *Commentari*, XI, 1, 1960, pp. 60-73.

Niccolini F., *Di un cartone di Raffaello Sanzio custodito nel Real Museo Borbonico*, Naples, 1859.

Niccolini F., in *Real Museo Borbonico*, Naples, 1824-1857.
berini, Rome, 1998, pp. 34-35.
Nicodemi G., *Raffaello Sanzio*, Milan, 1939.

Noé H.A., "Messer Giacomo en zÿn Laura", in *Nederlandes, Kunsthistorisch Jaarboeck*, II, 1960, pp. 18-19.

Northall J., *Travel through Italy*, London, 1766.

Nucciarelli F.I., Severini G., *San Pietroburgo, Ermitage. Raffaello Madonna del Libro o Madonna Conestabile*, Perugia, 1999.

**O**

Oberhuber K., Brown D.A., "'Monna Vanna and Fornarina': Leonardo and Raphael in Rome", in *Essays Presented to Myron Gilmore*, edited by S. Bertelli et G. Ramakus, Florence, 1978, pp. 25-86.

Oberhuber K., "Die Fresken der Stanza dell'Incendio im Werk Raffaels", in *Jahrbuch der Kunsthistorischen Sammlungen in Wien*, N.F., XXII, 1962, pp. 23-72.

Oberhuber K., *Entwurfe zu Werken Raphaels und seiner Schule im Vatikan 1511-12 bis 1520*, Berlin, 1972.

Oberhuber K., "Raffaello e l'incisione", in *Raffaello in Vaticano*, exhibition catalogue, Milan, 1984, pp. 333-342.

Oberhuber K., *Raffaello, l'opera pittorica*, Milan, 1999.

Oberhuber K., *Raffaello*, It. transl. edited by M. Magrini, Milan, 1982.

Oberhuber K., "Raphael's drawings for the Loggia of Psyche in the Farnesina", in *Raffaello a Roma. Il convegno del 1983*, Rome, 1986, pp. 189-207.

Oberhuber K., *Raphaels Zeichnungen. Abteilung IX. Entwürfe zu Werken Raphaels und seiner Schule im Vatikan, 1511-1512 bis 1520*, Berlin, 1972.

Oberhuber K., "Vorzeichnungen zu Raffaels 'Transfiguration'", in *Jahrbuch der Berliner Museen*, IV, 1962, pp. 116-149.

Odescalchi P., *Istoria del ritrovamento delle spoglie mortali di Raffaello Sanzio da Urbino*, Rome, 1836.

Oettinger K., *Zu Raffaels Kardinaltugenden im Vatikan* in *Mouseion. Studien aus Kunst und Geschichte für Otto H. Förster*, Köln, 1960, pp. 101-102.

Offner R., "A portrait of Perugino by Raphael", in *The*

*Burlington Magazine*, LXV, 1934, pp. 245-257.

Ojetti U., "Raffaello Sanzio", in *Celebrazioni marchigiane*, Urbino, 1935, part 2, pp. 5-27.

Oppé A. P., *Raphael*, London, 1909.

Oppo C.E., "Accanto alla gloria ufficiale di Raffaello. La Fornarina e alcune nuove riflessioni", in *L'idea Nazionale*, 30 mars 1920.

Orsini B., *Guida al forestiere per l'augusta città di Perugia*, Perugia, 1784.

Ortolani S., *Raffaello*, Bergamo, 1948.

Ottaviano C., *La legge della bellezza*, Padoue, 1970.

Ottino dalla Chiesa A., *Accademia Carrara*, Bergamo, 1955.

**P**

Pächt O., *Van Eyck: Die Begründer der altniederländischen Malerei*, Munich, 1989.

Pallucchini R., *Sebastian Viniziano*, Milan, 1944.

Panzeri M., "Morelli e la collezione Lochis nella Pinacoteca dell'Accademia Carrara", in *Giovanni Morelli e la cultura dei conoscitori*, proceedings of the international meeting, edited by G. Agosti, M.E. Manca, M. Panzeri, coordination M. Dalai Emiliani, 3 vol., Bergamo, 1993, I, pp. 221-239.

Papini M. L., *L'ornamento della pittura. Cornici, arredo, e disposizione della Collezione Corsini di Roma nel XVIII secolo*, Rome, 1998.

Partrige L., Starn R., *A Renaissance likeness. Art and culture in Raphael's Julius II*, Berkeley, 1980.

Pasini W., *I tipi estetici della donna italiana nella letteratura e nell'arte dai primi secoli a tutto il Settecento*, Rocca San Casciano, 1914.

Passavant G.D., *Le Peintre-Graveur*, Leipzig, 1860-1864.

Passavant J.D., *Raffaello d'Urbino e il padre suo Giovanni Santi* (Leipzig, 1839, I et II; Leipzig, 1858, III, Paris, 1860), Florence, 1882-1891.

Pater W., *Raffaello in The Renaissance, with an introduction and notes by K. Klark*, London, 1961.

Pedretti C., "Quella puttana di Leonardo", in *Achademia Leonardi Vinci*, IX, 1996, pp. 121-139.

Pedretti C., *Raffaello*, Bologna, 1982.

Pedretti C., "Uno 'studio' per la Gioconda", in *L'Arte*, LVIII, 1959, pp. 155-224.

Pedrocchi A.M., "L'iconografia: il gioiello", in *Raphael Urbinas. Il mito della Fornarina*, exhibition catalogue edited by A. Englen, A.M. Pedrocchi, L. Mochi Onori, Milan, 1983, p. 20.

Pellizzari S., (OA-SBAS Roma) *Raffaello, Ritratto di dama con liocorno*, Rome, 1980.

Pellizzari S., (OA-SBAS Roma), *Raffaellino del Colle, La Fornarina Borghese*, Rome, 1980.

Persico G.B., *Descrizione di Verona e della sua provincia*, Verona, 1820.

*Personaggi e interpreti. Ritratti della Collezione Corsini*, exhibition catalogue edited by S. Alloisi, Rome, 2001.

Petrioli Tofani A., De Vecchi P., *I disegni di Raffaello nel Gabinetto dei Disegni e delle Stampe degli Uffizi*, Milan, 1982.

Petrioli Tofani A., *Gabinetto Disegni e Stampe degli Uffizi. Inventario, I, Disegni esposti*, Florence, 1986.

Petrucci A., *Catalogo generale delle stampe tratte dai rami incisi posseduti dalla Calcografia Nazionale*, Rome, 1953.

Piancastelli G., "Archivio Galleria Borghese. Manoscritto, Catalogo dei quadri della Galleria Borghese inscritti nelle Note Fidecommissarie", 1891, in P. Della Pergola, *Galleria Borghese. I dipinti*, II, Rome, 1959.

Pigler A., *Katalog der Galerie Alter Meister*, Budapest, 1967.

Piranesi F., *Schola italica picturae, … cura et i impensis Gavini Hamilton*, Rome, 1773.

Pistolesi E., *Descrizione di Roma*, Rome, 1856.

Pittaluga M., *Raffaello. Dipinti su tavola*, Milan, 1955.

*Pittura in Umbria tra il 1480 e il 1540. Premesse e sviluppi nei tempi di Perugino e Raffaello. V centenario della nascita di Raffaello*, edited by G. Guidi, P. Scarpellini, F.F. Mancini, Milan, 1983.

Pizzichi F., *Viaggio per l'Alta Italia del Ser. Principe di Toscana poi Gran Duca Cosimo III descritta da Filippo Pizzichi*, Florence, 1828.

Poggiali P., *Raphael in Rome. A study of art and life in the XVI century*, Rome, 1889.

Pommier E., "La notion de la grâce chez Winckelmann", in *Winckelmann: la naissance de l'histoire de l'art à l'époque des Lumières. Cycle de conférences du musée du Louvre (1989-1990)*, Paris, 1991, pp. 39-81.

Ponente N., *Qui était Raphael?*, Geneva, 1967.

Pope Hennessy J., *Raphael* (New York-Hagerstown-San Francisco-London, 1970), It. edition Turin, 1983.

Pope-Hennessy J. , *The Portrait in the Renaissance*, London-New York, 1966.

Popham A.E., "Drawings", in *A Commemorative catalogue of the Exhibition of Italian Art held in the galleries of the Royal Academy*, exhibition catalogue edited by Lord Balniel and K. Clark, London, 1931, pp. 236-237, no. 743.

Portigliotti G., "La morte di Raffaello", in *L'Illustrazione medica italiana*, II, 1920, pp. 23-26.

Pouncey P., Gere J.A., *Italian Drawings in the Department of Prints and Drawings in the British Museum. Raphael and his Circle*, 2 vol., London, 1962.

Pozzi C., *Il ritratto della donna nella poesia d'inizio 500 e la pittura di Giorgione*, in *Giorgione e l'umanesimo veneziano*, I, Florence, 1981, pp. 309-341.

Puccini T., *La Real Galleria di Firenze*, I, Florence, 1817.

Puccini T., *Lettere due del cavaliere Tommaso Puccini ad un amico intorno a due ritratti di mani di Raffaello da Urbino*, Venice, 1825.

Pungileoni L., *Elogio storico di Raffaello Santi da Urbino*, Urbino, 1829.

**Q**

Quatremère de Quincy A.C., *Istoria della vita e delle opere di Raffaello Sanzio di Urbino, voltata in italiano, corretta, illustrata ed ampliata per cura di Francesco Longhena* (Paris, 1824), Milan, 1829.

Quednau R., "Aspects of Raphael's 'ultima maniera' in the light of the Sala di Costantino", in *Raffaello a Roma. Il convegno del 1983*, Rome, 1986, pp. 235-250.

Quednau R., "Raphael und 'alcune stampe di maniera tedesca' "in *Zeitschrift für Kunstgeschichte*, XLVI, 1983, pp. 129-175.

**R**

Raczynsky A. N., *Les arts au Portugal*, Paris, 1846.

*Raffaello a Firenze. Dipinti e disegni delle collezioni fiorentine*, exhibition catalogue, Milan, 1984.

*Raffaello e Dante*, exhibition catalogue edited by C. Gizzi, Milan, 1992.

*Raffaello e i suoi. Disegni di Raffaello e della sua cerchia*, exhibition catalogue edited by D. Cordellier, B. Py, Rome, 1992.

*Raffaello e Michelangelo*, exhibition catalogue edited by A. Forlani Tempesti, Florence, 1984.

*Raffaello in Vaticano*, exhibition catalogue, Milan, 1984.

Raffaello, *Lettera a Castiglione*, in *Scritti d'arte del Cinquecento* (1971), Turin, 1979, pp. 1530-1531.

*Raffaello, Michelangelo e bottega. I cartoni farnesiani restaurati*, exhibition catalogue edited by R. Muzii, Napoli 1993.

*Raffaello. La Fornarina*, exhibition catalogue edited by L. Mochi Onori, Rome, 2000.

Ragghianti C. L., "Raffaello. Nota postuma. Raffaello a Firenze", in *Critica d'Arte*, N.S. 43, 1978, pp. 143-151.

Rambaldi L., "Donne e Madonne di Raffaello", in *La Donna*, 5-10 avril 1920, p. I-XVIII.

Ramirez di Montalvo A., *Catalogo dei disegni scelti della R. Galleria di Firenze*, manuscript stored at the Gabinetto Disegni e Stampe degli Uffizi, dated 1849.

Ranelli F., *Storia delle Belle Arti in Urbino*, Florence, 1845.

*Raphael and his Circle. Drawings from Windsor Castle*, exhibition catalogue edited by M. Clayton, London, 1999.

*Raphaël dans les collections françaises*, exhibition catalogue, Paris, 1983.

*Raphael in America*, exhibition catalogue edited by D.A. Brown, Washington D.C., 1983.

*Raphael Invenit. Stampe da Raffaello nelle collezioni dell'Istituto Nazionale per la Grafica*, edited by G. Bernini Pezzini, S. Massari, S. Prosperi Valenti Rodinò, Rome, 1985.

*Raphael Urbinas: il mito della*

*Fornarina*, exhibition catalogue edited by Englen A., Barbiellini Amidei R., Mochi Onori L., Milan, 1983.

*Raphael. The Holy Family with the Lamb of 1504. The original and its variants*, exhibition catalogue edited by J.M. Lehmann, Landshut, 1995.

*Raphael: The Pursuit of Perfection*, exhibition catalogue edited by A. Weston-Lewis, Edinburgh, 1994.

Ravaglia E., "Il volto romano di Beatrice da Ferrara", in *Roma*, I, 1923, pp. 53-61.

Ravazzini A., *Raffaello*, Bologna, 1939.

Redig de Campos D., *Raffaello e Michelangelo*, Rome, 1946.

Redig de Campos D., *Raffaello nelle Stanze*, Milan, 1965.

Rehberg F., *Raffael Sanzio aus Urbino*, Munich, 1824.

Rembadi D., *La Madonna del Libro. Quadretto in tavola di Raffaello Sanzio da Urbino*, Florence, 1873.

Renzetti L., *Raffaello e la Fornarina*, Urbino, 1912.

Reumont A., "Il ritratto della Fornarina", in *Archivio della Società Romana di Storia Patria*, III, 1880, pp. 233-235.

Reynolds J., *The life of Raffaello Sanzio da Urbino*, London, 1816.

Ricci A.M., "Di alcuni dipinti a fresco della scuola di Raffaello rinvenuti recentemente in Rieti", in *Effemeridi letterari*, 1822.

Ricci C., *Raffaello*, Milan, 1920.

Ricci S., *Leonardo, Raffaello, Michelangelo*, Milan, 1915.

Richard J., *Description historique et critique de l'Italie*, VI, Dijon-Paris, 1766.

Richardson J., *An account of the Statues, Bas Reliefs, Drawings and Pictures in Italy, France*, London, 1754.

Richter I.P., *La collezione Hertz e gli affreschi di Giulio Romano nel Palazzo Zuccari*, Rome, 1928.

Ridolfi E., "Di alcuni ritratti delle Gallerie fiorentine", in *Archivio Storico dell'Arte*, IV, 1891, pp. 425-455.

Riepenhausen, *Vita di Raffaello da Urbino, disegnata ed incisa*, Rome, 1833.

Ripa C., *Iconologia*, edited by P. Buscaroli, foreword by M. Praz, I e II, Turin, 1986.

Rizzatti L., *I Geni della Pittura. Raffaello*, Milan, 1975.

Rohlmann M., "Raffaels Sixtinische Madonna", in *Römisches Jahrbuch der Bibliotheca Hertziana*, 1995, 30, pp. 221-248.

*Roma e lo stile classico di Raffaello*, exhibition catalogue edited by K. Oberhuber et A. Gnamm, Milan, 1999.

Rondani A., "Discorso su Raffaello", in *Atti della Regia Accademia Raffaello in Urbino*, Urbino, 1873.

Rosa S., *Poesie e lettere edite e inedite*, edited by A. Cesareo, I, Naples, 1892.

Rosand D., "So-and-so reclining on her couch", in *La Venere di Urbino del Tiziano*, Cambridge, 1997.

Rosenberg A., Gronau G., *Raffael* (Stuttgart-Leipzig, 1904), Stuttgart-Leipzig, 1919.

Rosenberg P., *Raphael and France. The artist as paradigm and symbol*, n.p., 1995.

Rossi A., "I passaggi di proprietà, le stime e la vendita della Madonna del libro", in *Giornale di Erudizione Artistica*, VI, 1877, nos 11-12.

Rossi F., *Accademia Carrara*, Bergamo, 1979.

Rossini P., *Il Mercurio errante delle grandezze di Roma*, II (1693), Rome, 1760.

Rovigati Spagnoletti P., "Il trasporto di Cristo al Sepolcro e i disegni preparatori", in *Raffaello nelle Raccolte Borghese*, exhibition catalogue, Rome, 1984, pp. 33-49.

Ruland C., *The Works of Raphael Santi da Urbino, in the Raphael Collection in the Royal Library at Windsor Castle*, Weimar, 1876.

**S**

Sacchetti Sassetti A., *Lorenzo e Bartolomeo Torresani pittori del secolo XVI*, Rome, 1932.

Saccone E., *Grazia, Sprezzatura, Affettazione in the Courtier*, in *Castiglione. The Ideal and the Real Renaissance Culture*, edited by R. W. Hanning e D. Rosand, London, 1993, pp. 45-67.

Salmi M., *Raffaello*, Milan, 1961.

Salvini R., *Raffaello*, Milan, 1961.

Sandrart (von) J. *Teutsche Academie der Bau-Bildhauer und Mahlerei-Künste*, Nuremberg, 1675.

Sangiorgi F., "La Muta di Raffaello: considerazioni storico-iconografiche", in *Commentari*, XXIV/1-2, 1973, pp. 90-97.

Santi B., *Raffaello*, Florence, 1979.

Scannelli F., Il *Microcosmo della pittura*, III, Cesena, 1657.

Scarpellini P., *Perugino*, Milan, 1984.

Scherillo M., "Raffaello poeta e tra poeti", in *Emporium*, LI, 1920, pp. 198-208.

Schlegel (von) F., *Pagine su Raffaello*, edited by R. Assunto, Urbino, 1973.

Schlosser Magnino J., *La letteratura artistica*, Florence, 1935.

Schöne W., "Raphaels Krönung des Hl. Nikolaus von Tolentino", in *Eine Gabe der Freunde für Carl Georg Heise zum 28.VI.1950*, Berlin, 1950, pp. 113-136.

Schwarzenberg (von) E., "Raphael und die Psyche-Statue Agostino Chigis", in *Jahrbuch der Kunsthistorischen Sammlungen in Wien*, 1977, 73, N.F. Band XXXVII, pp. 107-136.

Scotti L., *Catalogo dei disegni originali dei pittori, scultori, et architetti, che si conservano nella celebre collezione esistente nella Imperiale e Reale Galleria di Firenze con note ed illustrazioni, Firenze 1832*, manuscript stored at the Gabinetto Disegni e Stampe degli Uffizi.

Sebastiani G., *Raffaello e la Fornarina*, lyric drama, 4 acts, Rome, 1878.

Serra L., *Raffaello Sanzio* (Rome, 1922), Turin, 1941.

Shearman J., "Die Loggia der Psyche in der Villa Farnesina und die Probleme der letzten Phase von Raffaels graphischen Stil", in *Jahrbuch der Kunsthistorischen Sammlungen in Wien*, 60, 1964, pp. 59-100.

Shearman J., "Le portrait de Baldassarre Castiglione par Raphaël", in *Revue du Louvre et des Musées de France*, no. 4, 1979, pp. 261-272.

Shearman J., "Le XVIᵉ siècle européen", in *The Burlington Magazine*, CVIII, 1966, pp. 59-67.

Shearman J., "Leonardo's Colour and chiaroscuro", in *Zeitschrift für Kunstgeschichte*, XXV, 1962, pp. 13-47.

Shearman J., *Only connect... Art and the spectator in the Italian Renaissance*, Princeton, 1992.

Shearman J., "Raphael at the Court of Urbino", in *The Burlington Magazine*, CXII, no. 803, February 1970, pp. 72-78.

Shearman J., "Raphael's Unexecuted Projects for the Stanze", in *Walter Friedlaender zum 90. Geburstag*, Berlin, 1965, pp. 157-180.

Shearman J., "The born architect? in Raphael before Rome", in *Studies in the History of Art*, 17, National Gallery of Art, Washington 1986, pp. 203-210.

Siepi S., *Descrizione topologica-istorica della città di Perugia*, Perugia, 1822.

Sohm P.L., "Affestation and Sprezzatura in 16ᵗʰ and early 17ᵗʰ Century Italian Painting, Prosody and Music, in Kunst, Musik, Schauspiel", in *Actes des XXV Internationalen Kongresses fuer Kunstgeschichte*, Vienna, 1985, vol. II, pp. 23-40.

Springer A., *Raphael und Michelangelo*, Leipzig, 1895.

Stendhal, *Idées italiennes sur quelque tableau célèbre*, in *Œuvres complètes*, Geneva, 1972, XLVII.

Stendhal, *Journal littéraire, Œuvres complètes*, XXXIII, Geneva, 1970.

Stendhal, *Promenades dans Rome*, Paris, 1973.

Strachey H., *Raphael*, London, 1907.

Strada G., *Sebastiani Serlii Bononiensis architecturae liber septimus*, Frankfurt, 1575.

Strinati C., "Raffaello", in *Art e Dossier*, encart, no. 97, January 1995.

Strocchi M.L., "Il Gabinetto d'opere in piccolo del Gran Principe Ferdinando a Poggio a Caiano", in *Paragone*, 309 and 311, 1975-1976, pp. 115-126 and pp. 83-116.

Suida W., *Raphael*, London, 1941.

**T**

Tarchiani N., "Committenti e mecenati", in *Il Marzocco*, 4 avril 1920, p. 4.

Tarchiani N., *Ritratti e dipinti vari*, Florence, 1920.

Tatarkiewícz W., *L'esthétique italienne de la Renaissance*, Turin, 1969.

Tàtrai V., *Museum of Fine Arts: Old Masters Gallery*, Budapest 1991.

Tea E., *Raffaello*, Brescia, 1963.

Tervarent (de) G., *Attributs et symboles dans l'art profane 1450-1600* (Geneva, 1958), Geneva, 1977.

Tetius H., *Aedes Barberinae ad Quirinalem*, Rome, 1642.

*The Engravings of Marcantonio Raimondi*, exhibition cata-

logue edited by E.H. Shoemaker, Lawrence 1981.

Tinagli P., *Women in Italian Renaissance Art. Gender, Representation, Identity*, Manchester-New York, 1997.

Titi F., *Descrizione delle pitture, sculture e architetture esposte al pubblico a Roma*, Rome, 1763.

Toscani O., *Alla finestra della Fornarina. Serenata*, in *L'Associazione artistica internazionale di Roma nel IV centenario della nascita di Raffaello*, Rome, 1883, pp. 43-46.

Toulgaet (De) E., *Les Musées de Roma*, Paris, 1867.

Touriseus E., *Catalogue des estampes gravées d'après Raphaël*, Frankfurt, 1819.

**U**

Ugolini L., *Il romanzo di Raffaello*, Turin, 1943.

Ullmann E., *Raffael* (Leipzig 1983), Leipzig, 1991.

*Urbino e le Marche prima e dopo Raffaello*, exhibition catalogue edited by M.G. Ciardi Dupré Dal Poggetto and P. Dal Poggetto, Florence, 1983.

Urlichs L., "Beiträge zur Geschichte der Kunstbestrebungen und Sammlungen Kaiser Rudolph II", in Zeitschrift für *Bildende Kunst*, V, 1870, pp. 50-51.

**V**

Valentini S., *Roma antica e moderna*, Rome, 1750.

Valeri A., "Nelle feste di Urbino, Chi era la Fornarina?", in *La vita italiana*, III, 1897, no. 17, pp. 353-363.

Valery M., (Antoine Claude Pasquin), *Voyages historiques et littéraires en Italie, pendant les années 1826, 1827 et 1828 ou l'Indicateur italien*, 3 vol., Paris, 1831-1832.

Valsecchi M., *Raffaello Sanzio (1483-1520)*, Milan, 1960.

Van Marle R., *Iconographie de l'Art Profane au Moyen Age et à la Renaissance*, The Hague, 1931.

Vanzolini G., "Dei sonetti di Raffaello Sanzio", in *Rassegna bibliografica dell'arte italiana*, V, 1902, pp. 41-45.

Varchi B., "Lezzione nella quale si disputa della maggioranza delle arti e qual sia più nobile, la scultura o la pittura", in P. Barocchi, *Trattati d'arte del Cinquecento fra Manierismo e Controriforma*, I, Bari, 1960, pp. 1-58.

Varchi B., "Libro della beltà e grazia", in P. Barocchi, *Trattati d'arte del Cinquecento fra Manierismo e Controriforma*, I, Bari, 1960, pp. 85-91.

Vasari G., *Le Opere di Giorgio Vasari*, edited by G. Milanesi (Florence, 1878-1885, 1906), Florence, 1973, IV, pp. 315-416.

Vasari G., *Le Vite de' più eccellenti pittori, scultori ed architettori italiani*, edited by L. Bellosi et A. Rossi, presentation by G. Previtali, Turin, 1986.

Vasari G., *Le Vite de' più eccellenti*, transl., edition and comments by A. Chastel, Paris, 1984.

Vasari G., "Proemio" of the 3rd part and "Vita di Raffaello da Urbino pittore e architetto", in *Le Vite dei più eccellenti pittori, scultori e architettori*, Florence, 1568, edited by R. Bettarini and P. Barocchi, Florence, 1976, vol. IV, pp. 155-214.

Vasari G., "Vita di Tiziano da Cador pittore", in *Le Vite de' più eccellenti Pittori, scultori ed architettori scritte da G. Vasari*, notes and comments by G. Milanesi, IV (Florence, 1878-1885, 1906) Florence, 1973, vol. I.

Venosta F., *Raffaello e la Fornarina, racconto storico del secolo XVI*, Milan, 1874.

Venturi A., *Il Museo e la Galleria Borghese*, Rome, 1893.

Venturi A., "I quadri di scuola italiana nella Galleria Nazionale di Budapest", in *L'Arte*, III, 1900, pp. 185-240.

Venturi A., *Raffaello*, Rome, 1920.

Venturi A., *Orme di Raffaello in Roma*, Rome, 1924.

Venturi A., *Storia dell'arte italiana*, Milan, 1901-1940; *La pittura del Cinquecento*, vol. IX, Milan, 1926.

Venturi R., *Accurata e succinta descrizione topografica e istorica di Roma moderna*, I, Rome, 1767.

Venuti R., *Accurata e succinta descrizione topografica e istorica di Roma moderna*, Rome, 1767.

Viardot L., *Les musées de l'Allemagne et de Russie*, Paris, 1844.

Viatte F., "Les débuts, 1500-1504", in *Raphaël dans les collections françaises*, exhibition catalogue, Paris, 1983, pp. 163-198.

Vigny (de) A., *Le Journal 1er juillet 1833*, in *Œuvres complètes*, Paris, 1948, II, pp. 992-993.

Vittoria V., *Osservazioni sopra il Libro della Felsina Pittrice per difesa di Raffaello*, Rome, 1703.

*Vivant Denon. Directeur des Musées sous le Consulat et l'Empire. Correspondance (1802-1815)*, 2 vol., Paris, 1999.

Volpe C., "Due questioni raffaellesche", in *Paragone*, VII, mars 1956, no. 75, pp. 3-18.

Volpe C., "Notizia e discussione su Raffaello giovane", in *Arte Antica e Moderna*, January-March 1962, pp 79-85.

Von Arnim L. A., "Raphael und seine Nachbarinnen", in *Taschenbuch zurn geselligen vergnügen auf das Jahr 1824*, Leipzig, 1824.

Von Braun G.C., *Raphael's Leben und Werke*, Wiesbaden, 1815.

Von Rumohr C.F., *Italienische Forschungen*, III, Berlin-Stettin, 1831.

**W**

Waagen G.F., "über in Spanien vorhandene Bilder", in *Zahn's Jahrbücher für Kunstwissenschaft*, I, 1868, pp. 89 ff.

Wackenroder W. H., *Effusioni di un monaco amante dell'arte*, n.p., 1797.

Wagner C., *Farbe und Metapher: Die Entstehung einer neuzeitlichen Bildmetaphorik in der vorrömischen Malerei Raphaels*, Berlin, 1999.

Wagner H., *Raffael im Bildnis*, Berne, 1969.

Walter J., "Ginevra de' Benci by Leonardo da Vinci", in *National Gallery of Art. Report and Studies in the History of Art*, 1967.

Wanscher V., *Raffaello Santi da Urbino his life and Works*, London, 1926.

Weil-Garris Brandt K., "Raffaello e la scultura del Cinquecento", in *Raffaello in Vaticano*, exhibition catalogue, Milan, 1984, pp. 221-245.

Weil-Garris K., "Raphael's Transfiguration and the Legacy of Leonardo", in *The Art Quarterly*, XXXV, 1972, pp. 342-374.

Welker H., "Die Raffael Portraits", in *Zeitschrift für bildende Kunst*, XXIII, 1888, pp. 17-24.

Wind E., "Charity. The case history of a pattern", in *Journal of the Warburg and Courtauld Institutes*, I, 1938, pp. 322-330.

Wright E., *Some observations made in travelling through France, Italy, in the Years 1720, 1721 and 1722*, London, 1730.

**Y**

Young P., Joannides P., "Giulio Romano's Madonna at Apsley House", in *The Burlington Magazine*, 137, 1995, pp. 728-736.

**Z**

Zampa G., *L'opera completa di Dürer*, Milan, 1968.

Zanotto F., *Trenta disegni di Raffaello posseduti dalla I.R. Accademia di Venezia*, Venice, 1860.

Zazzaretta A., "I sonetti di Raffaello", in *L'Arte*